Arts for Change

Arts for Change

Teaching Outside the Frame

by Beverly Naidus

New Village Press • Oakland, CA

Published by
New Village Press
PO Box 3049
Oakland, CA 94609
Orders: 510 420-1361
press@newvillage.net
www.newvillagepress.net

New Village Press is a public benefit, not-for-profit publishing venture of Architects/Designers/Planners for Social Responsibility. www.adpsr.org

Front cover illustration: "Mama Mammogram Queen" by Beverly Naidus
Back cover author photo by Shahreyar Ataie
Cover design by Lynne Elizabeth
Interior book design by Leigh McLellan Design

Printed and bound in Canada.

The text of the book is printed on acid-free, 100% post-consumer re-cycled paper. No trees have been cut to make this paper. No chlorine has been used to process this paper.

In support of the Greenpress Initiative, New Village Press is committed to the preservation of Endangered Forests globally and advancing best practices within the book and paper industries.

ISBN 978-0-9815593-0-8

Library of Congress Cataloging-in-Publication Data

Naidus, Beverly, 1953-
 Arts for change : teaching outside the frame / by Beverly Naidus.
 p. cm.
 Includes bibliographical references.
 ISBN 978-0-9815593-0-8 (trade pbk. : alk. paper)
 1. Art—Study and teaching (Higher)—Political aspects—United States. 2. Art and social action. I. Title.
 N345.N25 2009
 707.1'173—dc22 2008054292

Contents

Acknowledgments ix

Preface An Anchor xi
First, Eat a Rose xi

Prologue Present Moment xv

1 Words as a Compass 1
An Expansive View 4
Relaxing into Theory 5
They Sing, Therefore They Will Pay 6

2 Avoiding Amnesia 9
History Lesson #1: Ancient Roots 9
History Lesson #2: The WPA 12
History Lesson #3: Red Scare Redux 16
History Lesson #4: The Cold War Chills the Art World 18
Cracks in the Folds 21

3 How an Art Practice Morphs into Pedagogy 23

Stories of Mrs. Generic 30

Art Ed, Revised 32

Liberatory Education 38

Subverting in the Museum 42

A More Distinct Definition of Community Art Practices 44

Then Find a Garden 47

Activist Art in Community 48

4 Facilitating an Interdisciplinary Arts Curriculum 51

Arts in Community at the University of Washington, Tacoma 54

The Current Curriculum: Teaching Art to Non-Majors 57

Eco-Art: Creating Art in Response to the Environmental Crisis 59

Art in a Time of War 71

Body Image and Art 80

Labor, Globalization, and Art 88

Cultural Identity and Art 98

Idealism Aside: What Makes this Work Really Hard 105

Pulling Apart the Questions in the Creases 109

5 My Peers: Who Can't Be Easily Framed (Thank Goodness) 111

Martha Rosler 115

Suzanne Lacy 117

Amalia Mesa Bains 118

Stephanie Anne Johnson 120

Deborah Barndt 122

Olivia Gude 125

Krzysztof Wodiczko 129

Sheila Pinkel 130

Nancy Buchanan 133

David Haley 135

Richard Kamler 137

Sharon Siskin 138

Fred Lonidier 141
Ruth Wallen 142
Ruthann Godollei 144
Greg Sholette 147
Jerri Allyn 148
Karen Atkinson 151
Keith Hennessey 152
Ann Rosenthal 155
Mindy Nierenberg 157
Ju-Pong Lin 159
John Jota Leaños 161

In the Fertile Margins 163

Magdalena Gomez 164
Loraine Leeson 167
Devora Neumark 169
Jane Trowell 171
Elaine Carol 174
John Jordan 176

The Next Generation 179

Emily Caigan 179
Sarah Kanouse 181
John Feodorov 183
Beth Ferguson 185

Strengthening the Immune System 187

6 Toward a Liberatory Art Practice 189

Considering Cuba, A Frame Unhinged 189
Good Intentions, Rotten Pie 195
The Dream Behind the Nightmare 197
The Crack in the Now 201
Folding in the Roar 204

Appendix 207

Socially Engaged Art Bibliography 217

Notes 233

About the Author 239

Dedication

*This book is dedicated to my ninety-year-young mom,
Rhoda Seretean Naidus, who has been a teacher at her core,
although she hasn't taught in a formal classroom for many,
many decades. She has continually offered me a passion for
research and critical thinking, an inexhaustible generosity
to share information, a thirst for social justice, and a deep
appreciation for cross-cultural communication.*

*I also dedicate this book to my teachers, especially the
ones I never acknowledged and to my many students,
who were some of my best teachers.*

Acknowledgments

Many thanks to the enthusiastic publishers at New Village Press, Lynne Elizabeth and Karen Stewart, without whom this book may have miscarried, and to all the remarkable and often unsung artist-teachers who gave of their valuable time to participate in this book.

Blessings go to my readers, Charles Frederick, Bob Spivey, Margot Boyer, Barbara Resnick, and Anne Petrocci. Without their efforts this book might have floundered on the shores of endless explanations and redundancies.

Deep gratitude and love goes to my teenage son Sam, for his unexpected but invaluable pep talks. On our precious evening walks in the woods, he shared his passion for alternative rock, hilarious jokes, and his unhidden despair about the future his generation will inherit.

And to Bob, my life partner, for resiliently living through this writing process with a woman consumed by continual deadlines and an often-profound sense of being overwhelmed. For twenty years he has continuously offered his advice, encouragement, and love, and most recently helped to create the space for this book to emerge.

A book written as a montage of ideas, memories, histories, herstories, and fable requires a simple anchor to moor the reader. In these pages you will find multiple ways of thinking about how pedagogy, the arts, and social change intertwine. I have combined personal memoir with theory born organically from experience and readings, and some relevant chapters of social and cultural history.

Reclaiming the idea that art can act as both a deconstructive force (to analyze and question what exists and existed) and as a reconstructive one (providing a visionary role) is a pivotal theme within these pages. I dare the reader, along with my students, to imagine the world we want and to think utopically, about how things ought to or could be, rather than just consider how they are.

As added inspiration for the reader, thirty-three practitioners offer different perspectives from our field, along with curricular and practical information about how to teach art from a socially engaged and interdisciplinary perspective. Sewn into the seams of this book is a fable that emerged quite unexpectedly. May readers take what they need from these words and images as fuel for the journey ahead.

First, Eat a Rose

There once was a sweet ball of a girl, who bounced around the room, rebounding off the walls and floor and ceiling, with questions and delighted squeals. This honey-brown girl radiated a warm light that had so much energy it couldn't

be contained; she was glad there was an outside to go to where she could inhale more deeply. There she crawled through thick, neat rows of planted tomatoes, snow peas, and cucumbers; the seemingly uncontrollable tangles of vines reached out to her as she dug her bare heels and toes into the humus. The beauty of the bounty made her want to eat, and so she grazed like any good forager on berries and leaves of mint, and popped roses into her mouth, not knowing they weren't food. Beauty asks to be eaten, she thought. Although the words came out more like, "Pretty—must eat."

Her wanderings took her to magic rocks that provided steppingstones into other worlds. Under almost every one, if she looked carefully, she found elaborate, delicate strangers, busy with the events of their day, and often oblivious to her gaze. Eventually both their predictability (there was always some creature under a rock) and their surprises (they're not here today; where'd they go? Hey, you're new) won her over. Bugs were her friends, and snakes (if she was so lucky), and frogs and toads. Outside was where the friends were always available for tea and conversation. They didn't mind if she stared, and didn't care if her hair was a mess or if she chattered incessantly.

When she couldn't go outdoors, she explored the cozy pleasure of closets, where the hanging clothes embraced her with vast histories she didn't understand. The pungent smells of tangy leather, mothballed wool and freshly washed dresses became a refuge, and nameless mysteries surrounded her there.

As the family moved from town to town, it seemed that each time they arrived at a harsher place. Unfair things, mocking voices, and uncomfortable events began to accumulate, like too many scraped knees and elbows, and they folded her energy in on itself, several times over. The folds contained the shapes of things that she couldn't make sense of, so out of some innate stubbornness, she wandered outside to another, much bigger garden. There were more rocks to lift up, and bugs that were loyal to her and continually full of surprises. Here the trees began to talk. She didn't understand their language completely, but she had so much gratitude that she would share her secrets with special ones, and ask for their forgiveness when she carved bumps off their bark, like a monkey removing fleas from a family member.

One day she began to sing, as a way to push away the small pains and rejoice for the sweet ball of a girl who was still alive (after being folded inside herself many times), and the sound glided with effortless grace from her belly to her tongue, giving back roses to the world. Her voice joined with others in chorus, and she felt herself lifted off the ground, and carried by something bigger than she could imagine, and when she was asked to sing alone, to offer up her unique roses, she felt something powerful tugging inside and the unfolding was exquisite.

At some point her differences, and there were so many, became apparent to others and were named back to her, often harshly, and with hate in people's voices; some she didn't understand, others she did too well, and she began to sink into the folded place for longer times with sticky things she couldn't pull off; and then suddenly the voice that vibrated with roses was left behind by an embarrassing moment on stage. She was lacking in sufficient poise to turn her gaffe into a joke. But being the trooper that she was, she finished her performance. There was no mentor or coach to erase the chorus of cruel laughter, for such a one did not exist in her life. She was left to imagine herself deeply flawed, and the sweet ball of a girl grew quiet.

Still the swirling, golden, energy creature could come alive unexpectedly through dance, and she would leap and crouch and wiggle, delirious in those moments, before the clumsy lessons of some folded-in teacher made her ache to escape, and similarly she could move into a trance while running her fingers in special, made-up patterns on the keyboard of her dad's piano, where he always played the same beloved song, "Greensleeves", over and over. Her patterns became ocean waves that had storms and eddies, twisting the girl into a place of such rightness that she had no words for it; that something called her inside and then out again. At the end of the concert she played for herself, she felt open-hearted, just like the bugs who asked for nothing.

Lessons were imagined to shape the wildness; the first teacher allowed the ball of a girl to breathe, but the next was such a cruel abomination that the piano bench became a straitjacket. No more concerts called her. Sticky, ugly names accumulated.

One day the folded-in girl started to draw, and it pleased her. There were no roses evident; in fact there was barbed wire—twirling ribbons of it crawled across paper, turning into thorns and then faces and back again. Within these patterns there was some secret key she didn't understand, but she kept it close.

Wandering into a room in a museum one day, she found a painting called Hide-and-Seek[1]. *In it was a dark, large tree radiating with hot yellows and burning reds, embraced and pierced by many swirling children, some burning into the bark, becoming one with the tree. Although the patterns were different than hers, she recognized another key. In the next room, a quiet room, where she was allowed to sit all alone and where the minutes disappeared, she found two more paintings that became her friends, like the bugs who let her stare at them for hours. She was allowed to stare at the screaming baby with its large, pained head, an even larger head behind it, amplifying the agony, surrounded in the gray-browns of industrial trash, not folded in, demanding redress. She read the title,* Echo of a Scream[2] *and kept it close, even though it scared her.*

Years passed, and the folded-in girl learned to cross her legs tightly together, hold her skirt down around her knees, and keep the questions inside, a limp arm, once always raised, sat still at her side. Yet the pattern making remained, and morphed into paintings of nightmares and the various shadow worlds of adolescence. She haunted the library stacks, where books fell out into her arms, claiming her, claiming attention: books about war, nuclear war and sufferings so vast that she could not swallow them.

Another pulse grew in her, something demanding attention. That combined with the nightly news that poured body counts on the dinner table, began an insistent call to grow her toolbox. And so she found her way to poetry where she wrote of punches, shattering panes of glass, and a world where a broken heart was first felt, as new to her, offering a sadness she couldn't contain.

The sweet ball of a girl/woman had found a few non-bug friends by this time. They read long poems that bled, danced to pulsating beats, and went on long pilgrimages through what little remained of the nearby woodlands, stopping to do sun salutations and share hallucinations when the moment seized them. Their swirling energy broke through their folded-in selves and held her in an exuberant embrace. They tried to peel off some of the sticky names.

With the courage born of these friendships, the sweet ball of a girl/woman put on the most gnarled mask she could find, a shadow self, and got on stage again. Her improvisations of hobbling, deranged ladies, and coughing, tubercular women put some bounce in her gait, made her feel the exquisite delight of stretching out folds and grasping at roses. She didn't know where these characters were channeled from, but they arrived in her young, ball-of-fire body, that shifted from folding into bouncing in very unexpected ways.

In college, the question became whether to choose the stage or the room alone. The folded-in girl/woman pushed her into the room alone with a view of horizon lines expanding in all directions, and she watched balls of energy bounce off the walls. She didn't know how to understand them. She lived above the neck in that room, and couldn't recognize the sweet ball of a girl or her folded-in twin, although the two began to fight. She dived below the neck in all sorts of counterculture ways, where she saw the sweet ball of a girl standing alone in dark corners, and occasionally was able to nudge her out to stand in the sun.

prologue
Present Moment

I am trying to imagine this book being read ten or twenty years from now, and what the reader looking back at this time is thinking about this moment in history, a moment that for many carries enormous weight. Immense and complex problems need to be faced if our species will survive the next century.

A year ago, when gas prices were two dollars lower per gallon, it seemed that most of the public was still in a profound state of denial. I wrote then: *The sun is shining and warm this morning, after one of the coolest and wettest summers on record. One can feel the long "ahhhhh" of relief from other ferry passengers quietly dozing in their cars as we wait for the next boat on this Monday morning. With the newly washed view of the Olympic Mountains, it's possible to imagine that there is nothing to worry about, that the world is in good shape. The sense of isolation, anxiety and hopelessness that fills many lives can be pushed away as one contemplates the next latte, the next deadline, and the spectacular view. In this moment, where all seems soothed by the gentle roll of the icy blue, it is hard to imagine that the polar caps are melting or that innocents are being bombed in lands across the sea.*

All of these circumstances exist simultaneously in this moment. Like a roulette wheel with multiple balls each representing some unbearable suffering, they land at different stops all at the same time. Some of us see these things, and some of us just don't. The latter's blindness often amazes those of us who do see. Being able to see can be dangerous: we weren't physiologically designed to contain so much pain. In order to keep ourselves whole, we look for ways to process it all.

In what has appeared to be very little time, unprecedented numbers of people have begun to awaken to the immensity of global warming because it has landed in their pockets. This coming to our senses is partly due to the artificially inflated prices of gasoline, the repercussions on the whole economy (and the current crisis on Wall Street) and the dramatic changes in weather patterns; the effect on everyday life has been devastating for many. Vast numbers of people, mostly of the quickly decreasing white middle class, have finally wrapped their heads around *change* of enormous proportions and taken it in. Having people imagine new shorelines and displaced populations is no longer an impossible task. People are reacting with anger, but often with no skills to understand how to process or make sense of the mess. Many are in that place of choosing fundamentalist thinking (scapegoating someone or thinking of it as "God's will") or paralyzing despair. Activists who have been working on these issues, some for decades, have other suggestions, but few have venues in which to be heard in the mainstream. Often *we* are cast as the danger, rather than the danger itself being acknowledged.

All humans need to grab hold of something mythic in order to make their daily experiences, good or bad, coherent. Even the most secular among us has some scientific theory to explain reality, and, as provable as that theory might be, it is just another frame in which to perceive things.

The awesome predictability of the sun, moon, and the seasons worked for many of our ancestors as the essential grounding pieces of life. Some of the first images created by humans were celebrations of those natural cycles. What we call art reinforced that wholeness.

A symbolic life (imagery, artifacts, dance, music, poetry and ritual) emerged from early peoples as a way to make the chaos hold together. Most of what has been left behind remains mysterious to us, like Stonehenge, but we can see that art making was a fundamental human impulse and continues to be one, despite the fragmentation in our current civilization.

Art has both served the powers that be, and subverted them. When it is domesticated as entertainment and propaganda, it is allowed space and status. When it becomes a truth teller, a healer, a form of resistance and a promoter of dialogue, it is often shut down and called dangerous.

In this book, we will be exploring why art can be an essential part of the social transformation and healing that needs to happen if we are to survive and thrive as a species. The conflicts and struggles that have developed our zeitgeist are reaching their endgame. Art, in its many manifestations, can help us find the vision to move through this time. The scope of the art we will examine is very wide and inviting. Art can provide a means for processing paradox in this moment, this present moment.

Words as a Compass

Words have become my compass in this chapter of my journey, to help me expose a complex field, a practice, sometimes called "art for social change," and look at how it is shared with students.

I have battled with a discursive, formal voice that wanted to dictate lists of what to think about and explain every detail. That voice, at one point, turned into something predictable, unlike the practice I want the reader to embrace. So I will bring out *the sweet ball of a girl* to help the energy when it lags. She is holding the compass.

In part, this book was written to counter the fear-based attitude that all movements for social change will inevitably result in a totalitarian state. Seeing that there are other possibilities beyond the corrupt model of the Stalinist dictatorship requires a capacity to see and critique the evidence, retrieve other more positive examples, and imagine new ways of community and society self-organizing. Cultural work can be a significant part of developing fresh approaches to social change.

Just as importantly, I have written to confront another attitude that I have encountered numerous times over the years: *Art that intends to provoke social change is informed by some dogmatic approach and will "beat people over the head" with its point of view.* I have heard this perspective so frequently, especially from artists, that I wanted to look at the roots of this opinion.

What really makes me curious about this moment in history is how so many artists say that they are not fueled by any ideological position in their

work. At different points this book will examine more carefully how privilege creates an ideology of "not having an ideology."

Socially engaged art, as my peers and I have experienced it, is created in an expansive place that awakens peoples' voices, minds and spirits in various ways. As for the clubs beating people over the heads, I am more concerned about the real ones that might hit my *compañeros* when they demonstrate for peace and equal rights, than ones that might emerge from a sincere heart.

These pages offer a multifaceted view of an art practice that is not as common as it could be. It is a practice of many threads each needing encouragement and support so that wary neophytes might find a thread of their own to follow. Some versions are gentler than others, and there is no shaming involved in choosing one strategy versus another. There are mural makers, songwriters and cartoonists, collaborative groups of puppeteers, dancers and clowns; communities revealing their stories through photo-documentaries, cookbooks, cyber art, tapestries and theater; there's eco-art, interventionist art, and people doing site-specific, audience-participatory installations; there are poster artists, filmmakers, culture jammers, weavers and community *animateurs*. There is no one way to transform our society into a non-oppressive, egalitarian place, but there is a multitude of ways to meet our human craving for poetry in a socially engaged way.

● ● ●

On the morning that I write this paragraph, the headline from a British newspaper shouts "Earth Is Reaching the Point of No Return Says Major UN Environment Report." The alarm in this headline is not new, but most of us are less prepared to respond to it in useful ways. Humanity has come to many crisis points in its history, but perhaps never to one that has threatened the future of the species as gravely as now. That so many people seem to still be so ignorant to this fact, or perhaps unmoved by it, is disquieting. Also truly disturbing, is the common belief that most folks are just plain apathetic.

Those of us who are engaged with social change can get easily discouraged when we see how many seemingly insurmountable problems get added to our list everyday. But there are reasons to take heart. Paul Hawken stated in his address at the 2007 Bioneers conference,

> It is my belief that we are part of a movement that is greater and deeper and broader than we ourselves know or can know. It flies under the radar of the media, by and large. It is nonviolent. It is grassroots. It has no cluster bombs, no armies, and no helicopters. It has no central ideology. A male vertebrate is not in charge. This unnamed movement is the most diverse

movement the world has ever seen. The very word "movement," I think, is too small to describe it. No one started this worldview. No one is in charge of it. There is no orthodoxy. It is global, classless, unquenchable and tireless. This shared understanding is arising, spontaneous, from different economic sectors, cultures, regions and cohorts. It is growing and spreading worldwide with no exception. It has many roots, but primarily the origins are indigenous culture, the environment and social justice movements. Those three sectors, and their sub-sectors, are intertwining, morphing, enlarging. This is no longer simply about resources or infractions or injustice. This is fundamentally a civil rights—a human rights—movement. This is a democracy movement. It is the coming world. It may be 500,000 groups. We don't know how big this movement is. It is marked by kinship, community and symbiosis. It is Pachamama. It is the earth waking up.

Hawken's video of this talk is so moving that I routinely show it to my students when what they are learning about the world depresses them. His words work magic among those of us who are burnt out and discouraged. Still it is important to say that the movements that Hawken refers to are part of a long river of people rising up against oppression. The river has been flowing for centuries, for millennia, forever. As part of the work we do as educators, we not only need to inspire and create more momentum for the cultural aspects of these movements, we need to contextualize and critique what we do, as well.

The late C. L. R. James, the Afro-Trinidadian intellectual, writer, organizer, and revolutionary, put it this way back in 1968:

> The whole world today lives in the shadow of state power. . . . this state power, by whatever names it is called, one-party state or welfare state, destroys all pretense of government by the people, of the people. All that remains is government FOR the people. Against this monster, people all over the world, and particularly ordinary working people in factories, mines, fields and offices, are rebelling every day in ways of their own invention. Sometimes their struggles are on a small, personal scale. More effectively they are the actions of groups, formal or informal, but always unofficial, organized around their work and their place of work. Always the aim is to regain control over their own conditions of life and their relations with one another. Their strivings, their struggles, their methods, have few chroniclers. They themselves are constantly attempting various forms of organization, uncertain of where the struggle is going to end. Nevertheless, they are imbued with one fundamental certainty,

that they have to destroy the continuously mounting bureaucratic mass or be themselves destroyed by it.[1]

There have been choruses of people writing about social change and ways to achieve it, and while this book mentions some of their writings and ideas, it is not intended to be a compendium of these. Like an annotated road map, I will be sharing a few key places I have traveled, like the inns of my pilgrimage, that readers might visit to fertilize their own thinking on these issues.

Knowing that we have a multitude of challenges and a long row to hoe, we need communities that are grounded, imaginative, open-hearted, questioning and well-informed. Bringing a socially engaged art practice to communities in a way that can be non-threatening and inviting might be one of the most crucial pieces necessary for social change.

Perhaps this project we are engaged in is the ultimate act of faith.

I am trying to imagine a wonderful dream called the future, where people use art every day to orient themselves, to process their dreams, to think about their next move, to strategize, to focus, to deliberate, and to pull strands of history together into an elaborate weaving. Like the utopias so gorgeously depicted by Starhawk and Marge Piercy, the people dance when they are moved to, they sing of their pain and their glories, they create performance to highlight the contradictions, the foolishness, and the hypocrisy in their lives. They paint for joy and celebration and to honor the suffering of those who went before them. They make artifacts that are used in rituals that create meaning. This is the world I am imagining, the dream behind the dream, a world we have to imagine if we are going to continue.

An Expansive View

Before I get too far ahead of myself, the girl holding the compass has asked me to define socially engaged art. At the roots of its meaning, engagement means connection, so we can first understand this kind of art as one that is about connecting the pieces, connecting people with their feelings, their pasts, their dreams, and each other. One of my standard definitions has been that such art talks about social issues that affect the lives of individuals and communities. The real distinction between socially engaged and activist art can be understood as one of alignment. Socially engaged work can be done in isolation or within community but usually activist art explicitly or implicitly aligns itself with a social movement of some sort.

Some of my colleagues differ with me on this issue, saying that the words are interchangeable, and a few believe that spending too much time

defining the field may distract us from our real task, doing the work. It has been suggested that the terms used to describe this practice change, just like fashions change. In the end, it is what the work means to the communities in which it is made that is most important.

Socially engaged art can be made with many intentions, including:

- to process or document something that the artist has experienced or witnessed,
- to offer questions about—or solutions to—particular problems,
- to foster dialogue between polarized groups,
- to awaken those who are numb or in denial,
- to compensate for social amnesia,
- to heal the maker,
- to make the invisible visible,
- to express outrage, alert and alarm,
- to stretch the mind,
- to develop positive images of the future and to envision a different reality,
- to find others of like minds,
- to make what is most compelling and beautiful in image, object, word, motion and sound.

I have tended to use the term "socially engaged" throughout the book. The reasoning behind this choice is that my students find the term more inclusive than "activist," and many of them have negative associations with activism (the causes of which we will look at shortly).

Relaxing into Theory

I write this book with daily ambivalence. An internalized judge sits worrying that my examination of the issues will be perceived as being too parochial, too self-absorbed and will, at its core, disappoint readers. Knowing as much as I do about the perils of creating a new work of art, I am developing compassion for that inner judge as she lurks, taking me to task and away from task, waiting for the passion to overcome the self-doubts. Mindfully and persistently wrestling with that voice is helping me develop the compassion necessary to teach others—and to teach myself.

Ultimately I have given myself the space to be carried by the words and the shapes of the stories, knowing that they need to be expressed in the world. If the gait of my language is unconventional, in its shifts from formal sobriety to a casual patter, imagine that we are sitting in a classroom together. I am

working toward this rhythm. If you are expecting a more rigorous theoretical work, please open your mind to a less coded way of theorizing experience.

My good friend and mentor Charles Frederick, a cultural activist and theorist, reminds me that over two decades ago, I told him I didn't like theory and then admitted that I was afraid of it. I frankly didn't know what theory was then, except that I would fall asleep reading it, getting lost in countless cryptic turns of phrase. When I attempted yet another foray, I would spend half my time looking up the latest trendy words and I would lose patience with the process. It made me feel intellectually inept, without the muscles to compete. Thankfully, over the years, I have been offered new definitions of theory from reading people like bell hooks[2] and from working with Chaia Heller[3] at the Institute for Social Ecology in Vermont.

Theory is not necessarily stuff that is unreadable, incomprehensible, and elitist. It can be an articulation of an understanding that comes from lived experiences. Without that comprehension, people would continually live with a fragmented misunderstanding of what surrounds them daily. Movements of resistance against dominant culture, artistic or otherwise, have either consciously or unconsciously embodied a theory that pushes their ideas forward.

The artist and teacher S. A. Bachman describes theory in this way: "Both art and theory are transformative cultural practices. Artists are often creating and illuminating new theories in the process of making. We are all engaged with theory—we negotiate theoretical models constantly in our daily lives—some are simply more invisible than others."

So here I am, twenty-five years since my claim that theory didn't work for me, combining polemics with lived experience, putting together theories about all of it. It is up to you the reader to find out where it makes sense and where it is useful.

"They Sing, Therefore They Will Pay"

When I was in graduate school I read an essay by ethnopsychiatrist George Devereux that included a description of a conversation between seventeenth-century French cardinal Jules Mazarin and Louis XIII. Cardinal Mazarin and Louis XIII were in the palace, listening to a wandering minstrel singing in the street far below them. The song complained bitterly about the rising taxes and loudly critiqued the corruption of the monarchy and the church. The king was dismayed upon hearing these lyrics, and asked Mazarin whether he should jail the singer. Mazarin smiled and said, "They sing, therefore they will pay." Devereux used this story to illustrate how art can be "a harmless safety valve," and then added, "when the press or art is truly influential, it is made

unfree. The American press and the American artist are free only because they have either muzzled themselves or they have nothing upsetting to say." Devereux went on to suggest that defining art as outside ordinary reality allows it to make statements not ordinarily permitted. Quoting Devereux, Mari Womack says in her book *Symbols and Meaning*[4] that art can provide an impetus for change, while preserving the status quo, but at the same time, because it takes place in a symbolic world, it allows for the taboo to be spoken, and that taboo might rise to the surface in public eventually. In other words, it is very possible that the song of our wandering minstrel may eventually encourage the people to rise up and demand change.

Over the years, I have thought about this story and the complex questions it raises. Whenever I lose faith in the work that I do as an artist, and wonder whether it will really make a deep impression, I think about steam rising out of the pressure cooker and wonder if it would be better to give up my art for the direct action of street activism. Many of the artists in this book face this question as well, and have had chapters in their lives where their roles as artists takes have taken a back seat to their roles as activists, or have found different ways of merging these roles. Others believe that the work of social change is necessarily shared and integrated by many walks of life and professions. To imagine that the work of activist artists and engaged teachers is sufficient for the shifting that needs to happen shows a lack of understanding of the larger puzzle of which we're all a part.

2

Avoiding Amnesia

History Lesson #1: Ancient Roots

When I sit down to write or make a drawing, I don't always have a coherent idea in mind. Often it is an amorphous feeling, bound up in the tissues of my body, waiting anxiously for release. I put the stylus on the tablet and brush to paper, and something that needs to flows out. It could be a confused memory or some spirit moving through. This impulse to make substantive that which easily floats away or embeds deeper in one's core is profoundly human. Our ancestors did it; making symbols and artifacts, and telling stories and acting them out—through movement, sound, and gestures—were actions required for survival, as well as intellectual and emotional growth. That art is necessary to survive and thrive is not a well-understood concept in today's society, because art is so often perceived as being risky or frivolous. Without adequate support or introduction to art's merits, most people never get to find out whether they might have an artist inside, or how they might benefit from experiencing another's art.

So stereotypes accumulate, and we imagine that art is for some special elite, an indulgent frill, or perhaps a sign of an aberrant mind, and definitely not for the pragmatic, the weary, and those without the luxury of leisure time and expensive resources. It seems to me that our growing disconnection with art as a daily practice is directly related to our disconnection with the web of life as a whole. The public's need for a creative life has been colonized. We believe

the spectacle or simulacra are real. We don't make time to walk in the woods or to cook foods from scratch. We are glued to glowing screens, looking for connection and exhausted by our debts. We are easily manipulated, dizzy from too much information, and floating in a rising tide of inchoate fears. If we've been told that art is not for us, or that it's another out-of-reach commodity, how could we imagine that it might help us out of the mess we're in?

Our culture has framed ancient sacred events and objects as "art," but the word seems inadequate, partly because the framing usually involves some form of colonization of the visual culture. In other words, the symbols and artifacts are taken out of context, appropriated and translated by modern western culture, and have lost their meanings.

When I taught students in the African wing at the Metropolitan Museum of Art, I used to say that seeing a spiritual artifact, such as a mask, in a glass case was like seeing a baseball bat and a baseball in a similar case, and having someone telling you that it was baseball. Of course, this analogy presumes that the reader finds some of the sacred within the ritual of baseball.

Without the smell, the sounds, and layers of meaning carried from one generation to the next, the objects are mute. When ritual happened among these indigenous peoples, the artists spoke, moved, or made forms in a code created by their clique, one that had special membership requirements.

This notion of the artist as special, one who carries sacred truths and uses a mysterious and secret language, seems to be quite old but it may be that the colonial mind has imposed these characteristics on shamans, dancers, storytellers, and makers of sacred objects. The intentions of these ancestors were quite different from the distorted role some artists are given today. Those ancestors are sometimes understood to have been facilitators of their tribes' healing and growth, and as such, enabled each member of the tribe a pathway into her and his imagination. Of course, there was also a shadow side to this cultural production. Rituals could be born of fear of the other (outside the tribe), superstition, and abuse of power, as easily as more altruistic goals.

As societies became more complex and "civilized," religion became more organized, bureaucratic and often brutal. A multitude of fears (of difference, the Other, the body, and nature, for example) resulted in the repression of indigenous cultures and their arts. Desire for vast economic power also fueled the repression of women with old knowledge or creative, healing, or spiritual strengths. Artists whose work might depict experiences, mystical or otherwise, outside of the doctrine of the church, were immediately suspected of doing the work of the devil. Some subversive forms occasionally emerged in the form of the jester and satirical street theater performances, and were perhaps ignored, to avoid an explosion, or occurred under the radar.

When the church or the aristocracy commissioned work by artists, the goal was to immortalize their power or glorify carefully selected stories of the Bible in paint, sculpture, word, or song. Those in power were very cautious about what they assigned artists to depict. They recognized the transformative and manipulative capacities of art, and did not write it off as a frill. It was a way to educate or manipulate illiterate people.

Visual art as a tool for seeking truths, questioning the status quo, or documenting everyday injustices, began to emerge soon after the development of the printing press, heralding the Enlightenment. This technological revolution allowed for the distribution of broadsheets, and some visionary metal engravers saw that their images of the peasant uprisings could be disseminated throughout their regions and beyond.

Ralph Shikes in *The Indignant Eye* has written about the art created in response to the feudal system and the oppressions of the church, and the socially engaged awakening that occurred among some of the artisan class. Goldsmiths and silversmiths were among the first to record images in their engravings and etchings of the strife between the classes and the church. While some work was documentary, portraying the brutality of the civil wars, there were some artists who chose to use exaggerated characterizations, making fun of the powerful. Their work fertilized the cultural soil for future satirists, like French artist Daumier and the British artists Hogarth and Rowlandson.

There is some dispute about whether illiterate peasants viewing images of brutal massacres or injustices became more passive out of fear, or developed the required righteous indignation to organize in their own communities and revolt. There is also discussion about whether seeing satirical images of corrupt leaders makes people more complacent. In other words, if artists are still allowed to complain publicly, then things can't be that bad (as in the story of the singing troubadour, previously mentioned). Less responsible or more exhausted citizens might rationalize after seeing satirical work that someone else is taking care of the mess and decide that they can continue with their own individual and immediate struggles without so much anxiety about the corruption around them. Yet, as suggested before, the emergence of such art can imply an awakening that has broader repercussions.

The post-printing-press period heralded the tentative beginnings of alliances between artists and social activists that became, especially in the post-Enlightenment era, a long-standing, albeit conflict-ridden tradition in Europe and elsewhere. This has shaped many cultural and progressive social movements, including Constructivism, Surrealism, Dada, Critical Realism, conceptual art, feminist art, and the art of numerous liberation movements internationally.

There are many permutations of artists' roles that have evolved in different social and economic contexts. In this book I will focus primarily on polar opposites: artists who are either seen as an integral part of the community, where every individual's creativity is honored, and those who are separated out, either put on pedestals and fetishized or perceived as Other and dangerous.

History Lesson #2: The WPA

Let's take a look back and imagine the mid-thirties in the United States, a time when economic collapse had pushed masses of people to the edge. Many people were forced off the farm by both the ravages of nature and foreclosing banks; businesses closed, workers lost their jobs by the thousands and people were starving. Yet this was one of the most culturally radical periods in American history, giving rise to all kinds of radical political, economic, and cultural thinking and programs.[1] Inspired by the Russian Revolution, some people found ways to organize themselves and were able to imagine a world where everyone had enough to eat, a place to rest their heads, education, and a chance to improve their lot. Some college students and workers created coalitions and agitated in the streets. President Franklin Delano Roosevelt responded slowly to the social unrest, but eventually created his New Deal and later proposed the Works Progress Administration (WPA)[2] a program developed to remedy the massive U.S. unemployment.

The WPA philosophy was guided in part by Harry Hopkins, a long-time aide to FDR. The goal of the program was to put the unemployed back to work in jobs that would serve the public good and conserve the skills and the self-esteem of workers throughout the country. This proposal moved into legislation quickly. With the advice of his old classmate George Biddle (who had studied with Mexican muralist Diego Rivera), FDR created several cultural programs as part of the WPA that offered jobs to unemployed artists, as teachers, public artists and documentary photographers. Some of these artists traveled while others stayed in their communities to record the suffering caused by the Depression and to document other histories. One of these programs, started in 1935, was the Federal Art Project (FAP). It was guided by two novel assumptions: that artists were workers and that art was cultural labor worthy of government support. The FAP provided employment for artists on relief, creating over five thousand jobs, and leading to 225,000 works of art.

Some FAP artists created new relationships within their communities, using murals and public sculptures to tell the stories of everyday farmers and laborers. Most of the work was representational, and had the goal of communicating or documenting a piece of history. Many artists developed their

artwork in the context of community, and in many cases the art produced gave the residents a sense of pride about their community's history, struggles and unique skills. The artists themselves felt freed to venture into familiar subject matter, creating work that both responded to or mirrored their own or unfamiliar communities. While recognizable content was a priority in much of the government-commissioned work, there were also many formal innovations influenced by late Modernist experiments in abstraction and surrealism. Stuart Davis, the well-known abstract painter, said, "The artists of America do not look upon the art projects as a temporary stopgap measure, but see in them the beginning of a new and better day for art in this country."[3]

Programs were also created for writers and performers, both musicians and theater artists. The Federal Theater Project (FTP) was responsible for some of the most innovative staging of its time. While the primary aim of the FTP was the reemployment of theater workers on public relief rolls, including actors, directors, playwrights, designers, vaudeville artists, and stage technicians, it was also hoped that the project would result in the establishment of theater so vital to community life that it would continue to function after the program was completed. Don Adams and Arlene Goldbard, two significant writers on the history of cultural policy in the United States, have created a very useful summary of these WPA programs in their online "Webster's World of Cultural Policy."[4]

The very visible, federally funded art programs had the effect of mobilizing the forces of reaction in U.S. culture. The threat to the status quo posed by the ground-breaking work of the period—the socially relevant productions of the Federal Theater Project, the legitimization of working people's history in Writers Project publications, the images of social change depicted in Federal Art Project murals—could not have been clearer. Along with the content of the art being produced was the threat of the alliances being formed between artists and workers, a collaboration that had informed previous avant-garde movements, and heralded the possibility of a true social and cultural revolution. Susan Platt writes in her book, *Art and Politics of the 1930's,* "In the United States, artists and critics aggressively intervened in both the art world and the 'real' world in order to put art in touch with society, to interpret and to celebrate an art that protested injustice, and to encourage participation in political activity"[5]

This was unacceptable to some. Imagine being an FTP theater director in the thirties. One day, feeling better fed than usual, you're rehearsing for a play that talks about the frustrations of looking for work. Your cast has been playing to huge houses. The public loves the new content of this FTP theater: they are hearing and seeing stories that reflect their experiences, and the critics love

the new productions as well. You are totally excited about the way the world seems to be shifting, but the next thing you know, the theater is visited by a bureaucrat who says that the show must close before it opens; the funding has been cut.[6] When you ask why, you're told that they don't like all these "commies" making art, forcing their views on "regular folks." Harry Hopkins had said, "I am asked whether a theater subsidized by the government can be kept free of censorship, and I say, yes, it is going to be kept free from censorship. What we want is a free, adult, uncensored theater." But where was Hopkins now?

In 1938, a forerunner of the House Un-American Activities Committee, the Dies Committee—named after its chair, Martin Dies—was organized to investigate the "hotbeds of communists" lurking in these federally funded programs. The successes of the Dies Committee campaigns against the WPA provided tactical experience and lent legitimacy to the reactionary critique of "foreign ideas" and radical ideologies. The anti-WPA Red Scare was a springboard for postwar witch hunts, and certainly led to later reactionary moves against publicly funded art.

Almost a quarter of the funding of the FAP went to art education. Community art centers were created in remote places that had never had local art programs, and some of these centers still exist. The vast cultural change precipitated by these initiatives cannot be underestimated. Imagine adults and children who have never been exposed to living artists and art materials being invited into public spaces to both watch artists at work, and to get arts training themselves.

At same time that the FAP was developing its programs across the country, two important organizations that supported "social content art" were created. One was the American Artists' Congress and the other was a radical art school in New York City, the American Artists School, born out of the John Reed Club School of Art and including instructors of the radical magazine *The New Masses*. Their vision of art pedagogy included an emphasis on art that looked at social conditions, class psychology, and, implicitly, the social and didactic role of art.[7] When criticized for encouraging their students to create art that was propaganda, the Critical Realist painter Philip Evergood responded by saying that the school encouraged art that looked at society realistically:

> Art can and should deal with our lives in a way that adds to them and still not be propaganda in the derogatory sense of the word. . . . There is no rule for creating an American art. We of the American Artists School don't presume to have the secret. But we are doing this. We believe that artists who can see clearly see the complicated structure of America and pick out its basic social pattern, who are sympathetic to its people and

its culture and traditions, who are interested in psychology of the classes and groups, have the basis of saying something about America.[8]

While the American Artists School did not survive financially (its doors were open only from 1936–41), its mission had an impact on many artists and communities.

In New York City alone, thousands of artists were affected by the energy born of the FAP in some way. That art could be valued as work, despite the low salary, was a source of great enthusiasm. Tony Velonis, a silkscreen artist hired through the WPA, described the time like this in an oral history collected by the Smithsonian: "[The WPA] saved my life. . . . I mean, literally, you know, it gave it some meaning, and it was the best university I've ever gone to. . . . The contact and the dialogue with all those artists and the work that took place was just invaluable. You couldn't have gotten it in any other way. I was conscious at the time how precious it was and I said 'I must get the most out of it.' It wasn't the money that came through. It was the interaction."[9]

Another well-known artist, Ben Shahn, described the time in a 1964 interview:

> There never has been a period in art without some large patronage. . . . The Church is no longer a patron. Industry, during the war when they had nothing to sell, became a patron in a way. . . . The labor unions (and I've had experience with them) they're not going to be a patron. So the only thing that's left is the government, the federal government. Aside from the ugliness of the pauper's oath, and so on, to satisfy the lawmakers, it ran beautifully. The fact that Stuart Davis could stand beside a Soyer, nobody questioning it. . . . Since we were all on equal salary, it didn't make much difference. The competition was there mostly [focused on] the work and not on how much you'd sell a picture for, because you didn't sell anything.[10]

The way that art was taught in the public school system was affected as well. The move to integrate the arts into the social studies was encouraged during the thirties, owing to the renewed attention given to the social sciences and in the climate of social experimentation generated by the New Deal. Conservative forces also played a role in elevating the subject of social sciences, as some wanted to help combat communism and fascism.[11] It was an interdisciplinary time.

One can imagine that this government-sanctioned cultural policy might have become mainstream practice after the mid-1930s, if there hadn't been a groundswell of reaction among the conservative power brokers against its success. During that time seeds were sown for a practice of cultural democracy,

seeds that germinated and grew into plants that have been tenderly nurtured in the margins by communities of artists, writers, policy makers, historians, and theoreticians.

History Lesson #3: Red Scare Redux

"Of the Jewish daughter it has been written: To inherit a father's dreams makes you the eldest son. To further his ambitions makes you heir to the throne."
—Bettina Aptheker, *Nice Jewish Girls*

Each of us carries our ancestors on our backs, whether we want to or not, and the wellspring that has nurtured my passion for the work of social engagement continues to bubble up from my father's story. In order to more deeply understand how my search for a more integrated understanding of art and social issues came about, I will share some of his story.

My father, Ed Naidus, was one of thousands of young people whose passion and idealism was honed in the 1930s, swept up in the sense of possibility that emerged from so much desperation during that time. Diving deeply into that sense of possibility to learn from it, I want to see how that time was like other times when enraged people rose up and said enough of the status quo, enough with inequality and injustices, enough of fear, enough of muckety-mucks deciding who gets what, when.

What did it take to have the courage and energy to organize during that time, and what pushed people in the direction of one ideological camp versus another? From my readings, I have a sense of the daily details of how that movement manifested itself, but it is through my father's story that I most deeply understand that period.

Ed Naidus grew up in an Eastern European, Jewish immigrant enclave in New York City. His parents were nonreligious descendants of the Jewish Enlightenment that encouraged young Jews to get secular educations and work for social justice. As young teens my parents were part of an unusual and lively social club in their neighborhood where they regularly discussed philosophy, culture, and politics. They and their friends went to free museum exhibitions, classical music concerts (for a quarter), read books together, and listened to guest speakers. There they were introduced to socialist philosophy.

Ed attended City College in New York City from 1932–36. City College in the thirties was a hotbed of student activism. A free and highly competitive school, sometimes referred to as "the poor man's Harvard," it attracted the brightest among children of immigrants and the white, working-class poor. Though many of the students were working while going to school, some still

found time to meet in the cafeteria, between and after classes, to question and discuss the political and economic underpinnings of that time.

Ed was studying chemistry and playing football, but that didn't stop him from attending meetings and participating in street rallies with other students and the general populace. As the family legend goes, one day my dad, then a reserved man, took his place on a soapbox in Union Square when the scheduled speaker didn't show up, and so began his work educating the public against the rising tide of fascism in Europe. At the heart of the philosophy he preached was a deep humanism.

This was not a secret. My dad was proud of having found his voice one bright day in the mid-thirties, but the fact that he was a member of a communist cell during his college days was well hidden.

When I was thirty-two, my father, who had just read Vivian Gornick's *The Romance of American Communism*, handed me the book and said, "Read this. It's about my life." I was truly startled, and asked him if this was his "coming out." He said yes, in a quiet and solemn voice, while looking down at the floor. When I asked for more information about how the years of anticommunist blacklisting had affected him and my family, he offered little.

I wondered about the depth of the trauma that would keep this story hidden for so long, and so began some research on the time of great idealism that preceded the New Deal, the effects of the fifties blacklisting, and the shock many experienced upon learning the truth about Stalin's murderous regime.

From an early age, I had listened to my parents and their friends extol the virtues of the New Deal, FDR, and Mayor Fiorello LaGuardia. They had sung the praises of the social safety nets that had been woven by those administrations that befriended the working family and people down on their luck. It wasn't until I was older that I understood that it had taken many years of mobilizing and organizing neighbors, communities, and elected officials to get those programs in place. I didn't know about the transformation of their idealism into caution and then terror (as people with social activist pasts were fired from their jobs and some foreign-born with similar leanings even deported).

From reading memoirs written by "red diaper babies," I learned that children of activists were followed on their way home from school, to football practice, and birthday parties. Many of these children connected the persecution dished out by the Red Squads (those searching for "commies" under every rock and desk) with the Nazi extermination of the Jews, union members, and social activists. In the minds of these children, this persecution was conflated, causing them to wake with terrifying nightmares even into adulthood.[12]

I try to imagine what it was like for my father and thousands of his peers to have had their vision of a world with more social justice and cooperation

turned into something slimy and corrupt by the terrified men in power and their media minions. It is not hard to see this process if I look closely at the ways that today's media, including right-wing blogs, demonize or distort valuable programs or say that groups of people are dangerous or counter to national interests. My research indicates that in the past anyone who believed in the rights of the working person was suspected of consorting with the enemy. In much the same way, today's activists are sometimes described as traitors rather than patriots.

Most Americans never learn about the McCarthy era in their high school history classes, so in effect the repression was successful. It tainted people and their ideas, and silenced people using fear. I didn't really understand how my U.S. history textbooks had in effect been censored until I read Howard Zinn's *A People's History of the United States* soon after my dad's "coming out of the closet."

One of the immediate results of my father's admission was that I subsequently paid more attention to emotion-charged words like "Red" and "Commie." I began to notice how the word "activist" was alarming to some people, whether it meant an individual so described was working for the PTA or for free-speech issues. People would avert their eyes if someone made too much noise about an issue. I began to understand the anxiety that some had about my doing activist art and where that fear might have originated.

When I discuss the chilling effect of the McCarthy period on civil rights, critical thinking, progressive movements, and culture, my students often look dumbfounded. Some may have heard about it before, but they don't understand how the legacy of that time is still affecting their education. When the similarities between that time and now are pointed out, some nod their heads with concern, and some shrug as if there is nothing to be done except to follow the rules and not make waves. This offers an opportunity for discussion about what infringements on their rights might make them so incensed that they would start organizing to do something about it.

History Lesson #4: The Cold War Chills the Art World

"The erasure of content—particularly political content—was a Madison Avenue inspiration long before it was a gleam in Clement Greenberg's eye."

—Adrian Piper[17]

During the beginnings of the Cold War, the dominant culture in the United States, buoyed by the U.S. World War II success, promoted the myths of American democracy and individuals' freedom to pull themselves up by

their own bootstraps. Although optimism for a better future was evident, as was the desire for social and economic stability, one could also see the psychological effects of the McCarthyism then underway.

Within the high art world the values of Abstract Expressionism and making "art for art's sake" were being hailed as the new American style and being promoted as symbols of America's belief in individual freedom and experimentation. Seemingly overnight, the art of the thirties was considered passé, something to be sneered at or ignored. Regardless of the style or content of WPA-funded art, WPA programs were seen as "hotbeds of Marxist ideology and Communist subversion" and New Deal art was described as "poor art for poor people." As WPA art historian Francis O'Conner said, after the war "[t]he depiction of poor people was considered subversive, illustrations of national weakness. The (WPA) projects were a dim memory."[13] Artists who still cared about WPA-funded art were seen as dupes of a cultural dictatorship.

One of the most influential art critics of the time, partly due to his position as senior cultural editor for *The Nation*, was Clement Greenberg. His belief in a socialist future guided his theories about the relationships between culture, politics, ethics, and social theory. Greenberg believed that artists should abandon their involvement with social realism, Critical Realism, and surrealism (that was often critical of bourgeois values).[14] Greenberg believed that truly advanced or evolved art would focus on form itself: spaces, shapes, colors and so on, a so-called "universal language" that would transcend other cultural boundaries. Within this worldview, only abstract art was of value, inspired by the goals of individual creative freedom.

There were inherent contradictions in Greenberg's viewpoint. While he was advocating an avant-garde that represented his idea of the best human cultural production to emerge from socialist ideas, Abstract Expressionism was being packaged in an entirely different way by market forces: as the New and the Modern, and so American.

At the same time, understanding the philosophical underpinnings of this art required a special education, thus reinforcing the existence of a cultural elite and a public who is mystified, baffled, offended, or uninterested. That's not to say that the uninitiated can't occasionally benefit from an unschooled viewing of the work. I've heard a student tell me of a relative without any theoretical framework who cried while looking at a Rothko painting. But the dream of a cultural democracy that embraced other stories besides formalism was shattered.

This new art was championed by other forces in the postwar era. The director of the Museum of Modern Art, Alfred Barr, claimed in an article in the *New York Times* that "totalitarianism and realism" go together, smearing

all art that didn't follow his narrow ideological path.[15] Muralist and arts writer Eva Cockcroft wrote in her infamous article "Abstract Expressionism: Weapon of the Cold War" that the Museum of Modern Art, fueled by the Rockefellers and the wealthy elite, was part of an explicit international program, supported by the CIA, to promote American Abstract Expressionism as the most modern and the most "universal" movement of the era. As part of that promotion, all art that wasn't "art for art's sake" was framed as being "backward."

Ironically many of the artists who identified as Abstract Expressionists had very left-wing politics, but their politics could not be read in their images. The content appeared to be neutral. This factor was particularly useful to the ideologues who wanted to promote U.S. mass culture as being free of ideology compared to that of the socialist world.

This shift in what was culturally sanctioned was profound and any remaining multi-vocality in the art world of that time was silenced. Without public funding or the support of mainstream art institutions, most of the artists who did socially engaged work were either marginalized or changed their practices. Still many artists, Alice Neel for one, continued their more humanist-inspired art in the shadows. "You can't leave humanity out," Neel said. "If you didn't have humanity, you wouldn't have anything."[16]

Adrian Piper, one of the most articulate socially engaged artists to come of age in the 1970s, noted the cultural chill's international nature:

> Characterized by its repudiation of content in general and explicitly political subject in particular, Greenbergian formalism gained currency as an opportunistic ideological evasion of the threat of cold war, McCarthyite censorship and red-baiting in the fifties. To the extent that this ideological repudiation of political subject matter has prevailed in the international art context, American imperialism has succeeded in supplanting the longstanding European tradition of art as a medium of social engagement with a peculiarly pharmaceutical conception of art as soporific and analgesic.[17]

The framing of Abstract Expressionism as radical by some and reactionary and a tool of capitalism and imperialism by others can be confusing. What is crucial, though, is that art pedagogy changed. While traditional art programs still allowed for the teaching of figure and other classical training in realism, the goal was to achieve technical expertise rather than any exploration of social content. As practitioners of abstraction began to secure university positions, there was often polarization between those who could "render" or draw well and those who could "express." But until the social

movements of the sixties and seventies took hold, art teaching focused on form, whether figurative or abstract.

Lately I've spent many hours listening to music on a Web site called Pandora. This site, developed by the Music Genome Project, allows listeners to create their own "radio stations" based on artists or songs that they like. It matches musicians or songs with others that sound like them, but the tools of analysis are purely formal ones, involving instrumentation, melody, orchestration, and the like. I found that I could not create a radio station that grouped anti-racism music or music focused on any topic. This sort of thing doesn't seem to be in their database, further evidence of the widespread formalist approach to the arts.

The ideology of making art "for art's sake" rather than for humanity's sake continues in many art departments and academies to this day. Such schools produce graduates to work in industry, with adequate skills but little ability to think in an interdisciplinary or socially engaged way.[17]

Cracks in the Folds

The cracks in the folds of the sweet ball of a girl/woman attracted others with cracks, some with more elaborate tucks and folds than hers. They came to her with downward glances, nervous smiles, and many special gifts. One boy/man turned everything he touched into beauty; his fingertips flowed with ink and his eyes shifted the world into crystals. Most of the male teachers scorned him, and she watched him fold more deeply right before her eyes. She witnessed several girls/women being told that their jewels were inadequate. Instead they were encouraged to develop their skills for flirting and shopping.

After observing these injustices and listening to similar stories, the sweet ball of a girl/woman gave informal counsel in her makeshift office next to the painting studio. Some were so relieved by her words that they called her "earth mother," but this label made her blanch with disgust; she wanted to be cynical and sharp-edged, and to attract others like that, those in the know, those with smooth gray surfaces, the invulnerable ones who made pithy remarks without pause. She was easily misled, and folded in on herself even tighter, her torso becoming stiff as armor. Her confusion made her prey to all sorts of seductions, greedy for approval and distractions. She lost focus frequently and daydreamed about future glories.

Then, one spring day, unexpectedly, the sweet ball of a young woman unfolded into a garden of other young women. Well, actually it was a messy, smoky studio of young women, all riled up.

3

How an Art Practice Morphs into an Art Pedagogy

To illustrate how the reactionary aspects of Greenbergian ideology might have influenced young art students, I will share the story of my first true encounter with Abstract Expressionist pedagogy. I did not feel particularly drawn to this way of working, but abstract work was spoken about in such a mystifying way that I intuitively felt that I needed to grasp it both emotionally and intellectually in order to pursue my artistic voice. It was the summer of 1974 and at the recommendation of a high school art teacher I went to a painting workshop in Provincetown, Massachusetts. I was keen to learn more about the intentions behind formal abstraction, and the two teachers at this school were highly regarded abstract painters from New York City, both former students of Hans Hoffman.

When I arrived in Provincetown, I got a job as a housecleaner for some rich summer residents, working for a few hours each morning and spending much of the rest of each day and evening painting in the workshop studio. The second-story studio was divided in a hierarchical manner. One room was occupied by paying students, most of whom were primary- and secondary-school art teachers on vacation, retired architects, and designers wanting to develop their inner muses, and a few street portrait artists who came to draw from the nude model. The other room was filled to the brim with young scholarship students, many who came from New York City's Cooper Union, a renowned and highly competitive art school with a very nominal tuition. In the scholarship room the paint was more copious, the gestures more

extravagant, and the attitudes more pronounced relative to the shy, curious, sometimes self-doubting postures of the paying students.

Into this strangely delineated context walked one naïve liberal-arts-college art major: me. I wanted to understand why people were devoting their passions and creative energies to painting cubes, lines, circles, and all manner of organic shapes and splashes. I just didn't get it. What was this about? What motivated this kind of obsession to make art about *form*? Was it a spiritual quest? Was there a lust born from manipulating paint that had not yet captured me?

The goal of these students seemed to be to develop a personal iconography, a visual language that had to be as impenetrable as possible. The teachers spoke harshly to students whose work had more overt content, asking them to reconsider the "illustrative" components of their work. "Illustrative" was an adjective that carried a death sentence. Heaven forbid that your work had a communicative intent. "Didactic" was another adjective that had a pejorative cast. Horrors if your goal was to teach something. Even thinking about the audience in any particular way other than as consumer of your work was forbidden. I can hear those teachers saying, "Why be hemmed in by an audience's needs or desires? Your creative spirit will be imprisoned by this kind of responsibility. How can you presume to know what the audience wants anyway? They will misinterpret your work."

I have recently learned that concern for audience or the reading of one's work has been given the name "reception theory." While only recently applied in the world of visual art, reception theory started in literary criticism and then moved into performance studies. To me it sounds like the new catchphrase for social responsibility.

My knowledge of Clement Greenberg's formalist theories was very limited at this stage in my art career. I knew that the process of making abstract images could be based on a philosophical system, or inspired by the unconscious or emotions, but little more than that. I also understood that some of the abstract artists felt liberated by this formalist path. They didn't feel responsible to their audience or to communicate with anyone other than themselves. What a privilege to experience aesthetic purity, enter the unconscious, and make art about color, shape, texture, space, line, scale, and repetition, with no accountability to anything or anyone but the process itself. It seemed to be a strategy tailor-made for those who were alienated and disaffected.

Don't get me wrong. I enjoyed the process of dancing into a painting with only a mark and a color to guide my way, and I still find this totally pleasurable from time to time, like singing into the wind, stacking stones, or making sand castles. It can be very "present moment," like a meditation, but

this way of working—self-expression and craft for its own sake—does not seem to be enough to meet the needs of our times. It might meet my need for rest between more challenging tasks but it is not enough. If art is nothing more than a symbol of one's individual freedom to play the violin while the planet burns, then we have lost a key means for sounding the alarm.

During the years before attending summer school in Provincetown, I had been confused about a perceived need to define my forms as an artist. I knew that deep inside I had to communicate through the arts, but picking one medium puzzled me. I was drawn to performing in theater and modern dance, writing out my adolescent angst in poetry, and singing my heart out, but I was told that doing *everything* would turn me into a master of *nothing*. With more than a little anxiety and not much clarity, I somehow chose visual art to be my anchor.

I began figure drawing, in the manner of the academy, at the Art Students League in New York City, for a year of Saturdays during my last year of high school. There I did not learn to question what art was for, but rather began to develop a perceptive eye and hand, sensitive to the edges of forms in space. People became bodies; bodies became shapes. The story that each model might have shared about her or his life on that day was not supposed to be a part of our lesson. Our translation of the experience was formal. It was my first experience of the dehumanizing aspects of art education. In the service of the craft we will put our knowledge of the connections between things on hold.

Fortunately for me, in college my printmaking teacher, Dean Warnholtz, encouraged a connection between visual grammar and content. One of his favorite adages was that "work generates inspiration, rather than the other way around." Under his tutelage I became a workaholic and learned to be prolific. Dean encouraged us to plow our imaginations and personal stories; there was no distinction between the value of the inner and outer worlds as subject matter. Dean had been a student of the internationally known, political printmaker, Mauricio Lasansky, and although his own work was more abstract than socially engaged, somehow he understood that I needed to read Ben Shahn's *The Shape of Content.* He handed it to me one day and said simply, "read this, you need it."

Shahn's book discussed how the roles of teacher, artist, and socially responsible citizen could be integrated, and this resonated deeply for me. Instead of seeing a life of teaching as "less than," I began to see that work in the classroom could be an extension of my art practice and that my art practice could be an extension of my social engagement. I had heard some artists complain that they had to teach, and that they would rather just be

in the studio making art. I realized that they had swallowed the old saying, "those who can, do, and those who can't, teach." They were actually ashamed of being teachers. Years later, when I was desperate for a teaching position, I wanted to tell each person I heard complain about "having to" teach to please resign so that I could have his or her job.

Another influential teacher of mine was Andrew Leicester, a sculptor and public artist. Under Leicester's tutelage I began to engage in a conceptual and site-specific process that informs my work to this day. I designed installations, built earthworks, and wrote proposals for public art projects. I discovered Lucy Lippard's then-new book on conceptual art, became an avid fan of Ad Reinhardt's satirical cartoons of the art world during the forties and fifties, and was intrigued with neo-Dada interventions, like the work of Fluxus, John Cage, and others. I began to experiment with an art process that was about posing theories and playing with ideas, rather than doing purely formal or perceptual exercises. My site-specific installations used found objects and scavenged materials. The idea of the gallery or museum as the only site for art became stale for me, and I placed old school chairs marching up the side of a hill, and wove army-surplus elastic bands between trees to catch unwary hikers. Not yet socially responsible, perhaps, but thinking outside the white box.

What probably made the biggest impact on my art thinking during this time was an unexpected but much-needed exposure to feminism. The first awkward embrace of my female peers showed me that being treated as a queen bee by the male-run dominant culture would mean a lifetime of alienation and unnecessary suffering. The year was 1973. The work of the Feminist Art Program at CalArts and the startling installations and performances that emerged from its 1972 Womanhouse exhibit had just made their way to our campus via videotape and word of mouth. Buoyed by the excitement of these West Coast projects, the female art students on my campus began to meet. In our discussions we vented our frustration about having no female role models; there were a few female artists in the art history lectures but the lecturers were all male, as were the studio art teachers. We demanded our own budget from those in power to bring feminist artists to campus, mount a women's art show, and organize women-directed and women-written performances of poetry and theater—and our demands were all met.

Most importantly, the content of our work began to reflect the voices we were claiming. We made art about our lives as young women, our pains and pleasures, and the questions we were asking about the world. Some teachers said that what we were doing was "therapy" and therefore not art. We were both outraged and ashamed by the negative connotation of this word. Some

felt the stigma so intensely that they dove deeply into abstraction, retreating from more literal or explicit investigations of gender identity, patriarchy, sexuality, and other taboos.

I think it is important to note that feminism's legacy, along with the impact of the civil rights and antiwar movements, changed the way that many artists approached their work. Many of us felt that the rules of engagement regarding our art practices had profoundly shifted. We gave ourselves permission to explore realms that some of our teachers disdained. We felt newly released from inner and external censors, and saw a whole new realm of content waiting to be explored. Nevertheless, I left college with enormous impatience and confusion. During my senior year I had applied to three graduate schools to get my MFA, and had been rejected by all three. I applied to these schools knowing only their prestigious names and little else. I figured that one of these blue-chip names on my resume would guarantee me a teaching position somewhere, and teaching seemed practical. I had no sense of what graduate school would offer me, and was fumbling around trying to understand what an artist's career path might be.

In truth, I really wanted to go live on a commune and develop an alternative society somewhere, but I was hooked on the energy I got from my creative process, as well as the ego strokes and the possibility that I might make it as an artist and redefine how women artists were perceived. I really did not understand why I was making art or for whom I was making it. I had some sense that it was about rebellion, creating a new identity, or following some inner muse, but I had not found resources or mentors to guide me.

I had no conception about the New York art world I was about to enter, nor how the marketplace both interfered with and contributed to the creative process. I had dreams of participating in a radical bohemian enclave of some kind. Aspects of my undergraduate years in college had fed a desire to be famous, not rich so much, but recognized and written about in significant places. As much as I was drawn to live on a commune in northern California, and create a utopia in the rural hills, I had been reading every copy of *Art Forum* magazine and *Art in America* in the student lounge, absorbing the carefully arranged images of self-importance, glamor, and intrigue. The subtext was palpable: your art doesn't mean much unless it is recognized in these pages. With that naïve spirit I left college hoping to be discovered, like an ingenue heading to Hollywood. My sense of striving for a better society went into the closet while I moved into an intense period of individualistic, competitive self-searching.

While I haven't researched the topic deeply, I believe that an addiction to celebrity is one of the most destructive impulses nurtured in today's society. It thrives off the lack of meaning, connection, and empowerment that most

people feel in their daily lives, and without grounding in something that offers those qualities it is easy to succumb to its lure.

My first year in New York went by like a speeding train. Like many of my generation, I found odd jobs on and off the books. I created artwork on the floor of my cockroach-infested room in the East Village apartment I shared with a roommate. I struggled to figure out why I was painting what I was painting, but I was lost. Personal iconography was my mantra, but it had no meaning. There was no sense to what I was doing, except that a strange workaholism impelled me to make piles of stuff.

I was thirsty to learn from whomever crossed my path. We hosted a few feasts in our tiny place, and, when we could afford it, hung out in cafes and bars, finding cronies with whom we could bat around ideas about art and what it meant and who it was for. We debated and argued, resolving nothing, and in the end I knew I would be writing another series of graduate school applications.

During the winter break of my junior year in college I had visited San Francisco with a college chum, a gifted art student. We spent days walking the city, soaking up the atmosphere, visiting an art school and many museums, with an intention of attending an art school there someday. One day we wandered into the Museum of Conceptual Art, located in the Mission District. The cavernous warehouse space was empty, save for a refrigerator well stocked with Anchor Steam beer, a couch, and a desk crammed with stacks of loose-leaf notebooks. The director, Tom Marioni, met us as we walked in, invited us to sit on his couch, and gave us each a beer.

We talked for over an hour about the museum, our student experiments with installations and performances, and our dream of studying conceptual art in San Francisco. Tom let us know that we would be sorely disappointed if we came to the city to study art. Was there a school on the West Coast that might meet our needs? Definitely not, he said, suggesting that we consider just one school, located on the opposite side of the continent, the Nova Scotia College of Art and Design (NSCAD). I mentally filed that information and didn't take it seriously until I'd had my fill of minimum-wage jobs in New York and learned that NSCAD actually paid their graduate students to attend school. Since I wasn't getting any support from home for my "crazy" career choice, Nova Scotia began to sound attractive. I sent out graduate school applications and, to my great astonishment, I was flown to Halifax to be interviewed, and then was invited to enter the NSCAD MFA program. I packed up my bags and headed north.

I was one of five incoming grad students in my class, the only one from the United States, the only woman, and the only painter. I shared a studio with fellow grad student Bruce Barber, whose suggestions to be more mindful of

how and why I was painting, to read John Berger's *Ways of Seeing,* and to pay more attention to what concepts I wanted to explore, deeply impressed me.

I became distrustful of the seductions of paint, but before I shoved the brushes away I did a series of works on paper that examined bourgeois notions of propriety. One of that series, a painted drawing of white pants with a red dot in the crotch, was called *The Wrong Day to Wear White Pants.* Embarrassed, I hid the small drawing in a pile of others on my table. Bruce was idly leafing through the pile one day, discovered the drawing and began to laugh uncontrollably. Mortified, I wanted to run away, but Bruce stopped and said with authority, "*This is it.* You have touched a deep, honest place. I am going to tell others about this piece and you will see. They will come here to see it and share their own stories."

Bruce was right. My studio became a very busy place and a repository for all the stories of shame that came with one of the most commonplace accidents of being an adolescent or premenopausal female. Blushing and laughter-filled stories came via phone, mail, and in person, and I was truly astonished. I had understood that art had that capacity to generate community, but hadn't experienced this particular magnetic pull before. I developed a taste for it right away.

In the coming year I made art about my nuclear nightmares, what it meant to grow up in the suburbs, and the alienation of consumer culture. The forms of the work shifted from paint on paper, to typed texts combined with objects, to video, to audio installations. *THIS IS NOT A TEST,* my audio installation about growing up with nuclear air-raid drills, touched a similar nerve with my audience, and stories poured in about the Cuban Missile Crisis and the mushroom clouds that appeared in the dreams of many of my peers.

As I saw how transforming the power of story could be, I became eager to find ways to help students experience the same thing. I wasn't sure how to do it, and wasn't experiencing inspiring examples in the classrooms.

As a teaching assistant and as a student, the predominant style of teaching I observed was one of asking lots of questions about intentions and influences. Often the intimate one-on-one conversations and group critiques sounded more like therapy sessions than pedagogy. Students following the fashion of the time would get more attention. If they innovated from that style or did something quirky with the work's content, they would get more attention. Help came in the form of formal, technical, or psychological advice. It was not typical to talk about social issues in the classroom, though, unless you were lucky enough to be in a class with the one female professor, and then the discussion usually focused on those first debates within feminist art.

These strategies didn't feel right to me. I wanted to go deeper, into how art communicated something about the contemporary world, and wanted to get

students to tap into their stories about the issues they faced in their everyday lives, but I didn't know how to get there. I found a handful of books about socially engaged art—Paul Von Blum's *The Critical Vision*, Ralph Shike's *The Indignant Eye*, Lucy Lippard's *From the Center*, Ernst Fischer's *The Necessity of Art*, and Arnold Hauser's *The Social History of Art*—but there was nothing about how to teach students to make art about social issues. I didn't know how to find the resources I needed.

Stories of Ms. Generic

Perhaps some of you remember a perennially underpaid, and often-ignored, typically female art teacher, rolling her cart of predictable arts-and-crafts supplies into your grade school classroom. In the cart one could find rolls of crepe paper, reams of construction paper, oak-tag folders, pots of glue, piles of safety scissors, and well-used jars of tempera paint in all the primary and secondary colors. Occasionally you would find an insidious box of Popsicle sticks, bags full of wooden spools, and containers of stale pasta, all put in the service of this teacher's agenda for creativity and expression. This cart probably only existed in the middle class and predominantly white schools. From my years teaching in various "artists in the schools" programs in New York, I can say with little doubt that the cupboards were bare in most inner-city and poor rural schools, unless they were lucky enough to have a principal with vision who had somehow wrangled the local district into believing that an art teacher would temper the possibility for student violence.

Do you remember those mimeographed sheets (or, younger readers, those photocopied ones) that looked like poorly reproduced pages from coloring books, with seasonal images of pumpkins, snow sculptures, and flowers? In the lower-middle class town where I grew up, those sheets of paper and those "busy work" assignments were just more tiresome symbols of conformity. More often than not the teacher would carry these simple templates into class, onto which the unwary youngsters would be encouraged (or pushed) to "express themselves." We were told that our participation in these tedious exercises was artistic expression, and that we could express our individuality by choosing the colors and patterns to fill the voids. Rewards of special treats or gold stars were offered to those who met the teacher's standards for neatness and acceptability. A very rare teacher would give points for risk taking. An even more unusual teacher would engage our hearts and minds in an art process that took us out of the classroom and into other worlds. I didn't meet such a teacher until I was much, much older.

In Ms. Generic's classroom, the canned art activities, from coloring book exercises to pipe cleaner sculpture, were not so different from being fed fast food. What kind of fear informed this fractured sense of creativity? By age ten I had spent many hours contemplating powerful art in books and on the walls of museums. What did it have to do with this experience of neatly filling the bulletin boards with pretty and acceptable pictures? Is it any wonder that students would leave Ms. Generic's classroom thinking that good art was tidy, pretty, and easy to quantify? The notion of art as anything other than entertainment or decoration would henceforth probably be inconceivable.

This way of teaching art can offer another window into understanding the degradation of public education in general, with its tedium and authoritarian rubric. Is it any wonder that students leaving public schools with this sort of introduction to making art end up alienated from the art-making process? Was art somehow seen by the educational system as being dangerous because it loosens the soul from its moorings, frees the inhibitions, and can vacillate from telling lies to truths? Was this the legacy of a culture that wanted no great pleasure, no sensuality, no integration of the soul and the body?

In some schools Ms. Generic's classes are still the only familiarity with art our young citizens have access to, if they are lucky enough to have any art experience at all.

Sir Ken Robinson, in a TED conference[1] lecture, talked about how we systematically kill the creative impulse in our children by forcing them to sit at their desks and take tests. In many institutions art has been eliminated as part of the curriculum altogether, considered a frill, a luxury. Art is usually the last subject to be added and the first to go when funds are short. Some bureaucrats, having experienced the busywork of Ms. Generic when they themselves were children, may think of art as a waste of time, given the urgent issues of the day. Even within general education, the arts have historically been seen as peripheral, at least within dominant culture (with the exception of the WPA years). As a result of this treatment, many art teachers have resisted being seen as specialists and have developed curricula that are interdisciplinary, based in the subject matter of everyday life.

Of course, Ms. Generic is an extreme example, or hopefully now just a bad memory, within the spectrum of behaviors and orientations of art educators.

I recently talked with an art educator who has quite progressive politics and makes some political art but only teaches technique in his high school art classes. He says that he does this not only because it is expected of him (he says that he would have his hands slapped otherwise), but also because he has no idea how to teach in another way. He didn't learn other strategies when

he got his master's degree. He told me that he that he doesn't feel qualified to teach more than technique and formal issues, and asked me how I managed to teach craft while focusing on content. I responded that in my classes, in our feedback sessions, we always discuss what makes a work compelling and list the important aspects of visual grammar in a work of art, while keeping in mind that the intentions of a work are equally important. He countered that he has always felt it better to leave sociology and history discussions to sociology and history teachers, but that he could easily imagine them using art to teach the subject matter in their classes. When I suggested to him that there were historical and contemporary precedents for teaching art in a totally different way, grounded in the everyday lives of students, he seemed startled. I expect that there are hordes of other art educators who have disempowered themselves in this way. They believe that they are only qualified to teach that which they have learned in school, displaying "competence" within a single field, and don't want to risk exploring what it might be like to unveil what they and their students *don't* yet know, but might research or discover.

Our conversation reminded me of comments made by my tenure review committee in a more traditional art school at California State University, Long Beach (where I taught for nine years and did receive tenure). They said that they would never presume to teach content in their classes, and were amazed that I was able to get my students to make the kinds of work that they did. They asked me what I was doing in my classes that encouraged this kind of work. I told them that I shared work that inspired me, asked them lots of questions, gave them things to read and discuss, and encouraged them to tell their stories. It wasn't very difficult to go beyond the specialized model of teaching craft alone. They said that they didn't feel competent to teach such things. In truth, I think it frightened them to have so much of the uncomfortable world in their classes.

Art Ed., Revised

Progressive educational theories have influenced a significant constituency in the art education world, especially in the past three decades. Yet because I did not go through an art education program, and perhaps because of Ms. Generic's influence, I didn't even think to look in that direction. What I have discovered only lately, both through library and Internet research, is that there is a mountain of writing on ways for art educators to engage with social issues. Much of it can only be found in professional journals, though, and, significantly, very little of it seems directed toward artists who teach.

Much of the material I discovered was written for the scholarly world of art education and its language is dense, coming out of the waters of critical theory and semiotics. While the information once translated can be highly useful, it does not seem directed to an audience of artist-teachers and cultural activists.

Like bell hooks, who said that much of feminist theory was not written for ordinary women but for those who could master an elite code, I can see an inherent contradiction in much of the radical cultural theory written since the late sixties. Who was it written for other than a small clique of those who have been initiated into the vocabulary? What about this is radical practice? I know it may sound anti-intellectual to ask for plainer speaking about sociocultural pedagogical issues, but I am asking for just that. How are we going to increase our numbers if the specialized code excludes or repels people like me? I recognize that I have to take myself to task, to view my own writing with the same critical lens. Finding precise language is important, but perhaps big ideas are more significant than big words. On the other hand, we need to be better educated, to use our minds more fully and stretch—after all, sometimes big ideas really are so complex that simple language is insufficient to describe them.

I want to honor the research and writing that I have recently discovered in the realm of art education, some of which has been highly accessible. (Thank you to those of you who saw me as your audience.) The impulse to integrate art more fully into progressive education on a primary and secondary level has been around since the beginning of the twentieth century, and I will speak to this later in this book. Socially engaged arts education has also had a longer and less-dismissed tradition in England. (The work of four artist/teachers based in England will be discussed later in here.) Yet it is important to note that most practicing artists who come out of MFA programs (unlike those who get master's degrees in art education) and go on to teach art on the college level, have, in the majority of cases, no experience of pedagogy except in their roles as teaching assistants—and not every MFA student has had that opportunity, either. In other words, people who graduate with MFA degrees have rarely studied strategies for teaching art, socially engaged or otherwise, unless they attended an unusual graduate program with a single seminar class that might have addressed these issues briefly. The approaches to the classroom that these MFA graduates receive are, at best, an imitation of their mentors' approaches.

There are various causes for this significant hole in the vast majority of visual art MFA programs. Some MFA students have no interest at all in teaching and are only in school to develop the intellectual, aesthetic, and

networking skills to operate within the high art world. Some believe that teaching will be their last resort profession, and have only disdain for those who have a passion for it. I also believe that some people believe that you can't teach practicing artists how to teach; this is considered inappropriate or somehow disrespectful of each artist's inherent abilities. Perhaps this reaction to the vocation of teaching arises from a sort of snobbery that is quite prevalent in the elitist art world: *Real artists will know how to teach what they know.* This way of thinking may be handed down from earlier centuries' art academies where artists whose work was respected by men in power were awarded teaching positions in the academy.

The reality is that even those of us who may have some natural abilities working with students need help, especially in the interdisciplinary realm. My research has lately introduced me to many resources that offer pieces of what the budding artist/teacher/activist/community member might want, but it takes persistence to find them and the body of knowledge can seem fragmented and hyper-specialized. As my ambition to give as complete view of the field as possible increased, the piles of articles and books grew higher in my two offices. Synthesis seemed far away. I felt a bit like a dizzy Helen Mirren in *Prime Suspect*, tenaciously looking for clues and tracks in the mud. At some point, I realized that this book would not be the definitive compilation of all that has been discussed in the field.

Groups like the Caucus for Social Theory in Art Education (CSTAE) have been actively discussing ways to bring more social issues into art classes since 1980. As part of my quest to find mentors back in the early eighties, I attended a few conferences in New York City where I was then living. At one of them, I met Bob Bersson, one of the founders the CSTAE. Through our meeting I learned that there were art educators trying to merge the teaching of art with social-justice education. I purchased a pile of their photocopied journals and carried them with me as I moved across the country. They became an important touchstone for me. Bersson said in his introduction to the "Atlanta Papers":

> Given the range and subtlety of our cultural conditioning, art education must of necessity become critical. It must place critical cultural literacy in the heart of its theory and practice. Cultural literacy does indeed open the way to personal and social emancipation. It brings in its enlightening wake the preconditions of emancipation, knowledge and freedom: knowledge and freedom to think, feel and perceive as human individuals and not as manipulated social products; knowledge and freedom to experience and create forms of visual culture which are liberating

rather than enslaving; knowledge and freedom to conceptualize and build toward a more aesthetic, humane and democratic culture and society, knowledge and freedom to develop an art education which would be an agent of critical understanding and progressive social change.[2]

When I googled "CSTAE" recently, I found that they have been going strong all these years. Here is what they published as their mission statement in the early nineties: "CSTAE seeks to promote the use of theoretical concepts from the social sciences, to study visual culture and the teaching of art, to inform art educators about theory and practice in the social sciences, thus acting as a liaison between social scientists and art educators, to encourage research into the social context of visual culture and teaching art and to develop socially relevant programs for use in teaching art."

From Don Krug, professor of art education at the University of British Columbia, in a 2008 phone conversation, I learned that the innovative integration of the arts curriculum with a discussion of gender, race, class, sexuality, place, and environment was developed by key arts educators in the 1970s, including June McPhee, Vincent Lanier, Graham Chalmers, and Ron Neperode. Their socio-cultural approach to the arts had a huge impact on subsequent generations of arts educators who have gone on to teach more teachers. While this field is small, its impact has been felt internationally.

Two other related areas of pedagogical innovation include the fields of Visual Culture[3] and Critical Theory.[4] Both of these areas of study have affected educators, giving them new tools to bring into the classroom and new ways to synthesize social context with aesthetics. While I have not done sufficient research to compare and tease out these areas of study as they relate to our work as socially engaged artists and teachers, I want to mention them here.

The progressive art educators who are training the next generation of primary- and secondary-school art teachers have argued in support of an art curriculum that is more interdisciplinary, that advocates how the arts can promote an ethic of caring, and they stress the importance of the arts in developing thoughtful, creative, and engaged citizens. As a result of their contributions to the field, there are public and private schools around the world where interdisciplinary art educators use critical pedagogy to engage their students.

Many of the essays published by CSTAE members argue that visual culture is an essential direction for contemporary art educators who are committed to examining social justice issues and fostering democratic principles through their teaching. There have been studies exploring how visual-culture education can empower students to perceive and meaningfully engage in the ideological and cultural struggles embedded within the everyday visual

experience. Some writings examine the work of resistance theorists and socially engaged artists, including culture jammers, in an effort to support and inform the teaching and learning of visual culture. Some of the authors have investigated cultural production as a pedagogical strategy within the visual culture classroom for generating and facilitating student awareness, understanding, and active participation in the socio-cultural realm.

David Darts, a progressive art educator now teaching at NYU, has written about a high school course he designed and taught in Canada,[5] called "Contemporary Issues and Visual Arts." The course included social issue–themed projects and introduced students to socially engaged artists whose work is concerned with cultural examination and social transformation. Darts focused his curriculum around the visual cultures of students' everyday lives, engaging them directly in the planning, teaching, and evaluation processes. Connecting visual culture and artists to larger social and cultural issues are critical components of producing a meaningful art education for students.

One of Darts' projects at a suburban Canadian high school was an interventionist piece at a school assembly at the beginning of the school year. Ten students got up, one by one, interrupting the principal's speech, and yelled out racist and homophobic slurs, until a group of fifteen students yelled out in unison "STOP!" Then all twenty-five students walked to the stage, where they joined the principal, introduced themselves by name, and invited the audience to join in focus-group discussions about violence and hate in the school. These ongoing discussions catalyzed more art works that were displayed around the school all year long.

I suspect that the influence of progressive art educators on the dominant culture of art education is not as widespread as it could be, partly because so many art educators are just trying to hold onto their positions in this era of budget cutting in the arts, but there are other factors involved. In conversation with art educator and public artist Olivia Gude (who will be discussed later in this book), I learned that the Getty Foundation's impact on progressive trends in art education was profound. By funding Discipline-Based Art Education with its focus on the traditional practices of production, art history, aesthetics, and criticism, many art educators did not stray into the interdisciplinary, multicultural, or socially engaged territories, as attractive as they might have been. Gude says, "Under the banner of normalcy, the Getty reinscribed practices that were being critiqued and cast aside by socially engaged artists because of postmodern, feminist, and postcolonial thought." Nevertheless, many innovations have persistently emerged on the margins during the past three decades, with some easily noticed in listings of conferences around the country (and others that will be discussed by artists later in this book).

Here is the promotional text for a conference entitled "Arts Education—To What End?" at NYU in March 2008:

In an era of standardized testing, shrinking budgets, and educational reforms that purport to keep teachers accountable and to leave no students behind, what is the role and place of arts education? How are arts educators contributing and responding to national and local arts and educational policies? How can arts education programs foster innovative forms of creative cultural expression, intercultural understanding, and civic engagement? Is arts education adequately preparing students as cultural producers—artists, teachers, researchers, and intellectuals—who can successfully negotiate a rapidly transforming and globalizing world? Where can arts educators turn for rich pedagogical models and reflective contemporary artistic frameworks?

A panel organized by artist/performer/educator Jerri Allyn (Otis College of Art and Design, Artists, Community, and Teaching Program) promises to address related questions:

New college programs reflect the changing nature of art. Fine-art majors now concentrate in education, community arts, or public art to strengthen communities and build audiences for art. Even art-world "sites" have grown more horizontally than vertically in the last twenty years. New practitioners do not see skyrocketing prices that trendy artists do; however, these emerging artists manage to earn a living. This panel focuses on programs with perspectives on teaching art as social practice. Does community-based art-making trace its history in social science instead of Western aesthetics? How do we broaden traditional critique, introduce team-based learning, and model collaboration within a profession that rewards individual stars? Why is there not excellence in both process, highly valued in community practice, and product, which is more important to the art world? How do we strengthen economic infrastructures to support graduates whose art projects help to solve challenges our global village faces?[6]

It is immensely gratifying to feel this tide of consciousness continuing to grow and move in the direction I have yearned for since my first taste of progressive educational ideas so many years ago. What is remarkable is that—in the United States, at least—this is happening despite the lack of widespread institutional support and resources, and with little public awareness. This work has been done on the backs of keenly passionate people, in some cases driven by a sense that time is running out.

Liberatory Education

I was first exposed to radical pedagogy in my high school history class. My teacher, Al Deaett, the school football coach and a former marine, underwent a radical transformation after taking a summer course on the history of Vietnam at the local community college. Pro-war and virulently anticommunist before taking that course, he developed a much more complex understanding of the forces of imperialism and colonialism and their effects both on that small country and our dominating one. Like other citizens were doing, he'd had to rethink much of the propaganda he'd been fed about U.S. foreign policy and patriotism.

Witnessing this transformation between the spring and fall of 1970 was truly extraordinary and gave me a sense that our world was being rocked in powerful ways. After all, this was a man who had been regaling us daily with stories of patriotism and the rigors of Parris Island the previous year. As the horrific bombing of Cambodia and Laos catalyzed the student antiwar movement and precipitated national moratoriums in the spring of 1971, my teacher invited several of us to help create a teach-in on the war in Southeast Asia. This unexpected process of opening up led my teacher to revise his whole curriculum for his advanced placement history class. We spent several months reading a variety of progressive education books, including George Leonard's *Education and Ecstasy*, A.S. Neill's *Summerhill*, and several essays by Paul Goodman. Discussing Leonard's book gave me a sense that the whole education system needed to be reorganized to develop humans to their full potentials, and I developed a craving to learn about other utopian projects. That class became a crucible for some of the most potent ideas put forth during that countercultural time.

Although my undergraduate experiences strengthened my passion for radical pedagogy and exposed me to more resources, it was rarely in a classroom that my excitement was kindled. The education classes that I registered for and then dropped after each first meeting were pitiful. If the faculty teaching those classes could not engage me, someone who was truly interested in the topic, then there was little I saw that I could learn from them.

A few of my teachers were gifted. Paul Riesman, the late anthropologist and son of the famous sociologist David Riesman, had a gently persuasive manner. I was startled by how closely he paid attention to who I was at that time and how tenderly he encouraged me to find my true voice in my writing. He introduced me to the lifelong benefit of keeping a journal and asking lots of questions from my gut. Paul Wellstone, my political science teacher during freshman year, reinforced the values that I had learned at home: find

out what's going on under the surface, don't accept what the authorities tell you, organize, and develop an ability to communicate compassionately across all sorts of boundaries.

While there were other faculty members who had a positive influence on my values and thinking skills, during the early 1970s there was so much intense learning going on outside of the classroom. During late-night discussions, long walks in the woods, and rallies on and off campus, fellow students were asking crucial questions about the type of education we were receiving and what alternatives might exist. "Relevant" was the buzzword of the time, and the teachers and peers who exposed the hypocrisies of the world around us and helped us to develop the critical thinking skills to see them for ourselves were our heroes.

I went to live on a kibbutz for half a school year and examined what the benefits of raising children collectively—separate from their often dysfunctional nuclear families—might be. I came home disillusioned with the Israeli state and its racist policies, and more convinced that nation-states should not exist. One of my friends went off to be part of the burgeoning alternative school movement in the Twin Cities, and was reading all he could about new strategies for learning. Many of our classmates worked in the successful community co-op movement, started community gardens, worked in progressive educational programs, and were experimenting with all forms of social institutions from open relationships to bartering and various forms of communal life. There was a visible and visceral explosion of alternatives to every status quo institution. Saying that it was inspiring and an optimistic time is not sufficient to describe what it was like to live with the conviction that the world was going to become a better place for everyone.

One of the great benefits of attending graduate school in Canada was the exposure to more critical views of U.S. foreign policy and the effect of cultural imperialism on our northern neighbors. So while I shared this sense of optimism with many of my peers, I recognized that I needed to get grounded in the meat of what was going on. I read voraciously, trying to figure out why society was so screwed up, and why education seemed to be making it worse rather than better.

First I read Edward T. Hall, Erving Goffman, and Ivan Illich. Hall and Goffman got me thinking more deeply about social behavior and how a particular cultural context conditions those behaviors. My early experiments in interactive installations were partly inspired by those readings, but they also got me focused on how to educate people so we could generate more humane, compassionate behavior among humans. In other words, to think about what steps needed to be taken to generate the next evolutionary leap.

I became very interested in Illich's theories about "deschooling society" and was able to hear him speak in person in 1977.

> Many students, especially those who are poor, intuitively know what the schools do for them. They school them to confuse process and substance. Once these become blurred, a new logic is assumed: the more treatment there is, the better are the results; or, escalation leads to success. The pupil is thereby "schooled" to confuse teaching with learning, grade advancement with education, a diploma with competence, and fluency with the ability to say something new. His imagination is "schooled" to accept service in place of value. Medical treatment is mistaken for health care, social work for the improvement of community life, police protection for safety, military poise for national security, the rat race for productive work. Health, learning, dignity, independence, and creative endeavor are defined as little more than the performance of the institutions which claim to serve these ends, and their improvement is made to depend on allocating more resources to the management of hospitals, schools, and other agencies in question.[7]

Breaking down the walls of the authoritarian and stultifying classroom, and bringing students to question all the institutions that Illich mentions above, seemed like a no-brainer to me. There had to be ways to work with students to make the illusions transparent. So I was incredibly grateful when I discovered the work of Neil Postman and David Weingarten. Their book, *Teaching as a Subversive Activity,* was primarily written for high school English teachers, but I saw ways to translate some of their exercises into conceptual art projects for my students at NSCAD.

The first class I taught on my own was a distillation of one of the core ideas in *Teaching as a Subversive Activity*—that reframing meaning is a political, socially engaged act. Words have connotations and denotations, and the ways that artists translate those words into images, objects, interventions, site pieces, and events, can reframe the values of those who witness or participate. So why not have the students create works of art inspired by particularly charged words, like "exotic," "masculine," or "power"? This process, I thought, would lead to more complex critical thinking, if not engaging art.

During my last year in grad school I met an anthropologist from Bolivia who was living in exile in Canada. His literacy campaigns with rural peasants had gotten him thrown into prison once too often. He introduced me to *Pedagogy of the Oppressed* by Paulo Freire. Freire, like my friend, felt that

teaching people to read without teaching them the words that would help them navigate the power structures in their world was not enough. He taught his students how to read the words "boss," "landlord," and "oppression," and helped them parse out the social and personal meanings of those words as they became literate.

Freire's ideas reinforced my sense that teaching form was not enough, and I began to see that I could teach art in such a way that it would reveal hierarchy and systems of oppression while providing healing and insight. The techniques of mark making, composing and putting objects in space, would serve ideas and critical thinking. I just needed to figure out the best exercises to make this process unfold in an effective way for my students. I had to model something that would not solicit clichéd, self-righteous, or pedantic work from my students. It needed to go to the roots of disempowerment and then build from there.

Years later, my reading of the work of critical theorist Henry Giroux amplified and built upon what I had learned from Freire. Critical theory attempts to create new forms of knowledge by breaking down disciplines and creating interdisciplinary knowledge; looks at the margins and centers of power in schools; examines new ways of reading history, through the lenses of race, gender, class, and ethnicity in order to reclaim power and identity; rejects the distinction between high and popular culture to make curricula responsive to everyday knowledge and people's lived histories; and foregrounds ethics and social responsibility as part of learning.

The bell hooks book *Teaching to Transgress: Education as the Practice of Freedom* entered my world of thinking about pedagogy over a decade after the theorists just mentioned. In the early 1990s, after devouring every feminist author I could get my hands on, I discovered the work of bell hooks and had a wonderful sense of many lights going on in my brain at once. Not only did I recognize that I could use the multiple lenses of race, class, and gender to examine many bodies of knowledge, I recognized how important it was to have the classroom material informed by the particular histories of the students. Criticizing colleagues for using the classroom "to enact rituals of control that [are] about domination and the unjust exercise of power," hooks' message about the liberatory aspects of education is profoundly hopeful.

My liberatory pedagogy has been informed by everything that has created synthesis, ecstasy, resonance, and wholeness in my life, particularly those thinkers and doers who went and continue to go against the tide of their times, using satire, their bodies, and their dreams to manifest what is possible, despite the plentitude of fear and greed.

Subverting in the Museum

After graduate school I was eager to go out into the world and apply some of my newfound pedagogical impulses. I say "impulses" rather than theories or approaches, because I had such little experience testing them and there was no one mentoring me. Unfortunately there was a recession going on, there were barely any academic positions to apply for, and the competition in the New York City area for teaching positions was intense.

I was counseled by a few older and wiser peers to go to New York and get my work out into the public realm, and find whatever art-related job I could. Fortunately many of the visiting artists, curators, and writers who had come to my grad school helped to network me into various margins of the art world, and I had several people to call for help.

My first job was working as an administrative assistant for the museum aid program at the New York State Council for the Arts (NYSCA). What an extraordinarily learning experience it was, to sit in the panel meetings where the directors and curators of major museums schmoozed and expressed their value systems through the ways they voted on applications from similar or less-powerful institutions. After a year of this fascinating crash course, de-mystifying some aspects of the art world, I decided that I'd had enough of the stress of that particular office. I met with one of the people I knew through my NYSCA job to discuss the prospects of finding teaching work in one of the local museums, a conversation that landed me a short-term position working with high school and college students at the Jewish Museum.

While I couldn't create curricula there (this had been predetermined in a grant written a year earlier) I was able to get a sense of what questions to bring to students who come through museums. Who funds museums? How does the funding control what exhibitions get precedence? How do curators determine what gets shown and what doesn't? How are systems of oppression (racism, sexism, classism, and homophobia) evident in the choices about what is seen and what is invisible in the museum? How do the space and the placement of art effect how we create meanings?

My second museum teaching job, at the Metropolitan Museum of Art, allowed me to flesh out these questions and develop curricula that would give the students an opportunity to really question the purpose of museums and how museums help to determine the values of dominant culture. My position as artist-teacher was ostensibly designed to bring "culture" to the "underprivileged" living in the remote boroughs and poorer communities of New York City. Fortunately, Randy Williams, an African-American artist

who had been working to revamp and humanize the museum's relationship with the diverse communities of New York City, became my mentor and encouraged me in my path to subvert the normal patronizing paradigm.

Although my time with each group of high school students was limited to no more than eight sessions, I was able to expose them to crucial questions, develop a rich dialog and learn about their world and value systems.

During our first meeting, I shared a slide show, a short history of socially engaged art (not often seen on the walls of the museum). Then we did a brief media-literacy workshop where they developed a better sense of how the dominant culture's values are revealed in magazine advertisements. (I learned how to do this work by reading early issues of *Adbusters*.) After those two sessions, I would take them through the museum, pointing out whose work and what stories weren't represented on the walls. Those absences became a loud voice in relation to our awareness. As we strolled the marble corridors I shared how a work of art, the placement of works of art, and the museum's architecture reinforced privilege and attitude.

We would go back to students' high schools, some impoverished and under siege, and discuss the contrast between the world represented by the museum and their everyday lives. We talked about art as a way to gain insight about the world and power over one's life, and students would develop art projects that represented their visions and value systems.

At one school in the South Bronx, the art teacher, without supplies or adequate equipment, had created a sanctuary for her troubled students. Her slide projector was from the early sixties, requiring me to load one slide at a time. The windows of the classroom lacked shades, so the students crowded around the wall farthest from the windows to look at the projected images, the size of postcards. Despite this handicap, the students were completely attentive. I noticed that the teacher had a numbered tattoo on her arm and expected that her experience in the concentration camps had uniquely prepared her for working with these students whose lives within an authoritarian educational institution felt very much imprisoned. These students painted escape fantasies, imagining new worlds in outer space or far away from the 'hood, where they might find some relief from the never-ending stress of poverty and violence.

In a lower Manhattan alternative public school for older teens who were returning to school after arrests, drugs, homelessness, or pregnancies, a social studies teacher taught the art classes. He loved my approach to teaching art with social content, and exposed to me to the benefits of working with students in an interdisciplinary way. While walking the students through the Met's African art collection and raising questions about how the exhibitions revealed aspects

of colonialism and imperialism, we decided to develop a mask project for his students. The students created animal masks and invested them with the power to confront aspects of society that oppressed them.

As a paltry gesture of inclusion, the museum allowed the students to exhibit their work in the lobby for one short evening. Offering a crumb of recognition within the palace of high culture seemed to be a strategy to pretend interest that did nothing or very little to upset the power relations. The potential for learning *from* the communities was rarely considered. Thankfully, I realized that the benefit of working with these students was the critical thinking and creative work we did together. The patronizing experience of entering the halls of high culture for a minute had its allure, but the students were not taken in for long. They recognized that museum officials were trying to look altruistic while really doing very little for the poorer communities and schools.

A More Distinct Definition of Community Art Practices

The term "community" needs defining because it is tossed up in so many complicated and generalized ways in relation to socially engaged art practice. To allow some stepping outside the frame, let's agree that community is a distinct space defined by place, tradition, ethnicity, life experiences, and/or spirit.

When artists choose to consciously work in community, their impulses can be guided by multiple desires. Some see themselves as cultural or community animators, artists who facilitate a creative process *within* the community rather than as artists making pieces *for* communities or directing the communities to make works based on the artists' visions.

Some artists are driven by a desire to find connection with their neighbors or people who share a life experience like a serious illness or prejudice. For other artists the inclination that draws them to this work is learning about a community that will give them a wider perspective on their world. An artist in the latter category usually requires an intermediary, a "bridge" person trusted by (or a part of) the community) who connects them with the people of the community.

I did some of my best learning about community arts while training with the late, great, English community arts group Jubilee Arts, now known as THEpUBLIC. Jubilee was one of several groups that really defined the concept of cultural/community animation through their work. One of my mentors, Charles Frederick, exposes the profound dialectic of this work:

> Cultural/community animation means to revitalize the soul, the subjec-
> tive and objective, collective and personally experienced identity of a

community in historical or immediate crisis. Using a plethora of art and performance forms, the community gathers in all of its internal diversity with autonomous democratic authority to explore critically its social and historical existence. The product of this cultural work is for the community to create new consciousness of itself and a renovated narrative of its imagination of itself in history expressed in a multitude of forms. This new narrative is created beyond the boundaries (while in dialectical recognition) of the previous, external and internalized narrative of oppression. Identifying itself within this new narrative of subjective and objective history, the community is empowered, while publicly expressing its presence in history, to make new history and a new destiny for itself, in an organized program of social and political action, thus adding new chapters to its historical narrative. While in the aesthetic project of composing its narrative and while at the same time in the political project of acting from its new story, the community is re-composing itself, both symbolically and actually in freedom and with justice.[8]

In 1993, three members of Jubilee—Sylvia King, Brendan Jackson and Beverley Harvey—traveled to Ukiah, California, invited there by Don Adams and Arlene Goldbard, leading writers and theorists in the community arts movement, with the help of some major grants, to develop a community art project and teach activist artists in the United States some basic strategies for working in community. I was a part of that workshop and our goal was to learn how to use art to create dialogue between communities in conflict and to make the narrative of invisible groups visible. We had a laboratory to learn about the process. Every day we participated in a series of exercises that were standard fare for Jubilee cultural workers. "Action/Research," a term to describe a way of gathering information and making art from it, was one of the most important lessons we gained from our time together.

We broke into small groups and were asked to share a social issue that concerned each of us. We each discussed our individual issue for several minutes, and shared a story with the group that illustrated our concern. We created a list of issues and discussed how our issues were interrelated.

After that we were invited to make a skill inventory. The skills that we listed were very broad, from "writes poetry" to "makes good soup" or "talks well on the phone." With this list and the list of social concerns, we began to brainstorm a form, an intention, and a context. In other words, we developed an art piece that connected many of our social concerns and that could be made in the space of twenty-four hours using the skills that we had brought to the table. We thought carefully about who our audience was, what the

limitations of our skills, materials, and exhibiting space were, and what we hoped to accomplish.

While the product of our efforts was not memorable, the process was. In fact, I learned from this experience that it was the process itself that had become the artwork, and that was invaluable knowledge. Within two days we had developed new ways to communicate and create consensus with a group of strangers, and we had deeply enjoyed our discussions about our intentions for the work, the context in which it would be seen, and the audience. Discovering a process that was somehow both fertile and full of healthy friction, we were ready to go out into the world and practice with these new skills.

Our group was assigned to the local senior center where our intention was to collect stories about the elders' perceptions of both the tensions and the benefits of living in the Ukiah area. We found different ways to start conversations and once a little trust was established we asked people if they wanted to photograph each other. The portraits and the stories accompanying them became the substance of an exhibit at the local mall. Since the stories were gathered in the cafeteria we decided to exhibit the portraits and the stories as place settings.

While not altogether satisfying, either aesthetically or conceptually, this taste of Action/Research whetted our appetite for more. To be effective community cultural animators all participants need to commit time and resources. Trust must be built slowly. An artist/facilitator who dips into a group for a short stay and exploits the group's talents for his or her own benefit can create bad feelings all around.

There are many who believe that community arts practice is the new avant-garde, taking our society's cultural production to the next necessary step. The contemporary version of this form of cultural production has been around since the seventies when neighborhood mural projects and performance work were being funded with CETA grants[9] and feminist artists galvanized nonprofessional artists to participate in large public pieces. It has gathered strength through some important organizations, institutions, and networking despite the continual disappearance of funding. Among those organizations are Alternate Roots, Community Arts Network, Imagining America, and the late Alliance for Cultural Democracy.

The concept of cultural democracy, that every group has a right to its own cultural production and expression (and every individual a right to her or his own), is quite threatening to the status quo. The high art world seems to need an injection of the authentic expression of people's voices in order to maintain some liveliness in its often deadened, decadent state,

but it typically dismisses the art produced within the community context as lacking aesthetic merit. Plenty of other negative adjectives are hauled out of the closet if the aesthetics card doesn't work; still the energy is exploited when it suits the powers that be.

Some artists express ambivalence about working in community because they feel that they lose their creative freedom when their unique voice becomes subsumed in the collective process. Perhaps if art were truly valued in our society and the individual artist's ego was stroked more frequently, the experience of being an animator or catalyst would just be another aspect of one's creativity. Of course, it's true that not everyone is suited to participating in the group process, just as not everyone is drawn to making visual art.

Another common complaint is that community arts funding dominates individual artists' funding in state and urban arts policy. Often community arts are seen as a pragmatic way to deal with social ills. I have heard it stated directly, "Let's throw an artist at this gang violence and see if the alarmed public will shut up." Of course there needs to be a more enlightened approach to how community arts is perceived and conceived, a more enlightened policy and public. Some of the artists discussed later in this book have some excellent suggestions regarding these issues.[10]

Then Find a Garden

The women who were so riled up recognized after hours of finishing each other's sentences that their messy, smoky studio had become a garden, a refuge. Some looked like they had emerged from pressure cookers, with limp arms at their sides, often weeping, with foggy brains. After a time, the other women told them jokes that allowed their muscles to revive, and they found work to do, pounding things, that helped them heal. Others arrived in the garden cursing, making sarcastic remarks that sliced the others. They were allowed to sit in hot springs until their bodies melted into their folds. In each other's company, the steam that had built up over many years began to leak out, sometimes fast, causing explosions that made most everyone flee.

When the steam was leaked slowly, they could unfold a bit, and tell the stories of the folds, and their bellies rippled with laughter, and tears poured into fountains, and sweet balls of girls were given the space to just be. Fierce warrior women would occasionally lock horns and some would leave the garden in distress, sometimes returning after years of foraging, covered in new scars. Eventually all who arrived were taught how to eat roses, and if they'd forgotten, how to look under rocks.

It didn't take long for them to bring both their roses and their folds steaming with rage into the world, and they demanded redress for all that had been done to them.

Some of the women became nomadic (with wanderlust or a desire to find more sisters). Amazingly they discovered gardens with women wherever they went. In prisons, in secretarial pools, in kitchens, and in locker rooms, and they knew something was happening that was like a vibration, that had its own ebb and flow.

In time it was noticed that a few brave, tender men—some who were burnt at the edges or were covered in the ugliest of scars, yet men with sweet bouncing boys inside—had entered the gardens. Sometimes they arrived parched and bitter, so folded in that they had to sit quietly for long periods of time until the laughter melted them. Some came as if they had been washed up from a flood, confused and punching at shadows. They were given heavy tools with which to dig and were offered rags to polish things, and in time they could talk and sing roses. Occasionally a few men arrived like skaters, their feet gliding on the soft ground, and did awesome pirouettes for the women, moves that left them speechless.

In some of the gardens, the men and women began to braid the threads of their stories together, and the braids often had questions tucked into the creases that brought curious folded-in people to gather and sit with them.

Activist Art in Community

Prior to my arrival at University of Washington Tacoma (UWT), where I now teach, I developed a course called Activist Art in Community that I facilitated at several schools. Although I was grateful to be given the space to teach the course, I often felt like I was cramming the class with too much information and too many exercises. This course might have been my only chance to affect these students, and I felt a need to expose them to multiple topics and approaches. Students could explore personal stories and the politics revealed by them, develop collaborative projects, and refine their concepts and forms.

When I co-taught this course with my partner, Bob Spivey, at the Institute for Social Ecology for many years, it was a month-long session, meeting four days a week. Many of the students then were environmental and community activists with little art experience.

During the first slide lecture I would introduce students to art about war, gender, cultural identity, fear of difference, racism, work, environmental issues, and more. There was rarely time to show more than five to ten slides on any one topic. I approached this task with a passion that was laced with both

impatience and frustration—there was so much ground to cover and so little time. I was trying to compensate for all of the art history classes that failed to cover socially engaged art, and the continuing absence of this kind of work in the public consciousness. I had a sense that if students could see enough of the spectrum of work being done, something would touch them and they would see a way that their story might be valuable to share. Often there was one artist or one project that opened the door in a student's heart, and gave them permission to finally share the story that they had been holding back.

After the slide show, we would invite students to meet in small groups to share a social issue that affected them personally, on a gut level. Here is where the work with Jubilee Arts began to enter my own teaching practice. The stories each student chose became the source material for a collaborative art piece. We encouraged students to think about the issues that affected them directly on a daily basis, rather than engaging only intellectually or superficially with a topic. Sometimes students don't want to be open with strangers, so they share a story that they feel will make them appear virtuous, rather than speaking a truth that they have lived. But if the chemistry is right, hearing their peers' stories gives them the strength and courage to plunge deeper into their angst or to offer up a more honest portrait than they might have otherwise. One student was concerned about the growing global disappearance of clean water. She didn't feel that she was truly confronting that issue emotionally on a daily basis, but working on the topic was a good way to avoid dealing with her own ambivalence and conflicts about more immediate problems: her girlfriend's eating disorder, her dad's alcoholism, and her job worries. We talked about a way that she could combine her more intellectual but still very valid concern, with the emotional ones that fueled her daily stress. That made for a piece that had more immediacy and pathos, and spoke more deeply to her peers. One way to describe this process is to say that it means working from the core, rather than from what you think you should be talking about in your art.

Students would share their stories for about ten minutes each, without cross talk, listening carefully to each other. After every student had spoken, all were invited to discuss how the stories were connected and then they began brainstorming how their stories might weave together to create a piece.

The next step in the process was to create a skill inventory, where each student would list on paper what skills they already had, everything from making signs, to writing poetry, speaking in public, making puppets, and organizing files. With this list, the students could begin to imagine a form that their collaborative piece could take. Perhaps it was an audience-participatory installation, or a performance piece, or an interactive game. Depending on

the group and the amount of time that we had to accomplish the work to-gether, students could create diagrams for planned pieces or develop more elaborate works and place them in desired sites.

Usually in the middle of the course workshop, students would get stuck or frustrated with the creative process. Bringing them out of their heads and into their bodies was always useful. As part of this loosening-up process, we would offer up some games and exercises from Augusto Boal's Theater of the Oppressed work and Playback Theater. Some of the games would give the students strategies for understanding power and hierarchy through manipulating their bodies in relation to their peers, and this opened them up to new ways of telling stories of oppression.

Sometimes students had only an afternoon, evening, and morning to create a collaborative project, and the materials they could use were scavenged from the site where I was teaching. This required them to be enormously in-novative and gave them skills that would allow them to adapt these strategies to whatever community contexts they chose to work with in the future.

4

Facilitating an Interdisciplinary Arts Curriculum

Among many of the experimental and progressive ideas that percolated in social upheavals of the 1930s, were ways to improve upon the traditional models of higher education. Among the schools sharing similar open-minded ideas were Bard, Bennington, Black Mountain, Antioch, Sarah Lawrence, and Goddard. Since 1938, Goddard has been inspired by John Dewey's philosophy of student-centered learning, and innovative curricula influenced by William Heard Kilpatrick of the Teachers' College at Columbia University.

Goddard students are encouraged to talk a lot (you always hear students talking about "the process"), and classes are facilitated rather than taught. It is holistic education at its core, where students create and develop personal curricula based on their intellectual and emotional lives, their experience of the arts and academic subjects, their pasts, their present lives, and their dreams for the future. Practicums engage students in the practice of the theory they are learning, and every program requires them.

At Goddard, learners decide what they want to learn, find an advisor who can guide them, and then work with that advisor for a semester or longer. The low-residency model of education, where students come to the campus for a weeklong residency once per semester, was first implemented in 1963 and was the first of its kind in the country. (It was the outcome of a Ford Foundation grant received in 1959.) The full residence program was dissolved in 2002 and the campus now runs only low-residency programs.

I taught at Goddard from 1991–2003, and it revolutionized the way I saw myself as a teacher. When I was hired to work with BA, MA, and MFA

students in various interdisciplinary programs, I never knew from one se-
mester to the next what I would be studying with my students. My areas of
interest would grow with each new advisee, who would choose me because
of some shared passion. When a student decided to work with me, it might
be that they wanted to make visual art about healing from domestic abuse,
create performance art about racist incidents, develop a story board for a film
about environmental issues, do radio about the global justice movement, or
facilitate a community-based art project about meditative art forms. I had to
let go of being an expert in the field of study or the art form (not that I ever
really had such presumptions), and instead see my qualifications as those
of a resource person, touchstone, mirror, question asker, and unraveler of
chaos. What a shift in thinking this new model required. I didn't have to have
all the answers, but I did have to know how to ask the pertinent questions,
and truly engage in the story of each student.

The structure of each semester involved attending the residency, meet-
ing with advisors, attending workshops facilitated by faculty and students
on diverse creative projects and scholarly research, developing a study plan
with each individual student, and attending performances and many informal
late-into-the-night discussions. When students returned back to their home
bases, they would send every three weeks a packet full of materials to respond
to. It might include process papers, essays, journal notes, documentation of
work in progress, and more. I would then sit down with it all, weaving the
often tentative explorations into more lucid questions, providing points of
view that would give the student a fresh perspective.

When the process worked, it was exhilarating for all. Both the student
and the faculty member had the kind of dialogue that was fully coherent,
embodied, and integrated into the everyday life of both participants. Subjects
weren't separated into discrete, sealed packages, and the narrative of life as
a daily education remained whole.

Here is how my colleague Ruth Wallen describes the process:

> I think that it starts with deep listening, listening to students' needs
> and desires in a way many students have never or seldom experienced
> in the past. While an exchange over the computer may seem distanced, in
> essence I write long letters to my students, an average of five single-
> spaced pages every three weeks. I have more time and space to reflect
> on their work than I ever had with graduate students with whom I've
> worked on independent studies at UCSD. The attentiveness alone of
> advisors is deeply validating to students who are encouraged to develop

their own vision. Students learn to make connections between personal experiences, often deep wounds that impelled them to make art in the first place, and larger social/political realities. They learn to contextualize their work in terms of what others are doing and a range of interdisciplinary perspectives of their own choosing. They learn that theory can lead, and is not a tool of obfuscation as many were unfortunately led to believe in mainstream institutions. While a perturbing number enter with formalist ideas of art, they are often excited to develop a more public, community-based, relational and/or activist practice. Those entering already with engaged practices . . . experiment and . . . expand the reach of their work.

Writing narrative assessments at the end of the semester, in place of a grade, was the one of the most difficult assignment of the semester for me, but it diffused the power relationship somewhat, giving students a more thorough understanding of their progress.

What was exceptional about Goddard's MFA in Interdisciplinary Arts program, started by Montreal interdisciplinary artist Danielle Boutet back in 1998, was the decision to accept students who were not from the most elite schools and whose art educations or portfolios might be considered spotty in places. Many students came from working-class backgrounds. Some students had portfolios that were disorganized, or, at best, eclectic. MFA programs looking for students with more tightly packaged work would have rejected them.

There were quite a few students who had already had stellar careers, working with top people and institutions in their specialized arts fields or innovating in their forms. Some had received Canada Council grants for their performances or had run unusual community arts programs. Yet all were ready to go deeper into their practices, and some wanted an MFA so that they could be eligible for tenure or tenure-track positions in academia.

Students arriving in the program with undergraduate degrees in any art form would rarely have been exposed to the critical issues about contextualizing their work within society or how to shape an intention for a project. This is standard fare at Goddard.

My years working at Goddard spoiled me, not financially (otherwise I would still be working for them), but intellectually and emotionally. I was deeply stimulated by the dialogues with my colleagues and students there, and despite the joys that I have with my current position, creating new curricula, it is nothing like the dynamic dance, the non-compartmentalized investigation of culture and the world that I had with my Goddard students.[1]

Fig 4.1. "Garden Project at Hudtloff Middle School, Cloverpark School District, Tacoma, WA. Created with Hudtloff's Environmental Club and UWT's Eco-Art students: Ashleigh David, Kayomi Wada, Meredith Cook and others. Photo by KayomiWada, 2007.

Arts in Community at the University of Washington, Tacoma

When I was invited to join the fledgling interdisciplinary program at the University of Washington, Tacoma (UWT) in 2003, I was one of the first two visual artists hired on the tenure track there. Aside from the privilege of having a full-time teaching position for the first time in many years, I was given the rare opportunity to create my own interdisciplinary studio art courses. I was told quite directly, "You can teach whatever you want." Is this not every teacher's dream?

Since the school is expected to grow exponentially in the coming years, I was told that one of my responsibilities to my new institution would be to create an arts program that would suit the community and the school's mission statement. Working for Goddard's interdisciplinary MFA program for six years had uniquely prepared me for UWT. My style of teaching was no longer a good fit within the narrow vision of most art departments, so I was eager to become part of this experiment in interdisciplinary education and much relieved to be teaching outside the realm of a traditional art department.

Soon after receiving tenure, during my second year at UWT, I collaborated with my artist colleague Tyler Budge to develop a curriculum that would be part of a new major in the Interdisciplinary Arts and Sciences Program. We determined that our program would have an interdisciplinary, conceptual approach to art making. In other words, students would create work starting with the stories, ideas, and metaphors that interested them rather than focus on the media or techniques first.

From the beginning of our process together, Tyler and I have had a congruent vision. We are both interested in developing students' creative voices, their sense of themselves in relation to the world, and their abilities to use art in multiple ways, but particularly to stimulate dialogue and create community in all of its manifestations. Over the past five years Tyler and I have created ten courses, five each. Tyler's courses deal with representations of self, gender, and autobiography; site-specificity; the public; and the object. My courses are focused on ecology, war, cultural identity and fear of difference, body image, labor, and globalization. Detailed descriptions are discussed below.

In the summer of 2007 we received a grant from the university to create the official proposal for our new major program, Arts in Community. After months of research and meetings, and conferring with an outstanding crew of consultants (some of whose stories are detailed later in this book), our colleagues and various review committees at the university received the proposal with great enthusiasm. The proposal states that the Arts in Community major will immerse undergraduate students in an interdisciplinary arts program that emphasizes visual, verbal, and media literacy; aesthetic and technical skills; and critical, analytical, and creative thinking. Arts in Community students will participate in internships with cultural institutions, community arts organizations, and social service agencies, as well as with local artists, cultural workers, and scholars. The curriculum addresses issues such as the environmental crisis, gender and cultural identities, homelessness, globalization, labor, and social justice.

The Arts in Community major gives students an opportunity to develop aesthetic and media literacy; explore the social, philosophical, and psychological content of art; question what role they wish their art to play in community and society; and explore many dimensions of the creative process. The primary course work in our interdisciplinary major is idea-based rather than medium-based. We offer our students conceptual, autobiographical, and socially engaged strategies for making art. Art is discussed as storytelling and metaphor, as a tool for healing, and as a form of communication. Students learn how to define their intentions, pinpoint their audience, and

find the appropriate context for the audience they wish to reach. With this conceptual approach to art making, students still develop a skill set that is competitive with other art programs, including skills in drawing, collage, digital imaging, and mural painting; construction with metal, wood, paper and scavenged materials; mold-making; video; audio; site-specific installation; and performance skills. Students practice writing artist statements, and grant and project proposals, as well as developing a portfolio.

Studio space is essential for our students to turn their ideas into actual projects. (At the current time we teach our classes in just one room). Our majoring students (and those who take our courses as electives) develop their critical thinking skills as they are exposed to many of the concerns of the communities in which they live. Our graduates will be able to understand and articulate thoughts about their work within larger historical, theoretical, and cultural contexts; will have interdisciplinary tools for interacting with society and community; and will have developed creative processes that empower them both as individuals and as citizens.

Our program gives students the ability to choose from several artistic paths, from that of the artist who works alone in the studio to communicate social concerns or heal personal traumas to that of the artist who sees community members as her or his primary collaborators. It is our expectation that our majoring students will go on to pursue careers as practicing public artists, art educators, media literacy teachers, curators, writers, graphic and Web designers, museum administrators, facilitators of cultural work in specific community groups, participants and founders of youth art programs, art therapists, and collaborators in the creation of nonprofit arts organizations. Students will learn how to work with communities in a process of conversation, proposal, response, and analysis. Some of our graduates will go on to attend graduate programs focused on community-based art and social practice.

At this point our proposal remains a dynamic vision with lots of community support from students, colleagues, and community members. Until funds are raised to retrofit one of our local buildings, however, the momentum to make the vision a reality is stalled. With only one classroom and two faculty members (although we expect a new colleague in 2009), our program remains a dream until we can generate more energy by widening our circle of allies. We are hopeful that our vision will continue to resonate with students and community members, and eventually manifest in some way. In the meantime, we will continue to teach our current curriculum as electives, providing the only hands-on, interdisciplinary experience with studio arts that most of the students will ever have during their university years.

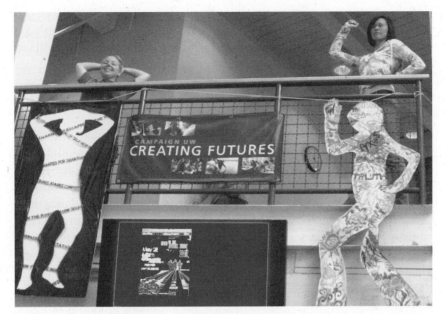

Fig 4.2. "Body Outline Site Specific Project" Rachel Delgado and
Brittani Hoeks, Body Image and Art class, 2008. Photo by Beverly Naidus.

The Current Curriculum:
Teaching Art to Non-Majors

In all the years I have taught, I have never felt more adventurous than I do
now, in my current interdisciplinary context. An accumulation of pedagogical
experiences allows me to ride this wild surf. How is it wild? Imagine working
with students for only ten weeks, trying to give them a taste of what it means
to find your own voice, be exposed to a social or philosophical topic in a
meaningful way, learn about the history of artists creating work on this topic,
and develop a series of art projects, both collaborative and individual, that
pay attention to intention, context, and visual grammar. It's quite the task.

I am sure that some of my more traditional colleagues, and even some
of the more daring ones, might find what I am doing ridiculous or not suf-
ficiently rigorous. Nevertheless most of my students are able to benefit in
profound ways from the diverse buffet in front of them, weaving together
a complex set of ideas with a creative process, both their individual stories
and a collaborative experience. With over half of the students lacking the
most basic visual literacy, both historical and contemporary understanding

of the concepts being addressed, I see them leave my classes able to deconstruct images and more confident that they have something significant to say through their art. They can analyze contemporary art and the issues that are addressed in socially engaged work, and are stretching both in intellectual and emotional ways, something they may never have imagined when they innocently signed up for an art class.

As teachers we can come into each new class with an open mind. Who are these people and what are they going to teach us? How will our sense of the world be expanded by their stories? Where will their artistic experiments take our own creative growth? How will the most difficult confrontations between students yield the most profound lessons? How can we expand their definitions of art beyond decoration and entertainment? How can we burst apart their stereotypes about artists? How can we unveil their assumptions about fame and talent? How can we be truly present, listening and sharing what we know?

As will probably be evident to the attentive reader when studying my syllabi and the stories drawn from in-class experience, my pedagogical style is an eclectic mélange of critical theory and what might tactfully be called strategies drawn from life, work, and every sort of workshop you can imagine. Some of my steepest learning curves came outside of academia, hitchhiking in New England and Canada; working as a housecleaner, cook, secretary and waitress; living on unemployment and surviving on a diet of rice and beans; participating in retreats with activist spiritual leaders; engaging in dream work and an intermittent but lifelong yoga practice; experiencing anti-oppression workshops and ceremonies led by indigenous peoples; attending meditation groups; and meeting with groups of other artists and women writers (activist and otherwise). The mix that these experiences bring to my educator's palette can make for a more skillful and grounded teaching practice. I don't think I would be able to sustain myself in this work were it not for this background.

Aside from the rich model for discussions that I developed while working at Goddard, there are exercises that might involve sitting and walking meditation, journal writing, collage making, culture jamming, theater games, and feedback sessions. (The feedback session is a compassionate form of critique where we evaluate artwork through its intention, comment on the strengths of the work in relation to that intention, and then suggest ways that the student's intention might be made more convincing by trying different strategies.)

Although some students are frustrated because they can't just memorize and spew back what they've "learned," adrift without a formulaic curriculum, the majority seem to benefit from the experience. Here are a couple of excerpts from self-evaluations:

This class has touched my inner core to such an extent that I am not the same person. It has deeply rearranged my perspectives and challenged many of my beliefs. I am in a continual process of examination and adjustment, yet at the same time, more centered than ever. Thank you for the "reality check" and for your caring compassion. I have learned so much and have so much yet to learn.

I so appreciate that this class is less about execution, and more about creation. Idea exchange, true education and a sharing of ideals. It's a powerful class. It makes me feel the great desire of continuing to have people in my life who are passionate about healing the planet. I will really miss this class.

As you read the course descriptions, please remember that each quarter the course is modified to reflect both the students' interests and the energy in the room. In other words, what might seem like a proscribed series of activities and set of questions shifts every quarter. Keep that flexible mindset while you are reading.

Eco-Art: Creating Art in Response to the Environmental Crisis

Although I started making art about environmental issues early in my art career—my first piece created in 1981 was a map about the damage James Watt, Secretary of the Interior under Reagan, was planning to do to the national parks)—I didn't have a coherent understanding of the interrelationships between the environmental crisis and social problems until I met my husband, Bob Spivey, in 1988. At that time Bob was a student at the Institute for Social Ecology (ISE), pursuing a master's degree in social ecology. After we met, Bob decided to focus his MA thesis on activist art (a long-time activist, he had done theater, music, and writing for many years). Our pairing precipitated a wellspring of new source material for my art making, and social ecology was one of the major touchstones for my inspiration.

In the early nineties, the ISE—where later we came to teach for many summers—invited me to be a visiting artist during their summer residency program. For those of you who have never heard of the ISE, I recommend visiting their Web site.[2] The ISE was founded over thirty years ago and offered summer programs to students until 2004. Both practical and theoretical courses were offered, including eco-technology, sustainable agriculture, social ecology in the Third World, media activism, eco-feminism, and community health. "From the antinuclear and ecology movements to the current one

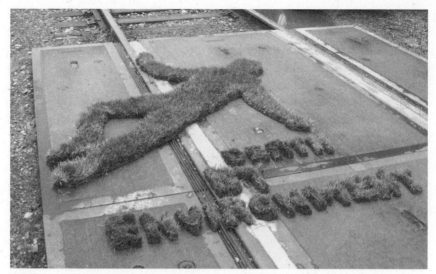

*Fig. 4.3. "Death by Environment" mixed media, UWT campus, 2008
by James Grayson Sinding. Photo by Beverly Naidus.*

against pervasive militarism and the bleak side of globalization," their Web site reads, "the ISE has inspired individuals involved in social change to work toward a humane, ecological, and liberatory society. Join the more than 3,000 students from around the globe—from Liberia to the Philippines, Italy to Iran, Norway to Uruguay, Israel to Ethiopia, the United States to Japan, and many more—who have attended the ISE in order to not only remake themselves but remake society as well."

During that first summer as an artist in residence I was able to witness some of the most inspired alternative pedagogy I had ever seen. It was my first contact with Goddard College's student-centered learning and the ISE was at that time housed and accredited on Goddard's campus. Although the ISE is no longer offering their summer program in Vermont, they still sponsor an occasional conference, facilitate a low residency master's program through Prescott College, and are responsible for spawning alternative institutions such as the one my husband founded, SEEDS—Social Ecology Education and Demonstration School.[3] I credit the ISE with helping to solidify the greening of my art pedagogy, although not in a simplistic way, such as a purist approach to art materials.

The sense that "another future is possible" was truly cultivated at the ISE summer residency program, and it gave me courage to make more hopeful work as well as engage in more disturbing projects. I began my series about

healing body image during my first summer there (*One Size Does Not Fit All*), and my projects about environmental illness, including *Out of Breath* and *Canary Notes*, were nurtured and later exhibited there.

During the decade that I taught at ISE, I had a pool of students who were already very open and aware of environmental issues. When I left to teach art students in Southern California and elsewhere, I would often be astounded by my students' lack of knowledge about where our food, air, and water comes from. Few of them understood how our information about these basic issues has been so manipulated and hidden that average citizens remain or choose to be ignorant. I do believe that a shift has gradually occurred in many communities. Recent documentary·films about aspects of the environmental crisis and other media attention has forced some people out of their denial, as has the growing explosion of cancer, asthma, and other environmental illnesses. Still, knowing that something is wrong, going from despair into action is not easily accomplished.

In my current Eco-Art class at UWT, I think that most of my students would describe themselves as being environmentally aware. They all know that something is wrong, although most don't know the specifics. They might be avid recyclers, fastidious about buying "green" products, deeply passionate about hiking in the woods, but the root causes of our world's ecological dilemma are not always accessible to them, and many don't really want to dive into the mess head on. It's not just that the situation seems overwhelming. The idea of actually analyzing how the environmental crisis is tied to broader social issues may not have occurred to them. For the most part, many students come into my classes thinking that they will be taking photographs of landscapes, or, at best, making a public art piece using natural materials. So I have my work cut out for me.

Here is the Eco-Art course summary:

> We live in a time when the environment that supports human life is in peril. Most of us find ways to ignore this reality on a day-to-day basis. To hold this information too close to our hearts would make it difficult to do the practical business of daily living. But as creative people we need to process and respond to this crisis in order not to become totally numb. We need to sort out how this ecological emergency is impacting our lives and those of our neighbors. We also need to imagine a future where our grandchildren can live in better harmony with each other and the natural world.
>
> There is a contemporary art practice that some people call "eco-art." This multifaceted movement addresses the environmental crisis

in a number of imaginative ways. Some of these artists see themselves as activists, their work acting as a lobbying force while it reveals the hidden (and not so hidden) realities of a polluted world. Some of these artists see their work as an opportunity for the public to reconnect with nature in new (old) ways and to heal from the alienation caused by living in a consumerist society.

In this course we will be exploring what it means to be a socially responsible artist and how an artist can both critique the dominant culture and create visions for the future. If we are aware of the environmental crisis, is it enough to recycle and live simply, or are there other ways we can use our artistic voices and imaginations to express our concerns about the world we live in?

We will experiment with different perceptual and conceptual approaches to art making and develop some aesthetic strategies for engaging an audience in particular environmental concerns. We will examine more carefully our senses of place: in the natural world, our local communities, and in the society as a whole.

As we go over the syllabus the first day, I give the students a very broad definition of eco-art: art that addresses the ecological crisis by reclaiming, restoring, and remediating damaged environments, and/or informs audiences about the environmental problems we face and how they are intricately connected to social issues, and/or re-envisions a just, ecological future. The forms that circle this genre of art are not restricted in any way; we look at large projects in remote, rural landscapes as well as Web interventions and performance pieces. The materials and tools used in eco-art can include scavenged and recyclable items, or involve technologies that are totally unsustainable (in the ecological sense). While I rarely raise this issue on the first day of class, it is important to note that the road to purism is chock-full of potholes, and may not necessarily be a useful route to take when it comes to social change.

That first day I offer the students a brief introductory slide show that includes restoration art as well as art that celebrates nature and ecological systems by creating an awareness of change, seasons, the interconnections between systems, and art that decries the devastation of the planet. Students spend the next few weeks choosing an artist whose works moves them. As in all of my classes, they will develop a ten-minute oral presentation on that artist's work. Some students find this to be one of the most inspirational aspects of this course, especially if they establish personal contact with the artist they choose. It allows them to develop a more intimate understanding of an artist's life and process, and gives them memories that are lasting.

After the brief overview of the field, we begin to explore the terrain of the course via a tactile exercise. First I tell the students that it is important for them to know that our campus is built on a Superfund site. An occasional student is shocked to hear this, and there are always some who do not know what a Superfund site is. We might look at a map of such sites, discuss what variety of chemicals might be in the soil below and around the campus buildings, how the toxins might be capped, and what might have caused the original damage to the site. After sitting with that knowledge for a few moments, I tell them that we will do a silent walking meditation through the campus for about fifteen minutes. During that time I want them to observe what they see, hear, smell, and feel on their skin. I ask them to follow their breath as we walk, and talk a little about the benefits of walking meditation, the goal of slowing down, and the intervention that we may cause via our silence and our attentiveness, on a campus where everyone is rushing past each other while talking animatedly into their cell phones.

The campus landscape, located in downtown Tacoma, is an unusual one. The buildings are mostly renovated nineteenth-century industrial buildings and warehouses. The handsome aesthetic, in a style some folks call "distressed chic," belies what is so quietly amiss underground, as does the well-groomed greenery decorating the spaces between buildings and the sophisticated public art interspersed throughout. In order to escape from the manicured landscape, our path diverges to a now abandoned railroad track behind the library where plants grow untamed (this thin strip of land is still owned by a railroad company). There the students usually stoop to pick up pebbles or twigs, or to smell a wildflower—this "crack in the pavement" offers an invitation to touch that the rest of the landscape does not.

Fig. 4.4. "Walking Meditation Fall 2008" Eco-art, UWT. Photo by Janie Cunningham.

I often feel like the Pied Piper as I guide these students through the campus. When we return to the classroom, I invite them to write about this walk in their journals. I encourage them to reflect about any strange or unexpected feelings and observations that they might have. After they write, they share whatever they choose with the group. Occasionally a student will be very aware of the temperature, the noise of a construction site nearby, or a smell in the air, some detail that the others may have missed. Sometimes several students will all tune into the same piece of visual or audio information, and they nod, smiling at their shared connection.

I then talk about how during the next ten weeks I will be expecting them to take similar walks, solo, in their own neighborhoods or yards. I require students to do a walking meditation at least once a week and to record their observations in their journals. They can go to a park, the beach, or to an urban site, or walk in their own backyard. They can take a dog, a family member,

Fig 4.5. "Walking Meditation, Fall 2008", Eco-art, UWT. Photo by Janie Cunningham.

or a friend, but they need to pay attention to where they are and which of their senses are most engaged. We talk about how unfamiliar the outdoors, particularly the natural world of the woods, the desert, the mountains, and the ocean, are becoming to many of the younger generation who are spending so much of their free time looking at screens. I refer to Richard Louv's book *Last Child in the Woods: Saving Our Children from Nature-Deficit Disorder* and students each share accounts of their good and bad experiences outdoors.

Our class discussions introduce the students to a very abbreviated history of the environmental movement from the beginnings of the conservation movement to the development of groups like the Sierra Club, the National Wildlife Fund, Earth First! and Greenpeace. We talk about what gets one of these groups more airplay and how their concerns get framed in a positive light, or how they are dismissed or put down by the media. While we don't have time to discuss all of the nuances of ecological theories in the space of ten weeks together, we do define some aspects of eco-feminism and look at how earth-based spirituality informs deep ecology. We also investigate some aspects of social ecology through the writings of Chaia Heller and Brian Tokar. Social ecology, while critiquing the economic and political systems that have fostered the environmental crisis, offers a way to develop a reconstructive vision of the future. That latter process involves a day or so of brainstorming what kind of world we want to live in, and has the potential to ground the students in ways that can be remarkable. We spend time imagining our neighborhoods dotted with community organic gardens, pocket parks, barter shops, free clinics, bicyclists, solar-powered cafes, and communal housing—sustainably built dwellings, with murals decorating outdoor walls on every block.

On rare occasions a cynical voice will chime in that we are wasting time with this idealistic daydreaming, but I remind them that there is no point in working for social change if we cannot imagine the world we want. One of my mantras is that cynicism is easy, but not very helpful. Creating visions is *courageous*. To bolster that daring, I urge the students to read the utopian/ dystopian novels of Ursula LeGuin, Marge Piercy, Doris Lessing, Starhawk, Margaret Atwood, Ernest Callenbach and Octavia Butler. More than any other art form, these novels have allowed me to imagine more complex and hopeful futures than the plentiful dystopias of Hollywood. A culture of impending doom has filtered from popular culture into the mainstream, giving my students a narrow range of possibilities, and as they debate the fine distinctions between a Mad Max, Matrix, or I-am-Legend world, they sometimes lose the ability to conceive of anything else. In earlier incarnations of this course I required students to read and write about one of the utopian books as yet

another assignment, but I now just summarize some of the plots to tantalize them. I have learned that, at least in this way, less is more.

During the second or third week of class we do media literacy exercises. Students are assigned the task of finding advertisements for products that are supposedly "green" or sold in a "green" way. This introduces students to the concept of "greenwashing"—products are sold by companies who make themselves look better by associating themselves with saving trees or wild creatures—and it gives them an opportunity to examine how easily even well-educated people can be duped when it comes to consumption: "If I just buy more of these green products and recycle more, the environmental crisis will be solved." Much of the critique of consumer solutions to social problems takes us to a more complex look at a dominant culture that allows for the extreme profit of a few, at the expense of the planet's health and the oppression of many.

Our first in-class art action involves bringing fifty to a hundred manu-factured objects and fifty to a hundred nature-made objects to class. With bags or boxes of these objects in hand, the students are invited to go out on the campus and create individual site-specific pieces. This activity gets them thinking about aesthetic choices, space, place, audience, context, visual

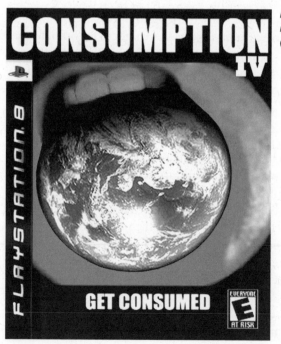

Fig 4.6. "Consumption" digital media, 2008 by Ailsa Hopper (Eco-art student).

Fig 4.7. "Bryan's piece" site-specific eco-art exercise, plastic bags and pine cones, UWT campus, 2008 by Bryan Deshawn (eco-art student).

grammar, and how to find meaning in everyday objects. A discussion about visual grammar is a mainstay of all my courses and necessary for students new to art. Whenever we have a feedback session, we refer to the list of formal issues such as line, space, texture, color, and composition, in order to have a shared vocabulary for analyzing an artwork. As a result of this breaking-the-ice exercise where mundane forms can take on powerful or whimsical metaphorical meanings, I find inexperienced students can leap more easily over the hurdles of conceptualizing and composing their own pieces. Students aren't given the time to prepare or develop performance anxiety; they often don't realize until it's "too late" that what they are doing is improvisational and has an audience, albeit a casual, temporary one. More often than not, this makes future public interventions much less daunting.

After an initial introduction to eco-art history during the first week of class, students continue to look, on their own, at the work of contemporary eco-artists.[4] They then choose one artist to report on, eventually giving an oral presentation. They are encouraged to establish an e-mail conversation with their chosen artist and that often helps to chip away at whatever pedestal they've put artists on.

Eco-art Web sites such as greenmuseum.org are an enormous blessing to have as resources for the students, but they also represent a paradox for the

more pure-minded among them. In order to communicate widely with the public, technologies are employed that use vast resources and create enormous amounts of pollution from their waste and by-products.

Students are also assigned several art projects in this class. These projects revolve around what are sometimes called the four elements: earth, air, fire (energy), and water. The students use Starhawk's wonderful text *The Earth Path: Ground Your Spirit in the Rhythms of Nature* as their guide in this process. I ask them to reflect upon the benefits of each element, what they celebrate about that element in their individual lives, and how that element might be at risk in our contemporary world. For instance, as they are doing their weekly walking meditation on water, I ask them to think about where their drinking water comes from, what might be lurking in the water in Commencement Bay, what's happening to local groundwater, and what's in the bottled water they drink. After they return from their walk, I ask them to research one aspect of water that deeply speaks to them, and then they have to brainstorm a project based on their research, experience, and emotional connection to the element being studied. Students can bring a project idea to class, expressed in the form of a drawing, collage, series of objects or props, projection, or performance, and the group gives them feedback to help them develop the work in terms of its intention, its aesthetics, and the context in which it will be presented. After doing exercises based on the four elements, each student chooses one of the exercises to develop into a final project that is presented to the group at the end of the quarter.

Collaboration is a key part of this class, like all of the others I teach. Sometimes I begin our group process with a few "despair and empowerment" exercises that I learned from my workshops with Joanna Macy, the deep ecologist. Macy's book *Thinking Like a Mountain: Towards a Council of All Beings*, co-written with John Seed and Pat Fleming, offers many readings that suggest ways of entering the emotions of grief and loss when it comes to species extinction. In order to establish the intimacy necessary to connect with the planet, Macy says, "Every atom in this body existed before organic life emerged 4,000 million years ago. Remember our childhood as minerals, as lava, as rocks? Rocks have the potentiality to weave themselves into such stuff as this. We are the rocks dancing." Thich Nhat Hanh, the Buddhist poet, peace activist and monk, says that we must listen within ourselves to "the sounds of the earth crying."

While the academic schedule and environment does not allow us to go as deeply as we might in an intensive workshop setting, we do a few of the visualization and meditation exercises to help the students confront their numbness. We talk about how all of us have this numbness to a certain degree, and how we wouldn't be able to function on a daily level without it. Neverthe-

less the potential for vast planetary changes brought on by global warming, along with the rising numbers of people developing environmental illness, are things that influence our psyches. In order to be effective at making any change at all, we need to recognize our interconnectedness and strength as a group, and our abilities to participate in even small ways. This work gently guides them to such a place.

After these exercises the class divides into groups based on themes that are developed in a brainstorming session. They are asked to produce a piece collaboratively, in any medium, that is sited in a public space on campus and that invites discussion about one of the issues we have discussed in class.

Among some of the best group projects in the eco-art class was a roped-off garden piece on the UWT campus grounds. Within the ropes were rows of "seedlings" labeled *ARSENIC, LEAD, CADMIUM,* and *MERCURY.* A title card enlightened the audience about the years of dumping that caused an EPA Superfund designation there, the decorative shrubbery belying its existence. Another project with a very different theme was a garden of native plants created for a local elementary school. (This month-long intensive collaboration re-landscaped a bare piece of the school grounds and involved the young students' participation). In a previous year students created two menus. One listed healthy meal choices rarely offered at local eateries and included organic, local, and non-genetically engineered foods. Its evil twin included a list of typical high-trans-fat, highly processed, genetically modified, pesticide-ridden foods. Students discussed ways to bring this kind of art intervention into the public realm and we talked about inserts that could be placed in menus or on placemats, and what the legal ramifications might be for educating people in this way.

Some of my students benefited from traveling to Vashon Island to attend workshops offered by SEEDS on creating community, permaculture and green mapping. When they got back to campus, they brainstormed a wonderful dream map for our campus—imagining what the campus would look like with soil remediation projects; community gardens; social gathering spots; a day-care center; a peace-and-justice center with counseling and community arts for veterans and military families; an organic café and organic fast-food carts; massage stations, and schools that teach alternative energy, alternative medicine, natural food preparation and socially responsible business practices. In only a week of classes, the students planned, painted, and collaged a green map of impressive size and complexity, and delivered it to a campus-wide meeting about the future development of the campus. They presented it to the architecture team as well as to the director of Campus Facilities and Services. Since that time the "UWT Green Map" has been on

display in one of the campus's main buildings, with a place for visitors to leave their suggestions.

Our final class features an eco-feast. I encourage students to find local organic foods, and, if possible, to make a dish from a recipe that has been handed down in their family. Prior to this, as part of our earth exercise, we touch on multiple issues surrounding food: where it comes from; how it is marketed, processed, industrialized, and genetically engineered; and the damage that chemical fertilizers and pesticides have created for both our health, the workers who harvest, and the ecosystem in general. Now in preparation and as part of this feast we have the opportunity to go deeper into this discussion, looking at who has the privilege of eating healthy foods, who has the space, time, and knowledge about gardening, who has access to organic farms and can subscribe to them, who can afford organic food, and who knows how to cook in nutritious and tasty ways. During the feast we talk about the most profound learning experiences of the quarter and ways we can implement what we have learned into our daily lives and communities. We talk about the difficult work we have ahead and the need to balance those burdens with laughter, music, and dance. Many students have been moved to join local organic farms or start shopping at the local farmers' market, several have

Fig 4.8. "Experience Underwater Living in 2075" digital poster project, 2008, by Elizabeth Pauline Young.

Fig 4.9. "UWT Green Map—Draft One," collaborative project by
Eco-Art class, Spring 2008. Mixed media. Photo by Angela Rueber.

developed curricula about food and environmental issues for their children's
schools, one is documenting the ways real estate development is affecting her
community, and, at the very least, all are spending more time outdoors with
their families. If I am lucky, the most eager and open of the students sign up
for another class with me and we continue our journey together.

Art in a Time of War

M., a full-time working, lesbian mother, has taken all of my courses. She is
the daughter of Mexican migrant workers and proud of her heritage. The
fathers of two of her children have served in Iraq. One of her ex-husbands is
suffering from PTSD but continues to return to Iraq for consecutive tours.
Her first class with me was Art in a Time of War.

The other night as she was driving me to the ferry she told me that she
was concerned about anyone else teaching that class but me. I had mentioned
that I intended to go on sabbatical in a year and a half, and would be hiring
respected colleagues to replace me during that time to teach the curriculum
I had created. She said she couldn't imagine anyone else teaching my classes
and when I asked her why not, she told me: "Your story of growing up with the
air-raid drills and the two different sirens that meant there was either enough
time to run home before the bombs dropped or not enough time: that story

Fig 4.10. "Losing Liberty" digital poster by Julian Close, (Art in a Time of War, 2008).

touched me in a way I can't describe; no one else could tell that story that way." I mentioned to her that many of my peers had grown up during the Cold War with similar nightmares and occasionally hilarious stories about air-raid drills. I also mentioned how the Vietnam War had affected all of my generation. Some of us had friends and schoolmates who never came home. Some of us spent many years protesting the war. A few of us had friends and family who ran away to Canada and friends who spent time in prison. I told M. that I would only hire someone who had experienced a connection to this topic in some profound way. The artist who teaches this course needs to have a capacity for compassion that comes from having deeply internalized the pain and suffering of war and learned to transform it. M. visibly relaxed and seemed grateful to have shared this worry with me.

Another anecdote will illustrate why I teach this course. I was on the shuttle to the airport at 6:30 a.m., on my way to a conference. The driver was a man I'd never met before. He was friendly enough and our conversation wandered around many subjects. At one point he said, "We all know that we are descended from one couple, Adam and Eve." I paused, took a deep breath in, thought about how early in the morning it was and contemplated the different worlds we live in. Soon he was telling us about his work as a

paramedic in 'Nam, and how much he loved his year at war, and that Jesus had absolved him of all his sins. He said that a week after he returned from his tour of duty, he had walked into a bar in uniform, where a woman attacked him verbally and spat on him. He concluded his story by saying that it was "these war protesters who made us lose that war." Again I breathed in deeply, trying to imagine the world this man came from, the media he consumed, and what reinforced his worldview. I knew that working with a student with his background would test all my abilities and resilience. I mentioned the story of Claude Anshin Thomas, the soldier who killed hundreds of Vietnamese and who after years of PTSD, addiction, and violence, became a Buddhist monk in the lineage of Thich Nhat Hanh. After a few sentences, it became obvious that my driver did not want to hear the story, so I meditated on the best way to be in dialogue with someone with his worldview.

Without a doubt this is the most difficult course I teach given the context in which I teach it. Having the emotional resilience to hold a safe space for all voices to be heard in the room is modeling what art about war can do. Working with students who are veterans or who come from military families and are resistant to hearing other points of view, and keeping the dialogue open and buoyant while maintaining my own grounding and openness, requires every bit of my strength.

We normally do three projects in this class. The first is a war story that is based on the students' personal experiences of war. Those who have fought in wars or have parents or spouses who have fought in wars usually have no difficulty coming up with a visual story. Sometimes the student knows someone who came back traumatized and unable to speak about their war experience. Doing this project may allow them to gently enter a dialogue with that person, or perhaps the story ends up being about that person's inability to share their stories.

One such project was a photo-collage created about a student's father, a man who had served in Vietnam. The father had a cigar box filled with photos of the war that no one in the family was allowed to touch. The student remembered watching his father, who never shared his war stories with his family, furtively carry the worn box into a room alone where he would leaf through the images in private. The box became the central image in the student's collage. His childhood memories and the insights he garnered about his father's life in adulthood became the text surrounding the box. Photos of father and son were transparent layers weaving through the composition.

Sometimes a student who has had no direct contact with war feels at a loss about how to enter this project. I ask her if living in a time of war has affected her, and sometimes the student will say "no, not really." So I ask her

to look at what it means to be oblivious or protected from this reality, and tell her it might be a good exercise to make a piece about this. One student made a provocative narrative piece about shopping for shoes in a time of war.

As in all my other classes the students look at contemporary advertising to see how the topic of war, demonizing the enemy, anxieties about security, and nostalgic and romantic yearnings for a less chaotic time are used to entice consumers to purchase unrelated items. Most students are startled by the ways these subtle messages play out, and feel as if they have been walking around in a fog before this exercise.

The media literacy exercise is followed by an examination of how photography is used in documenting the horrors of war. We read from Susan Sontag's *Regarding the Pain of Others*, a book that examines visual representations of war and violence in today's culture. Then we take an extensive look at the work of photojournalists. We always ask whether looking at images of war makes us not want to be involved in it, or whether it makes us numb.

Inevitably one of the questions that emerges in this course is why people go to war, whether it is genetically programmed in humans or whether it is learned behavior. We read essays by several authors to find our way through these ideas, and usually arrive at the conclusion that the movies and other aspects of popular culture seem to imply that war and violence will always be part of the human condition. We talk about alternatives, conflict resolution, and different understandings of human culture that come from stories from ancient cultures, and explore what the associations are with pacifism or diplomatic solutions to political conflicts. Our readings are selected from Chris Hables Gray's *Postmodern War*, Carol Becker's *Surpassing the Spectacle*, Howard Zinn's *Artists in a Time of War*, Eve Ensler's *Insecure at Last*, and Arundhati Roy's *An Ordinary Person's Guide to Empire*. Also useful in this discussion are several essays from an issue in *Yes! Magazine* devoted to this topic.

When there is time in this course, I have the students screen an antiwar film and write a short essay about it. This assignment helps them assimilate some of the issues they have been exploring in our class discussions.

The second project in this class is to create a graphic narrative about war, based on a witnessed or lived experience. In preparation for this project we look at many of the etchings by Francisco Goya from the series *The Disasters of War*. We also examine the powerful, painful, and humorous contemporary graphic narratives by Joe Sacco, depicting the plight of Palestinians in the Occupied Territories, Art Spiegelman's satirical *Maus* that somehow both softens and sharpens the Holocaust nightmares of his father, and Marjane Satrapi's remarkable autobiographical series about growing up in Iran during recent decades. Students sometimes combine photographs and drawing

Fig. 4.11.
Excerpt of Will
McCabe's "War
Games" digital
montage, (Art
in a Time of
War, 2005).

to complete this assignment and yield some startling responses, including a very engaging reflection about playing with war toys and some comics that examine a world without weapons.

Our last assignment is a peace poster, and for this challenge we survey the vast image collection of peace posters from around the world, many of them available online[5] and some of which I've collected with the generous assistance of Lincoln Cushing, political graphic artist, and the late Michael Rossman, a leader of the Berkeley Free Speech Movement who created one of the largest political poster archives in the world, All of Us or None. After previewing over a hundred posters, the students discover that the major chal-

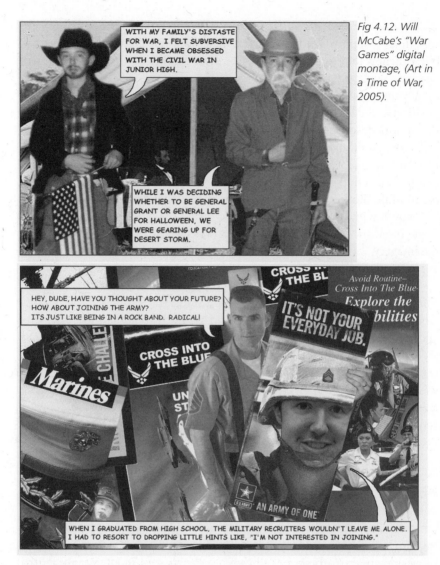

Fig 4.12. Will McCabe's "War Games" digital montage, (Art in a Time of War, 2005).

lenge found in this assignment is coming up with an image that is not clichéd. Amazingly the students seem able to rise to this test each and every time.

As in all my other courses, students are required to do a collaborative project to complete the course. Since many of our students are veterans of wars in Iraq and Afghanistan or married to soldiers who are currently serving, there is a lot of material, very close to home, that can be addressed in a public installation.

During the first year I taught the course, I found that the students were split in their support for the war, and their work reflected that polarization, but somehow they found a way to place these conflicting views in one project and have an engaging conversation.

By the second year, the majority of the students had moved to an antiwar position and decided to create a fence, broken into quadrants, with visual metaphors describing their feelings about the war. They placed the fence on a busy sidewalk in the middle of campus, and although the class took place in the evening, the spectacle of the installation attracted a good deal of attention. One section of the fence included baby dolls dripping with red paint, while another showed toy soldiers in two frying pans. The entire fence was woven with yellow ribbon that said "bring them home now, " but what made the work especially controversial was the use of U.S. flags as part of the imagery. Two veterans in the class felt they were entitled to use the flag as part of their imagery.

After a few days we noticed that the project was receiving negative feedback from some members of the campus community, including security guards (some of whom were also veterans). I told the students about the complaints and they decided it would be important to create a public dialogue about the piece, but it was the last week of the quarter and the students couldn't make time for it. A day or so after the complaints started coming in, the project was defaced and although we didn't know by whom, we assumed that some angry members of the community had made their feelings known in the only way they knew how. The students' impulse to facilitate a discussion about the emotions that the work provoked was a good one.

In the winter of 2007, with the public sentiment against the war in Iraq increasing, several students, one who was a veteran with PTSD, decided to create a healing project for the campus. They erected a modified army tent in the lobby of a building, and projected images of their war-story projects on the wall near the tent. One or more students sat on an army cot, soliciting war stories from the students who walked by. The audience could write the stories down, draw them, or tell them to the student in attendance. Word of this project spread around the campus quickly, and although it was only installed for a week, the students were thrilled to have created something that the audience seemed to want and to need.

Although it is clear that our campus needs more art projects about healing the pain of war, I decided to take a break from teaching this course so that I could develop more confidence in my skills. Some of the feedback on the anonymous student evaluations of the course seemed like "kill the

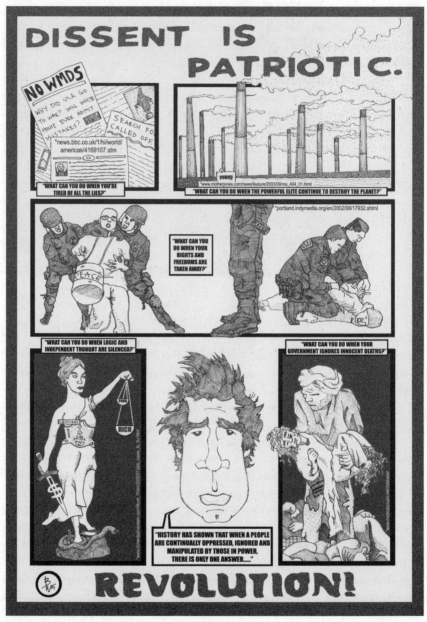

Fig. 4.13. *"Dissent is Patriotic" by Brandon Waltz,
illustrated poster, (Art in a Time of War, 2005).*

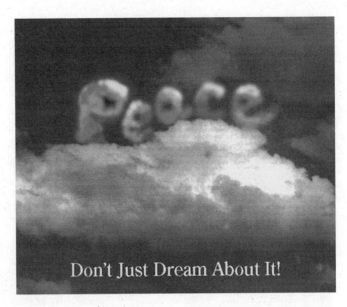

Fig. 4.14. Peace: Don't Just Dream About It! By Phyllis Egner, (Art in a Time of War, 2005).

messenger" sorts of reactions. I became frustrated that my strategies to reach this handful of students were not working, and needed to rethink how to approach the subject. Of course, I recognize that in a time of hyper-nationalism, someone who is asking questions about what is real patriotism might be regarded with suspicion.

Due to the enthusiasm of students who have previously taken the course, I decided to dive into the shadowy realms again this fall after a yearlong hiatus. The course filled with students whose sentiments are clearly against the war and who seem unafraid to express those opinions publicly. This is a significant shift in perspective that seems to reflect the trend nationally. Many of the student projects have been deeply concerned with how to help returning veterans heal or how to deal with their own sense of powerlessness and guilt. Others address how sensational language and images manipulate the public to see particular people, whether because of their religion, nationality, color, or politics, as enemies.

Reading our new text, *Art and Upheaval* by William Cleveland, has given the class new insights about art as both a personal and community activity that provides healing and education around violence in many different contexts around the world. The book exposes the students to a diverse history of conflicts and reading it provokes discussions about whether war is obsolete. In order to encourage that possibility, I share excerpts of *Is There No Other*

Way? The Search for a Nonviolent Future, by Michael N. Nagler, and suggest that is time for a paradigm shift.

When the students look at me with disbelief, saying that war is part of human nature and that it will never be eliminated, I say, " We will always have conflicts in our world, but we have to believe in other possibilities if we are to survive as a species. With nuclear weapons ready to wipe us out thousands of times over, we have to imagine another way." When the students respond by saying that they don't believe it's possible to change, I ask them to consider the 2008 election and what a huge paradigm shift that has been, and then we get back to work.

Body Image and Art

It was 1987. I was in an unhealthy relationship with a man with an eating disorder. Yes, a *man* with an eating disorder. Maybe it's not so shocking now, but then it was not spoken about, and barely understood. During a month's respite from the New York City heat and the soon-to-be-estranged boyfriend, I stayed with an old friend in Cape May, New Jersey and started painting my first nude self-portraits. They were done from my head and they were not pretty. They were sad, stubbornly self-conscious images, evidence of my painful discomfort in my own skin. I hid them away, embarrassed by the fact that I was painting such self-scrutinizing (what I then called self-indulgent) work. I wasn't supposed to be painting work like this. I was supposed to be making art about the real serious issues of the day: nuclear war, environmental issues, unemployment, gentrification. What neurotic obsession had made me descend so low?

Fig. 4.15. Body Image Outline Project with Jesie Holden, Ron Reardon, Jennifer Lane, Angela Rueber and Angela Neuman ,UWT GWP atrium, photo by Beverly Naidus, 2008.

Fast forward a few years to 1991 when I am sitting in an eco-feminism class at the Institute for Social Ecology. Our dynamic instructor, Chaia Heller, has invited Susan Stinson, a self-identified fat lesbian poet, to read her work to the class. After some very poignant poems describing the undeniable pain of being told one is unacceptable, unlovable, and deserving of abuse because of one's size, Susan looked around the room at a group of mostly twentysomething women and said, "most of you are probably unhappy with how you look, and probably most of you think you are fat but you have no idea what it means to experience fat oppression and how systemic and institutional this oppression is."

Chaia Heller explained fat oppression in relation to the term "ecocide" (the willful destruction of the planet and its ecology). Chaia told us that the oppression of people because of their size or looks is another way that patriarchy and corporate capitalism keep us in our place; we are so busy with efforts to keep our bodies "in control" that we ignore the devastating realities affecting our communities and the planet. We examined the diet industry and how fat oppression could be seen as part of the backlash against feminism. Through Chaia's analysis of this issue, I was able to recontextualize my interest in body image, and I finally saw this issue as a real social problem rather than a personal neurosis. I began to understand the legacy of growing up in a family that wanted me to have an upwardly mobile body style, and I began to fathom the referred pain of living in a very sick society.

Chaia asked us to form small groups to talk about our own experiences of fat oppression and body hatred. We were asked to name something we liked about our bodies and something we disliked. As I listened to each of the intelligent young women's long list of dislikes (and very short list of likes) a light went on my head, and I went back to my studio raging with righteous anger. I painted images of fat oppression and body hate from my life and those of my younger and older peers for a whole month. I couldn't stop painting these stories. Then when I went back to southern California I spent another month creating photo-collages and ink-wash drawings that talked about women hating their bodies; eating with anxiety; dressing to hide their "flaws"; worrying about how distracting this concern with their bodies was becoming; discovering that their self-identified personal problems represented, in fact, a social problem; analyzing the media conspiracy; learning to be at peace in their bodies; developing daily strategies for self-celebration; and educating others. The narrative of the work seemed simplistic at first, and I realized that a more honest portrait had to show the relapsing of women who understood the social causes of their body hate, but continued to succumb to it. ("Of course, there were still days when one look in the mirror could cancel out

all the progress she'd made." "Self-hate still haunted her from time to time, but she learned to live with it.")

By the end of that month I realized that I had created an artist's book. So I went to a copy shop in my neighborhood in Venice, California, with my stack of eight-and-a-half-by-eleven ink drawings and collages, and turned them into a box full of eighty-six-page, black-and-white artist's books. This first edition was called *The Fat Book*. As I was leaving the store, I sold a couple of copies to very curious customers, and I thought, there must be a big audience for this, so I better find a real publisher.

After several months of collecting the most flattering rejection letters one can imagine, from some of the best feminist publishers, I was about to give up the quest. Luckily the cofounder of Aigis Publications found the photocopied *Fat Book* sitting on a friend's coffee table, and less than a year later *One Size DOES NOT Fit All*, with its glossy color cover was selling in bookstores around the country. It is now out of print, but the images are still in circulation on the Web. Although the book is now sixteen years old, the audience for the book continues to grow, as is evidenced by the increasing number of invitations I receive to exhibit the work.

One of my former students, Emily Caigan, who has done a significant installation project called *Scale Dances* on women's complicated relationship to their weight, believes that the mainstream culture has only recently begun (in the past five years or so) to address body image issues in a concerted way. If the growing registration in my classes is any indicator, there is a ground-swell of interest in the topic. I could probably teach three sections of the class every quarter without difficulty. In recent years, the class has often been made up of entirely women, but an occasional male student wanders in and is welcomed.

Many of us grow up with pressures to look a certain way, and now, in our media-saturated culture, it is less and less possible to escape the pressures of measuring up to certain contrived, extremely narrow, and often Photoshopped standards of beauty. My students are often not aware of the social factors that have made them unhappy in their skin. They are in a trance, seeing the covers of magazines while standing in the check-out line (each one touting its own version of how to lose weight fast), succumbing to the self-scrutiny and the artificial and conformist notions of beauty that are airbrushed into our subconscious minds.

On the first day of class, the anxiety and excitement in the room are usually evident in equal doses. Students arrive in the classroom filled with complicated, sometimes intuitive understandings of how body hate permeates their lives, but they are in an art class now, and they will have to make art. This fact often

scares them more than having to confront their mixed feelings about their bodies. Part of my work on that first day is to open up the discussion about how their previous encounters with art making may have been damaging. A teacher or another adult may have told them that what they had made was inadequate or unacceptable in some way. We talk about the standard ways that they may have been exposed to art (as mimicry of the teacher's work or as technical exercises meant to decorate or entertain) and then I share some stories about the traditions of art being used for healing.

Of all the courses I teach, this one is without a doubt the easiest to teach because the students are not completely numbed to the fact that they are struggling with their own body images. Also the information about how dominant culture functions doesn't seem as shocking or as overwhelming as it might in my other classes, perhaps because each student recognizes on a cellular level how they have been oppressed.

After making introductions and explaining the syllabus, we discuss the role of art in healing the individual and the community. I share a slide show of art that focuses on body image in relation to size, sexuality, cancer, disability, skin color, aging, and feminist identity.[6] After discussing the slides, we introduce ourselves to each other using sound and movement while saying (or singing) our names, and repeating the gestures and sounds back to the person who has just named herself (a common performance exercise). I ask the students to pair off and do body outlines of each other on drawing

Fig. 4.16. Body Image Outline Project in workshop, UWT, photo by Beverly Naidus, 2008.

paper (butcher or craft paper works fine) that is laid out on the floor. The students being drawn describe one thing that they like about their bodies, and one thing they dislike. Then the drawer and the drawn switch places. Students then roll up their sheets of paper, and take them home to develop self-portraits of some kind (symbolic, illustrative, conceptual) using any materials that will attach to the paper. I encourage experimenting with the body outline, noting that there is no one right way to do this project.

The most typical way that students approach this exercise is to fill the body outline with cut-out photos of models from magazines and cut-out headlines that say, depending on their persuasion, things like "No More Dieting," "Desserts that Please," and "Love Your Hips." The students who find other ways to explore self-portraiture—using negative space, three-dimensional pockets, signs and labels, sewn-on clothing, or by turning the whole figure into a two-sided sculpture—always impress me. Recently R., a student who has taken four art courses at UWT, had the impulse to trash the paper, and make her outline from garbage bags. On the garbage bags she painted in red *Defective Product, Too Fat, Too Short, Too Weird Looking, Too Comfortable,* and *Too Masculine,* all things that had been said of her). Across the white silhouette of her figure ran yellow tape covered with the words *Warning! Escapee on the Run, Delusional Ideas of Self Worth, Wanted for Deviation, On the Run from Low Self-esteem, Dangerous to the Status Quo,* and *On the Run from the Norm.*

Students bring in this project to get feedback on their initial ideas, and then they have several weeks to develop it and bring it back to class for a final discussion. The discussion always begins with questions: What was difficult about this project? What was pleasurable? We also point out the strengths in each work: what attracts us to it and why, and give suggestions regarding what would make each piece more compelling visually so that the content would be given the attention it deserves.

While the reader might wonder what measures or standards we use to decide aesthetic strengths, let me assure you that I am always quite frank that my own art education created certain aesthetic biases. I am always open for discussion on this issue, especially given that there are many different reasons to subvert those aesthetic standards. If the aesthetic does not serve the intention of the student and if it distracts the viewer from spending time with the work, then the student has important indicators regarding the effectiveness of a work.

Given the provocative content and the liveliness of this project, we usually take the self-portraits out to a public site on campus, sometimes hanging them from balconies in the atriums of two busy buildings. The work

usually attracts lots of discussion, and without a doubt is very popular with the campus community.

Some aspects of traditional art training occur in this course, but they are subverted in interesting ways. First we do exercises from *Drawing on the Right Side of the Brain* so that students can expand their tool set, and develop better hand-eye motor coordination. Before starting to draw, we do breathing meditation so that students can begin to connect their bellies and their breaths. This helps them calm down from "drawing anxiety" and be present to the work of meditating on the body.

They begin with the standard blind contour drawings of their hands, and move on to their feet, and then to a classmate's feet. (Sometimes this exercise brings up issues about the aesthetic acceptability of one's feet.) After sufficient practice with blind contour work, the students begin to experiment with line weight, scale, overlapping, composition, and other aspects of visual grammar. They do a few self-portraits using the continuous-line contour technique, both blind and not, and begin to ready themselves for drawing a nude model.

Before Rose, our model, arrives, the class has read many articles that examine the causes of fat oppression, the history of fat phobia, the diet and plastic-surgery industry, the media backlash against feminism, and how to celebrate one's body and develop one's gifts and strengths.[7] Besides this reading, we have discussed the notion of "the gaze," a concept that comes out of film theory,[8] so that students are prepared for looking at a model with a different mentality than perhaps most students of the figure bring to their work. We talk about what it means to experience Rose's subjectivity by conversing with her, instead of having the objectifying experience of staring at her body with mute concentration.

The students have four sessions with Rose, during which they try their hands at contour, gesture, and value studies. It's hard work for them, since most have never had a drawing class before, but they are committed to the process, so they persist. These sessions help them develop peace with their own bodies, give them an experience of looking at another woman openly and without shame while expanding their artistic skill set. Rose is a large and joyous woman, very comfortable in her skin. She loves modeling for this class because she gets to talk about her own unapologetic journey from tall and skinny to tall and plump, and she helps the students see how interesting it is to draw a curvy, generous body, and what it means to accept the body that you have been given with compassion and delight.

Typically the less experienced students get frustrated with drawing the figure, and their impatience with their perceived lack of skill echoes

throughout the room. The breathing meditation with which we start these sessions, however, may help them to be attentive, present and gentle with themselves. Students practice drawing friends and partners when they are at home, and if they practice enough, some of them begin to develop some facility with realism as well as other styles of drawing. It is not unusual for the most terrified students to return to my office a year later with a journal full of sketches. They are hooked.

After a midterm review of drawing portfolios and journals, we do some in-class collage exercises to prepare students for the next project. Students are given the option to create a series of photo-text works, a series of collages, or a series of culture-jammed images. With a minimum of four images, students create a visual rhythm with their content and think about presentation and siting the work publicly. Students who are technophobes have the option of avoiding Photoshop, but we have a wonderful technical crew who help students accomplish at least part of what they imagine in their heads.

After introducing this project and sending the students write in their journals, to imagine what stories they have or want to tell through images and text, we do some Theater of the Oppressed exercises, including creating a machine of body hate and body celebration. After our theater games we begin to brainstorm collaborative works.

The last few weeks of the class are filled with oral presentations about contemporary and historical artists who deal with body image issues, and developing public projects. The oral presentations give the students the opportunity to research, reading three articles or book chapters that analyze an

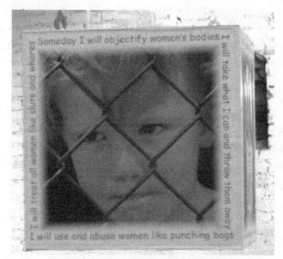

Fig 4.17. Photo-Text Installation (detail) by Angela Neuman, digital and mixed media, Body Image and Art, 2008. Photo by Beverly Naidus.

artist's work, along with communicating directly with the artist, if possible. In this way students can learn more about what artists' intentions are and how social context might influence the creation of a work.

Artists whose work is found to be disturbing by some provoke fascinating discussions about the appropriateness of certain topics, and questions about audience usually come up. The artists discussed have gotten critical attention in the art world and my stories about the high art world give the students a window into an aspect of dominant culture that they might not have otherwise. While that world is no longer the stage that draws my attention, it may appear glamorous to some students and pretentious to others. I try to explain that this stage, with all its contradictions, affects our culture as a whole, for better or for worse.

The Culture Wars[9] sometimes play out in our classroom. Students being offended by Ana Mendieta's work about rape, Kiki Smith's work about bodily fluids, or John Jota Leaños's work about Pat Tillman's death to friendly fire opens up a discussion about censorship, public funding, and who determines what artists should and can say. That audiences may need to be shocked or deeply provoked in order to pay attention is something many of the students wonder about, given the sensational media that surround us, and they continue to reflect upon this as they continue their own inner journeys, debating the merit of expressing certain stories or keeping them secret.

Recently students in my Body Image class decided to do a performance piece that involved wearing T-shirts with text that revealed hidden stories. On the front of each T-shirt was printed "JUST IN CASE YOU WERE WONDERING…"and on the back of each shirt each student completed the sentence in her or his own way: "I am STILL Hungry," " I am a thick size 6 and proud of it," "I am not an object for your objectification so stop staring at my ass," "I am more than my body" or "Sometimes I skip meals." The brainstorming process brought the class together in touching ways, with students jumping in to help each other on every aspect of the project.

In a class filled with women who were becoming more assertive everyday, the task of being the one male could have been daunting. But R. struggled to bring his own body image issues to his art like everyone else, and listened to the women with respect. For some of the women who admitted having abusive partners, they marveled that men like R. existed.

One day the topic of feminism was brought up in the classroom by a student who said, "Well, I assume we're all feminists here." I stopped her and said, "Wow, did I just hear you say what I think you said? How many of you agree?" There was a murmur of consensus, but I prodded, "Does anyone in here have a bad association with the f-word?" One brave woman, who is

Figs 4.19–4.20. In Case You Were Wondering, a collaborative public intervention by Body Image and Art students, Spring 2008. Photos by Beverly Naidus.

forty, said, "yes, to me the word means *man-hater*." ¹And so our discussion continued, fleshing out why the word had that stigma for her and why, in the context of the class, it might have gained a different meaning.

Labor, Globalization, and Art

The privileged among us get to dream about the lives we want to live, and actually imagine that we will realize those dreams. My lower-middle-class roots and my experience as a grandchild of immigrants who labored tirelessly, coupled with that of being the daughter of parents who went to college

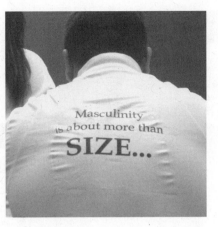

Figs.4.21–4.22. In Case You Were Wondering, a collaborative public intervention by Body Image and Art students, Spring 2008. Photos by Beverly Naidus.

on full scholarships and became upwardly mobile, gave me the belief that anything was possible. Combine that belief in a particular trajectory, with the times I grew up in—when the idea of fulfilling your individual potential fueled and transformed a whole generation—and you get a significant sense of entitlement.

I believed that I would be able to choose my career or create a vocation based upon my get-up-and-go and my innate talents. Very few adults wanted to discourage that optimism. Having faith in oneself was believed to be half the task. I may have heard whispers about being in the right place at the right time with the right thing, but I didn't listen to those words carefully, although I seemed to understand innately that knowing the right people, no matter what my career trajectory, would be necessary for me to continue my path. I would be among those lucky ones at musical chairs who would know intuitively when the music would stop and how to grab one of those ever-disappearing chairs. I had been raised to survive.

The trouble was that my partial understanding of the world under late capitalism gave me pause about diving into its midst. The art world was squarely in its center, although I imagined it was not. It was 1975 when I arrived there. There were still echoes of bohemia, and people living in low-rent apartments, gathering for potlucks, figuring out how to survive on part-time jobs as cooks, carpenters, housecleaners, and secretaries, and still be artists the rest of the

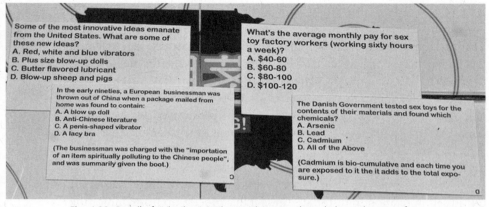

Some of the most innovative ideas emanate from the United States. What are some of these new ideas?
A. Red, white and blue vibrators
B. Plus size blow-up dolls
C. Butter flavored lubricant
D. Blow-up sheep and pigs

What's the average monthly pay for sex toy factory workers (working sixty hours a week)?
A. $40-60
B. $60-80
C. $80-100
D. $100-120

In the early nineties, a European businessman was thrown out of China when a package mailed from home was found to contain:
A. A blow up doll
B. Anti-Chinese literature
C. A penis-shaped vibrator
D. A lacy bra

(The businessman was charged with the "importation of an item spiritually polluting to the Chinese people", and was summarily given the boot.)

The Danish Government tested sex toys for the contents of their materials and found which chemicals?
A. Arsenic
B. Lead
C. Cadmium
D. All of the Above

(Cadmium is bio-cumulative and each time you are exposed to it the it adds to the total exposure.)

Fig. 4.22. Detail of "Yin Jing" An interactive game board about the manufacture of sex toys, by Marisa Mezs and Cheryl Carino-Burr (The Global Journey of an Object -Labor, Globalization and Art, 2008). Photo by Marisa Mezs.

week. There were many young artists pouring into New York City every year, all of us full of dreams. Many of us had counterculture values honed at college, doing anti-war protests, attending consciousness-raising sessions, and we had little patience for the pretensions of the art market. As a result NYC was filled with alternative spaces and artists' groups, each one adding to the energy that made it an exciting place to be.

When I confronted a disconnection between my working life and my dreams, I made art about it. I created two temporary installations to vent my frustrations. *Daily Reminder* was an audio installation that explored the painful reality of working nine to five in an office and transferring one's pleasure into the daily minutiae of chatting with office mates, lunch plans, and fantasizing about the weekend. *Apply Within*, which set up a satirical employment agency, talked about the struggle to find meaningful work and ways to subvert the stultifying options offered to many college graduates. Creating both of these installations allowed me to find community with the audience who participated in them. Some people told me that they felt less lonely in their job searches or were encouraged to find more rewarding work. The positive audience responses led me to think that my students would benefit from focusing on this topic as well.

J., who has taken several classes with me, said last week, "The labor class was my favorite one." I asked her why and she said, "Because it connected everything together." If any of my courses allows the students to develop more understanding about the power relationships and economic forces that control our lives, this one does. It is not only the therapeutic value of making

art about a tedious or frustrating work life that can be gratifying, but imagining job satisfaction as a given and a requirement can be empowering as well. There are some students who get annoyed and anxious because the likelihood that their dream vocation will manifest seems so remote, but the majority find their way to that scrumptious place of possibility with time.

Connecting the students' present or past job experiences with the issues of globalization is fairly easy, although it has its complex edges. We look at outsourced jobs and the effect of the free trade agreements on their everyday lives. We parse out the distinct differences between corporate globalization and thinking and acting globally. We read many articles, view films, and create art.

The first exercise we do in class is to have each student introduce herself or himself in relation to history.[10] I model this process up front, indicating that coming of age in the sixties, with all its glories—rock and roll, liberation movements of all sorts and that expansive sense that we could create the world we wanted—had a huge impact on my identity. The older students often have difficulty keeping their contributions brief, but their stories are frequently wonderful. One retired fellow talked about his immigration from England to the United States and what it was like arriving here in the fifties and how the Cold War affected his values. Another older gentleman, who had witnessed many eras, said that the falling of the Berlin Wall had shifted everything for him. Being able to travel and offer his skills as a consultant to Russian communities had changed and enriched his worldview forever.

Sometimes the younger students have a hard time thinking historically, but when they do, I learn so much from them. One young woman mentioned the impact that Title Nine legislation had had on her life and how she had enjoyed competitive sports throughout school. Since I had graduated from college by the time Title Nine went into effect, I had not felt its impact on my life. It was wonderful news to me that it had changed things for my younger sisters. In one rare case, a very young student wasn't able to think of a single historical event that had had an impact on her life, and although some students offered suggestions, she wasn't moved by one of them. This perceived lack of connection to the world around her affected her participation and commitment during the entire course.

Hooking into the issues surrounding globalization often requires lots of storytelling, and I sometimes begin by sharing recent traveling experiences with students. Many who have traveled, either with the military or with their families, can relate to how chain stores and fast-food restaurants have infected landscapes all over the world. Some of us remember when it was not this way, but hearing our stories, the younger students sometimes look at us with dull interest, wondering what the big deal is. "Isn't this a more

convenient, comfortable, and predictable world?" So I have my work cut out for me, compensating for the lack of historical knowledge and an absence of making connections between how the proliferation of convenience as a value may have affected their quality of life, their health, their community, their job opportunities, and even the future of the planet.

One important aspect of globalization is that it can numb and disconnect people from the deeper meanings of life. It promotes bland conformity, erases local cultures, languages, rituals, and economic independence. Most of my students, who haven't had the economic resources to travel unless they've served with the military (and some would argue that that's not really traveling), are unaware of this larger picture, unaware of the effects that this homogeneity has had on their lives. Some do have a gut-level understanding of the economic issues, and how globalization affects their jobs and their lifestyles, but there are confusing twists in the way the mainstream media explain and idealize globalization. My job is to expose some of the patterns and contradictions, and let my students unravel the knots through their art and discussions.

Last winter, before the quarter started, I sent out a message via e-mail to students who would be in my class. I do not know the author of this prose poem I sent:

> Joe Smith started the day early having set his alarm clock (MADE IN JAPAN) for 6:00 a.m. While his coffeepot (MADE IN CHINA) was perking, he shaved with his electric razor (MADE IN HONG KONG). He put on a dress shirt (MADE IN SRI LANKA), designer jeans (MADE IN SINGAPORE) and dress shoes (MADE IN TURKEY). After cooking his breakfast in his new electric skillet (MADE IN INDIA) he sat down with his calculator (MADE IN MEXICO) to see how much he could afford to spend today.
>
> After setting his watch (MADE IN TAIWAN) to the radio (MADE IN INDIA) he got in his car (MADE IN GERMANY) filled it with gas (SAUDI ARABIA) and continued his search for a good paying AMERICAN JOB.
>
> At the end of yet another discouraging and fruitless day checking his computer (MADE IN MALAYSIA), Joe decided to relax for a while. He put on his sandals (MADE IN BRAZIL), poured himself a glass of wine (MADE IN FRANCE! France!!) and turned on his TV (MADE IN INDONESIA), and then wondered why he couldn't find a good paying job in AMERICA.

The first art project in this class focuses on a personal work story. The students read excerpts from *Liberating Memory*, the wonderful book by working-class historian Janet Zandy. The book contains autobiographical

stories of working-class artists. From this reading, students are, I hope, inspired to write down a few stories about their own experiences in the labor force. I ask them to focus on instances where they witnessed or experienced an injustice, boredom, or alienation in their jobs, but sometimes, amazingly, this is hard for students to recall. In those cases, I ask students to recall what inspired them about their jobs, or what was unique about their positions.

The students read these stories when they come back to class, and we help them brainstorm ways that they could depict one of the stories visually or as a performance. Students work on this project all quarter, bringing it in for feedback every few weeks. I usually grade the project in process around midterm, so that students can assess whether they wish to keep developing the project for a better grade or not.

One of my favorite student projects entailed the story of growing up with a mother who was a housecleaner, and the student's learning the drudgery of that work by going to work with her mom. The piece was a series of white rags with images of cleaning a bathroom floor printed on each one, along with a brief series of words that described inner thoughts during the cleaning process. Another student created a cage surrounding a desk with computer, with extensive, heavy chains and harnesses surrounding the chair. She asked people to sit in the chair, and then clasped the chains to their wrists, ankles, and heads. She then took their photos and made a narrative piece with high-contrast, gritty images.

The second project in this class is called the *Global Journey of an Object.* Students work in teams of two to develop a piece based on an everyday, ubiquitous object, a shoe, for example, or a piece of furniture or a bag of sugar. Students look for a logo on the object and from the logo they can do a Web search for information about the company. Where was it made? What resources were used to create the object? Where were the raw materials taken from, and what environmental effect might that have had regionally? Who made it and what were their working conditions (including environmental health stresses)? What are the material and social costs of transporting and advertising the object? How is it advertised and marketed? Web sites exist that shine light on some of the murky underside of various products[11] and allow students to compare this view of the dirty side of each industry with corporate marketing of each product. Sometimes the contrast is so startling to students that they become deeply committed to more mindful purchasing, but often students are perplexed and express a great deal of frustration.

Students are told that they will probably encounter more than one dead end in their research, and they are encouraged to be imaginative in their digging, to ask people who might know more about the object's history, for example,

or to research a similar object to fill in their blanks. Then the students create an art piece based on the most provocative aspects of their research.

Since our students are often living on limited means, the idea that they might have to pay more for items that aren't made in sweatshops or are grown organically creates enormous conflict. They need to budget very carefully. Watching films like *Wal-Mart: The High Cost of Low Price* and *Life and Debt* causes them to have similar anxieties. We talk about ways they can economize by joining or creating food-buying clubs or co-ops, growing their own food, patronizing a community-supported agriculture (CSA) farm, and developing different strategies for gift-giving or purchasing clothes, furniture and appliances (like buying used items, trolling garage sales and thrift stores, joining the Freecycle Network, and having swap parties). Yet ultimately changing habits that are socially acceptable among their peers and developing a new way of understanding economics are not easily done for most of them. Imagining themselves as upwardly mobile, seduced by advertising, they are encouraged to buy new products, even if it puts them into deeper debt. Once the hidden prices of certain products become evident, there is more incentive to make a lifestyle change, but it is definitely a steep learning curve for some.

Aside from the sense of social responsibility that might emerge from this project, students often have quite a time coming up with a project that speaks to all the issues they have researched. The process of editing and deciding what is most important to say about their topic is as important as figuring out the visual metaphors that will symbolize the issues they want to raise with viewers.

When I first started assigning this project, I noticed that there was a tendency to want to develop this art project to look like a science fair display. For students with little art experience this was not unexpected. So we had to have

some discussions about what forms could raise questions about the content they were addressing without having to explain absolutely everything to the viewer. Of course, there are circumstances when a science-fair-display format might make ironic sense, but I encourage students to brainstorm their forms more widely. Some of the solutions have been particularly playful. Favorites include an enticing game board—complete with playing cards and game pieces that discussed the working conditions, environmental costs, and production of plastic dildos in China—and a tree made out of Victoria's Secret brassieres, a work that contrasted the toxic pesticides saturating the brassieres with the provocative advertising of the merchandise.

Only once during the three years I have taught this course have we had the time to do the third project written into the syllabus. This project involves looking at the dynamic art made as part of the global justice movement, and developing puppets or masks that could be used in public performance. We usually start this project doing some Theater of the Oppressed exercises, and then talk about what aspects of the global justice movement inspire us. Reading David Solnit's *Globalize Liberation* gives students a context in which to think about these issues. We look at the work of Bread and Puppet, Heart of the Beast, Art and Revolution, The Backbone Campaign and Burning Man, and talk about the value of dramatic, interactive spectacle as a consciousness-raising tool.

We end the course with a sense that the oppressive aspects of globalization can be countered by both reconstructive visions and actions. The term "reconstructive vision" comes from social ecology and refers to how we want our ideal world to look. I suggest that the students might want to investigate or participate in some aspect of the global justice movement, like attending

Fig 4.23. The Office by Angela Rueber, Digital Photos of Interactive Performance Piece about the perils of working in an office (Labor, Globalization and Art. 2008). Photo by Beverly Naidus.

Fig. 4.24. "Yin Jing" An interactive game board about the sex toy industry, by Marisa Mezs and Cheryl Carino-Burr (Labor, Globalization and Art, 2008). Photo by Marisa Mezs.

a regional gathering of the World Social Forum (the WSF slogan: "Another world is possible"). There are so many fair-trade and nonprofit projects going on all over the world, and they might want to bring their creative skills to such ventures.

Students who are working in dead-end jobs, whether they are in retail, the service sector, or some other part of the labor force, often don't have many aspirations other than security and upward mobility. It is exciting to be able to offer them dreams larger than they thought possible.

The most poignant story from this class is that of R., a middle-aged man who was working in a lower-management job at a big box store at the time he took my class. He was finally finishing his BA so that he could get a promotion that would allow his family to achieve more economic stability. At one point early on in the class he admitted to me that his wife was a compulsive shopper and that one room in the house was devoted to her piles of unused purchases. A week or so later he came to me outside of class, extremely nervous. He said that the content of the class was beginning to disturb him deeply and he was worried that he would not be able to continue on his career path, knowing what he now knew about the connections between

things. His wife was deeply concerned about the questions he was bringing home, and he felt that he had to hide his journal. He had been bringing the latter to work and was making notes in it, when coworkers became curious. He felt that the questions he was posing within in its pages would create controversy among his coworkers and supervisors.

Close to the end of the quarter, this student confronted me and the rest of the class, saying that he felt that he had been railroaded into beliefs that were not his own and that he felt deeply disturbed by the class content and what it implied for people who were just trying to find their way in life and looking for a way to improve their lots. How did I feel hearing this? Well, I must admit that I am surprised that it doesn't happen more often. I was also startled that when I asked the other students to respond to the questions he raised, they ended up defending the open space offered by the class. They told him that he wouldn't be able to speak so critically about the course content in most other classes, and that none of them felt so intimidated by me that they couldn't speak their truth. I asked this student to come speak to me after class so that we could figure out ways for him to benefit more from the course content and the projects. We spent about a half hour fleshing out his concerns and both parted feeling relieved.

This story has a happy ending. On the last day of class, R. came up to me and gave me a big hug, saying that he felt the new critical consciousness he had developed in the class would make him a better manager. I haven't heard back from him, but I expect that I will someday.

Sometimes when the students evaluate me I learn that my words have been strangely misconstrued. If that didn't happen occasionally, it would be surprising. Last year I had a student who would occasionally make comments that were provocative, and I could tell that he was aggravated by my position regarding consumer culture. He said that he was pro-capitalist, and I asked him to explain more about his point of view whenever possible. In his evaluation of me (they are always anonymous, but often you can tell who has written them because his or her opinion was so distinctly different from others in the class) he complained that I was too communistic and socialistic in my approach to the class, and asked why I didn't present a more balanced approach to the topic.

I am always open with students about my biases, and share how inundated we all are every day with the positions of dominant culture. In the crack provided by my class, I am trying to present a different point of view, though my perspective is not ideologically sourced in the way this student imagined. I let students know that they are free to express their points of view as well.

Cultural Identity and Art

If you had asked me in 1990 whether I was interested in making work about my cultural identity, my response might have been ambiguous. I had lots of confusion about my cultural identity and didn't really know how to locate myself in relation to my peers of color. (I look like a person of color to many people, but according to the governmental, racial identification forms I am not one.) At the time, I felt a bit lost, not feeling like I fit in anywhere. So when a former student and talented artist, Ben Valenzuela, invited me to be part of a counter-quincentennial exhibit in 1992, I was flattered, but wasn't sure I was up to the task. He assured me that I wouldn't have any trouble creating work that critiques the old lies about Columbus's "discovery of America." He told me that many artists of color and their allies were creating works that examined the history of racism in America, so why not me?

Fig 4.25. "Why Let a Racist Disrupt Your Life?" Digital Subvertizement by Janie Cunningham, 2006.

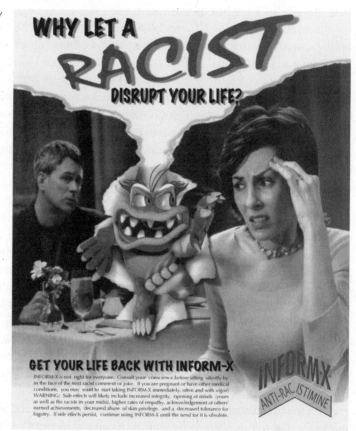

So I sat with this and started writing down my stories about my sense of cultural identity, and all the confusion I had about it. I examined in what situations I was made to feel like a person of color and in which contexts I took white-skin privilege for granted (as well as other privileges). Then I looked at how 1492 was a year that had twin oppressions, the Inquisition in Spain and the beginnings of the genocide of indigenous peoples on this continent. The marriage of those oppressions offered an interesting mirror of my own marriage, my husband and I being descendants of those whose victimization became explicit and insidious those five-hundred-plus years ago. Bob, a descendent of the Eastern Band of Cherokees (the Tslagi) and I (the daughter of two non-practicing Jews) had both been raised to assimilate and, in that process, I had internalized a bit of anti-Semitism, something I was startled to realize and admit. In fact, I much preferred passing as any other "other," and I did frequently without intending to. Questions like *What are you?* and *Do you speak ENG-LISH?*—and a comment, *You don't look American*—were not unfamiliar to me.

From these reflections, I went on a journey into a new body of work, an audience-participatory installation that morphed into an artist's book and later into a series of digital prints. As part of my research I visited Ellis Island with my mother who told me the story about some Jewish immigrants cursing Columbus when they realized that the streets in America were not paved with gold. An expression, "A Klug Tzu Columbus," would be used something like this: "A Curse on Columbus for having discovered this god-forsaken place to begin with, where I am struggling and starving." This story inspired the title of my installation, where I invited visitors to share their own stories of prejudice and hang them on the walls of a hut made of intricate lattices of branches.

Just prior to this installation, my husband and I had attended some anti-oppression and antiracism workshops. These helped me fine-tune my discomforts and understandings in this new terrain of self and social examination. Bob and I cautiously took on the difficult task of facilitating some of these workshops at the conclusion of my installations, and they seemed to provide people with insight and healing.

Having this experience gave me the confidence to take this work into the classroom, although I knew that what I was doing was very risky. Having seen my colleagues at the Institute for Social Ecology do this work, I knew that functioning as the facilitator would likely make me a target of rage and other confrontational emotions; nevertheless, I felt it necessary to push through my own fears and see what would happen.

On the first day of class, I invite the students to pair up and ask each other questions that will uncover some aspects of cultural identity.[12] What does your

last name mean? What parts of the world did your ancestors come from? When did they arrive in the United States? What brought them here? What did your ancestors encounter once they arrived in the United States? Did any of the languages or rituals from the "old countries" get handed down? Do you know or use any languages beside English? Do you have relatives in other countries? What economic class do you identify with? Has your family always been from this class? Do you have any ancestors or family members who were considered artists? Were there or are there things made or collected by family members that might be considered art? What creative skills have been handed down in your family? The students listening will write down their partners' answers and introduce their partners to the class. In this way we begin by discovering details about everyone's cultural heritage and start to explore how art can reveal more about those stories.

Our task in this class is similar to the other interdisciplinary studio classes I've created. We examine the concepts of cultural identity through readings, discussions, and an analysis of contemporary media and art. We discuss current critical theories about race, including the growing studies about the construction of "whiteness." We also discuss stereotyping "the other" in terms of ethnicity, class, geography, sexual orientation, and ability. We make art pieces that explore both personal and collective stories about cultural identity and fear of difference.

This course goes beyond creating work that simply celebrates cultural heritage, but that's the place where we start from, because it usually provides some comfort or at least curiosity for beginning our creative process together. Many students are quite befuddled by the whole concept of cultural identity, having had their ethnic heritage erased several or just a couple of generations back, so we do some readings to help them understand why knowing more about one's roots might be useful, how complex cultural identity can be, and what factors may have made their families give up rituals and customs that would have marked them as different. In our discussions students begin to question what motivates members of our society to dismiss, discriminate against, or oppress others because they have different color skin, sexual orientation, religion, and ethnicity.

As in all of my courses, we examine what is meant by "dominant culture," naming which groups are in power and how they might influence the media and other institutions to determine what is valued and what is not. We also look at how various groups might want to conform to its strictures, and why others would want to define themselves as distinct from dominant culture. We look at how many of the students identify with brand names

rather than the traditions of their ancestors, and ask what that says about the world we live in now.

During the course, I share work by dozens of artists whose work explores cultural identity, fear of difference, and issues of being an "other,"[13] and, as is required in my other classes, students choose one of those artists to research for a presentation.

Our readings include *Cultural Democracy: The Arts, Community and Public Purpose,* by James Bau Graves, from which we launch into discussions about what true cultural democracy is in a society where diversity is given space and resources to flourish. *White Lies: Race and the Myth of Whiteness,* by Maurice Berger, gives us a rich selection of autobiographical stories about growing up Jewish, gay, and poor. Lucy Lippard's *Mixed Blessings: New Art in a Multicultural America* throws the whole notion of a happy multicultural world up for grabs and sensitively compares contemporary art by artists of color in relation to big questions about place, power, and naming. "Whiteness in the Black Imagination," a bell hooks testimonial essay in *Yearning: Race, Gender, and Cultural Politics,* startles many of the white students who never imagined that they might be perceived as terrifying by people who don't know them. *Home Grown: Engaged Cultural Criticism* is an extraordinary dialogue between Amalia Mesa Bains and bell hooks, two remarkable, creative thinkers

Fig 4.26. "You Don't Belong Here" Digital photo by Rachael Delgado, 2008.

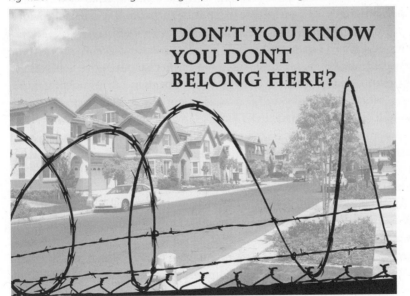

and educators. They offer a rich and complicated picture of what it means to be an artist of color working in today's world.

Our reading of *White Privilege: Unpacking the Invisible Knapsack*, by Peggy McIntosh, usually invites the previously polite and reserved students to a new emotional and intellectual awareness of systemic oppression. We talk about race as a social construction and look at who benefits from its existence. We distinguish the differences between institutional (economic and political) racism and bigotry, intolerance, and prejudice. Students usually come into the class with the media-inspired attitudes that minorities can be racist, and we dissect this misconception in a variety of ways. It is a semantic issue with profound implications and it is very important that students understand that bigotry, intolerance and prejudice exist everywhere, but only those in power can be racist.

McIntosh writes, "I was taught to see racism only in individual acts of meanness, not in invisible systems conferring dominance on my group." Among her list of fifty privileges she includes, "I can go shopping alone most of the time, pretty well assured that I will not be followed or harassed."

Exposing these privileges often causes such intense distress, with students saying things like "I am not responsible for this mess," that I wish I was co-teaching the course with someone who could give me a minute to rest and recuperate from the reactive comments that surface in our discussions. I am still learning how to facilitate this well. Because I was raised to be white, and am perceived as—and identify as—a person of color, I can easily go back and forth, sympathizing with the pain and rage on both sides of the fence. For my students who identify as bi- or multiracial, I am keenly aware of the battles that sometimes go on inside each of them. I encourage students to take their feelings and questions into their journals to process what they are experiencing more deeply, and also advise them to visit the campus Diversity Resource Center for counseling, workshops, and the like.

The first assignment asks students to bring in an object that has been handed down in their families, a family photo of an ancestor, and a story that has been passed down through the generations. Usually there are very few students who can find the three items requested. My students' lives have been affected in a variety of ways, including relocation, immigration, divorce, and disconnection from other family members. So they usually come into class complaining about the lack of material available to use for this first project, saying that there are no objects that have been handed down, nor are there photos. They are often lost when it comes to coming up with a family story, too. "What kind of story are you talking about?" they ask me. I suggest that there might be a story about how the family arrived in the United States, or

how they arrived in Washington, or perhaps there is the story of the courage or eccentricity or struggle of a particular family member. Eventually they usually find a photo of their parents' wedding, or father or grandfather in military uniform, and somehow an old rosary or Purple Heart or grandmother's comb is discovered. We take each student's photograph and scan it, and then scan the object. Then the students play with visual grammar to compose an image that combines abbreviated pieces of the story.

The latter exercise gives them a chance to commemorate some aspect of their family's history while developing some skills with collage or Photoshop. Some surprising aspects of this project are that students learn stories from family members that they had never heard before, and some become aware of ethnic roots that had been hidden or assimilated. One student learned of a slave contract in a grandmother's attic and this propelled her to make work about the topic for the rest of the quarter. It was not an easy process; she felt enormous guilt, but she moved through it and was able to carve out an identity as an ally.

As in all my other courses, students look at magazine ads to deconstruct their hidden messages. In this case, the students are looking for ads that reinforce racist and stereotypical thinking, and that appropriate multiculturalism (creating an illusion that all oppressions have been erased). For their second assignment they make a "subvertisement" or culture jam, taking an ad and breaking its trance, its intended effect, by inserting a personal or witnessed story, and changing the ad to reveal its hypocrisy. Sometimes students get into trouble with the assignment because they have not yet unpacked their racism. They create pieces that are unconsciously racist, or they just don't understand why having an ad that shows one person of each color in it might be problematic. Last quarter I had a student who felt that all ads with white models were inherently racist, so I told her to explore that in her work.

As in all my other classes, students do oral presentations on contemporary or historical artists who have done work on this topic. On a rare occasion a presentation can have an explosive effect. Not long ago, one very bright but not exceptionally empathetic student of color used the final minute of her presentation to attack the other students (most of whom she perceived as white), making short work of erasing all the efforts made to create a compassionate classroom. The room became polarized, and my attempts to gentle it, by talking about the rage that simmers in people who witness and experience prejudice on a daily basis, were not as convincing or effective as I would have liked. The irony of this situation was that she had made an assumption about "whiteness." The majority of the class was invisibly biracial, but none of them chose to ally themselves with her aggressive tactics.

While this sort of situation had not occurred before, a few white students have taken me to task in previous years, having felt that I was dismissing their cultures as somehow flawed. It was hard for them not to take everything discussed personally, and recognize that the racist society we live in privileges them and oppresses others. I don't assume that the steps from guilt and defensiveness to alliance and compassion are particularly easy without continual support and questioning, and I don't have a way of tracking how the course resonates after students leave the class.

Students view a few provocative videos about racism in relation to cultural production and that always stimulates good discussions. Many of the students are struggling with how they feel about race as a social construct and whether they can have cross-cultural dialogue that is without friction. So their last assignments offer them opportunities to put their stories into their work as photo-text projects and collaborations. Some of the best collaborations involve audience interaction, and students often create installations where members of the campus can look at their own assumptions and stereotypes.

One of my best hopes for this course is that students will have expanded their notions about who they are, owning the things about their heritages that give them pride, and recognizing that there might be shame tied into the complex story that has been handed down. Learning that so many of their

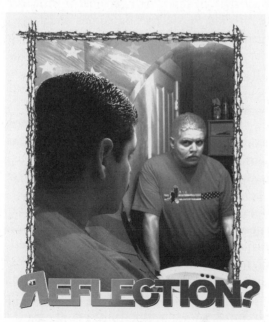

Fig. 4.27. "Reflection?"
Digital Photo by Victor Moreno,
Cultural Identity and Art,
UWT, 2005.

peers struggle with similar wounds might be the medicine to make them a better ally. And perhaps they have a sense that art can be part of the healing transformation, creating dialogue between polarized groups and retrieving things that have been lost.

Idealism Aside: What Makes this Work Really Hard

Elizabeth Conner, a respected public artist who has taught my classes while I have been on leave, is deeply interested in the new curriculum we have created and loves working with the students at UWT. This is what she says about the difficulties of our work:

> The curriculum is hugely challenging—the content is almost guaran-teed to be brand new to 100 percent of the students and 50 percent will be disoriented and shocked by it. But despite that you've built ways to manage that shock and get them moving. They are required to com-municate to their peers, and that whole critique model is something really valuable for them—the critique structure encourages truthful and open discussion. The classes contain huge expectations, but there is a well–organized structure to hold the students during the process. Your syllabus challenges them intellectually and emotionally. It's a real double whammy. Still students would make reference to other classes where there were shouting matches, but they felt safer in the art classes because they knew that they were expected to respect each other in conversation. . . . The students feel too stressed doing all this work in ten weeks, but I ask them to pay attention to what they CAN do under pressure.

There are other difficulties, too. I have my own short list about the hurdles encountered while working within an institutional model:

Grading No matter how you dice it, this phenomenon creates a power dynamic that is hard to deal with. Yes, you can use self-evaluations. Yes, you can have students grade each other (which can be a tricky business, full of various pitfalls). You can try to make the grading process as transparent as possible. I strive to do that, and combine it with a midterm self-evaluation, but I still find grading one of the stickiest aspects of work within the system. I've heard of people who give everyone A's as a way of supposedly buck-ing the system. I think that strategy doesn't serve anyone (except perhaps the teacher who gets excellent student evaluations). I prefer to give narra-tive assessments as is done at several progressive schools like Goddard and Hampshire Colleges, but they are a lot more work for me. I think that we

need to be teaching in institutions where assessment takes a back seat to more important things happening in and outside of classrooms. This attitude runs counter to the current bureaucratic inclination for assessing everything in sight. This trend was shaped by enormous insecurity about our ungrounded, non-holistic and unbalanced educational system run amok, and imposed by people with inadequate educations. My colleagues in the next chapter have more to say on this topic.

Power If one's work is about exposing the mechanisms of power and oppressive systems, how does one make one's own power transparent so that students will have more agency? This is particularly hard when the teacher has the final say in the form of grades.

Students come to our classes with mixed agendas. Some are very open to learning, but others arrive with long histories of dealing with abusive authority figures and have shut down in many ways. There are those who are extremely needy, never having received adequate attention or just plain insecure from not being supported in their processes. The psychodynamics in one class can reveal many of the troubles our communities face as a whole.

There are new experiments in excavating the power relationships more fully, from the very beginning of the class, rather than jumping right in with the first "lesson" or lecture. Talking it out with the students, engaging them in a wider discussion about power in our society, can be very useful. Again my colleagues in the next chapter offer more on this.

Shortness of the quarters Of all the difficulties I face in teaching my current curriculum, the biggest hurdle is that I am squeezing so much theory, history, and practice into such a short period of time, a ten-week term. Every quarter I confront the old breadth versus depth issue; the students are deeply engaged, but are they breathing sufficiently between thoughts so that the latter sink in? It's a buffet-style sort of education. I much prefer the semester system (typically fifteen weeks), rather than this ten-week fiasco, probably designed to bring in more money to the schools that use it. I hope that for some students the process of developing a story or two, researching an artist's life and practice, developing some opinions about a current social issue, and deepening understanding about the interconnections between cultural practice and the current state of the world are beneficial. But sometimes I feel that the stress of doing so much takes away from the experience I want the students to have. Each quarter I try to edit the amount of what we try to do, cutting back a bit more.

Students with enormous health, stress, and economic challenges Absenteeism has become more commonplace in recent years. Some students seem to be perpetually in crisis. It is understandable but this makes it hard to have continuity and a sense that students are really meeting us halfway. Also, when we open students' eyes to different realities than they have known, there can be some serious backlash. It is important to help them construct safety nets if they don't have them or give them resources and contact numbers; many students don't have adequate support systems.

Students who are uncomfortable with sharing their stories There are times when students do everything to avoid sharing *anything* about their lives in class, and I have to respect that. Every one has different boundaries, and I can't push students into doing something just because I think it will be good for them.

Students who feel challenged by the edginess of interdisciplinary education Some of our students would prefer what they call more "normal" classes, with names like Drawing, Glass Blowing, American History, 1700–1900. They worry that their transcripts with course names like Body Image and Art will not be comprehensible to graduate schools. I tell them that our school is in the vanguard along with many other schools that value progressive education, a more holistic approach to education, and tell them that to be part of this experiment requires taking risks. Stretching to imagine education in a new way takes some courage, and not all of the students have that. It is not always possible for students who prefer a more traditional institution to find another place to go. They are primarily on limited incomes and rooted in a place, so this can be a challenge.

Working with the "products" of America's right-wing public school system Across the country I have colleagues complaining that students are arriving in their classes "dumbed down" to such an extent that they, the educators, want to run, screaming, into the hills. To soothe their own frustrations, sometimes teachers compete to tell each other who has more ignorant students: "They don't know when the Vietnam War happened, they don't know where Vietnam is, and they think we won that war." The real tragedy is that the number of young people falling through the educational systems cracks is staggering. How do we solve this? Have we become a nation with *Most Children Left Behind?*

Lack of funding and tax base Across the country, the backlash against public funding of education has had a bitter harvest. There are not enough seats or classes for students, and faculty are being asked to teach more, increase their class sizes, and do more administrative work, with no pay raises or help in sight. Most of us don't have unions to help mitigate these issues, and much of the public seems not to care, or does not have time to organize around these issues.

Interface with administration and corporate education model The business model of education has increased exponentially since the mid twentieth century. Administrations grow, and top administrators' salaries increase, while the number of faculty shrinks, their salaries and resources stagnate, and more temporary adjuncts are hired, staff with no job security or benefits. Combine this issue with the last one mentioned, and you have a recipe for the next one.

Burnout There are days when some of us go to work and have no idea what we are doing there. Who gave us the authority to claim that we could teach anyone anything? The students seem uninterested, our brains aren't working well, our sense of humor is so unlike the students' that we wonder what language they are speaking. We are multitasking at such a furious rate, attending meetings, answering way too many school-related e-mails, writing grants, facilitating another project, creating more curricula, dealing with another cut in funding, and our boundaries are gone.

Clearly, it is time to take a break and get nourishment elsewhere. A walk in the woods, a talk with a supportive colleague, or perhaps a meditation retreat over the weekend might do the trick.

If we are lucky there is one or perhaps a few students in our class who get what we are talking about, who are not angry at us or totally alienated by being in school, who are not stressed out by an abusive spouse or by having no health insurance and sick kids, who are not skipping lunch because it's either that or gas money, who are fully present and grateful to be there. We hope that those students will be our bridge to the others. We hope to get them excited, and that they in turn will get us excited. We hope that the energy we generate together will spread like wildfire.

Backlash Currently academics in the United States are experiencing a wave of repression precipitated by the more general attack against free speech anywhere, and against progressive thinking in general. I recently attended a workshop entitled "Politics in the Classroom" put on by the Practical Pedagogy group at

the University of Washington, Seattle. In our discussion we examined recent legislation that would mandate the content of curriculum, with much of the momentum for this legislation coming from the leadership of people like David Horowitz, a neoconservative who believes that the university classrooms in the United States are teeming with radicals. I won't go into the strange evolution of Mr. Horowitz's belief system, but his work rallying politicians and students to eliminate "ideology" from the classroom, seems to be about as ideological as one can get. Telling university professors that they cannot encourage dissent among their students and that they cannot critique American capitalism (as if the latter represents the essence of democratic values) seems like another step in the direction of outright fascism.

To broaden the discussion of the challenges we face, I want to include a British perspective, offered by David Haley, whose work will be discussed in the next chapter. David believes that the following issues need to be addressed:

- Bureaucracy as a belief system ("the dominant culture determines language and shapes our thoughts, thereby normalizing mad value systems," David says; "global market economics are a good example)
- Tick-box [check box] social engineering ("in the spirit of 'meaning well,' David says, "the delivery of social change as a commodity has become an effective means of 'dumbing down' radical, activist intervention")
- Institutions promoting themselves, rather than the objectives they were created to address
- Art reduced to "predetermined, quantifiable design, problem solving and meaningless decoration"
- Selfishness (throughout the eighties, David says, a generation grew up in England—"Thatcher's children"—to be "de-politicized, selfish and impotent."

Pulling Apart the Questions in the Creases

Over a period of many years, nomadic women and men brought news of gardens flourishing in many parts of the world. They were filled with such a variety of ages, colors, and other differences, that it was breathtaking, and the sweet ball of a woman took heart when she learned about her peers in Vermont, Barcelona, Berlin, Taipei, Austin, Managua, Kenya, and Sonoma County. One could respectfully stroll into a garden on another continent and take up the same conversations, while learning a whole new way of framing a question. In this way, some of these wanderers developed new tools for understanding how things

worked and they began to braid them into their folds whenever they could. The lucky ones who saw the world this way tried to inspire the others.

There were difficult stories, too, when the folds returned more creased than ever: a person arrived whose story was so different and no one had the tools for understanding it, and divisions that weren't well-mediated caused explosions, ripped apart gardens—seemingly forever. Some became fearful of all gardens as a result. Still those who had experienced the unfolding and witnessed the braiding, kept sniffing around, looking for a new garden.

The golden-brown woman was a wanderer, though not always by choice. When far from a garden, it was more possible for her to trip on her folds, to fall into delusion, and join others who sat watching vast entertainment screens, imagining themselves as rock stars, airbrushed and invulnerable. She watched mirror images rushing about in a great hurry (because there was always more that needed to be done), and observed how some of them pushed down others that they believed to be below them, and how carefully they preened themselves to smile falsely at those they perceived to be above them. Their inner bouncing selves were so lost in folds that they could only see enemies around each corner.

Whether inside a garden or outside, she became aware of many insistent, melancholic rumblings that seemed to swallow all of her joy, building in a slow but quite palpable crescendo. They told her to be scared, really scared, and to prepare for the worst. She saw pictures of mountains with exploded tops, their innards pouring into the valleys and the drinking water, giant islands of plastic bags and bottles choking everything around them, and great winding conveyor belts of death in factories that never closed. Confusion, hate, and ignorance wrapped their sweaty palms around knuckles, slugging at walls and tender flesh. Holding her heart firm in the face of this monster, this growing roar, became so tiring, that she became ill.

5

My Peers Who Can't Be Easily Framed (Thank Goodness)

This book is written with the help of many peers. Their help has come in phone conversations, answers to questionnaires, and supportive e-mails. I cast my net as widely as I could, primarily using the Internet where I posted open calls on various lists and discussion boards, and I used the recommendations of trusted colleagues to pull in whomever was willing. Some were initially enthusiastic, but chose not to participate; others have stuck through the process.

Partly it was my isolation that drove me to gather colleagues together in this book. My life's trajectory has created huge geographical distances between my peers and I; and, in truth, even those of us who live near one another are too busy for regular contact.

Many of us make time to participate in online dialogue, but this is rarely sufficient to flesh out ideas fully. And these dialogues are rarely shared widely and fade quickly in cyberspace. So this book convenes colleagues, brings them to this place where we can learn more from each other and find out where our paths converge and diverge, while also sharing the conversation with a larger community.

We are lacking representation from many parts of the world, sadly, despite my efforts in that regard. Another volume is needed for a more international and multilingual perspective on the field.

I expect that there are many dozens, if not hundreds (dare I hope for thousands?) of significant artist-teachers missing from the table, but I hope

that they will endeavor to make their work known in other anthologies, articles, or Web sites. It would be a shame to lose their stories.

My colleagues vary in significant ways: they are people who have been deeply involved in dynamic groups that both spawned and branched from the likes of feminist art, mural collectives, community-based performance, artists-in-the schools programs, Berkeley's Free Speech Movement and other student activism, popular education, and long-term collaborations born out of social justice movements—for civil rights (Chicano, Nuyorican and Black Liberation movements, among others), gay rights (AIDS and queer activism), prisoners' rights, and disabled persons' rights—as well as environmentalism and the peace movement.

I have met some of these colleagues through exhibitions, jobs, conferences, artist groups, and networks of peers; others are more recent acquaintances who have offered me new ways of seeing our practice. Some I know by reputation alone, and I am deeply grateful that they were willing to contribute to a book written by someone who is a stranger to them. Others are former students who have gone on to do important work as community-based artists and/or socially engaged teachers. Most of the participants are old-timers, though a few are recent innovators in the field. All are practicing artists as well as teachers.

The process of interviewing these colleagues has brought me to new levels of understanding of my own teaching practice, as well as showing me how our work is connected in this movement for social change. I have learned so much from each and every one of them, and am enormously grateful for their willingness to participate in this project. It is also important to note that the stories of these colleagues could fill several books and are much abbreviated here. It is my hope that more of them will write of their work and share the nuances and depth of what they do.

The reader might note that many of my colleagues are located in California. While one might think this is coincidental or a logical result of the networks I created there during my nine years teaching in California, there are other factors at play.

The beginnings of the feminist art movement whose epicenters were located at CalArts (Valencia, California) and later at the Woman's Building in Los Angeles most definitely helped to foster a socially engaged art practice and pedagogy. Several peers had their points of view shaped by their participation in student protests at various schools in California (UC Berkeley, San Francisco State, and UC Irvine). The Chicano movement and its energizing effect on Chicano cultural production were also deeply felt in both Los Angeles and in the Bay Area.

As a few of those artists found tenured or administrative positions, their institutions (or competing ones) became more open to a similar kind of teaching practice. Several socially engaged artists were hired, at schools such as UC San Diego, UC Irvine, Otis, CalArts, and Cal State Monterey Bay, although most institutions have preferred to hire only one of our kind (more than one of us will signify something menacing, without a doubt). Martha Rosler told me, "They hire you and cannot get over the feeling they have been invaded, even though they invited you."

The issue of being perceived as a threat, because we ask difficult questions of our students, straying outside the safety of formalism, comes up frequently. Art departments and art schools, despite the stereotype of the arts being a field of liberated thought and creative expression, are often a site of surprising conservatism, where interdisciplinary work is dismissed as dilettantism. Dogmatic ideas of what is permissible as curriculum linger until certain faculty retire. There are also the issues of sexism, racism, classism, and homophobia, all of which have pushed out many caring, beloved, and committed individuals from their jobs, especially when they go up for tenure. Innovative, hard-won programs, and long-established relationships with communities often evaporate with their departures. We are hopeful that only a limited time with inspired students will be sufficient for new programs to sprout in new and unexpected places.

My peers often came to their work through their own healing from trauma, resistance to an injustice, or the witnessing of oppression that became intolerable. Many have both traditional and unconventional training. Quite a few did not study art as undergraduates, and a few never received any degrees in art. At least two have no degrees at all. Some did not have any intention of becoming an artist initially, much less a socially engaged one or a teacher.

It is my belief that the colleagues discussed in this book represent a small percentage of our peers teaching socially engaged art and cultural production around the world. Yet the numbers may be lower than I think, due to the high attrition within the field. To receive tenure, or even to find or create a decent-paying job doing this kind of work, is truly a rare thing.

It has been difficult to decide which of my peers' stories would bring the reader deeper into this expansive vision of art for social change. Describing their art and teaching practices adequately would require a series of volumes. At times I felt the whole task was absurd, for how could I squeeze the extraordinary talents of each artist-teacher onto a few pages? The process felt like using containers the size of thimbles for vast oceans of treasures. These summaries should be understood to be teasers, a small sampling of what you might learn if you contact these artist-teachers directly. I have chosen to highlight what

inspired me about their practices as teachers, and will describe their art only briefly, as frustrating as that might be for the curious reader. Contact information—including that for other notable peers—can be found in the Appendix.

After sitting with my colleagues' words for many months, I am yearning to sit in their workshops and classes, to soak up their insights in person. Often I had tears in my eyes, as I read or heard the intensity of their passion. I identified with their frustrations and delighted in learning about new wellsprings (books, stories, and epiphanies) that support their practices. I wish to honor these people who have brought their students into vulnerable and awkward places, knowing the ultimate reward of that task is catalyzing more people who can use their gifts to transform their lives and the world. As many of their students have told them, *I came into your class to learn about art, and I learned to see the world in new ways.*

I sent all the participants a questionnaire and a few made time for phone interviews. I asked my colleagues what brought them to their work, what their work with students consists of, how they define their practice, what they find challenging and rewarding, who their pedagogical influences were, what they think attracts people to the work, and how they keep their spirits up despite discouragement. I asked them for stories of transformation.

As I've mentioned, some of my colleagues were catalyzed by some specific events that awakened their hearts and spirits to the work; others were part of significant social and cultural movements and/or were raised with the values of social justice as Quakers, Jews, pacifists, socialists, populists or Catholics influenced by liberation theology. The sources of inspiration that my colleagues named were so copious and overlapping that I have listed them on a resource page in the Appendix.

The task of categorizing these dynamic colleagues seemed so totally paradoxical that I have mostly abandoned such ambitions. Matching practitioners with geographical/cultural locations or social movements that helped shaped their visions offered too superficial an understanding of the complexity each individual represents. As I delved more deeply into the process of neatly boxing my colleagues in cohort groups of eco-art or some other category, it seemed ultimately contradictory to the overall interdisciplinary thesis of this book. So I have chosen to introduce them following an intuitive rhythm that has to do partly with when I met them or their work, the contexts in which they teach, and the synergy between the stories.

The stories of colleagues with extensive practice within academia begin the first section, though not all of them work exclusively in that realm. Many were pioneers within the field. The second group consists of peers whose practices are equally extensive and pioneering, but their work as teachers has

not often been in traditional academic contexts. I conclude with the stories of the new generation, artists who were not able to directly participate in the social movements of the sixties or seventies but who have been inspired indirectly by that time or by other factors. I should mention that many of these colleagues are changing positions and programs more often than they would like, and in fact, two colleagues in this anthology have lost their positions since I interviewed them.

One question may seem quite small: how to address my colleagues within the context of their stories. By first name? Last name? With titles? I posed the question to the group, and received many different responses. Ultimately I chose to respect each individual's wishes on this matter and address them in the way that they chose. When no preference was stated I have used last names, out of respect. This process is like the ways we try to work in community, without using a "one size fits all" formula.

Martha Rosler

Born: Brooklyn, New York
Professor, Rutgers University, in New Brunswick, New Jersey
and the Städeschule (Staatliche Hochschule für Bildende Künste)
in Frankfurt am Main, Germany

> *"I realized long ago that it was not possible for me to be anything other than socially engaged. . . . everything takes place within a matrix, or a context of social relations, so it's not possible to have any other perspective. Of course, there are other criteria and considerations when talking about aesthetic objects, but everything starts with its embeddedness in social relations."*

Martha Rosler's recognition within in the mainstream art world is impressive, given the edgy politics in her work. Her photo-collages bring the war into the bourgeois living room with no apologies. What has also struck me is her down-to-earth self-presentation; she is always curious and accessible. As an intellectual and artist, she deftly weaves together vast amounts of critical theory with an informal street savvy. She connects many dots before most of us can see them, and this ability has served her quite well as a teacher for the past few decades.

Rosler says that her broadly political, feminist, and artists' groups in Southern California during the seventies gave her the intellectual, theoretical, and emotional grounding to weather the challenges of her career. In particular, her experience of women coming together at that time and becoming a community energized her and everyone around her. There was an insistence that

art really was about the things that formalist aestheticians were pretending it wasn't about. According to Rosler, feminism was at the base of bold new ways of thinking about everything: gender, social relations, and specifically the different ways of living with people that manifested during that time.

Despite a career with many challenges, Rosler has been deeply committed to her work as a teacher, and most recently has been inspired by her work with students in Germany as well as the United States. "I am something of a liberal when it comes to what I expect of students' work," she says. "I don't demand that they always polarize or orient themselves toward questions of social life. But it's not possible to be in a classroom with me without at least understanding [that those are always the questions] hovering behind what we are looking at or making."

In her photo studio classes at her U.S. university, Rosler gives students assignments where they make observations of real-world conditions, then make posters that express some point of view, or produce sequences of photographs that deal with neighborhoods or work. She emphasizes that in photography one is always thinking about the relationship between the person holding the camera and what (or who) is in front of the camera, and considering where the work stands within the context of social relations. She says that the Socratic method influences her teaching, in that she guides students toward thinking for themselves about these questions rather than trying to impose it on them. "My aim is to think how people's good intentions toward their work and the world can be united in such a way as to further humanity and social justice," she says.

Rosler says that art makes a difference to social movements only when it is made in cognizance of those movements. She believes that socially engaged art gives people a sense of hope and a sense of forward motion: "It helps coalesce your thoughts, especially critical ones—or even positive ones that have a particular direction. It helps people feel affirmed and energized"

Rosler sees among her students a return of interest in utopian and feminist thinking in relation to art making. "They want to collaborate with each other and they want to evade the market imperative," she says. "Young people really feel cheated and angry, and want a totally different orientation on everything, and that's a start…"

Suzanne Lacy

Born: 1945, Wasco, California
Chair, MFA Public Practice, Otis College of Art
and Design, Los Angeles, California

> *"It is important to call out the way in which personal transformation, conscious-raising self-disclosure, grieving, fearing, and raging about past issues were seen as part and parcel of socially engaged art (although we didn't call it that at the time). These personal themes challenged the boundaries for women, and very quickly we connected with broader discussions of gender, class, and race."*

Suzanne Lacy's work as a feminist artist has had an international impact, but her work as a pedagogue has had wide repercussions too, particularly evident in California. Lacy's innovative art forms themselves often have a pedagogical component and are characterized by community activism, feminist issues, and antiracist concerns.

After a year in Judy Chicago's Feminist Art program at UC Fresno, in 1971 Lacy went to CalArts to work with Chicago, Sheila De Bretteville, Arlene Raven, and Miriam Shapiro. With an undergraduate degree in zoology graduate work in psychology, Lacy was well prepared for interdisciplinary work. She was part of the groundswell of artists in California influenced by psychodynamic work, Gestalt therapy, and the Human Potential Movement.

Lacy says that the proliferation of co-counseling, or reevaluation counseling, among the students and faculty at CalArts (along with the practice of tai chi) affected the culture of the campus, leveling power and hierarchy, not unlike the mission of Paulo Freire's work. Comfort with intense emotions there affected the work created, particularly by female students. And self-revelation connected to identity politics led to social change.

While teaching at the Women's Building in Los Angeles, Lacy said that the students would do projects that involved self-interrogation and investigation of others' realities. She asked them to make artworks based the students' initial, often stereotyped, perceptions. Next they conducted research and in the process met people ("tracked them almost anthropologically"), and then, if possible, created a collaborative work or interactive intervention. Lacy says "When you understand social situations from their original research into context, you often encounter the uncomfortable space between your perception and perception of the other; add together both perspectives, with a social-political analysis, and you keep building communication."

Her teaching has run the spectrum, working with both adults and teenagers on art or activist practices, designing programs, and situated in traditional

college settings. She sees her large-scale artworks as complex pedagogic processes, with workshops, interns, and apprentices, and even public media campaigns. Of primary concern to Lacy is context—specific contexts within particular communities. She asks how the public minds work as she undertakes a project, and her research into local experience and institutional positioning, and with social/political texts on specific issues, is lengthy. Her insights on race, class, and gender come from diverse sources, including media studies, sociology, psychology, and community organizing.

Lacy describes her teaching style as "negotiative" and somewhat psychodynamic, attending to the histories and experiences of her students and how these impact their work. Rather than adopting a fixed political position, Lacy's style is interrogative and discursive. She says that she "doesn't have the privilege of absolute positional clarity" with many of her projects and that "this way of working translates into the classroom as well." She does not consider herself an activist, per se, but rather an artist activist, which implies a concern with aesthetics that is not always directly causal.

Amalia Mesa Bains

Born: Santa Clara, California
Director and cochair, Department of Visual and Public Art,
California State University, Monterey Bay

> "From the beginning of their education as artists this possibility (of being socially engaged) has not been presented to them in a way which they can imagine it. And on the other side, something else has been presented to them, which is fictional, which is the artist star, the one in ten million, who actually makes a full-time living and gets accolades. There's that fantasy, that is between the artist and their reality, that fantasy lives in all of us in some way or another, if we've been trained in the model. . . . To imagine that one can make art outside of a social context, I think it's an illusion. To me the practice of making art is inherently social."

Mesa Bains brings insight, generosity, and grace to her work as a teacher, cultural critic, and artist. Her philosophy, both as an artist and teacher, emerges from the framework of the Chicano movement that positioned her both as a cultural worker and a member of a collective. Mesa Bains taught as a public school teacher before arriving at California State University Monterey Bay (CSUMB). She was recruited into the Teacher Corps in 1969, to work in inner-city schools, work that was by its nature activist. Her mentor was Yolanda Garfield Woo, a teacher from a Oaxacan family (and practitioner of Day of the Dead ritual in the Bay Area), whose pedagogical

approach was based in lived experience. Mesa Bains credits Woo with having the most significant impact on her life and work.

Mesa Bains is an accomplished artist, cultural critic, and speaker for our movement, and a winner of the coveted MacArthur Fellowship.[1]

The CSUMB program that Mesa Bains cochairs with Professor Stephanie Johnson is one of the most unusual art departments in the country. Developed with the vision put forth by Judy Baca and Suzanne Lacy, Mesa Bains joined them to develop curricula for this new branch campus in the CSU system. Supported by founding faculty members Johanna Poethig and Stephanie Johnson, they began the department officially in 1996. It was a great deal of work, involving remodeling buildings, but it was also exciting to start a new program. She says that they were very lucky because "we didn't have to kick old white men out of the way because they weren't there . . . we were all women when we started out." Creating something nontraditional when there was pressure from the affluent art communities in Carmel and Monterey to create something in the traditions of Edward Weston and Ansel Adams was a challenge, but they overcame it.

Mesa Bains is grateful that the CSUMB students are not "arty-smarty" brats; they are not jaded like so many art students at private colleges can be. They come to her "fairly tabula rasa" in regard to fine arts, and they haven't been browbeaten into accepting canon. They are open, eager to participate in the program, and bring with them their own diverse community aesthetics. Art having a social function does not go against what they are already thinking.

Having seen how often higher ed is based on the industrial cost-effective model, Mesa Bains says that the arts simply don't fit this model: they cost more to teach and require more resources, but administrators want the art classes to be run the same way as classes with a textbook and a computer.

Mesa Bains developed a case-based model class called "Ways of Seeing Ethical Issues in Public Art," where students study a monument, a memorial, a bus poster, and a mural, spanning from traditional ones to more innovative works. Students divide into teams, conduct research, and present their findings to their peers, and from that develop a set of principles. They ask who has created each public artwork, *how* each was made, who (or what) is commemorated by each monument and memorial, what social issues are involved, and what is the artist's role.

All of the theory courses in the CSUMB Visual and Public Art program have a public-practice aspect to them. They apply theory by making something, either in the digital lab or elsewhere.

Influenced by the work of David Perkins, who came out of Project Zero at Harvard,[2] Mesa Bains worked with faculty Gilbert Neri to design a course called Media Culture, that examines media construction and visual literacy,

where they deconstruct graffiti and advertising. The course introduces students to semiotics and "visual analysis": "They need to be trained because they look at a lot of things, but they don't actually see them," Mesa Bains says.

One of her favorite courses explores the traditions of the Day of the Dead. The students identify personal loss and memory, work through the process of identifying loss and remembering, and design portable shrines or other work that they can explore with their families.

The students also work with community partners, creating collaborative projects. For the past three years they have partnered with farm workers, creating banners (about the right to a home) and *fotonovelas*[3] (about environmental health problems). They get to know people, meeting farmworker families at their trailers and campsites, and learning about poverty right under their noses. It humanizes the situation and it gives them a sense of consciousness that they would not get any other way. The CSUMB faculty members teach them the rules of the game, in their community research. They develop a skill set for being active citizens, even if they don't necessarily become community workers.

One of the many extraordinary things about the VPA program at CSUMB is that the faculty members truly share a vision, and function as a collective. The family spirit they bring to their collegial relationships models something very unusual for the students.

Stephanie Anne Johnson

Born 1952, Harrisburg, Pennsylvania
Professor, cochair, and service learning coordinator, Visual and
Public Art Department, California State University, Monterey Bay

> *"I want the world to change energetically, and in order
> to do this I have to have the students on my side."*

Stephanie Johnson's lively intelligence, humor, and warmth must be effective in the classroom. She speaks of how necessary it is for her to project this comfort in her skin, in order to help others feel comfortable in her presence. Professor Johnson is an African-American artist who carries the dream of changing the world in tangible ways. To do this, she needs to be a mind reader, a coach, a role model, and an incessant worker, demanding much in the precious time she has with each student.

Professor Johnson works with Amalia Mesa Bains at CSUMB. Over the past fourteen years she has taught and created courses with such titles as Public Art Practice, Community Research Service Learning, Black and Chicano Art,

Installation Art, and Diverse Histories in Contemporary Art. Like many of my peers she admits that in theory her teaching and art practices feed each other, but in reality there is much interference caused by the teaching work. She suffers like most of us from exhaustion and lack of time, but has enormous passion for her work: She told me that patriarchal ideology (led by white men as the ones with authority and control) can interfere in the classroom, and that her age, gender, and race could make her vulnerable to reactive students. But she takes a firm position: "I know more than you do, I know what I know, and what I don't know, I can learn." Professor Johnson approaches her work with humility and tolerance, and inspired me greatly during our hour-long interview.

"I give them lots of work to do, and myself as well," says Professor Johnson. "I write narratives as well as grades." She says that she recognizes that she needs to be representative of her race, and is energized in all the ways she addresses students, colleagues, and the CSUMB administration. "I may be the only African-American professor that my students ever have," she says, and she feels a need to be a model for both her students of color and potential allies among her white students.

Over the years Professor Johnson has developed some exciting projects for her students, dealing with self-identity issues, environmental racism, and how the digital divide affects the community: "I am not often running up against the dominant paradigm in The Visual and Public Art Department." She invites her students to transform guilt about their privilege by turning it into advocacy. As a closing oral exercise at the end of her art history courses, each student makes a presentation beginning with a statement: "As a person with (gender or class or skin or other) privilege, I can be an ally or advocate for (an oppressed group) by doing the following things in my life." Professor Johnson calls this an "alliance testimony." Since many of her bilingual students speak the language of their heritages outside of school, many of them learn to be mindful of their student privilege, and go on to offer their skills in their immigrant communities. In that same way, mothers recognizing their privilege in that role can become allies of children and advocates for elders. I was inspired by this exercise, and have rarely felt this same level of inspiration on the closing days of a class as I do at the beginning of a quarter. I intend to try it out.

When I asked Professor Johnson why more artists don't choose the path of becoming socially engaged teachers she says, "Privilege prevents many from choosing this direction. They are trained to want money and recognition to the exclusion of any other goals, and it takes so much work to go up against the system consistently. There's no promise of fame or fortune in what we do." Art students are still infatuated with the illusion that "if you work hard, you will be famous," she says.

Deborah Barndt

Born: 1945, Maine
Associate professor of environmental studies,
Community Arts Practice Program, York University, Toronto

> "I really identify with postmodern caution: knowledge is partial;
> truth is dependent on particular times and places, but this
> shouldn't immobilize people from taking positions, and I feel
> it has paralyzed some people in academic contexts."

Deborah Barndt came to her activist pedagogy from her popular education research in Peru in the seventies. Influenced by the work of Paulo Freire, and very mindfully a "*gringa*," Deborah went to Peru with the goal of trying to understand how to transform communities and foster social justice through popular education and cultural work.

There are three different selves that inhabit her work, those of thinker, activist, and photographer. These terms come from her work in Peru—*pensadora*, *política* and *poeta*—when she felt pulled in three different directions: as critical analyst, activist, and artist wanting to touch people's souls and hearts

Fig 5.1 CAP consultation with community partners, community artists and organizations that mentor Barndt's students in their fourth year: during a one-day consultation in February 2008, where they carved out together an agreement about how they negotiate placements that will be mutuallly beneficial and developed some potential collaborative research ideas. Photo by Deborah Barndt.

with people's stories and images. Like many of us she is awkwardly sitting in the world of academia, not quite fitting in the usual mold. Her art as a community cultural practice also has an uneasy relationship to the art world. Yet, while blurring the boundaries, she challenges the divisions.

What was really formative for Deborah was being part of the Sandinista revolution in Nicaragua. She had the opportunity in the early eighties, as part of the Ministry of Education there, to train literacy teachers in popular communications (*comunicación popular*): how to gather oral histories and photograph communities, then use the stories, photos, drawings, silkscreens, and drama in their classes. Drawing on daily life and the life stories of learners, literacy texts could be built.

When Deborah returned to Toronto she was involved with the Participatory Research Group that did action research in factories and elsewhere using media and the arts as part of their popular education work. Deborah has worked collaboratively on many cultural and educational projects, both outside universities and within them. When teaching English as a Second Language (ESL) in the workplace to multiethnic populations, Deborah dealt with race, class, and gender issues in the workplace. This gave her the opportunity to apply Freirian techniques to teaching ESL: not just learning a language, but

creating a space where they could learn to talk with each other about their common experiences in the workplace as immigrants. They used photos, made *fotonovelas* and cartoon stories, and collectively wrote songs about how to strategize around common problems, such as machines breaking down.

From 1993 to the present Deborah has worked with the interdisciplinary faculty of the environmental studies program at York, which historically has promoted community-based practice as part of learning and alternative pedagogy, and has been more open to the use of visual and embodied knowledge

Fig. 5.2. Woman literacy student reading a foto-novela of her community's story (during Deborah Barndt's participatory doctoral research on Freire's approach, Peru, 1976). Photo by Deborah Barndt

than more conventional faculties. She has expanded the program, founding an annual Eco Art and Media festival in the early nineties that has been ongoing since. The most important development is a new Community Arts Practice (CAP) Certificate Program, shaping it with community groups and defining it with artist partners who are co-teachers, who mentor students in a fourth-year practicum in the community, working in popular theater, mural production, et cetera.

York is located next to a community with lots of gang violence, with a history of animosity with the university, so they are now working with a group of young black spoken-word and theater artists to create a summer institute, a non-degree program to train young artists in the neighborhood who wouldn't be able to undertake a four-year program; York graduate students will work with these artists.

Deborah has designed the graduate-level Cultural Production Workshop, which in 2008 was titled "The Art of Work and the Work of Art." It was linked to a community-based festival, the Mayworks Festival of Working People and the Arts, and the annual forum of Community Arts Ontario. This year students decided to do a culture-jamming process with the advertising strategies used by the university to market itself as an interdisciplinary institution. The students appropriated the school's marketing format, but examined workers in different parts of the hierarchy, and imagined how things would look to them from different perspectives. It was an important intervention (the critical ads were posted on campus), leaving the students both amazed and continuing to write and reflect about the experience months later. Deborah finds that the fine art students are sometimes blown away by the critical content and participatory pedagogy in her courses, since this was often ignored at the art schools where they studied as undergraduates.

Since 2004, Deborah has coordinated a transnational collaborative research project involving people within universities, in progressive groups, and in NGOs in five countries, called the VIVA! Project. Exploring "creative tensions in community arts and popular education in the Americas," each year the group has been brought together in different sites (Toronto, Panama, and Mexico) for a weeklong exchange to share their practices and the issues arising from them. The project initially defined five creative tensions:

- *process versus product*
- *aesthetics versus ethics* (concerning the debate about whether community arts are not up to snuff, probing what we understand as aesthetics)
- *cultural reclamation and cultural reinvention* (concerning recovering voices that have been silenced or repressed and the danger of repro-

ducing a static past or enforcing homogenous community, wanting to
honor multiple identities and subjectivities)

- *spiritual versus political* (moving out of the dominant western mode,
working with people who come out of other traditions such as indig-
enous or Afrocentric practices where the spiritual and political are not
separate; in Latin America there is an assumption that everything is
political, whereas in North America there is a claim of neutrality)
- *nature versus culture* (embodied practices are integral to so many cul-
tures, where the body is not outside of nature).

Through their intercultural dialogue, they have begun to look at their
work as a decolonizing practice, and they are trying to understand how deeply
colonial practices are embedded in all the places that they work and even in
their thinking, including the ways that art is discussed.

Olivia Gude

Born: 1950, Saint Louis, Missouri
Professor, Art Education Program, School of Art and Design,
College of Architecture and Art, University of Illinois, Chicago

> *"People have this enormous power to reshape culture; even artists say that
> we exist in the society of the spectacle, and get demoralized, and feel
> powerless in the face of this overwhelming force of media, but people in
> this project were interacting in ways that were more interesting than what
> the society of the spectacle could offer. . . . We do have this potential to
> make our own culture. That many artists have forgotten about."*

The work of Olivia Gude and that of her artist partner, Jon Pounds, came
to my attention more than two decades ago at a national conference of the
Alliance for Cultural Democracy (ACD). This group was formed through
the efforts of community-based artists, many of whom had made use of
CETA funds in the late seventies to do community-based art projects with
youth, such as murals, theater productions, and film and video documen-
tary projects. ACD thrived for a number of years through the eighties, but,
as with so many alternative arts organizations that struggled for funding as
the Reagan years progressed, the energy to keep the organization alive was
hard to maintain, as artists also worked to sustain their base organizations
and artistic practices.

Olivia studied alternative pedagogy at Webster College, reading Paulo
Freire, Ivan Illich, and Jonathan Kozol back in the seventies. There was a lot

of excitement about education being part of the movement for social change. She talked about being in conversation with elders who were "propositional" (imagining how we might reconstruct society) rather than being only *oppositional* (in struggle against the status quo).

Olivia says that she had the privilege of getting two graduate degrees: one as a student at the University of Chicago where she had the benefit of engaging with critical theory in the early eighties, the other as part of the Chicago Mural Group, an organization founded in the early days of the street mural movement. These two educations helped her to think in distinct and equally important ways about the strategies for making art and culture. Though the decade of the eighties was a time of much politically conscious art, there were not many models for engaging communities in using art to investigate and represent issues of importance in their lives. Olivia explained that in her collaborative public artworks she tried to combine accessibility and conceptual sophistication.

Sometimes working as a resident artist in schools, Olivia decided that the public-school art classroom was an important site for cultural change. In 1995 she began work as a professor of art education and focused her research on how pedagogical practices could incorporate the practices of community-based, socially engaged art. It was a very different model than curricula focused on modernist elements and principles and traditional masterwork, then promoted as quality art education.

Olivia sees public school art teachers as "radically proactive," people who were attracted to teaching because they wanted to make the world better through art. She sees good arts curricula as creating practices through which youth and others can understand the world and make personal meaning. Art teachers can be true community-based artists.

Olivia founded the Spiral Workshop in 1995, a Saturday program for teens, in order to give her art education students at the University of Illinois, Chicago, hands-on teaching experience. The teenagers who attend Spiral Workshop come from diverse neighborhoods in the Chicago area. The workshop was planned as a "curriculum research laboratory-creating project" that would encourage students to investigate how the self is constructed in various cultural and family discourses.

The Spiral Workshop is organized into groups that pair learning a media-related or aesthetic practice with the exploration of a concept or theme. Sometimes the connections are straightforward, as in the Look Natural group that taught naturalistic drawing skills while examining the artist's role in representing reality. Other groups explore an artistic practice through a surprising lens, such as in Chromophobia: Painting in a Color of Fear, which

studied modern and contemporary painting against the backdrop of world wars, the designation of avant-garde art as degenerate, and current life in a society with color-coded fear. At this community show, conversation exploded when visitors encountered a wall of Abstract Expressionist paintings on brightly colored paper, accompanied by student explanations of how to react at various terror levels. In another Chromophobia project, students painted plaques of familiar warnings and sayings and considered how the study of everyday rhymes and platitudes can reveal gender and cultural stereotypes that underlie cultural values.

Olivia described a group called Drawing Dirty Pictures that exposed students to methods of making that eschewed neatness and embraced the filthy, the abject, and the raw. Students unearthed personal experiences to create narrative works that investigated their own encounters with cleanliness and lack thereof, including discussing why students in art are often graded on neatness, but virtually never on their capacity to foment creative chaos. Students and teachers together analyzed the theme of dirt in our society, ranging from mere messiness to life-threatening toxicity.

The first day in all Spiral Workshops is designated as a day of Surrealist play. Students, educated in increasingly restrictive schools shaped by high-stakes testing, need to learn to reclaim their capacity for creative play. In the Dirty group, a teacher "accidentally" spilled inky water over a stack of pristine paper. The students initially gasped in shock, but were then encouraged to jump in and make their own messes, experiencing the pleasure and release that comes from beginning with "impure" surfaces.

Spiral curricula often make use of "subject surveys," worksheets that help students to recall personal stories and survey how a chosen theme operates to create notions of normalcy and inevitability. In the case of the Dirty group, this raised a number of questions. Were you ever punished for being dirty? Did you ever get dirty on purpose? Are there things you try to keep clean? Have you ever been called a dirty girl or boy? Using such material, students create such things as large-scale narrative drawings and autobiographical zines. Spiral curricula introduce students to a wide range of contemporary drawing styles because the teachers want students to engage with drawing, not merely as a skill or exercise, but as a means to tell stories about their lives.

Often a final project is focused on deconstructing cultural assumptions by investigating an underlying metaphor. In the Dirty group, students considered the many ways in which the designation "dirty" is used to discipline and punish. The metaphors of dirty and clean are used to shape ideas about who belongs and who should be excluded from American society and from public discourse.

Olivia talks about the push for Discipline-Based Art Education (DBAE) in the eighties. The sound idea was that education should be based on the actual disciplinary practices of a field. DBAE defined the disciplines as production, criticism, aesthetics, and art history. In the art world of the time, conversation was focused on multiculturalism, postmodernism, cultural studies, and psychoanalytic models—generating complex conversations about gender, race, and cultural values. "Just as the field was moving toward these issues, they [were] pushed towards the margins in public school art education under the banner of normalcy," Olivia says. "Money came flowing out of the Getty Foundation and it was used to reinscribe a traditional, formal approach to art education. This along with the educational standards movement reified old practices." Olivia has another vision for DBAE: "I'd like the 'D's to stand for dialogical, deconstructionist, and D.I.Y."

"Many people for whom I have deep respect, frame their work as 'social justice art education,'" Olivia says. "I don't think it's a particularly useful term. I think describing culturally engaged art education in that way marginalizes what people are doing. All good education gives people the capacity to choose and to be effective in shaping the world. All education should have social justice as its goal. We shouldn't marginalize the work that we do to shape a truly democratic society that lives up to America's highest stated ideals."

Educators and artists sometimes fear controversy surrounding their work. Olivia talks about her growing realization that, though communication and connecting is the goal of community-based work, tension and controversy may be an important part of that experience. She describes working on a mural titled *1984*, that was based on information culled from U.S. government publications. One of the images in the mural was of nuclear warheads pointed at various points on the globe. This image was very controversial in the school setting, even though it merely depicted something that everyone acknowledged was incontrovertibly true. "At first, I was so frustrated at the very idea that the students would have to cope with being criticized for depicting reality," Olivia says. "Now I believe that I misunderstood the process in which we were engaged. It was important for students to understand that sometimes people are invested in not representing reality because the system can't function if it is actually seen in its totality. The reactions that artworks provoke and how we deal with reactions to our artworks [are crucial aspects] of the educational experience for students."

In undergraduate teacher-education classes, Olivia doesn't allow students to share stories about teachers being fired for their classes' controversial social, sexual, or political content without substantiating the stories. "I'm not trying to suppress free exchange of information. I am challenging students to not

contribute to a climate of fear. I believe that even in the current difficult times there is much more self-censorship than there is actual censorship in public schools. Even if teachers are criticized or warned for introducing content that is perceived by some to be transgressive, it is unlikely that a responsible, well-constructed curriculum unit would lead to a teacher being fired—yet this is the fear that is transmitted to teachers."

When Olivia gets discouraged, she says, "I imagine what it was like for artists and intellectuals in 1959 or 1961. The McCarthy hearings had disrupted the lives of many progressives. The status of women and people of color was often bleak. However, activists and artists continued to work—movements caught fire and things changed. This can happen again. The biggest folly is to think that the ways things are is the ways things are going to be."

Krzysztof Wodiczko

Born: 1943, Warsaw, Poland
Director, Center for Advanced Visual Studies (and a head of the Interrogative Design Group there); professor, Visual Arts Program, MIT (a program of the Department of Architecture)

> *"I would not call it [his students' work] activist, or political. There is tendency for those projects to engage public space and create conditions for inclusiveness and the democratic process. [The art] creates a complex discourse whether electronic or physical, using various devices, combining the aesthetic, technological, psychosocial and cultural."*

Wodiczko's art causes an interruption of public space and the trance of everyday life. He uses video and photos projected on architecture to ask questions about the abuse of power, the state versus the individual, violence, isolation, and alienation. This award-winning, internationally known artist has been a committed educator for several decades.

Wodiczko combines studio teaching with seminar discussions and readings. He argues strongly for the merits of interdisciplinary classes, saying, "I've found that students in art schools are not that versed in philosophy, theory and cultural studies. . . . Artists historically were inspired by those theories whether they understood them in the ways that the authors wanted, or whether they used or abused the ideas, making a mixture of them that was very explosive or unexpected to any philosopher. So I like the idea of making a space around the table, where students question public art, public space, democracy, and experience . . . they surround these questions with discussions and projects. In the framework of each of those sessions, they bring their own lives, their own

suggestions, and begin projects that are often incomplete. . . . I have to really prepare myself to be a good companion in the discussions, and they have to do the same. I can bring more references to it, because I am older and have more experience. . . . They take advantage of that, and I take advantage of their pointed intuition, they are contemporary people so they are ahead of me."

His students, Wodiczko says, "respond immediately to any framework which focuses on the position of the stranger, issues of inclusiveness, projects about exclusion; often these are people who felt excluded in their countries of origin. For instance, Asian women are never expected to challenge others in public space, and open up to others with unsolicited truth—they take advantage of working on projects to advance their own development and social skills and to challenge their own cultural barriers. Among them there are communication difficulties, most of them are exceptionally bright and capable people, each of them was one of the best in their colleges, many of them were isolated, alienated, and treated disrespectfully by others who were trying to ridicule them for their exceptional performance. Therefore, coming to MIT they are shocked to find each other in the same classroom."

Sheila Pinkel

Born: 1941, Newport News, Virginia
Professor, Pomona College, California

> "The most difficult assignment I can give is to tell the students to do anything they want to do. Often, they have never had an opportunity to pursue their own ideas before. In addition, in more advanced classes there is often a period in the middle of the semester, when they produce very little. I have learned that this period is crucial in their evolution as self-determined producers. It is here that they are shifting from being outer directed to inner directed. So I view this seemingly fallow period as a crucial part of their evolution."

Sheila Pinkel has integrated social and political concerns in her art, including ecological, labor, and immigration issues, for over forty years. She is one of the most well-known and committed political artists in Los Angeles.

In 1982 Sheila had the opportunity to offer free silkscreen classes at the Social and Political Art Resources Center in Venice, California, where she was able to combine the teaching of technique with political content for the first time. She had visiting artists and art historians come to her classes and share their perspectives on socially engaged art, and felt that this project was a way to "jumpstart socially engaged art production."

Fig 5.3. Photo by Leticia Grosz from CROSSING OVER: Borders and Barriers, *a book produced by the students of Sheila Pinkel at Pomona College.*

Sheila has been teaching at Pomona College for several decades where she has enjoyed what liberal arts students bring into her classes. She says, "often the subject matter in the classes results in my pursuing those issues in my own artwork. For instance, several years ago I taught a class in which we researched immigrant labor in Los Angeles and Tijuana. As a result of this class I began my own research on this subject that led to a comparison of conditions for garment workers in Los Angeles and Bangkok. Had I not taught a class on this subject, I don't know that I would have pursued this subject in my own art."

Pinkel teaches a class called Photo as Document, which invites students to explore social and/or political subject matter. Students are expected to go into the local community and research, photograph, and interview people on a subject about which they are curious. "Some classes do not jell," Pinkel says, and so each person ends up pursuing his or her own project for the semester. However, when the class can work together, we generate a final group project that manifests itself into a class book at the end of the semester that we publish and distribute to the class. I teach them that the sum is greater than the parts and the group book reveals more about the subject than do the parts. For instance, during the spring of 2007, the class worked on a project about immigrant realities. The 144-page book that the class generated, entitled

Crossing Over: Borders and Boundaries, was more dynamic and broader than were the images or interviews by individual students. Each book we produce also reflects a new approach to publishing.

"Often," Pinkel says, "the students reject what I, a middle-aged white woman, have to say during critiques, especially young men. So I have found that letting the students lead the critical discussions and my judiciously adding comments periodically broadens the discussion and is generative for them.

"Last spring I wanted the class to study immigrant issues. One student said she wanted to study the lives of immigrants who had succeeded in the United States. Her family was upper-middle-class from South Africa. She was an especially strong person and other students echoed her ideas. By the middle of the semester I had had the students read about immigrant issues in the United States, especially in California, and had planned a two-day class trip to the Mexico border so that students could experience firsthand the realities and dilemmas that confront immigrants coming to this country. By the end of the semester,

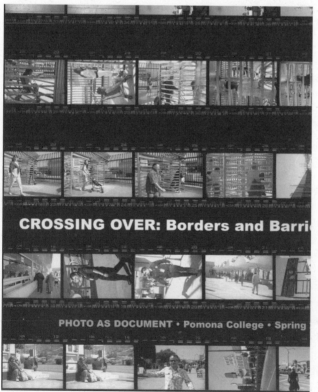

Fig 5.5. Toby Stopper's photo from CROSSING OVER: Borders and Barriers, *a book produced by the students of Sheila Pinkel at Pomona College.*

the student who had been only interested in middle-class immigrant stories was the most pro-active in assembling the class book on immigrant issues.

"In another situation, a student from Russia made the statement in class that black people are inferior and dangerous as reflected by the number of black people in American prisons. In this case I stopped the class and asked them to respond to this statement. Not one student countered this idea. So I spent the rest of the period talking about racism and the way it functions in the United States, as reflected in our penal system.

"Two years ago I cooperated with a philosophy and women's studies professor to teach a class about women and incarceration. Both classes went to a local prison for women to see an exhibition on incarceration and participate in group discussions with women prisoners about their lives and the problems they face. One class did research on prison issues and interviewed prisoners, women in halfway houses and people in the criminal-justice system. My class collected images on this subject and synthesized a book entitled *Uncuffed*, which included text and images from both classes. The spin-off from this class was a support group of students, faculty, and community activists who are continuing to work on getting parole for many women who have been overlooked by the justice system. Lawyers from the community are teaching students how to write arguments which can be submitted in behalf of parole for women prisoners."

Nancy Buchanan

Born 1946, Boston
Faculty member, California Institute of the Arts, School of Film/Video

> *"There is a negative attitude toward social critique at present; 'complicity' with the system is seen as being more honest. 'Political' art is judged as being too didactic (which, I admit, it sometimes can be). The overwhelming emphasis is on commerce and the re-commodification of art. Sometimes I feel as if Baudrillard was right. It's all seamless image, there is no escape. But that viewpoint is, of course, a luxury, as there are so many who have no choice but to struggle."*

In 1980 Nancy Buchanan began teaching her first classes that were experimental and involved going into the community or incorporating critique. Regarding her work as a socially engaged instructor, she says, "Teaching classes about which I feel passionately makes me feel more integrated; and according to feedback from my students, this brings out the best in all of us. I recently had a student tell me my class had been 'life-changing' for her."

Being involved in the antiwar movement of the 1960s and a member of SDS (Students for a Democratic Society) on the campus of UC Irvine (where all student-body officers were activists) inspired Nancy to become socially engaged. "We developed a guerrilla theater group in which I took part (one of our members left school to join and eventually head the San Francisco Mime Troupe). We would perform before hearing electrifying speakers; we also occupied the suite of . . . English Department offices, built a garbage monument, and had free, two-day screenings of Peter Watkins's *The War Game*. The most meaningful classes I took incorporated a philosophical perspective on the world."

Also inspirational for Nancy were Robert Irwin's seminars: "Robert Irwin led me to see the entire *context* for the work of art—which, for me, ultimately came to include not just the room in which the work was experienced, but its place in history and social relations."

Nancy says about her teaching, "I have been able to create several courses over the years: Art & Politics or Special Topics are headings that allow me to then focus content for a course. I don't always have the opportunity to offer specialized courses; but I always incorporate activist works into my classes. For example, I teach History of Video Art, and in video's earliest days, work by activists was as important as work within art galleries—and is almost always included in written historical accounts." A favorite assignment for Nancy is inviting students to find and present examples of artworks they find inspiring.

Currently, Nancy co-teaches a class with artist Sam Durant in Special Topics. The first year of this course they began with *A Simple Case for Torture*, Martha Rosler's 1983 videotape. During the class titled A Not-So-Simple Case for Torture, the class examined the Bush administration's policies and brainstormed how to make artwork addressing this topic. Durant and Buchanan invited Rosler to discuss her work and activism with the students. The class produced an exhibit and a DVD of video works, as well as a book, published by One Star Press.

"CalArts is extremely supportive of faculty initiatives," Buchanan says, "and the School of Critical Studies recently adopted an MA degree program in Aesthetics and Politics. Erik Ehn, dean of the School of Theater, has forged a relationship with organizations in Rwanda, which includes yearly summer trips for students and faculty. He also created the Arts in One World conference, co-presented with the Interdisciplinary Genocide Study Center, Kigali, Rwanda. . . . I believe the development of critical thinking and active citizenship is very much a part of our philosophy."

David Haley

Born: 1952, London
Researcher/teacher, Manchester Metropolitan University, UK

"I prefer to think of my classes as 'post-disciplinary' (Newton/Helen Mayer Harrison). That is, my students represent many disciplines and they engage with many other disciplines to address an 'ennobling problem' or question."

David Haley has been a practicing and award-winning eco-artist in England for many years. His art focuses on whole-systems ecology and critical-futures thinking, to question the narratives of global warming, the global economy, and the ongoing "sixth extinction" of species, demanding that new opportunities and meanings for the other side of collapse be found.

He says of himself, "Unofficially, I taught Life Drawing and Design for Community Groups at Battersea [Community] Arts Centre while organizing 'squats' (illegal dwelling of vacant houses) from 1974. I then gave social therapy to the final year BA Painting students in 1997. I took over the MA Art As Environment course at Manchester Metropolitan University in 2003."

David was inspired to teach in the way that he does by "a person's sense of justice, my father introducing me to Ecclesiastes, and many years practicing on the edge." "My life and art have had many interruptions," he says. "My teaching is constant."

Socially engaged curriculum and teaching has taken David around the world: the graduate-level Art As Environment program at Manchester Metropolitan University, where he shaped a course called Drawing on Life (it takes life drawing and ecological art into the realms of socially engaged practice), an Art and Ecology short course for Public Art and Urban Design PhD students at the University of Barcelona, and a postgraduate master class, titled Designing for Our Futures, for Guangzou Academy of Fine Art, China, and the National Kaohsiung Normal University, Taiwan.

One of David's favorite assignments, begun in 2007, he calls "The Great Wall of China and Pennine Lancashire." "Starting with the UK Government's housing and economic development program for the North of England and a short story by Franz Kafka," he says, "MA Art As Environment students, in collaboration with Elevate Housing Market Renewal and architecture students from the University of Sheffield are coming to terms with spatial planning and climate change through social and environmental arts practices. Incredulity subsided as the marketing spiel of each small town chimed with Kafka's discourse."

Another of his favorites is "A Walk On The Wild Side," begun in 2005. "So far," David says, "performing ten urban field-study walks in Manchester has touched over 200 diverse people directly and the initial three films have been seen by 90,000+ people in Manchester, Taipei, Beijing, Xiamen and Guangzou. The project generates many questions about our ability to observe and reflect on where and how we live with each other and other species, and about the role of spatial planning in response to climate change. Local government authorities, environmental organizations, museums, universities, schools and the BBC can't ignore it, as pupils and students of different disciplines participate in their own futures."

About the process of learning and making art David says, "My practice and my teaching starts with making questions. Question-based learning, unlike problem-based learning, opens students' minds to diverse possibilities. Placing the onus on them to devise the most appropriate tactics to apply their arts means that nothing is predetermined. The form, process, and structure of their practice evolve to meet particular situations—everything is up for critical analysis and then action. Initially students need to be provoked into thinking away from societal norms, so introducing them to Kaprow, Beuys, and the Harrisons can create resistance followed by a paradigm shift. It would be irresponsible not to manage the intellectual, emotional, spiritual, and artistic fallout as their worlds turn the right way up. Including students from different cultures and with different disabilities has meant that I need to structure the following discourse carefully—improvisation still plays a big part."

David says that his most successful moment with students is "the moment when, for most students, the penny drops, the light goes on, the lightning strikes, the Zen moment occurs, the angel appears, the paradigm shifts and they realize that being creative is a whole-life thing. That is when, as my father said, 'to teach is a blessing.' David has had reactionary students, of whom, he says, "You cannot 'deal with' them—that simply creates conflict from polarized positions. I offer them more radicalism. I offer them their peers. And then I offer them support and sometimes a handkerchief."

David says that what keeps artists from choosing the path of social engagement is fear. "Fear of rejection by peers. Fear of losing a job, a commission, or funding. Fear of stepping out of the norm. Fear of the unknown. Ignorance. Reluctance to be committed to long, hard, and often unrewarded work. You have to be very brave or very stupid to do this stuff—or both!

Richard Kamler

Born: 1935, San Francisco
Associate professor, University of San Francisco
Director, Artist as Citizen, a community-based arts outreach program

> *"I feel completely moral by talking about art in the bigger*
> *picture, without talking about activist or socially engaged [art].*
> *Our history is such that we need to be at the table right now."*

Richard Kamler became involved in the transformative power of teaching art while working with prisoners at San Quentin. Seeing work come out of these men with no apparent benefits other than expressing their deep impulses had a profound effect on him. From that experience Kamler's artwork developed a stronger activist component; his *Maximum Insecurity Series* looked at the prison system.

Kamler brings questions into his classroom. How do we look at war? How do we look at the election? How do we look at San Francisco? He asks students what issues they are angry about and what issues they are passionate about, and then adapts his teaching based on where they want to go. Kamler sees contentious issues as an opportunity to insert art into the mix. He told me a story about a student who was very interested in anorexia. She went to a variety of support groups, doing research, and eventually created a fashion show in which all the clothing was made out of razor blades.

In the mid nineties, after the University of San Francisco invited him to start a program with a social-justice mission, he collaborated with others to initiate a program called "Artist as Citizen." This collaborative, community-based program is based conceptually on a model of the former president of the Czech Republic, Vaclav Havel, in which artists are invited to come to the table, with other members of the community, to engage with issues of common concern. Havel was convinced that without the artist at the table the state would be dark, lacking in humanity, lacking passion and imagination, without grace.

"What is the social responsibility of the artist?" Kamler poses the question to his students at both the beginning of the semester and at the end. The students collaborate with a community group of their choice, and present a work publicly at the end of the semester. It can take many forms: an exhibition, a performance, a video, an action, or event.

Kamler tells the story of a young lesbian art student. "She wanted to construct a closet. She found a teen center for GLBT (gay, lesbian, bisexual, and transgender/transsexual) youth, named LYRIC, and there she built the

closet, and then took the piece further, by recontextualizing the piece to include Community Conversations, gatherings of people talking about the meaning of the object."

Kamler tells another story about a student at the San Francisco Art Institute (SFAI) who wanted to look at the economics of education. "He found everyone stonewalling him and he could not get the information. Finally he got the information in bits and pieces. He made a series of large posters, indicating where SFAI was spending its money and where it was going, and how the students were benefiting or not benefiting. No one at the school had known about this or ever done it before. It reverberated all the way up to the board [of trustees], which then made an enormous effort to be transparent about their economics, and it was because of this student's piece. He had gotten the whole community talking about this issue. The student had inserted art into the conversation and created a way to talk about a possible solution. An act of a 'citizen artist.'"

Kamler continues to educate wider audiences through his weekly San Francisco radio program *ArtTalk*, broadcast weekly on the University of San Francisco's KUSF FM. *ArtTalk* is a series of conversations, provocations, and interviews with cutting-edge artists, writers, performers, and educators who are working to expand and embed the role of art and who consider art a catalyst for social change.[4]

Sharon Siskin

Born: 1955, Elkins Park, Pennsylvania
Core faculty and adjunct professor, John F. Kennedy University
(JFKU) and art instructor, Berkeley City College

> *"Honestly, I believe that it was the AIDS pandemic that changed everything for me. My personal clarity about what I needed to do seemed a natural response to AIDS in the San Francisco Bay Area. With support from various government and private agencies I was able to afford to merge my activism around issues of HIV/AIDS with my art in a more public and more direct way. The seed for me was seeing the Names Project Quilt at the Moscone Center."*

Sharon Siskin was Richard Kamler's passionate co-conspirator in the classroom at the University of San Francisco (USF) for the past five years. Siskin has been very active as a socially engaged community artist in San Francisco for several decades. The enthusiasm she feels for her work is palpable.

Siskin works in her studio making objects that address personal, social,

Fig. 5.6. (In)Visible was a project where Sharon Siskin's students committed to speaking with at least one homeless person face-to-face. 2001-2002 "They asked a series of questions that we agreed upon, about their personal lives as they related to living without shelter and how they got through the day and also their political views of homelessness and other important world issues. Their responses were installed on the windows (for 10 months) in USF's Gleeson LIbrary in transparent vinyl text along with transparent B&W images of the migrant belongings of each of these people, in an attempt to make these lives that are invisible to most USF students more visible and real." Photo by Sharon Siskin.

and environmental issues with a poetic sensibility, trying mostly to avoid the didactic. At the same time, she works in collaboration with communities to make their stories visual in community-based public art, and to give community members the skills to make their own images, to represent themselves, and to put these images in the public sphere and engage the media.

Siskin formally began her career in academia in the fall of 1991, when she was invited to propose curricula for the Department of Arts and Consciousness, a graduate MA/MFA program at John F. Kennedy University (JFKU). She proposed three courses: Beyond the Studio: Community Collaborations; AIDS, Art; and Community and Artists' Resources. Informally, she was doing similar work through community colleges with older adults in long-term care facilities, people living with AIDS at community support organizations, and prison inmates.

"I feel that the goal is for me to have the teaching practice relate to my

own studio practice and my own social practice," Siskin says. "Often that is the case, but just as often the paperwork and ropes that you need to climb over in academia can frustrate my direct and sometimes prolific output and response to issues that are important to me or ideas I feel a passionate need to address."

Siskin has taught and co-created Artist as Citizen—Part A (Cultural Diversity), Artist as Citizen—Part B (Service Learning) as part of a one year program at USF; Beyond the Studio: Community Collaborations at JFKU (in the MA/MFA program) and Sew What?—a studio class using the act of sewing (only reused and recycled materials) as a metaphor for repair. She has been developing a class called the 5 Rs: Reduce, Reuse, Recycle, Rot and Repair, for both studio and community credit.

Some of Sharon's favorite activist art assignments, she says, include "deconstructing readings in our journals, making a 'visual response' to issues raised, and sharing these responses with the whole class in a check-in at the beginning of every class meeting. Writing a full project proposal and detailed budget before beginning the projects. Writing a full project proposal and detailed budget at the end of the semester with visual documentation (plus an exhibition) and an oral presentation of the projects. We encourage collaboration and model that in our teaching style. We also collaboratively arrive on a large group (whole class) project, like an upcoming election, or censorship of a student artwork, in our first semester. We create at least two Community Partner Roundtables consisting of 4-6 community-based organizations that are interested in working with artists/students. They each present their organization and then students choose one to work with for at least three hours each week for both semesters. Students write project proposals based on this research and embedding themselves in that community."

"The community is always welcoming and appreciative," Siskin says, "unless a student is irresponsible and doesn't follow through with their commitments. In that case, which is rare, I need to work with the organization to make things better for future partnerships. So these courses entail a lot more of my time than studio-based classes. The most successful moments are when students are welcomed in the communities that they worked with in class projects and the students and organizations decide to continue to work together, sometimes receiving financial rewards for their work."

Fred Lonidier

Born: 1942, Lakeview, Oregon
Teacher, University of California, San Diego

> *"If the road we have will not, cannot, get us where we*
> *want to go, we have to be open to other roads, no?"*

Fred Lonidier is a stalwart within the activist art community, hopeful to find new peers dedicated to ideas, long after others would have lost patience and gone home. For many years he has shown his commitment to the labor movement, using his photographic skills to document and teach both art and labor audiences about solidarity with American workers and militancy in class struggle. Most recently his projects have focused on exposing the world of labor rights and organizing in the maquiladoras in northern Baja California. He is primarily an installation artist who uses documentary photography, text, and video.

Deeply influenced by his student activism at San Francisco State in the sixties, he has taught art for decades at UC San Diego. Attending grad school he was part of the dynamic mix at UCSD in the early seventies that included Martha Rosler, Allan Sekula, and many other well-known artists and social theorists.

Fig 5.7. Fred Lonidier's poster for the Art & Politics class, Winter 2007 "
for the first time the students organized an exhibition in the Mandeville
Center Annex Gallery to show their work for the quarter."

Lonidier has inserted social content into his photo classes whenever possible. His biggest challenge has been the limited perspectives of students when looking at "social fields of power" and "the fairly anti-intellectual culture" that they share. However, every three years or so he has taught Art & Politics, an elective class where students are there because they want to be.

"Though I always let students know my socially engaged stands, largely by way of showing them mine and others' work, I respect their own interests," he says. "Pushing anything at art students tends to be counterproductive. Very few college students are or have been union members or are at all close to anyone who is or was; the subject matter does not connect that well for them even though UC is as union as General Motors. In our large, intro photo course, very few students are looking at art as a means of social critique and more than a few are threatened by the whole idea."

Ruth Wallen

Born: 1953, Berkeley, California
Lecturer, University of California, San Diego, and associate faculty, Goddard College (MFA in Interdisciplinary Arts program)

> "It took me some time to unlearn my evaluative habits, and it takes each student some time to learn to trust the process, so to speak, but when this occurs the exchange is profoundly meaningful. I don't want to fool myself that I . . . don't have some authority, or offer evaluative comments, but unlike a typical exam or assignment, these comments are not based on my terms of what a student should know or achieve, but a meeting of students' desires and interests, my background/expertise, and programmatic guidelines. The learning, the discovery is mutual . . . so much of what Freire, hooks, and others put into practice."

Ruth Wallen has brought her interests in science, environmental studies, cross-cultural communication, and peace work into a true interdisciplinary marriage with art. She was an artist-in-residence at the Exploratorium in San Francisco, has taught photography at community colleges and UCSD, and is a devoted member of the faculty in the MFA in Interdisciplinary Arts program at Goddard College. After teaching as a Fulbright scholar at the Autonomous University in Tijuana, Mexico, she became very active promoting cultural exchanges across the border, inviting students to participate in binational conferences.

One of Wallen's standard assignments in beginning photography classes involves self-portraiture. She first shows students a variety of strategies, from Laura Aguilar's work with her own body (and friends, clothed and nude) and Jo

Fig 5.8. A group project by Ruth Wallen's students at Southwestern Community College—includes self or family portraits about identity mounted in an installation for Dia de los Muertos. Photo taken by Ruth Wallen.

Spence and Rosy Martin's photo-therapy work, to the work of Richard Lou, who did a wonderful series entitled *Inner City Self-Portraits* and various other work about identity politics. She wants her students to analyze their self-representation in a deeply personal, psychological way, or to use their representation to make social/political commentary.

Wallen says that some of the work that comes out of this project is quite powerful. In terms of personal work, she recalls having a man who looked very strong and healthy (he self-identified as a jock) share what it was like to inject insulin daily for diabetes, and she remembers that another man documented his mother's life with Hepatitis B. One woman's work about her struggle with bulimia generated an important discussion in which many students expressed their identification with her work. Much of students' work explores identity politics, particularly ways that Asian and Mexican students feel stereotyped and students who are recent immigrants feel torn between two cultures.

One of Wallen's adult students at a community college talked with her about his living with AIDS. This was before the power of drug cocktails was

widely known, and his longevity with the disease, ten years, was most unusual. His presentation of his work allowed for open discussion of life with AIDS, something that the rest of the students in the class said that they had never experienced.

Wallen encountered a male student who was extremely hostile to the discussions the class was having about cultural identity and gender roles. In the second class he shared artwork and comments that were hostile towards women. The women were irritated and the whole class became increasingly polarized. Finally Wallen had several talks with the student, both privately and in class, and he revealed that he was irritated by all of the stories about discrimination and abuse shared by students of color and women. As a white male, he wanted to tell his story. Wallen encouraged him to do so and he did a photo installation piece about being sexually abused as a child. That was his final project for the quarter, but the whole atmosphere changed with that piece. He needed permission to share his pain and have it acknowledged by his peers. His work became rather political, particularly focused on environmental issues.

Wallen says that she began working at Goddard deeply skeptical about the individualistic focus there, in a culture that already overvalues individualism and where much activist work involves some kind of collective or participatory orientation. However her most meaningful teaching experiences over the last eight years have occurred at Goddard.

Ruthann Godollei

Born: 1959, South Bend, Indiana
Professor of art, Macalester College

> *"I don't want my students to do what I do. I certainly don't want people who don't care passionately about a cause to be making lame art about it. I don't want students to make political statements for fashionable reasons or to get a grade from me. What I do want is for people to make art about things they know and think and feel deeply about. So students need to know more. When they are moved to make a political statement, they need to know the precedents and appropriate media and risks involved. And it should be damn good, effective, moving, and powerful. That's my job, to convey those things, not to make clones of me."*

Some really bad teachers, nuns who hurt children physically and mentally, inspired Ruthann Godollei to hate injustice. She gravitated toward stories of fight and struggle against unjust power. "Once I became a teacher," she says, "I thought those heroic stories should be told and that art told them very compellingly." As an artist her prints tell stories about domestic violence

Fig 5.9–5.10. Ruthann Godollei and Macalester College art students print patches for the Student Strike For Peace, Nov. 16, 2007, St. Paul, MN. The Printmaking II class collectively agreed to participate in the Strike by hand-printing cloth antiwar patches and giving them away in front of the campus center. Left to right, Kit Osborn, Gretchen Keiling, Andrew Meeker, Carey Bergsma, Ruthann Godollei, with detail of hand-printed patches. Photos by Jenny Grinblo.

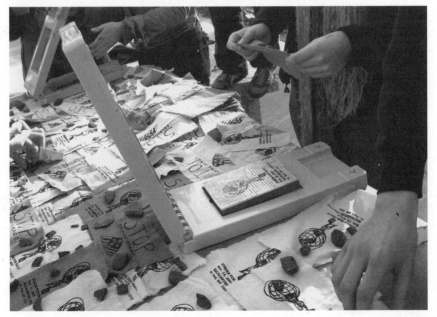

and homelessness, and she has made antiwar work related to the successive wars of the last decades.

Godollei consciously picks examples of activist art to show students. When she's talking about technique, she often selects a socially conscious artist. "A relief print by Elizabeth Catlett, for example, is a fine display of expert carving and printing, but we discuss the content along with how the medium and style promote her message," she says. "If we're discussing abstract art I can tell how McCarthy sent a letter to Mr. Barr at MoMA and basically scared him out of showing depictive modern art.

Godollei thinks that smart artists can be very good artists, so she deeply appreciates the intelligence of the students she has at Macalester. It runs counter to that image of the ham-headed brush-wielding brute so romanticized by part of the culture. "My students have something to say, even if as liberal arts students they may need their hands-on skills developed. Many have traveled and aren't the xenophobes so many Americans sadly are. The students from other countries have exposure to culture from a much earlier age and seem to appreciate art and artists from the outset. They aren't shocked by socially engaged art, in fact they tend to wonder why so little of it is seen in America. It makes for great discussions." Often her students are not aware of their own privilege, and often exempt themselves from social critique. They think they know everything and Godollei believes that their access to technology has fed this mistaken impression in unhealthy ways. She addresses these issues in her classes.

In 2D design, Godollei's students create graphics for a real-world nonprofit of their choice. "Students got to pick places and projects they wanted to help, everything from Veterans for Peace brochures to a Web page for pro-choice Christians. I wasn't telling them what to support, so it kept me politically clean, not indoctrinating them, while these very worthwhile projects got hip, updated, useful graphics for free. And students got to deal with real clients and see what being a designer for people really entails."

When asked about why more artists do not choose the path of socially engaged teaching, Godollei responded: "There is an understandable worry about personal risk. People can't afford to lose their jobs. They need to eat. They worry about reprisal from higher-ups who don't agree with them. And there is a lot of social pressure that it's not hip to have a strong opinion. Look at the backlash against musicians of considerable fame who early on decried the war or the president's policies. Burning their records? That's an object lesson to the timid. Today it's fashionable to think the war should stop, so it's not a risk to say that in an art piece now."

Greg Sholette

Born: 1956, Philadelphia
Assistant professor, Art Department, Queens College, New York

> *"My two basic rules for classroom discussion [are] respect for everyone*
> *who speaks, regardless of their politics or age or whatever, and [that]*
> *every participant must render their argument logically, without*
> *recourse to dogma or presumptions."*

Greg Sholette has been a devoted and skilled collaborator, as can be seen by his work with Political Art Documentation/Distribution[5], RepoHistory,[6] and other curatorial, public art, and writing projects too numerous to name.

In his course Contemporary Activist Art and the Public Sphere, Sholette asks these questions of his students: How do we define the public sphere, and in an increasingly privatized society is it in danger of disappearing? Why are so many younger artists today choosing to work together in groups and collectives? Is culture jamming and creative civil disobedience the new avant-garde art practice? What is the connection between art and gentrification or art and globalization? What might be the future of activist public art after 9/11 and the so-called clash of cultures?

Sholette talks about the challenge of assembling resources about politically engaged art theory and practice for classroom use. "Like many other instructors I have accumulated boxes of slides, folders of documents, stacks of books, and photocopied texts that collectively constitute not only my teaching library, but also a de facto historical archive in its own right. Today this difficulty has greatly diminished. First, a number of useful books have been recently published on this topic and more are in the works, and, second, there is today the Internet. Granted, no one Web site exists that brings all these materials together; however, numerous sites now contain images and texts that can be freely downloaded for digital slide presentations (Power Point). If anything, the problem is organizing the wealth of online information available." Sholette is currently creating an online archive of such material.[7]

About the power of keeping an open dialogue in the classroom, Sholette says "I find that an openly reactionary or conservative student who will engage critically and logically with issues is a boon to the discussion, far more so than a student who keeps her or his resentment about a topic to themselves, or expresses disenchantment to other students rather than in public debate. Once while teaching at NYU I asked students gathered for the first class . . . to tell me about their reasons for taking my course. The course was entitled

Interventionist Art and the Public Sphere. One young women with a distinct southern U.S. accent stood up and said she had signed up to discover "what the enemy was up to," meaning me! As things evolved over the course of the semester she turned out to be one of the most engaging students in the class, she even asked me later to write her a recommendation. The situation was less satisfying with someone else in the class who turned out to be unhappy with my understated yet clear leftist approach to art, and yet was unwilling to openly discuss this fact. Creating a space in which everyone feels comfortable expressing his or her position is of the utmost importance.

Jerri Allyn

Born: 1952, New Jersey
Director of Artists, Community and Teaching Program (ACT),
Fine Arts Department, Otis College of Art and Design

> "It's funny, I walk a fine line. . . . How do you introduce socially concerned stuff, because nothing is neutral. . . . I am dead set against demanding that students do work like I do. I felt that Abstract Expressionism was kind of forced on me, and I want to find out what is really your passion, your investigation. . . . The art world is an experimental lab and with the new data students gather, I also ask them how does it relate to the world? How are you going to make a contribution, give to your community? Everyone wants to make a contribution. In many instances their work has social implications."

Originally Jerri Allyn thought she would become a social justice lawyer, but art called her instead. Allyn does site-oriented, interactive performance events that become part of public life, and builds connections with communities and the art world. She is a founding member of The Waitresses and The Sisters of Survival.[8]

Allyn was deeply influenced by the feminist art movement, studying at the Woman's Building in Los Angeles. The pedagogical approach there emphasized the idea of "building anew" rather than "protesting against." She trained in "feminist art teaching" techniques that promoted "new ways to look at art," the belief that women's personal experiences matter, and that different art materials and media are valid. At the Woman's Building students also examined new ways of understanding power dynamics and engagement, from a Freirian perspective. They critiqued the banking system of education (where students open their heads and teachers pour in the "facts," as the written word, Allyn notes, "was supposed to be 'the truth'"). They looked at their stories (neither right nor wrong, but powerful).

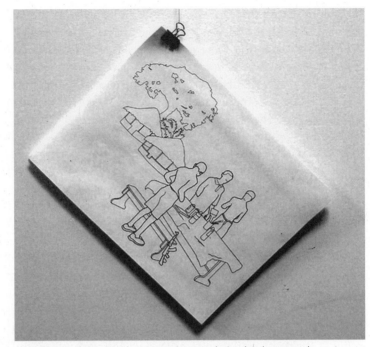

Fig 5.11–5.12. Jerri Allyn's student work: Occupation, a coloring book proposal for children in a country occupied by a colonial empire, by Janice Yu. 2006.

Allyn taught her performance classes, held on a bus and at other public sites, and asked her students two questions: What do you want to say? Who do you want to say it to? She wanted her students to see that art history is contextualized within economic, social, and political moments. Decades later, it is still very clear to Allyn that as a teacher she needs to be a guide.

Allyn has built programs around the country, including the Artists, Community, and Teaching (ACT) program at Otis College of Art and Design. This cutting-edge program is based on the last fifty years of developments within the community-based art and fine arts scene, and reflects the ways that professional artists are working in new ways in community. It's very informed by the feminist adage about "art which raises issues, invites dialogue and transforms culture" and has similarities with progressive programs around the country, like the one at the Maryland Institute College of Art where the Western Art History survey classes have been replaced with Visual Culture courses.

In ACT, students need two "teaching for learning" courses, which incorporate three fields of knowledge—education, child psychology, and social psychology. They look at theories of how identity is formed, and examine work that professional artists are doing in public schools. Students are introduced to artists who work in museums with community-based models. Another unit is focused on how artists collaborate with community. One of Allyn's students developed a conceptual art project about community gardens that included an artist's book of instructions on growing one's own food. She created a bartering market, where community members could trade services and food. This marked the student's transition, accompanied by a well-reasoned argument, from a career in the arts that she perceived as too self-serving, to a career in social justice. One possible future she envisions is that of curriculum designer in developing countries. This student will continue to draw on the arts and indigenous spiritual beliefs as an empowering strategy for self-expression, implementing innovative, student-centered education strategies for personal liberation, however that may be defined within given communities.

A discouraging moment Allyn notes took place during a discussion in a class about whether war was "natural." The students' consensus was that humans will always be killing each other off. Allyn was despairing for a while but remembered what she had learned from a conflict-resolution project, and realized that she couldn't live with such resignation. With much reflection she was able to see that we do have choice, even if we are prone to kill each other off for survival. "If we really hear each other's stories, we have hope to change this pattern."

Karen Atkinson

Born: 1956, San Diego
Faculty, California Institute of the Arts (CalArts) and Owner, GYST Ink

> *"I always thought of teaching as a part of my (art) practice. I learned a long time ago, that it is all connected, and if you try to separate everything you do, there is a lot of wasted energy. One thing about teaching is [that] I give a lot of ideas away. I could be doing some of them myself, but I find that sharing ideas is a way of collaborative thinking, even if it means that the student makes the work as theirs."*

Karen Atkinson has combined running a successful nonprofit community arts organization (Side Street Projects), a public art practice, and a teaching career for two decades. All three of these activities merge at times, causing some people with more traditional notions about the artist's career to raise their eyebrows. "I am lucky to work at a place that allows me to pretty much do what I want," she says. "It does not mean that everyone understands it."

Atkinson helped to start the Community Arts Partnership Program at CalArts and it now has thirty community partners in Los Angeles. CalArts students get paid to teach at community centers training junior and high school students in the arts; this includes creating public art projects and temporary and permanent installations of public art.

In the classroom, Atkinson has had freedom to teach in innovative ways. She says that she has been designing classes that provide knowledge not taught in most art programs across the country. "CalArts is the only school that has allowed me to pretty much teach what is relevant at the time. . . . You can only get excited about formal issues for so long, and many of my students were really smart, and were also interested in [social] issues. Those who were not, soon caught on, as the discussions were way more interesting. The rebellion by some just added to the conversations. Everyone is allowed his or her own point of view, and this is what makes it interesting."

Creating the curriculum for a class titled Getting Your Sh*t Together has gotten Atkinson and the class much attention. It is a professional practices class for graduating MFA and BFA students, "a thirteen-week course of everything you need to know as an artist to thrive in the art world today. . . . Contrary to most of these types of classes and workshops now being held, the information is not just for those interested in the gallery or museum world, but a lot of practical advice for those artists working outside the market, doing public and social projects." Atkinson has created software for individuals and teachers

who wish to use similar material in their classes.⁹ She also teaches a class called Context Revolt, about installation, public art, and online art, an introduction to artists working outside commercial and museum contexts.

Some of Atkinson's favorite assignments include designing temporary public art projects, doing a curatorial project based on only those images in the CalArts slide library, and creating artworks that are totally outside of what students are used to doing. "I like to challenge students to consider when and where an artwork takes place and how to evaluate a project. If you can't evaluate if a project is successful, then how do you know if you're making work that does what you want it to do? This is new to many artists, but really helps them in creating the work and not relying on the audience to complete the work for them. We spend most class time in discussions and planning, but the work is always created outside of class. They have free reign as far as the form it takes, as long as it is not dangerous or detrimental to others. Working in class means you have less time to make the work, and limited resources. We use class time to present work and discuss it. This means sometimes we are traipsing all over campus, or the work is presented in a documentary form if the project takes place off campus."

"I used to show a lot more in galleries and museums (which fits [students'] idea of an art practice), but I am just not very interested in that anymore. I find so much of the art world and work really boring. A lot of people do, but it still runs things. And if you have a career in this realm, you get rewarded. I find it interesting that a school that had a reputation as being progressive still clings to these notions. Fame is still a big recruiting tool, as they list all the famous artists who have graduated from there. It is going to be this way for a long time. Probably forever. So you do what you are interested in, and don't get merit raises or rewards. But you really kick butt in the work you do, even if you don't get recognition."

Keith Hennessy

Born: 1959, Sudbury, Ontario
Adjunct faculty, University of San Francisco; University
of California, Davis; New College of California

"My activist intentions and practice developed simultaneously with my dance/ performance practice. I have always been drawn to recognizing and confronting inequity, injustice, and cruelty. Maybe it was the Jesuit/Catholic training. Maybe it was being the fifth of six kids and getting lots of practice watching how power and hierarchy get played out, especially when money is involved."

Hennessy is a dynamic performance artist, combining dance, theatrics, and acrobatics with social content. In the mid eighties he started offering low-cost performance (including street performance) workshops in Dolores Park, San Francisco. He has also worked with the pioneering Arts & Social Change program started by Mat Schwarzman and others at the New College of California.

In 2007, Hennessy taught a class titled Performance Activism at the University of San Francisco. Currently he is a PhD candidate at UC Davis where he teaches choreography as aesthetic experimentation and a potential activist language.

Hennessy teaches a variety of practice, theory, and hybrid (practice/theory/research) courses with explicit and implicit socially engaged content. He feels that at most liberal art schools there is an immediate acceptance and even expectation that the art making will be connected to political ideas, to addressing personal or social ills, to change. He continues to find ways to teach a dance class or a dance history class, linking art histories to social movements. This includes an analysis of the actual class or institution and social relations/performances occurring in the moment.

Hennessy has found few students anywhere, regardless of class, race, or citizenship status, who have any articulate understanding of contemporary political or cultural histories, issues, and ideas. He also observes, "The resistance of youth who have embodied American exceptionalism and privilege to such a grotesque extent are unwilling to recognize the cruelty and injustice that supports their way of life." When he is tired he prefers to work with grad students who he feels are more aware of what they want to learn and generally more functional in terms of self-motivation, reading and writing, research, and production. He also really likes teaching in non-institutional settings: in grassroots situations, artist-directed projects and spaces, and local and international festivals.

While teaching, Hennessey like to work with the tensions of risk and fear: "I think getting students to physically trust each other, to touch each other, to catch each other when falling, is one of my most frequent activities. I do variations of Simone Forti's newspaper dance . . . looking through the news for words about movement or the body and building dances/actions in response to the way that an issue gets talked about, rather than what it is. I ask them what's up. Through fear/risk I can open the door to a wide range of topics including body issues, sex/gender, immigration, borders, terror and terrorism, the role of the media. . . . I like to get messy with themes and issues, experience their interrelation and interdependence, provoke a lot of different questions . . . then I encourage students to feel which issues touch them personally."

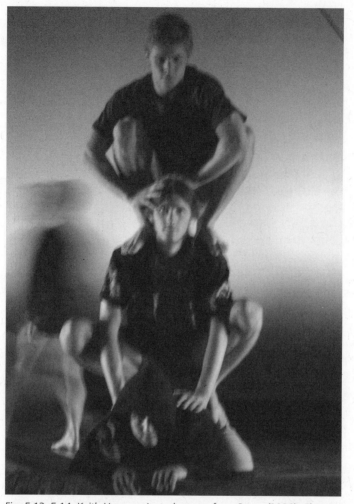

Fig. 5.13–5.14. Keith Hennessy's students perform Sense (2006). Choreography by Keith Hennessy. UC Davis Mainstage Dance/Theatre Festival, April 2006. Performers: Eric Koblenz, Matt Roberts, Lucas MacDonald, Brennan Figari, Bryan Bachar, Thom Sterling.

Six men, aged 20-40, undergrad and grad students, an ex-student, a wrestler, a therapist, a rock climber, an actor, and an aerialist responded to a call for performers that included, "Neither constantly afraid of pain nor unwise to danger" and "Must work well with others and be willing to try unusual things." Sense alternated between spectacular display and quiet ritual, challenging stale ideas about men dancing and men feeling. Photos by Keith Hennessy.

Hennessy feels that most artists who resist doing socially engaged work have a lack of understanding of how their work is already complicit with political stances of one kind or another. "They've experienced too much poorly designed/manifested socially engaged art that they couldn't appreciate. They find it easier to teach the things they care about through more formal questions, techniques and process."

"Aesthetics play a significant role in discussing the work with the students. Because I tend to foreground my activist intentions, I make sure to emphasize aesthetic questions, techniques, histories, process. I am a big critic of shallow political art, art that is more ideological than inspiring or questioning, art that is New Age or Pollyannaish in its approach to either unity or suffering, let's-all-get-along group mind. I think that aesthetics, especially via experimentation, are often ignored in activist art contexts and this limits the audience/participation for some very well intentioned art."

Ann T. Rosenthal

Born: 1950, Los Angeles
Lecturer, Art Institute of Pittsburgh

> "Students in general are not taught to be engaged citizens. Students are not taught to see how the subjects they are learning interconnect and relate to their values. In our post-9/11 world, young people have been thoroughly indoctrinated into being consumers rather than participants in a living democracy. This hyper-consumerism has also infected the art world, which continues to promote art as object. Thus, the process of environmental and socially concerned art is often erased. Despite this, artists are making a living from community and public work."

Ann Rosenthal brings to her teaching twenty years experience as an environmental artist and activist. Her site- and gallery-based installations juxtapose traditional media and digital imaging to complicate the social and natural histories of place. Informed by diverse interdisciplinary discourses, including postcolonial and gender studies, environmental history, and social and deep ecology, she interrogates how our social constructions of "nature" have compromised human and non-human systems. Her work is situated within the field of eco-art, which encompasses critical interventions and interpretations of the nature-culture boundary.

Ann authored the Educator's Toolbox on greenmuseum.org. One of the first forums for eco-artists to share teaching resources, this project offers essays, synopses of courses, and links to student work and syllabi.

"At Mt. Holyoke College," she says, "I was teaching a drawing class at the same time as a series of environmental forums. I took my students to these forums and had them respond visually to what they were hearing. These responses developed into some strong work, but they resisted it. The resistance manifested as confusion—they didn't understand that there might be a connection between what was going on in the world and art. I'm always trying to be expansive about the interpretation of disciplines. I don't want to teach any subject in a vacuum, devoid of context. I'm passionate about ideas and how you can translate them visually. This is very challenging for many students to understand."

Ann introduces her eco-art courses with a talking circle. Students bring an object from nature that has some significance for them, and they tell the

Fig. 5.15. Ann Rosenthal, "Regeneration: A Course of Lake," Panel 5 of 5, 2005, digital photo collage. This 5-panel work was created through a beginning drawing course taught by Ann Rosenthal, visiting artist at Mt. Holyoke College in 2005. The piece was exhibited as part of "Water Works," a multimedia arts event responding to a campus-wide series addressing the theme of water. The work reinterprets Thomas Cole's "A Course of Empire," charting the evolution of a lake from Creation State to Vacation State, from Industrialization to Desolation, and finally to Regeneration. The student states, "I wanted to portray the role people play in the destruction of our planet's water, and our ability to correct the damage we have caused." Photo by Theodora Peterson.

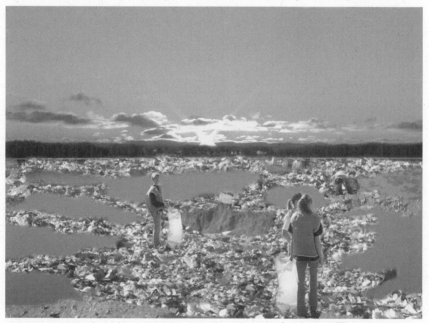

story that goes along with it. They also share an early memory of nature. Some students report being afraid or feeling threatened when they are in nature. These exercises build respect and trust between the students.

Using a research-based approach, Ann initiates class projects with students exploring a neighborhood or community through reading, searching the Net, and site visits. Impressions and images are developed into a conceptual and visual response to that place. Students usually work in teams to determine how their images might go together to communicate their concept. Many different formats and media are encouraged.

As an interdisciplinary visiting artist at Mt. Holyoke, Ann organized a multimedia extravaganza in a former textile mill, on the theme of water. The event included her drawing students' visual responses to the environmental forums, and her eco-art students' installations. Ann sought to be as inclusive as possible, inviting several classes within and outside the art department to join in. Video projections, performances, drawings, prints, and installations created an energized space and a memorable experience for several hundred students, faculty, administrators and the public—all on the theme of water.

Ann spoke critically about the hyper-managed lives of many of her students, with "helicopter" parents who check in on them several times a day. This produces risk-averse students. The creative process requires a tolerance of, and even a desire for, the unknown. Ann says that administrators need to explain this to students and their parents, to support teachers who push at students' comfort levels.

Mindy Nierenberg

Born: 1955, Brooklyn
Senior program manager, Jonathan M. Tisch College of
Citizenship and Public Service, Tufts University
Part-time faculty, School of the Museum of Fine Arts Boston

> *"It was when I arrived at MassArt to work in residence life with art students that the 'aha' moment came. I saw that the students living in the residence halls were neighbors to one of the largest public housing developments in the United States and there was no interaction. As a matter of fact, students were told during Orientation by public safety officers not to go 'up the hill' or 'out back' where the projects were; that it was unsafe. I believed differently and felt that there could be reciprocal relationships between the residents of the community and the art students, that each could 'open doors' for the other. That was the beginning for me."*

Mindy Nierenberg felt pulled between being a person who made a differ-
ence in the lives of others, who made an impact on social justice issues, who
worked in direct service with others—and being an artist. When she was
younger she felt she had to make a choice between the two. Luckily for her
students, she has merged her passions. Nierenberg has taught and co-created
many courses with socially engaged content, bringing students to work with
different communities (a homeless shelter, a hospital, public grade schools,
and Navajo living in Shiprock, New Mexico).

At Tufts Nierenberg has been teaching a course called Art, Activism,
and Community: Visual Art for Social Change. In this course she teaches
both students who are committed activists (knowledgeable about many
social issues, but knowing little about art and with no idea that artists can
be activists), and art students who are trained in process and aesthetics but
have limited knowledge about social issues. She organizes the course syllabus
by social issues, and compares and contrasts artists addressing social justice,
artists as activists and change makers.

Nierenberg developed a course on art and health care for medical students
at the Tufts University School of Medicine and art students at the School of
the Museum of Fine Arts. Ten medical students and ten art students were

Fig. 5.16. *Mindy Nierenberg's student at Massachusetts College of Art and Design
with Mr. William George, leader and elder of the Shiprock New Mexico Navajo
community, and Lavona George, artist, photo by Mindy Nierenberg, 2003.*

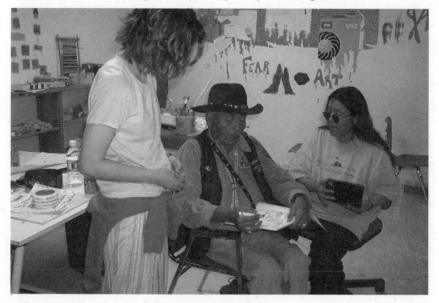

enrolled in this year-long course, working in pairs in a community-health clinic in Boston's Chinatown to create art installations. She has also organized the Institute for Art and Civic Engagement, a program of the School of the Museum of Fine Arts in partnership with the Tisch College of Citizenship and Public Service, the Tufts arts departments (dance, drama, and music), and the Museum of Fine Arts.

"For me, the work has always been about the transformational effects on students," Nierenberg says. "Having begun in higher education twenty-six years ago in the field of student development, with the last sixteen years focused on art and social change, I have seen profound changes in countless students over the years. Many students who majored in fine art or design discovered a different role for artists and became community art educators, Americorps and VISTA workers, and art faculty who themselves teach art for social change. I have also had Tufts liberal arts students who, once they have learned about art, activism, and community, pursue careers in the field."

"Tufts is an amazing place, and the Tisch College of Citizenship and Public Service where I work functions collaboratively across the institution to explore and develop every aspect of the interdisciplinary nature of active citizenship. I have been able to bring my knowledge, experience, and passion for art and social change into my work that has a broader, cross-disciplinary focus. I work with supportive and like-minded colleagues; we have reasonable funding and resources, appreciation for new ideas, and no doubts about the student-centeredness of our work.

Ju-Pong Lin

Born: 1961, Taipei, Taiwan
Associate faculty, Goddard College (MFA in Interdisciplinary Arts)

> *"As a community-engaged artist, my first priority is listening to people's stories and trying to understand who they are. I set aside my own agendas to remain open to the stories of people whose experiences may be very different than my own. Each kind of practice has its own value. Story offers a way to reveal and to embrace contradiction, the contradictions of a culture that lauds traditional family values yet restricts how we love one another; a culture that raises motherhood on a pedestal yet tolerates daily violence against women; a culture that simultaneously perpetuates a fascination with the 'other' while obsessed with securing its borders."*

Much of Ju-Pong Lin's interdisciplinary art looks at identity in relation to place. Her current project in Providence, Rhode Island—Neighbor to Neighbor—uses

oral history and community engagement to forge a collective answer to a question: Who has the power and privilege to make a neighborhood what it is? This project was partly inspired by encounters with racist real-estate laws.

Lin's ongoing and deep conversations about pedagogy with her colleagues at Evergreen State College had a lot to do with the way she teaches. "The co-learner relationships I build with my students/advisees challenge me to keep learning new ways of seeing and doing and hearing," she says. "I can't guide advisees to stretch and expand their practice without doing the same myself. I can't challenge them to examine their relationship with 'audience' and how they engage with audience or community without doing the same myself."

Lin has been an advisor at Goddard College for several years. "Goddard students are ones who have often experienced marginalization in some way or another and are therefore attracted to our unusual program. In other words, they come to us because they have struggled with traditional schools," she says. She enjoys working with "adults who have had a life and are now ready for transformation" but says that what makes it difficult about working with them is the very same thing. "Because they're adults, they seem to hold onto to their hard-learned lessons more tightly. They can be resistant in a different way than young people."

"I feel that students can sometimes feel lost when the options are too open-ended," Lin says. "While I don't want any student to feel hampered or imprisoned by disciplinary boundaries, I also feel it's important to recognize the value of a disciplined practice. It takes time to learn and understand any medium. I remember speaking to a prospective student once who spoke passionately about the need to respect the kind of dedication to a discipline it takes to develop a practice. He cautioned us not to confuse 'interdisciplinary' with lack of discipline or fear of discipline."

Lin writes that the greatest challenge she faces as an educator right now has to do with questions of "cultural appropriation," asking, "When does one have the right to use/claim/borrow cultural symbols or traditions from cultures that are not [one's] own? So often discussions around this question begin from polarized stances and never move to a place of real dialogue or deep understanding of the complexity of cultural exchange and interaction. I'm finding the old models are not working. I think we need to change the way we talk about 'cultural appropriation,' to replace the accusations of theft by teasing apart the knot of cultural identity, cultural property, lineage and history, racism and systems of exchange."

Lin feels most successful in small moments, "when you feel a seminar really taking off and people begin to ask questions in earnest, or in a workshop when I have felt a ground of trust has been built and an intense bonding

occurs through the sharing of stories. I remember when my class on international feminism worked collaboratively and pulled off an exhibition that challenged our understanding of gender; I watched community members stop in this public square, stunned by the transformation of the space. They walked through closets lined with stories, peeked into peepholes, played with gender-identified toys, and left the space changed."

John Jota Leaños

Born: 1969, Pomona, California
Assistant professor, California College of the Arts, San Francisco/Oakland

> *"As socially conscious artists, it benefits everyone if we deeply consider the potential meanings and access points of our work. We should open as many windows as possible for people to enter, participate, and understand the work from different perspectives. Within inner-city schools, alternative art spaces, [and] elite universities and museums, creative collaborations have the potential of not only crossing social and disciplinary boundaries, but of creating new possibilities and pedagogical insights to a larger audience beyond the circles of critics, curators, and collectors."*

While John was a student, he awakened to his Chicano identity and the civil rights movement and became socially engaged and conscious of his political being. Through this experience and identity formation he began to develop a social and political art practice that eventually led to teaching this subject. His aesthetic and work was informed and nurtured by the Chicano art movement of the San Francisco Bay Area and specifically through the (Re)Generation Project at the Galería de la Raza. His highly controversial poster project about the death of football star and U.S. Ranger Pat Tillman to "friendly fire" has generated fascinating discussions in his classes about the function of symbolic interventions, the potential of art in social and personal transformation, and the construction and deconstruction of imperial icons. His computer animations, such as *Los ABCs ¡Qué Vivan los Muertos!*, are powerful critiques of militarism, racism, and imperialism.

"My artwork is activist in that engages in and reacts to the symbolic arena of power," John says, "an arena that has a strong influence over one's social, political, and everyday imaginary. As an art activist, my process is quite different from door-to-door, grassroots activism, and community organizing. . . . My 'activism' takes form through specific political and aesthetic tactics, such as using satire and laughter, disrupting fixed discourse, asking forbidden questions, showing forbidden images, recalling forgotten history, and revealing the hidden face of power."

John tries to integrate his experience in collaborative and community art making with his teaching as much as possible. He will generally create a pedagogical collage and will always reformulate and experiment with what kind of collage will work in each particular context and with each group of people. He is not wedded to any particular process or media and instead heeds the Critical Art Ensemble's adaptation of Malcolm X's line: "By Any Media Necessary." He is continually asking himself and his students tactical questions: How does any given artwork situate itself politically, culturally, and economically? How do we expect our audience to react to and/or participate with our artwork? What is our aim and relationship to the work and the context in which we are creating it?

John taught four years in Chicana/o studies departments at Arizona State University and at the University of California, Santa Barbara, where he focused on Latina/o popular culture and "decolonial" art practice. He is currently teaching at the California College of the Arts (CCA) in Community Arts and Social Practice. His graduate courses at CCA focus on the meanings and tactics of social practice, public strategies, institutional critique, and radical pedagogy. In his undergraduate courses, he addresses the history and practice of community arts.

In a recent community arts course, John's students reclaimed the submerged history of a Native American burial site in Emeryville, California, where a large mall complex has been built. Students interviewed filmmakers, workers, and community members about the history of the area, and conducted research about the political process of covering up its history. The collaboration led to the installation of subversive monuments telling the "true" history of the site as well as the production of an "alternative walking tour" guide that was handed out to shoppers, some of whom were quite surprised and interested to find out that they were shopping above unmarked graves of the under-acknowledged Muwekma Ohlone people.

In the Fertile Margins

Sharing the work of those who primarily operate outside of academia is of utmost importance to me, especially given my own history of working on the outside for many years. These are people who have no job security whatsoever, although in Canada and the UK there is more likelihood of sustaining the work through grants and fellowships, than in the United States.

One advantage of working outside the academic world is the freedom to create curricula without bureaucratic supervision, and for this reason many of the artists described below have been able to take marvelous risks and do very innovative work.

In relation to early innovations in this field I want to tell a story. In 1982 I was invited by some activist-artist peers to moderate a panel on teaching art with an activist focus in nonacademic settings. Herb Perr, of Hunter College's Art Education Department, and Amy Snider, from Pratt Institute, were two of the team who suggested that the time was ripe to examine how the pedagogy in art was changing. Herb and I were members of an artist's collaborative group called Political Art Documentation/Distribution (PAD/D) that had been engaged in a number of activist art projects. Among them was an exhibition of protest art against the U.S. involvement in Central America, a satirical show looking at the legacy of the environmental disaster of James Watt, and street art action addressing gentrification, entitled "The Leona Helmsley Honorary Art Gallery."

Our panel "Teaching on the Edge" featured several speakers who worked with different audiences outside of academia (with youth, elders, prisoners, and within museums). The audience at the School of Visual Arts in New York City filled the room, packed with activist artists of all kinds, as well as artists working in schools all over the city.

During the discussion period a well-known artist-teacher confronted us all for being throwbacks to the sixties with our reference to Postman and Weingarten's *Teaching as a Subversive Activity* (actually published in 1971) and our desires to raise consciousness, empower, and heal through art. He said that the skills we were offering our students would not help them get ahead in the eighties, and that we were doing our students a disservice by not preparing them well. I was startled by this feedback and became, as I recall, quite concerned, wondering what his intentions were. I remember questioning whether giving our students an "entry card" into the high art world would serve them ultimately, or whether this was another lesson about who was in and who was out. I really didn't understand the nature of his work with his students at the time, and wished for his perspective to be fully explained.

The point in sharing this story is that we often have assorted intentions when we go into this work, and we typically have very different contexts in which we work. Working with students in challenging environments (such as prisons or inner-city public schools) versus more privileged situations requires distinctly nuanced strategies. Dismissing one strategy as being anachronistic or ill-conceived doesn't invite growth or offer the potential for beneficial exchanges. I hope that we have grown past that now. Here are some powerful examples of colleagues who work outside academia, in many contexts, using performance, writing, multimedia, and visual art.

Magdalena Gomez

Born: 1953, The Bronx
Co-founder and artistic director, Teatro Vida, Springfield, Massachusetts

> *"Being raised in the South Bronx when it was an arson-for-profit inferno and had one of the highest crime rates in the United States, contributed to my passion and commitment for using art not only as a tool for social change, but for finding authentic voice and as a vehicle for self-defense from social, political, and economic oppression."*

Magdalena Gomez is one of the most powerful poets I know, and a remarkable teacher. She was one of the early Nuyorican poets, and has gone on to win many awards, writing, directing, and performing in plays. Because her work as a teacher is so much about claiming authentic voice, I decided not to interrupt it. The words that follow are all hers.

"I attended some of the worst schools imaginable, where violence was normalized by racist institutions, overworked, underpaid, and poorly prepared educators, and a student body of abused, neglected, and underestimated children. Not unlike the current U.S. educational system, students were not being prepared to be thinkers and visionaries, but to become a submissive work force driven by an elusive 'American Dream' based in capitalist ideals of personal worth defined in terms of material acquisition, not character, ethics, or ideals. The message that to become an artist was to set oneself up for economic failure was pounded into us by the absence of art, the squelching of rebellion and creativity, as lessons were drilled by rote memorization.

"The 'No Child Left Behind' act has not only perpetuated this felonious approach that assassinates individuality and imagination, but has escalated it. The result has been staggering dropout rates among Latinos, African Americans, and the poor in urban and rural districts. We have also seen a

shameful increase in the need for remedial courses in math and English at the college level.

"As a teaching artist for over thirty years, I am a witness to how arts-deprived schools churn out dropouts and submissives, drowning in the low self-esteem of internalized oppression brought on by low expectations and narrow definitions of learning. The love of learning and the tools for enduring understanding that creatively address multiple learning styles seem to be absent from a majority of educational centers. We once had the excuse of unknowing; we now have information and tools (thank you, Howard Gardner, for codifying what teaching artists have always known) but the tools are applied sporadically and are the exception, not the norm.

"I can still remember being ridiculed by teachers and students alike for having a Spanish accent. In first grade I was drawing in my notebook, thinking that my artwork would be pleasing to my teacher. Her response was to yank the pencil from my hand, break it in half and bark: 'You are here to listen to me. Period.' As a working teaching artist, I still hear students being reprimanded in schools for speaking in their native languages, asserting their individual style, and approaching their work from their particular and unique way of processing information. Chances are, the student who fidgets is either bored by drone teaching or is a kinesthetic learner. The first response by too many educators, who are also the product of an outdated system, is often to blame the student and not look inward with a reflective mind or search for an alternative approach in reaching the student. Seeking out, developing, and implementing those creative approaches in as many venues as possible is the passion that drives my work. Although there are now many more resources available for teaching creatively, they are not always designed and executed by the culturally competent, and like the testing model are standardized through a Eurocentric lens of the colonized mind.

"These experiences, along with being the daughter of a Puerto Rican mother who was denied a childhood in the harsh circumstances of a slum area outside of San Juan known as "El Fanguito" (Little Mud), and a Roma father who survived the hatred of Roma under the rule of Francisco Franco, the indignities of Ellis Island, and the despair of the Great Depression, made me aware of injustice from an early age.

"Art was unintentionally a part of my life since early childhood, and saved my life. My father had a friend who was a disc jockey and supplied us with diverse music which played all through the days and nights; my mother was a gifted seamstress who could look into a Saks window and recreate Coco Chanel with patterns made from paper bags. Both were adept storytellers and

maintained a sense of humor even in the midst of horror. My father was often inspired to recite brilliant, spontaneous, and undocumented poetry—unlike my mother, he could write, but didn't know his worth as an artist. Neither of them did.

"The result is that I have dedicated my life to working with youth, adults, the incarcerated, the marginalized, and those who have been denied venue and voice, to access, nurture and protect their stories, their history, their cultural memory through self-generated art making. I am very selective about the adult artists I choose to collaborate with—I am not interested in mediocrities or missionaries. By intentionally working with artists who can meet, or better yet, challenge me, I continue to grow as an artist and the students benefit from the model of our mutual respect.

"Most recently I have started a theater, Teatro Vida (ᴛhe other TV) for inspiring leadership and civic engagement through the arts. Teatro Vida is the result of a collaboration with multiple institutions, artists, community partners, and individuals interested in creating art that addresses social issues that specifically impact our city. The Teatro Vida model reflects the influences of Augusto Boal, Viola Spolin, and Ruth Ziporah, among many others. In working with these models I have adapted and created materials and programming that speaks to the diverse voices of our community, but first honors the cultural heritages and nuances of the participants. Every workshop, every training, is informed by the needs and vision of the participants and artists with whom I collaborate. The process includes ritual and specific techniques, but evolves organically to meet the skills, passions, and vision of all involved. It is not a democracy, because one cannot create excellent theater by democracy—there has to be a last word and decision maker. I take on that role as artistic director, but am intentional in my listening and inclusion of all in our community of learning. If each member of the process does not feel seen and valued, then I must take responsibility and action as a facilitator, engaging all until there is a collective sense of balance and justice both in the process and final project.

"My only discouragement in this work throughout my adult life has been the struggle to maintain personal economic stability. I do not stage *Charlotte's Web* nor do I create work that portrays oppressed minorities as victims; we deal with issues such as domestic and other forms of violence, racism, chauvinism in all its forms, gender bias, heterosexism, and find ways to emerge triumphant in the face of struggle. This type of work is anathema to those in the dominant culture who are more comfortable with seeing us as victims they can 'help' rather than as co-liberators. At this time, I am building a think tank of artists and community leaders, so we may collectively find a way to sustainability. We are training youth artists to become not only socially

engaged writers and performers, but peer educators, who can take the Teatro Vida model to train and engage others throughout the city, creating a balance of power, a venue for eliciting authentic voice, and reclaiming cultural and personal history as an act of healing and self-defense. I have embraced my stories, culture, and history in order to work beside others to embrace theirs and break the cycle of colonial violence."

Loraine Leeson

Born: 1951, London, England
Director, cSPACE, University of East London, Docklands campus

> *"My inclination was to not teach in the way I had been taught. Not to pro-nounce/critique/make judgments, but rather base any interventions on listening. I discovered as a very inexperienced young art tutor, that it was only through listening that I could gain a sense of the bigger picture for that person, why they were doing art at all, and what it meant in their lives. Without this, any input from my perspective would be meaningless to them.*

Loraine Leeson created large public projects that confronted gentrification and development in the Docklands region of London back in the eighties, and has continued to address the changing environment of the Thames River Gate-way, one of the largest regeneration zones in Europe in her current Cascade project.[10] This is an area undergoing enormous upheaval due to industrial, political, and demographic shifts, which will transform forever the lives of those living and working there. Loraine creates projects addressing these changes, involving students from three levels of education who put forward their own views about how they wish to see the future of their neighbor-hoods. In the process for Cascade, students mentor each other and work collaboratively. Loraine had recognized that opportunities being offered to students for professional experience (mainly through under-funded com-missions which also put them in competition with each other) offered very little educational value to them. At the same time she was facilitating projects in the community involving young people. It seemed to her that everyone would benefit if she included students in the projects—they would gain ex-perience from working outside of the college as part of a team, where they could interact with young people while also addressing actual social issues. At the same time the young people would have some wonderful role models. All it would take was a lot of management. Loraine took the opportunity to raise some funds meant for encouraging young people into higher education, and that is where Cascade started, which she runs out of cSPACE, the small

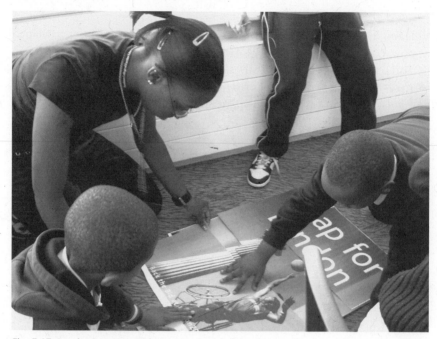

Fig. 5.17. Loraine Leeson's Sada mentee Sara helping in the Cascade Project. Photo by Loraine Leeson.

independent arts organization that she directs. This project has blossomed, developing a practice-based master's program ("Art and Regeneration") with colleagues from three universities, designed to take the Cascade process back into institutions.

One of Loraine's current projects is the creation of a Young Person's Guide to East London, which involves hundreds of teenagers who research and document what they think is good about their neighborhoods. This gets them thinking about what they want and taking ownership of what is there already, and also provides them with information on what is going to happen as regeneration initiatives take hold, which becomes a politicizing process. The guide will become an online resource for local youth, and is planned to be sufficiently developed by the London 2012 Olympics for use by the many thousands of visitors to this area. The youth collaborators will have become the expert guides to aspects of London that most of the world knows nothing about. At the same time the fine-arts students benefit through their involvement in the enormous problem-solving exercises, social content, and their workshop facilitation with the young people.

One of the best moments Loraine has had was the launch of the Young Person's Guide to the Royal Docks at the Museum in Docklands in March 2007. The presentation mimicked the Cascade process. As one of the college tutors put it, "I thought the presentation was fantastic . . . absolutely fantastic that they 'cascaded' it down, from the university students, and they introduced the college students, and the college students introduced the students from Royal Docks School." This was followed by a presentation by the director of the local business partnership, who, having outlined plans for the regeneration of the area, was subjected to a "question time" event with roving young people with microphones, who, following their experience on the project, had thought a lot about this location where they and their families lived. Though they started with prepared questions, these were soon set aside as they gained a sense of their own knowledge and right to be heard, raising spontaneous questions on climate change, homelessness, accessibility, and inclusion, to which they demanded answers. Loraine says, "This fulfilled for me what I had set out to achieve."

Loraine does wish for a more supportive university: "I work with individuals, who are excellent," she says, "but feel very unsupported by the institution. I raise all the money for projects myself through cSPACE, which pays my salary. We are always on a knife-edge with funding. The university supports us by housing cSPACE, and in return uses our work for its research outputs and to show what it is doing in the community. The challenge is to keep body and souls together while I deliver the work."

Devora Neumark

Born: 1959, Brooklyn
Associate faculty, Goddard College (MFA in Interdisciplinary Art);
codirector, Engrenage Noir—LEVIER (Montreal)

> *"In addition to tackling the sometimes-thorny question of collaboration*
> *(with all its extant complexities related to power, joint decision-making*
> *processes, and co-creativity to name just a few), one of the other issues*
> *we have considered critically from the outset was how, why, when, and*
> *for whom to document community art projects."*

Devora Neumark's work looks at the "dynamic interplay between risk, dialogue, and the creative process in art, healing and peace work." She and Johanne Chagnon are the codirectors of the LEVIER community-art/education programs.[11] Projects facilitated through LEVIER have used theater, music, installation, video, dance, photography, the written word, and public conversation to address the

Palestinian/Israeli conflict, Rwandan refugee culture, and, more recently, the criminalization of poverty and the impoverishment of individuals who get caught up in the criminal justice and prison systems.

"From the start," Devora says, "LEVIER, as a private nonprofit granting body, has assumed its ethical responsibilities in relation to the projects it has funded in order to assure to the best of our abilities that they don't end up creating more harm than good—something entirely possible given the interpersonal tensions, creative conflicts and significant socio-political stakes often present in community art practice."

"In addition to financial support," she says, "we provide training and frequent follow-ups with project participants throughout the creative process." Given the importance that LEVIER places on ongoing practical and theoretical reflection, Devora has organized meetings, workshops, round-table discussions, and dialogue circles on a regular basis, dealing with community art–related issues including aesthetics and collaborative creativity, the ethical dilemmas inherent in this form of art practice, accessibility, nonviolent communication, and the links between trauma, healing, and art.[12] Recent LEVIER programs focused on documenting community art projects in preparation for the production of the *Documenting Collaboration* video series, and a five-day training and exchange program in preparation for a three-year pilot project entitled *Agir par l'imaginaire*, in collaboration with the Société Elizabeth Fry du Québec, involving over seventy-five women from four Montreal-area women's penal institutions.

Devora says that both of her teaching situations informs the other: she has used popular-education principles within the academy on occasion and applied some of the graduate-degree criteria to the training and exchange programs she has organized for LEVIER Feedback from *Agir par l'imaginaire* participants points to the personal challenges and satisfactions inherent in the project-specific learning processes favored by LEVIER. Multidisciplinary artist Émilie Monnet says, "Before beginning the training and exchange program, I really wondered if I was the right person to get involved in this prison project. Would the theater workshop I was invited to facilitate really evolve a space of creative freedom within which we could share the pleasure of playing together? . . . The training and exchange program allowed me to remove several layers of doubt and fear. I now feel more confident even though there remains a bit of nervousness—something I believe is normal given the enormous implications of this project. The five days of preparation were deeply transforming in my case; I feel that I grew and that my heart has been opened."

Meena Murugesan, another participating artist, summed up her experience of the training and exchange program: "I am most challenged by the feeling

of slipping further and further away from the dominant values and norms prevalent in our society today. . . . While I feel grounded, the implications of this 'slippage' are far-reaching. Some people just tell me, 'don't get emotionally attached.' It's not even about that, though. Its about not subscribing to and supporting all the things that are dehumanizing, and if getting emotionally affected helps us do that, then we must get emotionally affected. Things will only change because a feeling triggers a thought and an action. The fact that I am blessed to do this work helps me to not feel paralyzed. Now I feel a greater sense of purpose in terms of the kind of work I want to do, but it also makes me less willing to compromise every day. This is a good thing, but something else to negotiate when having to live in society and make money, et cetera."

Devora affirms her own and Johanne Chagnon's commitment to this process of linking artistic practice with in-community learning programs: "Having participated in and witnessed our own personal transformations and the transformations of individuals who have been involved in the LEVIER programs over the years is both challenging and encouraging. This approach demands that one questions one's values, beliefs, and thought patterns profoundly. To do this one requires a lot of personal availability and a strong supportive network."

As for the issue of documenting collaborative art processes, Devora says: "We don't feel quite satisfied with our documentation efforts yet, however we are committed to continue exploring the practical and ethical issues related to the dissemination of people's stories, their personal and political challenges, and their creative efforts devoted to making this world a more beautiful, caring, and healthy place to live in and bequeath to future generations. We trust that with time we will become more proficient in contributing to the growing body of knowledge about community art practice here and elsewhere."

Jane Trowell

Born: 1962, London, England
Member of interdisciplinary collective PLATFORM since 1992; lecturer, Department of Art, Design & Museology, Institute of Education, University of London; teacher, Arts Policy and Management (MA program), Birkbeck, University of London

> "I identify primarily as a teacher, not as an artist, although I work directly
> with artists and other creative people. However, I view teaching as art.
> For me, aesthetics is both the rigorous attention to visual, audio, tactile,
> spatial, bodily form, and also an equal attention to the democracy of
> your practice. 'Educating involves ethics and aesthetics hand in hand:
> it is beautiful because it is ethical,' [according to] Paulo Freire."[13]

Jane Trowell is part of PLATFORM,[14] an organization that brings together people from the arts, activism, research, and education to create change toward social and environmental justice. During the past ten years, it has focused on work related to oil, climate change, and "climate justice." She co-teaches a course for PLATFORM titled The Body Politic, Social and Ecological Justice, Art, Activism.[15] Jane is also interested in how art, activism, education, and state policy interact.

As a teenager, Jane was alienated from the conservative art education that her secondary school offered, but was electrified by her immersion in contemporary art practice as a curator in late eighties Britain. It was an exciting time for the Left, for Black artists, feminism, disability rights, and the "new art history." In particular, feminist, Black, and postcolonial positions on art/culture confronted the status quo, while Thatcherism[16] was systematically dismantling the welfare state, in imitation of the U.S. model. Jane was mobilized by this, and dedicated herself to the potential of education as a bringer of social justice, and in the power of the arts as a force for critical understanding and social change through its aesthetic and relational impacts. In this context, she joined PLATFORM, having already trained as an art teacher.

However, the political and art scene has greatly evolved since then. Jane says, "Right now in the UK, there's a lot of money around encouraging artists to work in 'social contexts' (not necessarily 'socially engaged' in the political sense that I mean) [so] it's a rapidly changing situation. Basically, Labour Party policy on state arts funding since 1997 has put almost sole emphasis on funding arts and social inclusion projects, so more artists than ever before are in the field. Also, because of the 'BritArt' and Tate Modern effect, visual art is fashionable, fairly populist, and very high-profile these days. Increasingly the mass media is picking up on artists working on all kinds of social and political issues in all kinds of contexts in all kinds of media. This encourages other funders, such as charitable foundations and museums and galleries, to take the social (rather than the purely 'art for art's sake') function of art seriously and engage with how art can influence regeneration, urban renewal, disaffected young people, climate change, et cetera. We're awash with opportunity, even if the government's agenda is highly instrumental, manipulative, and controversial, and some of the projects really problematic.

"On the other hand, art schools have not really changed their course content to help student-artists understand their social context, how their conscious or unconscious politics shapes their work, how to deconstruct power relations, et cetera. With some pioneering exceptions, most fine art courses still concentrate on the genius of the artist, so there are huge flaws in the way this burgeoning social-practice art operates: many artists are ill-

equipped, yet others are blazing the way. From an activist perspective, most of the activity is at the reformist end of the scale—using artists to help show in microcosm what could be done (but won't be)—or to help bandage up a problem rather than identify and really change things systemically. Yet, because driven by the funding, there's been an explosion in debate, conferences, and publishing—seeds of reflective practice. Controversy and open debate is healthy, although a change of government could throw all of it out the window. You could definitely say that artists are seen much more as part of the social fabric and not as remote in their lonely studios as they were thirty years ago."

PLATFORM's educational work is varied, ranging from residencies in primary schools to working with students at Bartlett School of Architecture, University College London, one-offs at the London Business School, and running workshops and teach-ins in activist contexts like Climate Camp. In devising "The Body Politic," Jane and colleague Dan Gretton realized that there were few spaces for interdisciplinary, collective, activist reflection, and that there was a big need. They wanted to create a community of learning with a group comprised of activists, artists, researchers, people from business, and teachers. The issues that are worked on are contemporary, political, and collaborative, but rooted in experience.

A key exercise that Body Politic students do early on in the course, is to think about two aspects of listening. The first week ("Inner Ear") is devoted to listening to yourself. Week two ("Outer Ear") is devoted to listening to a community. The exercises are done through writing, drawing, and conversation, and the results are shared, bringing up issues of deep political and personal importance. The exercises (which the facilitators also do) set up foundations for the future close working of the group. It fosters collectivity, challenging the isolation of many areas of work (not just the artist). It raises questions of vulnerability, philosophy, stereotypes, notions of political urgency, and one's own subjective position when approaching a "community."

"The common denominator for me," Jane says, "is to spend proper time to hear and talk about what everyone expects and what everyone is assuming. That sets out what everyone (including the artist-teacher) wants, needs, hopes and fears. . . . Also we discuss what the institutional or other constraints are upon the process. This makes the individuals (young or old) and 'teacher' realize they are co-designing the process (whatever the constraints), that everyone has a stake in it being fruitful. It's also essential to see the artist-teacher as also a learner—if your excitement at learning through the process is real and communicated, it has an energy that is not only about democracy, but about desire, pleasure, and fun."

"The course has a structure but unfolds in a very negotiated way," Jane says. "Yet there are constraints, one of them being that the course is currently run at Birkbeck, University of London. Since the 1980s, under Thatcher, Major, [and] Blair (and continuing under Brown), the state education system has been completely obsessed with assessment and auditing. This is not the same as reflective practice, as it's driven by fear. It's still fairly flexible in higher education where practice-based learning and research is being increasingly validated. But at present assessment is the dead hand of a control-freak bureaucracy. Bangs for bucks. This is true for most funders, too—they want to have evidence of every impact, all positive, of course! This audit tick-box mentality can inhibit the development of really interesting ways of evaluating and taking stock of what has been learned, including learning from failure."

For PLATFORM, critically and creatively questioning political and cultural contexts—and monitoring self-censorship, coercion and co-option—is central. Jane cross-fertilizes this practice with her work in mainstream settings, a seesaw between the edge and the middle.

Elaine Carol

Born: 1960, Montreal
Artistic director, MISCELLANEOUS Productions, Vancouver

> "This is not like a traditional theater school where I am trying to mold them, instead I am trying to help them find themselves . . . and when they finally understand and have a breakthrough, that's uplifting. Most artists who don't work in a community-engaged model don't want to work that hard, they're navel gazers, they're all about their careers; they are capitalists. This work enriches the soul, and a lot of artists are soulless."

Elaine Carol comes from an at-risk background, and claims that art saved her life. Her self-transformation included developing her work as a performance artist and actor, working in a therapeutic model and activism, and coming out as a lesbian. She co-created an interdisciplinary arts organization, the nonprofit charity MISCELLANEOUS Productions.[17]

Elaine's arts ensemble facilitates projects with at-risk youth that can be very graphic, dealing with issues of race and violence. To do this work, MISCELLANEOUS receives significant funding to deal with intercultural tensions, although the sources of that funding are beginning to dry up.

Elaine described the racism of Vancouver as being very complex, with many intra-cultural tensions. As an example, she explained how different the

Fig 5.18. MISCELLANEOUS Productions' Stock Characters: The Cooking Show 2007 created and directed by Elaine Carol. Kneeling, Dakota Prince as Dr. Sister Cousin and standing, Karine Behmard-Larue as Chairman Dada. Photo by Elaine Carol.

Chinese immigrants who arrived during the Cultural Revolution are from the relatively new immigrants from Hong Kong.

Many of the youth performances look at the links between gang violence and the socio-economic roots of these problems. Elaine's students often live in extreme poverty, and many get involved in the drug trade, especially via South Asian, Aboriginal and Persian gangs. She described other challenges they face: violence within families, drug addiction, and alcoholism.

The youth go through a process that includes healing work and consciousness-raising. They meet with a social worker and a diversity consultant who is the theorist /philosopher/pedagogue on staff. A psychologist works with the staff to assist in evaluating projects. Elaine says, "We really appreciate having these people right here when we are doing this work. Everyone lives in the community who does this work; we're part of the community, working with the extended families, not parachuting in and out." Elaine describes her work

as truly engaged with the community rather than colonizing them, as artists with a more culturally imperialist perspective might."

A recent production of the ensemble, *Stock Characters: The Cooking Show*, included a deep analysis of class, race, and poverty around issues of food. The play was set in 2017, in "an apocalyptic world where there is no food, no integrity and no compassion." The production satirized the Japanese *Iron Chef* television program.

The structure of each production is Elaine's concept, but she works with professional production designers and the youth often write the script with her. She says that the youth are not often good writers because of their literacy shortcomings, but they are good improvisers. The participants in this work are selected through a form of audition. Elaine refers to them as a "polite cattle calls" during which the staff selects whom they think would best benefit from this work. Twenty are selected, and from that group maybe ten make it through the whole process.

The last show was the most successful, Elaine says, "in spite some of the longest and hardest challenges—there were severe mental health and addiction issues. We want to empower them; it was an extremely successful production, but risk factors have gone way up and the work is much more difficult now. . . . The younger you get them the better, because it's easier for them to change. . . . Prime Minister Harper is like Bush, but way smarter, so lots of money has been sucked out of our community. They're beefing up corrections, and crime prevention money has been cut off. The ensemble is limping along now and I'm not sure if we'll make it. . . . Our main source of funding is gone."

John Jordan

Born: 1965, Paris, France
Freelance visiting lecturer in the UK and Europe, most recently
at Warwick University (UK) and Tanz Quartier (Austria)

> "[I]n the end, for me, any contemplation of aesthetics, which comes from the Greek—meaning the ability to perceive to experience to sense . . . to notice our world . . . to feel through our bodies—makes it simply impossible not to be an engaged artist. . . [W]e are at in a moment of global crisis—ecological, social, economic, spiritual . . . to not feel this deeply is to not be engaged in an aesthetic process . . . to not attempt to develop the ability to respond to this is to be part of the problem—it's a question of RESPONSE-ABILITY."

Currently based in London, John Jordan gave up tenure to work in Argentina after the economic collapse there in 2002. He continues to teach part

time, and combines this with "art activist" projects. "I am most happy with projects where the art becomes invisible and what is most prominent is human creativity and imagination rather than the exclusive culture of the art world," John says. "I'm more interested in applying creativity to social movements, and dissolving the identity of the artist and art. For me, working in social movements is an art/life work; the movements are the material. This ranges from working as an organizer, designer of propaganda, writer and documenter, creator of creative forms of resistance, or political theorist." John was a founding member of the Clandestine Insurrection Rebel Clown Army and works with the Climate Camp and global anticapitalist movements.

John says that he sometimes feels that teaching is the most political thing he does, in that one is able to directly see transformations in students' thinking and action; at other times he feels that his work with social movements is the most transformative thing he does because it enables large numbers of people to be changed through taking radical forms of direct action.

John always wonders which context is more transformative, the more personal, intimate change that occurs in the classroom or macro changes that take place through organizing mass mobilizations. It's not either/or, and of course some people need the intimacy of the classroom to feel safe to challenge themselves, whereas others prefer the support of a crowd and the adventure of struggle to expand their boundaries of what is possible. "For me a radical socially engaged approach to art involves refusing to see it as something separate from life," John says. "This notion that art is not connected to our everyday life is part of the general problem of separation and disconnection that our suicidal industrial-capitalist logic entrances us with, a logic that separates us from each other, from our land base, from our capacity to be truly creative in the world and to determine our own lives.

"For me art is simply paying attention to an activity and doing it in the best possible way. We have to remember that for most of the world and for most of history art was neither an object, nor a performed activity that was autonomous [and separate] from social life. For me this is an ethical and aesthetic approach which expands restricted notions of what art can be. Alan Kaprow's work and writing is an important foundation for me. In his 1983 essay, 'The Real Experiment,' he wrote 'we may see the overall meaning of art change profoundly—from being an end to being a means, from holding out a promise of perfection in some other realm to demonstrating a way of living meaningfully in this one.'"

John has taught courses and workshops with titles such as "Radical Performance" and "Creative Resistances." He also teaches a short history of radical art from the anarchist artists of the nineteenth century (Courbet to

Pissaro) through the Yes Men and Reclaim the Streets, via Situationists and Dada.

John teaches his students to work collectively, making consensus decisions, questioning power and authority, employing critical thinking, using media, and crafting the aesthetic. He approaches teaching in the same way as he would approach the creation of a work of art. He gives it time, creativity, thought, and passionate attention. He thinks about it as form and content, art and activism, a political act and a poetic moment. In this way it does not get in the way but is simply part of the process. John always begins in university contexts by getting the students to look at and deconstruct the power relations in the classroom, by getting them to teach an activity in the architecture of the classroom without the hierarchy of expert and students. This immediately gets them to question specific contexts and issues of power and responsibility. He likes to use food in class, eating together and making the construction of conviviality a key aspect of the course. He teaches consensus decision making very early in the class, so that collective discussions and plans can be made.

John uses games and plays a lot with his students, including clowning exercises. These are key for building a good group dynamic and developing confidence and trust, as well as fostering a sense of fun and absurdity within the class. There is no limit to the form that John's students can use, as long as it's in public space and engages with the idea of breaking down the division between audience and performer, artist and spectator, and has elements of direct action.

One of his most successful collaborative projects with students grew out of a popular movement against bus fare raises in the city. The students were encouraged to find creative forms to support this traditional campaign of marches and petitions. The students created a Web site that parodied the bus corporations and performed (as fake employees of the corporation) at bus stops and on the buses to engage riders in a more critical, active way of responding to the situation.[18]

John finds that cynicism affects his students, a cynicism that wrongly tells them that art can't change the world. He says that there is great ignorance about the role artists have had in social movements and a fear that their identity as artists will somehow be effaced if they work in activism. "But art history is full of artists merging art and activism, from William Morris converting his print studio to a political meeting room and writing utopian novels on the way home from activist meetings, to Sylvia Pankhurst leaving the Royal College of Art to apply her fearless creativity to the suffragette movements, which included building bakeries for the poor, organizing creative forms of sabotage, and designing propaganda materials."

The Next Generation

Here are the stories of four colleagues who were my students at different institutions (Goddard College, the Institute for Social Ecology, Cal State Long Beach, and Hampshire College); all were born in the sixties and seventies. I am acknowledging their stories separately to show how the legacy of various progressive movements continues forward. I am glad to know that these four represent many more who are doing important, innovative, and courageous work around the world.

Emily Caigan

Born: 1967, New York City
Adjunct faculty, State University of New York, New Paltz

> *"Teaching students the tools of activist art and activism, in general, gives them a way out of feeling depressed or stuck. I insist that we can make a difference."*

Emily Caigan comes to her interdisciplinary activist art practice from the traditions of theater and voice teaching. Her most important mentor was Chuck Jones, a pioneer in the world of vocal instruction. He was both a feminist and an activist. Jones got Caigan involved in the process of "owning her whole voice." "Women no longer wear corsets," he said to her, "they're just supposed to sound and look like they do." Jones recognized that Caigan's former tendency of speaking with a smile had forced her voice to operate in a very limited range. As she began to open up to this work, she discovered the beginnings of a teaching practice that met her needs.

Her work as a voice instructor at NYU's theater school (Tisch School for the Arts) made her keenly aware of social issues. She tried teaching traditionally for a year or so, but she found that she wasn't reaching the students. She began to ask them to choose their own texts and bring stories into the classroom that were important to them. Their stories of struggle and privilege began to affect the way she taught.

Caigan noticed that a large, African-American male student in her voice class wasn't able to use his full voice. She asked him if he felt that people were afraid of him. He told the class that people crossed the street when they saw him coming. His story, told with emotion, made the students in the class more aware of how different his experience was from their own, and helped the young man become more self-aware. She asked him if he felt that he had to be especially nice to people, and he said yes. He took this awareness into his voice work, and with time he was able to take up more space.

One day in class, Caigan noticed that her women students seemed unable to open their mouths. At first she thought this was the result of wearing orthodontic braces (which many of them had worn), but after some presumably discrete inquiries she learned that many had had their palates split (a very painful process that involves tightening a screw into the upper mouth every night) in order to develop "pretty" teeth and mouths. Horrified to learn this, she began researching what other tortures had been used historically to keep women's mouths shut. Years later this research began to inform her activist art practice.

With time, Caigan's work with theater students began to create internal conflicts. She realized that she was not training people to become empowered to transform the system, but rather they were developing skills to more successfully manipulate the system. She also found that she was compromising her power when working in traditional theater, in ways that she could no longer tolerate. Even producing plays in a feminist context, about women and work, was not sufficient. As part of her journey, she went back to school to get her MFA in interdisciplinary arts and started working with the faculty at Goddard College.

Caigan's art practice was profoundly shifted by her studies at Goddard, during which time she started creating interactive installations about body image and other feminist issues. She has been inspired by the feminist art of the early seventies, especially that of Mary Beth Edelson and Edelson's audience participatory story boxes. She believes that all art is socially engaged if you think about who is receiving the work. Reception Theory[19] has influenced her thoughts in this arena.

Currently Caigan teaches as an adjunct instructor for the women's studies program at SUNY New Paltz. Her courses are Feminist Art and Culture; Women, Performance, and Social Change; and Women: Images and Reality. As part of the latter course, Caigan's students are required to create a liberating action, and that may be in the form of an art project or a paper. She has also taught them a WPA theater project exercise called "the Living Newspaper."[20]

Caigan gets excited by her students' work, even though they are not studying to be artists and are taking her courses as electives and for general education credit. Her students have spontaneously organized public art interventions in response to sexist and racist behavior on campus, some of which have successfully brought about changes in school policy and broadened public discussion.

Sarah Kanouse

Born: 1976, Los Angeles
Assistant professor, University of Iowa

> *"The faux-populist move in higher education that treats students as con-
> sumers discourages socially engaged teaching. End-of-semester evalua-
> tions are a market-driven form of accountability tacked on to an extremely
> hierarchical educational model that leaves students ill prepared and often
> unwilling to engage in ways that ask more of them than to be entertained
> in lectures. In many ways, it's inspiring that any socially engaged classes
> are taught and that so many students do enjoy them. In academia, we
> need to push for more structural changes in pedagogy and tenure."*

Sarah Kanouse was one of the most articulate students I worked with at the
Institute for Ecology. Her multimedia work is often interactive and applies
astute critical thinking to contemporary political and social issues.

Although she recently moved to the art program at the University of Iowa,
Sarah taught digital media and contemporary art practices in the cinema and
photography department at Southern Illinois University (SIU), a regional
public university serving a high proportion of first-generation college students
and people of color. Her comments here reflect that experience. At SIU the
student body was about 25 percent nonwhite, with an average family income of
$40,000 per year. Many of her students were veterans or had family members
in the armed forces, and quite a few were older students and parents. In this
context, Sarah found that her students understood class and race analysis in a
way that students from more privileged backgrounds often have a hard time
grasping. Many of them came to college already questioning corporate capital-
ism due to their own families' experiences with outsourcing and downsizing.
Some students felt privileged to be in school and worked very hard at being
students because they couldn't afford to waste time or money.

Sarah says that there were challenges working with first-generation col-
lege students. "Not everyone reacts to similar circumstances in similar ways.
Some students might 'get' class and race analysis, but they have internalized
a sense of helplessness and can't imagine the world in any other way. Their
cynical response is often to try to earn as much money as possible because they
see the world as hopelessly corrupt. A few students every semester complain
that the additional topics take away from time spent learning proprietary
software and are unmoved by our discussion about the treadmill of tech-
nological obsolescence. The college also has a 'party school' reputation that
contributes to an anti-intellectual atmosphere on campus. Some students

are very socially conservative and react strongly to anything I present in class that has feminist or gay-oriented content. Even the most motivated students often lack self-confidence and the experience to shape their own education, and it's been really difficult for me to get mutual learning tools (either online or face-to-face) to work here."

At Southern Illinois, Sarah taught courses in sound, video, web design and trans-media art within an undergrad curriculum that remained traditional overall and emphasized celluloid and chemical processes. The costs of making work could be prohibitive for many lower-income students, and many families discouraged their children from pursuing the degree because they didn't see it as leading to a steady income. Those who graduate from the SIU cinema and photography program often end up in commercial work or in the film industry, but many alumni are also critical and holistic filmmakers and artists working independently—in no small part due to the efforts of some dedicated independent filmmakers and documentarians on the faculty. However, Sarah notes, "There are also some strong voices at the university pushing for a narrower and more pre-professional approach. They use a faux-populist argument that tech skills are what students want and need so we should teach more of them, and it's often treated as a zero-sum game: the more critical thinking students learn the less they will be able to use technology. Aside from being patently absurd, this contention reveals the low expectations many faculty and administrators have of the students, which the students perceive and internalize."

Partly in response to this "zero-sum" attitude concerning the teaching of technical skills, Sarah taught a multimedia Web design course around the theme of food politics, which she called Food Systems. She hosted a potluck at her home at the beginning of the semester, and each student spent the next six weeks researching the origins of all the ingredients in the dish they had brought. Most had brought food that came from a box and was loaded with additives, so their research focused on finding the probable sources and production processes of bleached enriched flour, sodium benzoate, high-fructose corn syrup, and the like. In addition to learning software and design skills, the class read Michael Pollan's *The Omnivore's Dilemma* over the course of the semester, which Kanouse describes as being "a real eye-opener for the students. Most of them were outraged by the unhealthfulness and unsustainability of food production and alarmed at the many roadblocks corporations put up as they tried simply to learn where the food they had purchased had come from." The final group assignment combined individual research findings to create a multimedia Web site that depicted the state of food systems in the U.S. today. It was a gentle way

to start talking about more controversial issues like pollution, global warming, labor, immigration, and capitalism.

While Sarah recognizes her privileged position as a young artist who managed to land a tenure-track position, she often struggles to reconcile the expectations of her career with the political commitments she would like to make with her art. "Work that is political seems much more likely to be embraced by the art world if it is also very abstract or, at the very least lets the viewer 'make up her own mind.' The bias against the local, grounded, positioned, and materially specific remains entrenched in academia, and in many ways may be gaining as more schools embrace a Research1 model [21] that sometimes seems to believe in 'universal' knowledge, even after a generation of feminist and postcolonial interventions. Even my former dean at SIU, despite his Marxist identification, tended to valorize 'prestige' in art spaces and academic journals, as if prestige accumulated in a natural meritocracy, rather than a politically fraught field. The promotion and tenure guidelines at some schools openly discourage activist and community work, and implicitly discriminate against social engagement insofar as it means that 'productivity' is less (because these projects can take longer) or that work is exhibited in less prestigious places."

John Feodorov

Born: 1960, Los Angeles
Assistant professor, Fairhaven College, Western Washington University

> "I have a few friends that I would consider activist artists. I think that what they do is important but it sometimes it seems like they're rushing to plug up holes in a leaking boat. At some point, someone has to ask, 'Why does this fucking boat keep leaking?' That's the question I'm interested in exploring rather than reacting to more specific issues. I feel activism requires a more fervent approach; it demands the existence of a dichotomy: good/bad or right/wrong. I feel that there is also a potential danger of 'activist' art developing a parasitic relationship with the continued existence of injustice, war, and so on."

John Feodorov creates powerful satirical work, blending the politics of his Navajo heritage with commentary about cultural appropriation and contemporary life. His work has been featured in the PBS special *Art 21*, and he has been an important figure in the Seattle art scene. We first encountered each other in my painting class at Cal State Long Beach in the late eighties, where he told me at the end of our first semester that he did not want to pursue an artist's career, saying that it was too vapid and pretentious due to the effects of the marketplace. He

went on to create a powerful work his senior year, *The Totem Teddies*—a brilliant synthesis of content and craft, wit, and insight—and got hooked.

When John began teaching full-time at Western Washington University's interdisciplinary Fairhaven College in 2004, he felt grateful that he was not required to tailor his teaching methods to a more traditional structure. He admits that he has had to free himself from more conventional thinking about teaching art in order to effectively and successfully meet the needs of the students. Fairhaven's interdisciplinary program encourages social engagement.

John wants his students to understand the historical and political context of artmaking, and that "it is, or can be, more than merely self-expression. I suppose the goal is to somehow tap into one's humanity, instead of wallowing within some self-absorbed expression." Among the classes John has created are Art in the Public Sphere; Art and Popular Culture; Art during Wartime; and Art and the Other.

"The majority of my students come from a white middle-class background," John says. "The college is currently trying to develop better strategies for recruiting a more diverse student body. I would say that most of the students of color are taught to see art as a luxury, not as something that is relevant to their situation. This was true of my own experience when I was in high school. I hope to change this perception as more students get to know me and I them."

John enjoys his students' enthusiasm for social justice, but sometimes, he says, "their concepts have not as yet developed to the point where they can question their own complicity. There can be indignation when they are told that what they think and do might actually add to a problem. Many are still thinking paternalistically and are not happy to be told so. The other issue is that most of the students have had no previous art history or studio experience and will most likely never become art majors. Therefore it is sometimes difficult for them to embrace the need for both skill and conceptual development concurrently."

John describes a project he facilitated with his students: "Before Christmas, they chose to go into a local mall wearing Santa hats while handing out various consumer statistics along with candy canes to unsuspecting holiday shoppers. I discreetly videotaped the action. The students felt empowered and energized, which for me, was the most important aspect of this assignment."

Since students in his class are also taking classes in social issues and history, John says, "I have them use what they learn in these other classes as the basis for their art projects. I also ask that they have some sort of personal experience and attachment with the issue. I tell them that artists do not create in a vacuum and that my personal opinion is that art about art is just simply

boring. Even in my more traditional art classes like Beginning Painting, I have the last project address some social issue in order for the students to begin thinking differently about the possibilities of art."

Beth Ferguson

Born: 1977, Maine
Teacher, Metamorphosis Arte, Austin, Texas; candidate
for MFA in Design at the University of Texas at Austin

> *"In certain academic and artistic circles it seems almost taboo to have your art say anything socially conscious. This taboo makes many artists wash away the content from their work and stay in an abstract world. Artists have a gift to visually communicate powerful ideas and now more then ever people need inspiration to have the courage to change. Many successful socially engaged artists do not have fine arts degrees. Some received their training through apprenticeships, collaborations, and in the streets."*

Beth Ferguson creates visionary work, illustrating lush utopias filled with community gardens, solar energy, bicycles, and people dancing in the streets. As a student at Hampshire College, she was introduced to ways she could combine her community-based activism with her art. With multiple interests in the environment, politics, community, and the arts—and multiple talents—Beth creates giant street puppets, prints, posters, artist's books, mosaics, and murals, and is a consummate collaborator. She trained with Bread and Puppet Theater, was a volunteer for the Beehive Collective, and has gone on to found or to participate in several global and environmental justice cultural collaborations, including Cycle Circus and Bikes Across Borders. Beth spent several years creating green maps in Cuba with the Mapa Verde project, and participated in Tropazancos, a street theater puppet group in Havana. Due to her contagious enthusiasm, she has been the catalyst for Green Map projects both on my campus and on the island where I live.

Since moving to Austin, Texas, Beth has organized art workshops at the Rhizome Collective (a center for community organizing and sustainability), teaching printmaking and green design to eco-activists. In another project, Metamorphosis Arte, she has collaborated with other teaching artists to tour Austin public schools and street theater festivals in Mexico with a puppet show about the lifecycle of monarch butterflies. Metamorphosis Arte has collaborated with a group of three female Cuban hip-hop artists, Las Krudas Cubensi, and Buscando el Monte, a Cuban conga music group, to organize

community workshops. This project culminated with a neighborhood parade of over three hundred people, called "Community Celebration: A Walking, Cycling Festival of Arts & Culture," that included street theater, Cuban music, youth murals, bicycle puppets, and a youth bike project.

As a graduate student in design, Ferguson has been developing work that suggests solutions to the climate crisis. She has created relief prints that focus on ecological themes, and has illustrated a neighborhood green map. She also created concept designs for a solar plug-in station for electric bicycles.

Ferguson has continued to lead ecological design workshops and community-mapping exercises in public schools, museums, community forums, conferences, and universities. She created Austin's Mural Visions program in collaboration with the Theatre Action Project, which works with youth and local artists to create community-based murals that reflect issues pertaining to place, cultural heritage, solutions to climate change, and the natural world. Through the Mural Visions program, students who mostly come from low-income Latino or African-American families, work collaboratively, selecting a theme and building visual research and interview skills to create a community-inspired mural.

Fig 5.19. El Sol y La Luna, La habana, 2005.
Photo taken by Beth Ferguson, with an automatic timer.

Strengthening the Immune System

Outside the many gardens, in many parts of the world, glass and steel palaces had been built with cameras watching the doors. Women who ate roses were demonized, and would be imprisoned if they didn't hide their skill. Men who braided the threads of difficult questions were scorned, ridiculed, and often locked up. The prisons were elaborate structures with windows so high that you could not see a horizon line and barely a scrap of blue sky. But sometimes the people of the gardens were able to sneak in specially made scopes that made horizon lines visible. Like awesome kaleidoscopes, they were treasured and handed around furtively from cell to cell. These scopes opened up the tightly folded hearts of the prisoners, and allowed them to dream again. They began to scribble on notes and scratch out shapes on whatever surfaces they could find, to hum and tap and move about in excited rhythms. As if beneficial bacteria were infecting one prisoner after another, the immune system of the collective began to strengthen.

Outside the prison walls, bad action thriller movies entranced the public who believed that the ones with big guns always won, and that battles would always be fought. The folded-in men and women who guarded the palaces, foolishly dreamed of owning their own palaces someday, and so continued to behave like good boys and girls, grabbing the so-called demons and locking them up.

Toward a Liberatory Art Practice

Considering Cuba: A Frame Unhinged

I am sitting in my tiny, dark room in Rosalba's house. The window is open to allow a breeze, but mostly what comes in are diesel fumes. The noises of the traffic out on the boulevard are so loud that I need to counter the racket. My antidote is the raw, juicy rhythms of the Orishas, a hip-hop group of ex-pat Cubans. Soon the physical memory of last night's dancing in Patry's apartment pushes me out of my chair. I sway in motion with a room full of invisible dancers, until the contradictions of the day pull me back into my seat.

First there is the exquisite silence of no advertising, no neon signage selling me something, only the sober, ubiquitous heroic portraits, and the proclamations of the state. Simple things like "Viva Cuba" bring a smile to my face, as do the raucous murals shifting the public space into a constant party.

Almost everywhere the paint peels and concrete crumbles. Things that are broken are tied together with old bits of twine and wire. It's a patchwork of survival, everything recycled and reused, and people figure out ways to maneuver between the rules. For the average Cuban there is a constant scrounging, scavenging, and making do, especially since the "special period," when the Soviet Union collapsed—and as a result discontinued relations with Cuba. Add the U.S. embargo, lack of free speech and some significant political rights, no money (or visas) to leave the country, and you've got a formula for quiet desperation, but Cubans have a joy for life that's contagiously sensual and inviting, and brings tourists in constant busloads. Without the tourist

economy, the majority of the population would truly be desperate and tying more makeshift rafts together to escape by sea.

Those who get fed up with the limits of free speech and mobility, and are lucky enough to make a safe journey by raft or boat, and those who have connections to secure an exit visa and an airplane seat, face sharp challenges when they arrive at their new homes. The loss of family connections, sense and pride of place, the social safety net, and the easygoing warmth of neighbors can be deeply shocking, although many Cubans do thrive once they get their footing abroad.

Yes, in Cuba there is free education, health care, and a roof, of sorts, over everyone's heads. There's 100 percent literacy, government-supported organic farms dotting the countryside, and food rations so that everyone gets the bare minimum to eat. All of the latter, when compared with the lack of social services in our failing economic system, can make one envious. Still, anything new and shiny implies money or a gift coming from outside the country, and the social safety net has many holes, not the least of which is the lack of hypodermic needles and basic medicines at the clinics.

My first visit to Cuba was in January 2005. Like many progressives from around the world, I wanted to see the reality of Cuba with my own eyes, unfiltered by propaganda from either side of the border. I traveled with colleagues from the University of Washington, Tacoma, to present papers at an interdisciplinary conference of academics organized by our sister university in Cienfuegos. I went there with few preconceptions. I had known many older progressive artists who visited the country decades earlier. Some came back excited; some came back depressed.

Still I was quite taken, in the airport, when, having barely entered the country, the immigration and customs officers found my portfolio in my suitcase and wanted to discuss my art. This was not an interrogation or some brusque interview; they asked friendly, visually literate questions about how it was made and what informed its content. They became animated by my responses, eager to learn more about digital painting. What kind of country would this be where ordinary functionaries thought culture was worth discussing?

During that first trip to Cuba my efforts to meet Cuban artists were rewarded through the connections of Beth Ferguson who had volunteered for the Mapa Verde project in Cuba. She told me to look for a group of street theater puppeteers in Old Havana. I found them walking on stilts, masked, in colorful costumes, and playing wonderful, percussive music. A crowd was following them through the narrow streets. When I went up to one of them and shared that I was "Beta's" former teacher, a shout went out among the group and I was welcomed like a member of the family. The

group, Tropazancos, entertained the locals and tourists with stories about the environment, Afro-Cuban folklore, community empowerment, and feminism, stories for all ages. Not what we would expect as typical tourist entertainment up north.

My contact with these artists was brief, but long enough for me to be brought home to the family of one of the puppeteers, and welcomed royally. Leo's mom, Isabel, and I became fast friends. She writes poetry, practices Reiki healing (trained by visiting Canadian healers) and is a Spanish-English translator. We compared the circumstances of our lives during that visit and through a continuing e-mail dialogue. Isabel is descended from Spanish aristocracy and before the revolution her family had several homes, yet she told me of a poignant moment looking out the window of her private school, seeing poor children begging in the streets, and her sense that "things shouldn't be this way."

Isabel often declares her gratitude for the Cuban revolution. She lives around the corner from her daughters in a typically run-down tenement apartment building, with little evidence of material wealth in her humble abode, but she says that her life is rich with friends, family, and spirit. She has a positive outlook despite forty years of sacrifices, but continues to struggle with many everyday issues, particularly finding food and medicine. She wishes that she and her family could travel freely. The U.S. embargo has had a significant effect on every Cuban, as has their government's policies, but they are amazing survivors and very resourceful.

This first visit gave me a thirst to know more about the cultural life in Cuba, so when I was offered the opportunity to return in December 2007 I barely hesitated. A documentary photographer friend who had been visiting Havana frequently, taking photos of murals and delivering medical supplies, invited me to join a group she was taking to meet artists, including the community-based group called Muraleando. I was thrilled, loaded up my suitcases with medical supplies and other donations from neighbors, and received a license to travel there from Caribbean Medical Transport.[1]

One of the highlights of our ten days in Havana were the two days we spent with muralists and community artists who have transformed their poor neighborhood, Lawton, turning it into a thriving cultural center, Muraleando. Vibrant murals cover buildings everywhere, and sculptures sprout from the sidewalks. The murals are massive productions, created with paint donated by foreign artists, collaborators from Brazil, Germany and elsewhere. The imagery is playful, mythic (from Afro-Caribbean stories and spiritual traditions), and sometimes historic. It was a joyful place to spend time, especially since they had a community musical and theatrical festival timed for our visit, with youth participating in a dramatization about the Orisha goddess, Yemayá.[2]

Another highlight was meeting the well-known tile and mosaic artist, José Fuster, who has transformed his home and his community with huge mosaic sculptures, spreading like a magnificent tropical growth over the yard, the rooftops, and the walls in Jaimanitas, with fanciful animals, flowers, planets, and women, a Picasso- and Miro-inspired fantasy world covering every surface. This charming, self-taught artist and fisherman has become quite wealthy by Cuban standards, by selling his tiles to busloads of tourists. He sat us down in his mosaic-encrusted video screening room to watch footage of the filmmaker Michael Moore's visit to his home the previous year. Members of our group donated a tile mosaic that had been enthusiastically created at Ventura Community College and carefully carried from Ojai, California. It was installed on a wall around the block from Fuster's house while we were fed an abundant Cuban lunch of rice and beans, and fish caught that morning. As the new mosaic was dedicated, Fuster said in his speech that he envisioned mosaic tiles creating a bridge between California and Cuba.

Both visits, to Jaimanitas and Muraleando, gave us a glimpse of a work by artists who delight the communities' and tourists' eyes, and who have found ways to support their habit of making beauty in a tourist economy.

Yet I wondered how this particular art market coped with other sorts of content, artwork that looked at the problems within Cuba. Was there art about free-speech issues, frustrations with job satisfaction and pay, the diabetes epidemic, and the inability to freely travel? Would it be visible or hidden? Would it be allegorical like much political art produced in the former Soviet Bloc countries? Was socially engaged art taught in the schools, in the various ways this book encourages?

As our bus traveled the streets of Havana we saw how artists are commissioned to create state-supported, political, very visible billboards depicting Bush as Hitler (with the caption "Say No to Fascism"), admonitions against El Blocqueo,[3] and disturbing images criticizing Abu Ghraib. Some billboards are examples of the "hitting–you-over-the-head" political art, and others use irony and sophisticated contemporary art strategies to make their messages tangible.

We met sculptors who have done some of the most important public memorials for the martyrs and the heroes of the revolution (by Emilio Escobar) and a huge, neoclassical bust of Che Guevara (by Rene Negrin). Che is basically the logo of Cuba now, on every ashtray, cap, and wallet, so it is hard to look at his portrait with fresh eyes. But this sculpture of Che, looking like a Greco-Roman god, was captivating, as was Negrin's story of the journey of this sculpture, from being accepted to being thrown into disgrace, and later receiving accolades.

In subsequent days we visited the studios of successful male artists who show and sell their work abroad and who live and work in palaces relative to their highly skilled female counterparts who are working in their kitchens on small easels or tables. It appeared from my limited perspective that sexism was alive and well in the Cuban art world.

The artists' work varied in style. There were lush and eerie landscapes, skillful Op Art renderings of fruit, decorative ceramics, and serigraphs filled with floating nudes, but I saw little content that might be considered socially engaged.

Some of the artists we met are teachers at a prestigious art school, Instituto Superior de Arte (ISA), in Havana. We visited the school briefly one afternoon and I was able to talk with a printmaking teacher about the process of being selected for the school. It is an intensely competitive process in which students have to meet rigorous formal standards in their local schools, then compete regionally and finally on the national level to secure the very few spots at ISA. The students receive full support from the state once they are accepted into the program.

When I asked the teacher how much social engagement or community-based art is part of the curriculum, it seemed that he did not understand me or did not want to appear that he had. He said that they are teaching formal skills and developing high standards of quality. It made me wonder whether the art education being offered questioned the seductions of the marketplace, or whether the material poverty in Cuba had made the young artists unable to see other options.

My answers came after my return home, from speaking with Beth Ferguson, and doing more research. Cuban artists who leave Cuba can make art critical of things in Cuba, but it is extremely difficult to do such work in Cuba unless it is allegorical, at the risk of getting in trouble. Cuban hip-hop, like the work of the Orishas, has become extremely popular and does deal with racism against Afro-Cubans, but the artists who created the music live abroad. The street puppeteers do create incisive commentary about problems in Cuba, particularly in relation to environmental and women's issues, but they also make work to entertain the children in the neighborhoods, so they are valued and supported. If they were to make a piece that openly criticized the government they would probably go to jail, according to Ferguson. She also told me that there are several printmakers teaching at ISA who make prints with social content, especially about the Balseros, people who are so desperate to leave the island that they risk death on rafts in the open sea. Again Ferguson said that the teachers would never encourage students to make art critical of

the Cuban government, but work critical of the United States or examining social issues outside Cuba would be fine.

A more complex understanding of culture in relation to recent Cuban history was offered to me during our visit to the art- and bird-filled apartment of one of the heroines of the 1958 revolution, Natalia Bolivar. This strong-jawed elder had a daunting presence forged by years of fighting life-threatening battles and smaller skirmishes. When she talked she was like a scroll filled with powerful images that kept opening up and revealing another one. I was as awed by her art collection as I was by her tales of her emerging life as a Santera,[4] that led her from the privilege of her aristocratic line (she's a descendent of Simon Bolivar) and wealth to the warm embrace of her nanny's spiritual tutelage.

After I heard her shocking stories about the brutality of being tortured by Batista's[5] men (she lost hearing in one ear, had all of her ribs broken, and was raped multiple times), her vast art collection made me think about how much she had healed from such a tremendous shock. She had intended to be an artist and was proud to tell us that she had studied with Norman Rockwell, Will Barnet, and others at the Art Students League in New York City, before the revolution. When she learned that I was an artist who taught and made art for social change, she pointed out a painting she had done, when still a student, of slaves being brought in boats to Cuba. It was a poignant history painting, full of disturbing imagery.

I looked around the room to see how the walls were painted with im-promptu murals in places, and saw, among her private art collection, the movement from abstract to naïve to expressive to political to classical images, and became pensive. Here was someone without artistic prejudices, who had the privilege to enjoy both the aesthetic richness of the world and the depth of understanding to embrace the thorny with the smooth. Her collection made no distinctions between high and low art, the popular, the spiritual, and the socially engaged. There was no pretension. The collage of art and artifacts said loudly and clearly, "You can be an artist, too."

This visit made me wonder again about what it would mean if everyone felt entitled to art, healed and empowered by it. From my discussions with Beth Ferguson, Isabel, our guides, and the artists we met, I had a sense that art is highly visible and respected in Cuba, and it is not seen as an elite activity, but rather as one that everyone can participate in, even if they are not able to secure one of the coveted seats at the prestigious art school, ISA. But the most skilled of the artists struggle to get their paints—they need to sell their art to eat and to continue to make art. Without dealers or connections abroad, they cannot support their work, even though the government paid for

their education. The community-based artists have the ingenuity to serve the community and bring in the tourist dollars. Ferguson says, "There is a lot of trickle-down, where social engagement functions in a slightly different way. It's amazing that people can accomplish what they can with so few resources. It's inspiring, but families encourage their children to become artists so that they can find a way out, and Cuba has lost generations of artists because of this." Afro-Cuban folklore subject matter, where Cuban pride resides, has become the comfort zone for many Cuban artists, and a way to support their belief in a culture, where so many freedoms are inaccessible. Yet despite this lack of freedom, the government meets many basic needs much better than governments do elsewhere in the world. This is particularly obvious when the world witnesses their frequent acts and offers of humanitarian aid, and their ability to organize to evacuate huge numbers of people when faced with a Category 4 hurricane (unlike our own government's sickening inadequacies in this realm, with Hurricane Katrina, for example). Additionally, the evidence of a new government-sanctioned gay rights movement (President Raul Castro's lesbian daughter's leadership has been significant here) shows the capacity for this society to learn and grow.

After considering all the contradictions in Cuba, I am left with questions. What would a truly liberatory art practice look like? Is this a country where it might take hold as the next generation matures and takes leadership? If the embargo ended, and Cuba could trade freely, would their restrictions on free speech and travel be lifted? If artists felt free to tell their truths, and were still offered free education and state commissions, would that allow for a true cultural democracy? If not, what would it take?

Good Intentions, Rotten Pie

Not long ago I received a phone call from the student of a colleague in Southern California. My colleague had introduced this student to my work about women's body image through my artist's book, *One Size Does Not Fit All*. This twenty-seven-year-old student wanted to write her junior thesis on ways to transform the media so that women wouldn't feel so abused or oppressed by anorexic models or airbrushed stereotypes. She said she was tired of looking at the multiple causes of body hate and wanted instead to work proactively on solutions. I asked her to tell me more about her plan. She said that she had plans to work as a consultant to ad agencies to help them develop more respectful attitudes toward intelligent, educated female consumers. She noted that the women she knows realize that the media images encourage self-hate but they still continue to be obsessed with perfecting their bodies. By altering

the content of those media images, she believed her friends' behavior could be modified and improved. I was disturbed by her theory.

I asked her if she had studied media literacy. She said no, but she felt that she understood how the media functioned. I asked if she had noticed that the media eventually co-opts everything that is progressive, in its ambition to bend every value to serve its will. Would she look at how revolution, diversity, and ecological thinking had each become the latest, hippest way to market, to promote whatever product that they wanted to promote? I wanted this young woman to understand that shifting the marketing practices of groups whose bottom line is *profit* might not ultimately help the women she wanted to help. I continued to ask her questions, curious about her understanding of patriarchy and capitalism, and hoped her good intentions would not be overwhelmed by the tale of the "rotten pie." I talked about how new models of how to promote products might be introduced in a different economy. She seemed baffled, so I continued to share with her an understanding that I gained from Chaia Heller's ecofeminism class at ISE over almost two decades earlier.

Providing greener products to consumers, or less oppressive imagery to market those products, while seemingly helpful in the short term, is a liberal project that ultimately does not shift power relations or encourage people to create non-consumerist ways of solving the environmental crisis, sexism, or racism. We need to be thinking about strategies that shift the marketplace into a community where goods are purchased for their inherent value, and where people share, trade, barter, and invent new forms of exchange that do not impose slavery and objectification on some and while grotesque wealth and control of resources are accumulated by others.

Although I am fairly certain that my ideas sounded deranged or foolishly idealistic to this woman, I asked her to imagine where all the resources and energy to make these greenwashed products would come from, and on whose backs they would be made. I also suggested that developing a collaborative education project that trains young people to look more critically at ads, and to act creatively in response to them, might have a more long-term effect.

Seeing the whole system in its corruption is quite difficult for people who have lived in a trance most of their lives. Imagining the changes that might be necessary to truly disrupt an oppressive economic system takes extra effort and time. Many people want to find easy and practical solutions that won't disturb their privileged lifestyles. But those little adjustments and reforms, like helping the ad agencies see women as people, or creating an all-women ad agency, does not educate people about how the current system reinforces hierarchy and has to oppress others by its very nature.

Our phone conversation likely scared this woman away, since I never heard from her again. I realized that without the space and time to listen, to be more curious about her goals, I may have made some assumptions, or pushed her too far "outside the frame." I hope that whatever discomfort she felt did not make her completely dismiss the challenge I was offering. It's possible that a seed planted by my questions will sprout in her future.

Reaching for the radical—the roots of an issue—does not seem like a fool-hardy task in this moment, and educating people toward a whole systematic way of looking at things is crucial. While sharing the possibility of baking a new pie may feel too demanding or overwhelming to some, it is important to remind them that rolling out the dough for the crust may be all that is required of them. Others can make the filling and bake it.

The Dream Behind the Nightmare

I am lying on Karen's treatment table, face down in the cradle, and she is work-ing her special magic on the spaces between tissue and bone, the land of the dura, the layer between skin and organs where so much is negotiated. I call Karen the Great Unraveler. She untangles my parasympathetic nervous system in ways that I can't understand, soothing the inflamed, loosening the rigid, allowing me to continue my work. I am so grateful for this kind of healing.

Without alternative healers, people who have had the courage to chal-lenge the pharmaceutical industry (that would like to sell you pills to make the pain go away), I would likely be disabled, if even alive. My journey to full-fledged health, after years of chronic illness, required a bucking of the standard script (science will heal, everything else is quackery), enormous tenacity and a willingness to take risks with our limited resources.

Karen and her cohorts represent a long resistance movement against the dominant health-care profession that shifted profoundly in the United States, partly as a result of the Civil War (with quick amputations and surgeries on the battlefield heralding the advent of quick pain relief) and the formation of modern medical schools in the late nineteenth century. The latter institutions became the gatekeepers for what could and could not be considered a healing modality (not unlike the effect of modern art schools determining what art can be considered valuable). Add to these factors the profit motive, which has turned illness into one of the gross national products of the United States, and there is really little incentive for the corporate medical industry (and its insurance boss) to change and focus on actually healing people. Nevertheless, people devoted to wellness—both allopathic and naturopathic doctors, among

others who have retrieved older manners for healing—have existed in the margins and proliferated. The battles to do the work they do have not been easy ones, involving years of ridicule, legal opposition, and loss of income.

The growing acceptance of the work of alternative healers, many informed by a unique blend of modern science and ancient protocols (often perceived as irrational by modern scientists), is quite stunning. The next hurdle for these pioneers to clear is how to make their work more affordable. The Wellness Project on the island where I live offers the same quality of healing to low-income people, and I hope that many models of this sort are blooming or will bloom in communities around the country.

Resistance movements and reconstructive (or visionary) movements have influenced progressive changes in many professions, such as law, education, and agriculture. *Yes! Magazine* and a few other alternative magazines have done a good job of reporting on these shifts along these edges. In each case it's been a fight against commodification, dehumanization, and homogenization—the latter all in the service of profit—and it's been a move *toward* democratic principles and integrating wisdom, some of which appears irrational. We need to celebrate and acknowledge these shifts in these difficult times.

I started this book with a clear understanding that my work as an artist-teacher has located itself differently from work that supports the status quo. The cliché, the bumper-sticker admonition, is to *subvert the dominant paradigm.* I think the many examples I have provided take you down that road and then some. Now I am going to stretch this path wider, by telling you about some other influences, both ancient and relatively recent.

My dream life marked me as weird and different early on. My father, a scientist, scorned mysticism and intuition, anything not verifiable. So any investigation of this topic was not considered valuable, and I refrained from bringing that side of me to our conversations, but continued to explore the territory with curiosity on my own.

When I was younger I didn't know about indigenous cultures where the dream life of individuals affected the life of the collective, where without dreams the culture would suffer immense pain and unmooring of its values. But by the time I was a teenager, I had started to paint my dreams, and share them with an elder who understood bits and pieces of what dreams might signify. I learned that dreams can take us to places that our conscious minds are afraid of, and that my unconscious was working diligently to heal and speak to my conscious mind every night.

While explicitly making images and objects from my dreams has only been a part of my art practice, I am recognizing as I age how key it is to do this sort of work as part of a path for social change.

In recent years, I have been part of a women's dream group on Vashon Island. "Working" my dreams and those of the other women's to see what they reveal, through sand tray techniques, role playing, movement, and drama has become a rich part of my inner life, and is having a perceptible effect on my outer life, both being part of my creative life. In fact, *the sweet ball of a girl* I've written about arrived through a lucid dreaming process.

Most recently I attended a workshop with renowned mythologist/story-teller/drummer Michael Meade. He is a teacher and healer who has been influenced by depth psychology and Jungian dream work and just so happens to live on Vashon Island. One of his intentions is to share the teachings of ancient stories to help people cope with the challenges of living in this end time,[6] not as a placebo that will allow people to abandon responsibility for doing something, but to awaken us. He also is deeply engaged with helping each individual find the special gift that she and he have been carrying since birth, a gift that needs to be nurtured in order for the world to heal. He speaks about the various infrastructures of the world crumbling around us, and of those who are awake and curious and are looking for ways to understand and alleviate this suffering and move toward something beyond despair. Michael tells stories he has gathered from indigenous cultures around the world: about the birth hidden just beyond the death, "the world beyond the world" (the world of meaning that exists outside the ticking clock of our modern world), and helps his students become aware of the circle of life that cannot be broken by people who have failed to grow up (our warmongering leaders, among others). He calls upon his students to truly awaken to their life's path, and carry their precious thread into the weaving that needs to be woven.

While sitting in his audience and vibrating to the rhythms of his drum (embodying the work through vocalized rhythm and physical movement is essential to this process), I listened carefully to a story about a man looking for a key on the ground in the middle of the night. He was locked out of his house, so he fumbled around on all fours desperately searching for the key in a little circle of light. A friend came along and asked him what he was looking for and if he needed some help. The man said yes, so the two of them kept searching in the little circle of light. Eventually the friend asked, "Are you sure you lost the key right here?" And the man said, "No, I actually lost it over there somewhere," pointing to a spot in the darkness, some ways a way. So the friend asked him, "Why are you looking here then?" "This is where the light is," the man answered.

This simple, old story contains big wisdom: the answer is located "outside the frame," but it requires going outside the habits of the rational mind, a mind that is avoiding what it fears. It takes a friend (community) to support us and

push us away from delusion and into the uncomfortable, more-lost space, where answers might be available. In a similar vein, my quest to understand the insanity and confused values guiding our current society has required going outside the circle of light. I have many useful tools, but sometimes the explanations provided by critical theory, feminist theory, and social ecology are not sufficient, even though they greatly expand the circle of light, and poke into the darkness without hesitation. The tasks ahead of us require the courage of diving into the shadow world and owning it. It can be done through dream work, ancient myths, the sacred realms of meditation, or the anxious space of creating something unknown, and seeing what answers for the collective can be found in that seemingly messy compost. When this ancient story hooked into my fascia, the cynical and skeptical New Yorker within me had to stop her critique of all things amorphous and let the spiritual work take a seat.

This story also speaks to the fears my students face when truly encountering the creative process for the first time, and it speaks to my own inner battles with a stuck imagination. As a result, I am more actively bringing this dream and myth work into the classroom for interested students to access. Our students' skill bag would be incomplete without this archetypal piece of the puzzle.

Michael Meade's fresh look at the end times renewed my commitment to my work and the doors I have yet to open. While some people are hoping for an apocalypse as a great cleansing of the corrupt values guiding our society, and others are dreading the civil wars and hardships that may visit more and more of the world's population, my teammates and I are looking in the cracks, trying to nourish what emerges in them. This does not mean that we are busy with repairing the current system. We are trying very hard to give people the tools to create a new one, one that serves the needs of more than a few.

A couple of years ago, the late Michael Rossman, archivist/activist/naturalist extraordinaire, was taking me on a special activist art tour of Berkeley. While Michael's animated stories of the murals and public art were poignant and all the more meaningful since he had lived through much of the history of the student and popular struggles, the most memorable moment occurred while strolling on an ordinary street corner. His eyes lit up and he pointed with passion at the ground, and excitedly insisted that I look. I looked down expecting a spectacular insect, some surprising piece of graffiti, but initially I was baffled. He said patiently, "Look again." I strained my eyes, and then realized that he was pointing at some wild green vegetation coming up between the cracks of the sidewalk. I smiled and said, "Yes, Michael, I know." We smiled broadly at one another, hugged, and continued our walk.

A Crack in the Now

"Another world is not only possible, She is on Her way.
On a quiet day, I can hear Her breathing." —Arundhati Roy

I rode my bike to the farmer's market a few weeks ago, passing cars with bumper stickers all the way. "Mean People Suck" and "Bring Democracy to America" were just a sampling of what's available in our local culture. When I got to the village green, I was delighted to see people I haven't seen for months. While standing in line at one farmer's stand, an unfamiliar man asked me where he could buy organic ice on the island. I laughed, and thought what a reputation this place must have, and how privileged this place has become. Not that long ago it was referred to as "the hippie island" or "the artist's island," a place where back-to-the-land folks and bohemians would come, with no money, to carve out a different lifestyle. Now, like most of those places that were inexpensive and innovative several decades ago, Vashon has become gentrified—a place where the well-heeled retire or find a second home. Yet despite the cost of real estate (and more recently the rising cost of food, gas, and ferry tickets), the artist community has remained strong and progressive politics continues to inform the culture here, occasionally manifesting significant cultural and social projects, like the Backbone Campaign,[7] the Islewilde Community Arts Festival,[8] Vashon Household (low-cost housing to keep the island economically diverse), the Wellness Project (low-cost alternative health care), Sustainable Vashon, Vashon Islanders for Peace, SEEDS, and—well, the list could continue for another page. This community, with more organic farms per capita than anywhere else in the state of Washington, seems to recognize that we need to develop more tools for dealing with the continuing economic and growing environmental crises. Yet there are so many contradictions, not the least of which are the lack of cultural diversity and the "moat factor" that turns this place into a de facto gated community. The latter issue disturbs me more than any other, the idea that somehow we can separate, secede from what's going on elsewhere, hide from the craziness, and then there's the smugness that often emerges from this state of mind; it's a survivalist mind-set combined with a "we've got it together" attitude. Not pleasant. Those we hang with here are not smug types; they put in their time doing what they can to help people, through education, donations, and more. Yet there are plenty of people, here and in many wealthier communities, who are still saying, despite the wake-up calls of gas and grocery prices, that the problems out there are not theirs, or that there is nothing they can do. These attitudes, among many others, are what propel me off the island into my work on a kind of frontline.

So when people say, "that's so sixties" (or sometimes "seventies"), I often draw a blank, because those values have never stopped informing my life, and many of our friends far and wide have been similarly and continually informed by them. When people from my past reveal that those values no longer guide them, I become reflective about what might have caused their falling away.

What makes people turn away from social engagement? What bitterness, fear, cynicism, or series of rationalizations informs that choice? I am continually curious, rather than judging out of hand. Sometimes people have good reasons for stepping back from their sense of obligation to community or society, recognizing that self-care is part of the work. Sometimes there is world-weariness, a need to rest and reclaim joy, and that might be just as necessary for healing the world as any deliberate action to shift things. But it seems that if we don't take up the work of social engagement cyclically, we will lose the momentum we need to shift things.

We live in such an interesting time, and I have the privilege of seeing it so. For many this is one of the grimmest chapters in human history, where enormous wealth and extreme corruption are breathing simultaneously with the daily misery of despair. Refugees displaced, children with no sense of future, intricate and cruel oppressions born of fear, daily survival—these push possibilities for art and self-growth to the side, probably for a whole lifetime. When I wake up in the morning, and it is only the peaceful green of the woods and the joyous light of the dawn that greet me, I feel the preciousness of this time and this place. I have no daily needs that can't be met at the moment (although the current rising prices of gas and food, may change that sooner rather than later). Still, for now, all I must do this day is feed my son, get him to school, go to my school, teach my classes, read my e-mail, do my chores, and stretch my body. And I have found a way to be engaged with what gives me the most juice, writing this book, making meaning through art, a privilege everyone should have. It is a good life when I can keep the worries and anxieties at bay, and one that I feel needs to be used to help others live with as little suffering as my current life offers me.

Recently my son saw an open copy of *New Internationalist* on our kitchen table. Glancing down at the magazine he saw a photo of a mother and child living in a shack in Bangladesh, a mother and child who have to wade through toxic waste every day. He cried out to me in rage: Why is this depressing magazine on the table? Why are people living this way? What can we do about it? At age thirteen he wants to play and have fun, as he should, but almost every day the deep contrast of his privilege and the horrors elsewhere fill him and he asks me for answers. The optimistic words I try to offer frustrate him. I tell him that his father and I are working hard to awaken others, but it does

not soothe. It seems too pat an answer for his needs. I offer him strategies: make art or write about it, find friends to talk with, create a support group and decide on one small action, research more about the issues—but he is not convinced by any of this. I tell him to take a walk and look at the beauty we have around us, to breathe into his belly (in breath, out breath) and to think about whether his despair will benefit that mother and child, but by then he has usually moved on to another issue.

Imagine being an alert and sensitive young person, with few skills for understanding or knowing what to do in response to what is happening to our world, and multiply it by millions. We need lots more teachers doing this work, lots more, each bringing their gifts forward as an antidote to despair. It is this impulse that has guided the writing of this book.

One of the best things about traveling is the random conversations you can have with locals and fellow travelers about the serious challenges facing the world. Sometimes I bring them up, and sometimes the people I am talking with bring them up. It is always fascinating and often disturbing to hear how people cope with the possibility of mass extinctions as a result of human greed and fear. My inner cynic and my inner idealist are often in debate about the challenges we face as a species, and I haven't yet figured out how to resolve the conflict. It seems that it is best to hold the whole quandary in limbo. After all, it is truly arrogant to think one has figured it all out.

In a cab racing down the superhighway to the airport in Cancun (post-Havana) I had a long, conversation in broken Spanish with the young Mayan driver. We talked about our families, where we grew up, and about the effects of tourism and globalization on his life and on mine. At one point I decided to take the conversation into a wider territory, and I asked him what he thought about the world environmental crisis and the possibility that, within a few decades, global warming would put his whole community and much of the coastal areas of the world under water. He told me about the Mayan prophecy that there will be a major world catastrophe in the year 2012, and he added some details about the nature of the catastrophe that I couldn't understand fully (perhaps not being fluent was a blessing this time). It was something to be bumping down this superhighway at breakneck speed, contemplating the conflagration, the inundation, and the explosion. It was hard to imagine life continuing beyond that event. At that point I did some mental calculations about what age my son will be when such a mess might occur (seventeen) and I just wanted to weep. The tragedy that might unfold seemed and seems beyond what my heart and mind can hold. The cab driver and I talked about how important it is to enjoy what time we have, and then I had to remind myself about something that I am always reminding myself: nothing is written

in stone, nothing is certain, and deciding that the ship has sunk when there is still a chance to fix it is pure negative thinking (and part of my peculiar, but very ancestral addiction to worry). Yes, yesterday's news reported that some scientists are now saying that due to permafrost melt and the methane gas released, climate change will proceed at such a pace that humans may be extinct in a hundred years. But we still have to move forward with a sense of future and with some grace in our steps. It is truly paradoxical that we can make ourselves feel better by fixating on a doomsday scenario—sometimes it seems like the ultimate in rationalizing for those who wish to have a life of denial and self-indulgence.

So, as artists who engage with this gradually unfolding apocalypse, and teachers who engage with our students, we have a lot on our collective plates, and a sense of urgency about our work. Yes, the socially engaged artists of our parents' generation were also passionate about erasing social injustice and lifting the world out of oppressive systems, but it seems to me that there has never been such a multiplicity of messes facing humankind. Perhaps every generation has this sense of self-importance and overwhelming pressure to solve things before it's too late, but I think not.

I have had a sense of mission in writing this book, a sense that many activists own, that we are running out of time, and, in this time that we have, we have to convert hundreds of thousands of other artists to this calling. This has to be a diverse movement of activist artists if it is going to work, and it will have to be sneaky, smart, and effective. Artists will have to make work that helps their audiences overcome their learned fears about art, and empowers them to make their own stories emerge. With each unfolding of a person's story, a life becomes less alienated; a person becomes more connected to the whole. We have to be persistent and patient, open-hearted and ruthless in our risk-taking. We no longer have the luxury of waiting generations. Our window of opportunity is only open a small crack, and we need to stretch it as far open as possible. And remember that we don't need to do this work with the painful intensity that will scare away potential joiners. We need to do it with a joyful sway of our hips, with the pleasure of knowing that we have given our all.

Folding In the Roar

One day our sweet ball of a woman was trying to pretend she was invisible as she cautiously explored the city, searching for hidden gardens. She realized that she had entered one of those bad action-thriller movies with so-called heroes attempting to track her down, imprison her, and add more folds to her already creased surfaces. At every turn in the road when it seemed there was no hope,

people from the gardens popped up out of nowhere, to show her a strategy that made escape possible. They said, "unscrew this screen" or "walk more slowly than those who are hunting you" or "wait until night when they are sleeping," and so she traveled through an elaborate labyrinth, with fellow gardeners finding her just when she needed them, and soon the bad action movie seemed to collapse in on itself from exhaustion. Some so-called heroes and their devoted fans went home to sit with their folds, staring at wide, high-definition screens, looking for facsimile roses, but the screens were silent or full of static. Eventually some of them began to hear an insistent humming that drew them out into the streets. There they blinked at an unfiltered chaos, feeling dazed and bewildered.

At first it appeared to be a very frightening scene, replete with screams, smoke, and shots ringing out. Lines of folded-in people dressed in riot gear stood in formation, surrounding the still-standing palaces of commerce, and roared in anger at the crowds swarming in the square.

But just beyond the edges of the burning of eyes and ears was a humming. It throbbed around the corners of the buildings, coming closer. Somehow the rhythms created stillness in the midst of the confusion, causing a different kind of energy to bounce off plates of glass and steel. And in the center of it were sweet balls of people, some with feet dug in the dirt, arms outstretched and embracing, singing their roses. Very slowly, oh-so-slowly, their folds stretched and blew in the square, touching lightly, then embracing and becoming braids of folds. The braids grew like giant tentacles reaching across the square and pulled on the edges of things: on the fearful ones who were still dreaming of paychecks, and the ones who only knew fake roses, and then the roar itself was held firmly, folding in, so that the people could continue unfolding.

The sweet ball of a woman was alert to the cacophony of sound that poured from all directions at once. In the distance she could hear intensifying violence, and she realized that there was no running from it. She had dreamed of this moment many times, with either tanks or helicopters or bombers coming from all sides, with no escape. As in those dreams, her impulse was at first to run and hide, but a stronger inner voice told her to sit, to just sit. And apparently others were hearing those same inner voices at the same time. As she found the closest sitting rock and positioned herself as comfortably as she could, others in the crowd found their own ways to stillness. In her peripheral vision, she saw hundreds of dancing Shivas, fierce yoga poses, and people very peacefully standing and lying down, like pivot points of calm energy ricocheting across the square. A momentum seemed to be building everywhere at once but she closed her eyes and stayed with her breath.

The interior of her eyelids and forehead had become a screen onto which familiar yet strange images seemed to be projected. She saw wondrous things

she had imagined for decades begin to manifest: the slick ads on billboards seemed to melt away, their surfaces covered by poems, children's collaborative projects, and neighborhood green maps. She saw sumptuous gardens of all sizes accommodating hundreds of activities, zany and friendly public art attached to fences and gates, and murals that climbed up bare walls like luscious vines. The acrid smells of the square were replaced by the competing fragrances of locally grown foods cooking in large, playful outdoor kitchens that connected adjoining communities into a river of potlucks. Music poured from pedestrian malls where dances were improvised and continuous; griots and performers shared their stories of being folded in; tree houses and domes made from recycled skyscrapers sprouted wherever there was a need or a desire.

There was also lots of grieving and honoring, raging and storming, for many, many people had generations of healing to do, and the repair work of the planet was overwhelming and tiring, and not without worries, because people were fallible and often foolish. She felt elders and youth, like ghost spirits, walking though the warm air surrounding her seat, touching her head lightly. Their hands said, "this time around will weave things in new unexpected ways."

She returned to her breath and realized that many of the growing multitudes seemed to be engaged in a process similar to her own. A laugh erupted deep in her core, and as she wiped tears from her cheeks, she found herself humming into the swelling sound. Imagining a toothless lion, they all moved as one, without fear, into the roar.

Appendix

Interviewed Artists' Contact Information and Websites

Jerri Allyn
allynjerri@gmail.com

Karen Atkinson
karen@karenatkinsonstudio.org
atkinson@calarts.edu
www.gyst-ink.com

Deborah Barndt
dbarndt@yorku.ca
www.yorku.ca/comcult/frames/staff/profiles/barndt.html

Nancy Buchanan
buchanan@calarts.,edu
http://nancybuchanan.net

Emily Caigan
caigane@newpaltz.edu
www.scaledances.com/What

Elaine Carol
elaine-c@mdi.ca
www.miscellaneous-inc.org

John Feodorov
John.Feodorov@wwu.edu
www.johnfeodorov.com

Beth Ferguson
bethjeanferg@yahoo.com

Ruthann Godollei
godollei@macalester.edu
www.macalester.edu/art/ra.html

Magdalena Gomez
amaxonica@mac.com
www.amaxonica.com

Olivia Gude
gude@uic.edu
http://spiral.aa.uic.edu
www.cpag.net

David Haley
d.haley@mmu.ac.uk
www.artdes.mmu.ac.uk/profile/dhaley

Keith Hennessy
keith@circozero.org
www.circozero.org

Stephanie Anne Johnson
stephanieannejohnson@earthlink.net
www.lightessencedesign.com

John Jordan
john@labofii.net
www.labofii.net

Richard Kamler
richardkamler@sbcglobal.net
www.richardkamler.org
www.peacebillboards.org

Sarah Kanouse
sarah-kanouse@uiowa.edu
www.readysubjects.org

Suzanne Lacy
slacy@otis.edu
www.suzannelacy.com

John Jota Leaños
jleanos@cca.edu
www.leanos.net

Loraine Leeson
l.leeson@uel.ac.uk
www.cspace.org.uk
www.volco.org
www.ypg2rd.org

Ju-Pong Lin
neighbor@juponglin.net
jupong.lin@goddard.edu

Fred Lonidier
flonidier@ucsd.edu
http://depts.washington.edu/civilr/BPP_photos.htm

Amalia-Mesa Baines
amalia_mesa-bains@csumb.edu
http://vpa.csumb.edu/faculty/mesa_bains.htm

Mindy Nierenberg
mindy.nierenberg@tufts.edu
www.tufts.edu/home/studentlife/gallery/art_social_change
http://blogs.uit.tufts.edu/artistsaschangemakers
http://activecitizen.tufts.edu

Devora Neumark
fireside@progression.net
www.devoraneumark.com
http://engrenagenoir.ca/blog

Sheila Pinkel
spinkel@earthlink.net
www.sheilapinkel.com

Ann Rosenthal
atrart@gmail.com
www.studiotara.net

Martha Rosler
http://home.earthlink.net/~navva/photo/index.html

Gregory Sholette
gsholette@gmail.com
http://darkmatterarchives.net
http://gregorsholette.com

Sharon Siskin
sharon@sharonsiskin.org
www.sharonsiskin.org

Jane Trowell
jane@platformlondon.org
www.platformlondon.org
www.interrupt-symposia.org

Ruth Wallen
rwallen@ucsd.edu
http://communication.ucsd.edu/rwallen
http://sdpalestinianjewishdialog.org

Krzysztof Wodiczko
wodiczko@mit.edu
www.dialogcity.org/artists/krzysztofwodiczko.html
http://architecture.mit.edu/people/profiles/prwodicz.html

Other Practitioners, Programs and Hubs of Useful Information

I invite you to visit two websites: **www.artsforchange.org** and **www.newvillage.net.** At both you will find up-to-date links to the artists, engaged teachers, cultural policy makers, community arts organizations, educational programs, informational hubs and institutions that are connected to the subjects of this book. Out of respect to some of the significant players in the field we are listing them and their affiliations below. As our research, readers and colleagues suggest additions to this list, the online resource will expand. At artsforchange.org, the reader is invited to post questions on the blog <**www.artsforchange.blogspot.com**> and participate in an ongoing dialog and in continuing and necessary collaboration.

Socially Engaged Artists/Teachers
(just a taste of who's out there)

Mike Alewitz Muralist, Associate Professor of Art, Mural Painting program, Central Connecticut State University (New Britain, CT)

Marcia Annenberg Artist, Supervisor, Art Education Program, Teachers' College, Columbia University (New York City, NY)

Jacki Apple Performance Artist, Writer, Faculty, Humanities and Design Sciences, Art Center College of Design (Pasadena, CA)

Lauren Atkinson Artist, Manager, Faculty Development for Arts Corps (Seattle, WA)

Judith Baca Muralist, Community Collaborator, Professor of Chicano/a Studies and World Culture, UCLA and co-founder of Social Public Resource Art Center (SPARC) (Venice, CA)

S.A. Bachman Co-founder of the Activist Art Collaboration: THINK AGAIN, Senior Lecturer, The School of the Museum of Fine Arts (Boston, MA)

Barbara Schaffer Bacon Co-Director, Animating Democracy, Americans for the Arts (New York, NY and Washington, DC)

Lisa Bade Artist, Art Department Chair, Highline High School (Seattle, WA)

Brandon Ballengee Eco-artist (New York, NY)

Lillian Ball Eco-artist (New York, NY)

Claudia Bernardi Professor of Community Arts, California College of Art (San Francisco, CA and Oakland, CA)

Nancy Bleck Instructor, Emily Carr University of Art and Design (Vancouver, BC, CANADA)

Norma Bowles Artistic Director of Fringe Benefits (Los Angeles, CA)

Beth Carruthers Eco-artist and Instructor, Emily Carr University of Art and Design (Vancouver, BC, CANADA)

Lynne Constantine Associate Chair, Assistant Professor, Art and Visual Technology Department, College of Visual and Performing Arts, George Mason University (Fairfax, VA)

Brett Cook Community-based Artist, Muralist, Educator (New York, NY)

Michelle Corpus Arts Teacher, Multicultural Arts School (Chicago, IL)

Dipti Desai Professor of Art Education, NYU (New York, NY)

Ricardo Dominguez Assistant Professor, Visual Arts Department, UC San Diego (San Diego CA)

Ann Douglas Director of On the Edge Research, Professor, Gray's School of Art (Aberdeen, SCOTLAND)

D. Thor Elverum Assistant Professor, Design and Sustainable Systems, Emily Carr University of Art and Design (Vancouver, BC, CANADA)

Wendy Ewald Collaborative Photographer, Senior Research Associate at the Center for Documentary Studies, Duke University (Durham, NC)

Charles Frederick Independent Writer, Performer, Cultural Activist (New York, NY)

Elisa Gargarella Assistant Professor of Art Education, Myers School of Art, The University of Akron (Akron, OH)

Amara Geffen Eco-artist, Director of CEED (Center of Economic/Environmental Development), Allegheny College (Meadville, PA)

Steve Ginsburg Co-Founder of the Hart Beat Ensemble (Hartford, CT)

Eric Gottesman Collaborative Photographer, Community Artist (Cambridge, MA)

Marina Gutierrez Co-Director of Saturday Outreach Program, Cooper Union (New York, NY)

Wallace Heim Faculty, Arts and Ecology MA, Dartington College of Arts (Devon, ENGLAND)

Grady Hillman President of the Southwest Correctional Arts Network, Director of the Center for Community Arts, Texas State University (San Marcos, TX)

Fred Ho Independent Musician, Composer, Author, Activist (New York City, NY)

Grzegorz Klaman Co-founder of WYSPA Institute of Art (POLAND)

Don Krug Professor, Faculty of Education, University of British Columbia (Vancouver, BC, CANADA)

Kirsten Larson and Brendan Hudson Community-based Artists, Lot(s) Maypole Community Garden/park Project (Chicago, IL)

Robin Lasser Artist, Professor, Art Dept, San Jose State University (San Jose, CA)

Bob Leonard Director, Graduate Program in Directing and Public Dialogue, Virginia Tech (Blacksburg, VA)

Lisa Link Independent Graphic/digital Artist (Boston, MA)

Judith Marcuse Dancer, Choreographer, Co-director of the International Center of Art for Social Change, Simon Fraser University, Burnaby (BC, CANADA)

Meena Natarajan Playwright, Executive/Literary Director, Pangea World Theatre (Minneapolis, MN)

Margarat Nee Zine Maker, Book Artist, Member, Grrrl Zines A-Go-Go (Encinitas, CA)

Beth Nixon Puppeteer, Founder of Ramshackle Enterprises (Philadelphia, PA)

Lorie Novak Professor of Art, NYU (New York, NY)

Heather B. O'Reilly Sessional Adjunct & Teaching Assistant, Artist-in-Community Education, Faculty of Education, Queen's University (Kingston, ON, CANADA)

Bob Paris Professor of Kinetic Imaging, Virginia Commonwealth University (Richmond, VA)

Kathy Randels Director, ArtSpot Productions (New Orleans, LA)

Michael Rohd Founding Artistic Director, Sojourn Theater, faculty at Northwestern University (Chicago, IL)

Doug Rosenberg Professor of Art (Video, Performance, Installation), University of Wisconsin (Madison, WI)

Ed Ross Collaborative Partner, University of South Florida Collaborative for Children, Families and Communities or Community Stepping Stones (Tampa Bay, FL)

Jesikah Maria Ross Community Media Artist, Director, The Art of Regional Change, UC Davis (Davis, CA)

Sreejata Roy Community Artist (New Delhi, INDIA)

Shelly Sacks Eco-artist, Director of the Social Sculpture Research Unit and Coordinator of the Earth Agenda Project, Oxford Brookes University (UK)

Suzanne Scott Assistant Professor, Arts & Culture, New Century College, George Mason University (Alexandria, VA)

Judith Tannenbaum Writer, Teacher, Training Coordinator, San Francisco's Writers Corps Program (San Francisco, CA)

Andree Singer Thompson Sculpture/Ceramics Instructor, Laney College (Oakland, CA)

Mario Torero Community Artist, Coordinator of Fuerza (San Diego, CA)

Tom Tresser Cultural Policy Producer, Designer and Community Development

Consultant, Educator, DePaul University and Loyola University (Chicago, IL)

Carlos Villa Interdisciplinary and Painting Undergraduate Faculty, San Francisco Art Institute (San Francisco, CA)

Niklas Vollmer Associate Professor of Film & Video, Department of Communication, Georgia State University (Atlanta, GA)

Harry Waters Jr. Assistant Professor, Theater & Dance Department, Macalester College (St. Paul, MN)

Chuck Wieder Assistant Professor, Art Department, Southern Connecticut State University (New Haven, CT)

Lucy Winner Professor of Theater, Empire State College (Brooklyn, NY)

Billy Yalowitz Community-based Artist, Assistant Professor, Community Arts Program, Tyler School of Art, Temple University (Philadelphia, PA)

Shai Zakai Eco-artist (ISRAEL)

Programs, Places to Study

Below is a small sampling of the many innovative programs around the world. Go to the Community Arts Network website for a comprehensive list of current socially engaged and community arts programs: <**www.communityarts.net/training/index.php**>

Center for Community Art Partnerships, Columbia College (Chicago, IL). Associate Director: Nicole Garneau

Community Arts, California College of the Arts (San Francisco, CA). Chair & Assistant Professor: Sanjit Sethi

Community Arts Program, York University (Toronto, ON, CANADA). Faculty: Nancy Nicol, Maggie Hutcheson, Alberto Guevara, Heather Hermant, Honor Ford-Smith and Deborah Barndt

MA in Community Arts (MACA), Maryland Institute College of Art (Baltimore, MD). Director: Ken Krafchek, Faculty: Jann Rosen-Queralt, Paula Phillips, Fletcher Mackey, George Ciscle, Cinder Hypki, Rebecca Yenawine, Kristina Berdan, Kara McDonagh

Hubs of Information and Useful Organizations
(These are just a few of a much longer list)

Alternative Roots a regional arts service organization that primarily serves activist and community-based artists in the South (Atlanta, GA)

ArtCorps a social justice, arts education organization that focuses on afterschool programs in underserved communities (Seattle, WA)

Art & Ecology Research Unit, MIRIAD Social and Environmental Art Research Centre at Manchester Metropolitan University (Manchester, ENGLAND)

Art for Change art and community organization that explores social issues particularly in relation to cultural diversity (New York City NY)

Art for a Change a working artist's weblog of art theory and commentary by Mark Vallen (Los Angeles, CA)

Art Talk an arts radio talk show hosted by Richard Kamler (San Francisco, CA)

Arts and Healing Network international online resource for those interested in the healing potential of art, especially environmentalists, social activists, artists, art professionals, health care practitioners, and those challenged by illness (Stinson Beach, CA)

Atlanta Partnership for Arts in Learning (APAL) an interdisciplinary, community-based arts education program (Atlanta, GA)

ATSA collaborative urban arts interventions, (Montréal, QC, CANADA)

The Backbone Campaign provides creative tools (puppets, bannering, processions, public interventions, etc.) for citizens and the progressive movement (Vashon, WA)

Caucus on Social Theory & Art Education a caucus of the National Arts Education Association (Reston, VA and University Park, PA)

Center for Political Graphics a non-profit educational archive that collects, conserves and exhibits domestic and international posters relating to historical and contemporary movements for peace and social justice (Los Angeles, CA)

Community Arts Network a comprehensive online portal for information pertaining to community arts, a program of Arts in the Public Interest (Saxapahaw, NC)

Critical Art Ensemble a collective of artists who explore the intersections between art, technology, radical politics and critical theory—a founding member is Steve Kurtz, Professor of Art, New York State University (Buffalo, NY)

Eco-art Network an online network of diverse eco-art practices (INTERNATIONAL)

European Cultural Foundation's Art for Social Change artist & youth projects in eleven Eastern European nations (Amsterdam, THE NETHERLANDS)

Fifty Crows: Social Change Photography couples visual stories from world-class documentary photographers with action and media campaigns in order to effect change (San Francisco, CA)

Green Museum an online, international hub for contemporary eco-art, founded by Sam Bower (Corte Madera, CA)

Imagining America: Artists and Scholars in Public Life a national consortium of colleges and universities committed to public scholarship in the arts, humanities, and design (Syracuse, NY)

International Centre of Art for Social Change a global center for networking, training, professional development, research and community outreach in the field of art for social change (Vancouver, B.C., CANADA)

Islands Institute of Interdisciplinary Studies an online hub for sharing resources, tools and strategies for creating art about ecology and community, (Salt Spring

Island, BC, CANADA)

Just Seeds visual resistance artist cooperative creating posters, prints and publications (Portland, OR)

Littoral a non-profit arts trust which promotes new creative partnerships, critical art practices and cultural strategies in response to issues about social, environmental and economic change (ENGLAND)

Mandala Center for Change a multi-disciplinary education organization dedicated to community dialogue, social justice and societal transformation and a center for Theater of the Oppressed training Founder and Director, Marc Weinblatt (Port Townsend, WA)

Mondo Bizarro A collective of artists creating multidisciplinary art as a tool for understanding what makes us commonly human and individually unique. Co-Artistic Directors: Nick Slie and Bruce France (New Orleans, LA)

Mosaic Multicultural Foundation a network of artists, social activists and community builders (Vashon, WA)

M.U.G.A.B.E.E. (Men Under Guidance Acting Before Early Extinction) music for social change and creative writing workshops, Co-directors: Maurice and Carlton Turner (Jackson, MS)

Northland Poster Collective where art meets organizing (Minneapolis, MN)

PanLeft Productions video for social change (Tucson, AZ)

Prison Creative Arts Project collaboration with incarcerated adults, incarcerated youth, urban youth and the formerly incarcerated to strengthen community through creative expression. Members trained by Buzz Alexander, Arthur F. Thurnau Professor of English Language and Literature, University of Michigan, and Janie Paul, Associate Professor, School of Art and Design and Assistant Professor School of Social Work, University of Michigan (Ann Arbor, MI)

Provisions Library an arts and social change learning resource (Washington D.C.)

Public Domain Foundation: Music for Social Change creates curriculum to both introduce how songs have effected social change and to help artists create and promote such music (Wilder, VT)

Rebel:Art connecting art and activism (GERMANY)

SmartMeme: changing the story a movement of movements using creative strategies to change the stories and change the world within our lifetimes (San Francisco, CA)

The Social and Public Resource Center an arts center that produces, preserves and conducts educational programs and community based public art works (Venice, CA)

Social Sculpture Research Unit encourages and explores transdisciplinary creativity and vision towards the shaping of a humane and ecologically viable society, Oxford Brookes University (UK)

The Social Arts combines artistry and activism (Philadelphia, PA)

Teaching Artist Journal a wide variety of writing about the most innovative and powerful work being done by teaching artists across the US and around the world

TOPLAB Theater of the Oppressed Laboratory (New York City, NY)

Tucson Arts Brigade arts and education organization dedicated to the participatory arts with an emphasis on mural production and professional arts education for youth and adults (Tucson, AZ)

Virtual Concerts, A Public Think Tank podcast interviews hosted by Aviva Rahmani with contemporary eco-artists, environmental scientists and ecological thinkers (Wexford, PA)

Wochenklausur Collaborative Activist Art Group (Vienna, AUSTRIA)

Socially Engaged Art Bibliography

Author's note: In the spirit of working outside the frame, please note that the categories in this bibliography should be seen as porous. In other words, what you see in one category could easily fit in another. You, the reader, can use what suits you, as you see fit.

Activist Art Practice

Art and Ideology. New York: New Museum of Contemporary Art, 1984.

Art As Activist: Revolutionary Posters From Central and Eastern Europe. Washington, DC: Smithsonian Institution Traveling Exhibition Service, 1992.

Artists Meeting for Cultural Change. *An anti-catalog.* New York: Catalog Committee of Artists Meeting for Cultural Change, 1977.

Barndt, Deborah, editor. *Wildfire: Art as Activism.* Toronto: Sumach Press, 2006

Boal, Augusto. *Legislative Theater: Using Performance to Make Politics.* London: Routledge, 1998.

Botey, Mariana and Pilar Perez, editors. *Capitalart: On The Culture Of Punishment.* Santa Monica: Smart Art Press, 2001.

Buhle, Paul. *Insurgent Images: The Agitprop Murals of Mike Alewitz.* New York: Monthly Review Press, 2002.

Buhle, Paul, and Edmund B. Sullivan. *Images of American Radicalism.* Hanover, MA: Christopher, 1998.

Crimp, Douglas. *AIDS Demo Graphics.* Seattle: Bay Press, 1990.

Cushing, Lincoln. *Revolucion! Cuban Poster Art.* San Francisco: Chronicle Books, 2003.

Egbert, Donald Drew. *Social Radicalism and the Arts, Western Europe: A Cultural History from the French Revolution to 1968.* New York: Knopf, 1970.

Felshin, Nina. *But Is It Art? The Spirit of Art as Activism.* Seattle: Bay Press, 1995.

Franscina, Francis. *Art, Politics and Dissent: Aspects of the Art Left in Sixties America.* Manchester, England: Manchester University Press, 1999.

Hadjinicolaou, Nicos. *Art History and Class Struggle.* London: Pluto Press, 1978.

Hardt, Michael and Antonio Negri. *Empire.* Cambridge: Harvard University Press, 2000.

Harper, Glenn, editor. *Interventions and Provocations: Conversations on Art, Culture, and Resistance.* Albany: SUNY Press, 1998.

Heartney, Eleanor. *Defending Complexity: Art, Politics and the New World Order.* Lenox, MA: Hard Press Editions, 2006.

Hemingway, Andrew. *Artists on the Left: American Artists and the Communist Movement, 1926–1956.* New Haven, CT: Yale University Press, 2002.

Hirschman, Jack, editor. *Art on the Line: Essays by Artists about the Point Where Their Art and Activism Intersect.* Willimantic, CT: Curbstone Press, 2005.

Holland, Patricia, Jo Spence, and Simon Watney, editors. *Photography/Politics: Two.* New York: Boyars, 1986.

Jacob, Mary Jane, Michael Brenson, and Eva M. Olson. *Culture in Action.* Seattle: Bay Press, 1995.

Kahn, Doug, and Diane Neumaier. *Cultures and Contention.* Seattle: Real Comet Press, 1985.

Kester, Grant. *Art, Activism and Oppositionality: Essays from Afterimage.* Durham, NC: Duke University Press, 1998.

Lippard, Lucy R. *Get the Message? A Decade of Art for Social Change.* New York: Dutton, 1984.

O'Brien, Mark, and Craig Little, editors. *Reimaging America: The Arts of Social Change.* Philadelphia: New Society, 1990.

Pinkel, Sheila. "Art and Social Consciousness." *Leonardo: Journal of the International Society for the Arts, Sciences and Technology* 26, no. 5 (1993).

Reed, T. V. *The Art of Protest: Culture and Activism from the Civil Rights Movement to the Streets of Seattle.* Minneapolis: University of Minnesota Press, 2005.

Rodriguez, Geno, editor. *Artists of Conscience: 15 Years of Social and Political Commentary.* New York: Alternative Museum, 1991.

Rosler, Martha. *If You Lived Here: The City in Art, Theory and Social Activism.* Seattle: Bay Press, 1991.

Sakolsky, Ron, and Fred Wei-han Ho, editors. *Sounding Off: Music as Subversion/Resistance/Revolution.* Brooklyn: Autononmedia, 1995.

Selz, Peter Howard. *Art of Engagement: Visual Politics in California and Beyond.* Berkeley: University of California Press, 2006.

Sholette, Greg and Nato Thompson. *The Interventionists: Users' Manual for the Disruption of Everyday Life.* Cambridge: MIT Press, 2004.

Von Blum, Paul. *The Art of Social Conscience.* New York: Universe, 1976.

_____. *The Critical Vision: A History of Social and Political Art in the U.S.* Boston: South End Press, 1982.

_____. *Other Visions, Other Voices: Women Political Artists in Greater Los Angeles.* Lanham, MD: University Press of America, 1994.

Walker, John A. *Left Shift: Radical Art in 1970s Britain.* London: IB Tauris Publishers, 2002.

Wye, Deborah. *Committed to Print: Social and Political Themes in Recent American Printed Art.* New York: Museum of Modern Art, 1988.

Zingl, Wolfgang. *Wochenklausur: Sociopolitical Activism in Art.* Vienna: Springer Verlag, 2001.

Art and Cultural Theory/History/Visual Culture

Adams, Laurie Schneider. *The Methodologies of Art.* New York: Icon Editions, 1996.

Atkins, Robert. *Artspeak: A Guide to Contemporary Ideas, Movements, and Buzzwords,* 2nd ed. New York: Abbeville Press, 1997.

Atkins, Robert and Svetlana Mintcheva, editors. *Censoring Culture: Contemporary Threats to Free Expression.* New York: New Press, 2006.

Ault, Julie. *Art Matters: How the Culture Wars Changed America.* New York: NYU Press, 2000.

Barrett, Terry. *Criticizing Art: Understanding the Contemporary.* Mountain View, CA: Mayfield, 1994.

Barthes, Roland. *Mythologies.* New York: Hill and Wang, 1972.

Barnicoat, John. *Posters: A Concise History.* New York: Thames and Hudson, 2001.

Baudrillard, Jean. *Simulations.* New York: Semiotext(e), 1981.

Becker, Carol. *The Artist in Society: Rights, Roles, and Responsibilities.* Chicago: New Art Examiner Press, 1995.

_____. *The Subversive Imagination: Artists, Society, and Social Responsibility.* New York: Routledge, 1994.

Bird, Jon, Barry Curtis, Tim Putnam, George Robertson, and Lisa Tickner, editors. *Mapping the Futures: Local Cultures, Global Change.* New York: Routledge, 1993.

Blandy, Doug and Kristin Congdon, editors. *Art in a Democracy.* New York: Teachers College Press, 1987.

Bolton, Richard, editor. *The Contest of Meaning: Critical Histories of Photography.* Boston: MIT, 1989.

_____. *Culture Wars: Documents from the Recent Controversies in the Arts.* New York: New Press, 1992.

Brenson, Michael. *Visionaries and Outcasts: The NEA, Congress and the Place of the Visual Artist in America.* New York: Henry N. Abrams, 1994.

Clark, Toby. *Art and Propaganda in the Twentieth Century.* New York: Harry N. Abrams, 1997.

Debord, Guy. *The Society of the Spectacle.* New York: Zone Books, 1998.

Dissanayake, Ellen. *What Is Art For?* Seattle: University of Washington Press, 1988.

Dubin, Steven C. *Arresting Images: Impolitic Art and Uncivil Actions.* New York: Routledge, 1992.

Duncan, Carol. *The Aesthetics of Power: Essays in Critical Art History.* New York: Cambridge University Press, 1993.

Duncombe, Stephen. *Cultural Resistance Reader.* London: Verso, 2002.

Edelman, Murray. *From Art To Politics: How Artistic Creations Shape Political Conceptions.* Chicago: University of Chicago Press, 1995.

Fischer, Ernst. *Art Against Ideology.* New York: Braziller, 1969.

_____. *The Necessity of Art.* New York: Penguin, 1959.

Foster, Arnold, and Judith Blau, editors. *Art and Society: Readings in the Sociology of the Arts.* Albany: SUNY, 1989.

Foster, Hal. *The Anti-Aesthetic: Essays on Postmodern Culture.* Seattle: Bay Press, 1983.

_____. *Recodings: Art, Spectacle, Cultural Politics.* Port Townsend, WA: Bay Press, 1985.

Gablik, Suzi. *Has Modernism Failed?* New York: Thames & Hudson, 1984.

Goodman, Lizbeth, and Jane De Gay, editors. *Routledge Reader in Politics and Performance.* New York: Routledge, 2000.

Grossberg, Lawrence, Cary Nelson, and Paula A. Treichler, editors. *Cultural Studies.* New York: Routledge, 1991.

Guilbault, Serge. *How New York Stole the Idea of Modern Art: Abstract Expressionism, Freedom, and the Cold War.* Chicago: University of Chicago Press, 1983.

Harrison, Charles, and Paul J. Wood, editors. *Art in Theory, 1900–2000: An Anthology Of Changing Ideas.* Malden, Ma: Blackwell, 2003.

Hauser, Arnold. *The Social History of Art,* Vols 1-4. New York: Vintage, 1957.

_____. *The Sociology of Art.* Chicago: University of Chicago Press, 1982.

Hebdige, Dick. *Subculture.* London: Methuen, 1979.

Henri, Adrian. *Total Art: Environments, Happenings, and Performance.* London: Thames and Hudson, 1974.

Hertz, Richard. *Theories of Contemporary Art,* 2nd ed. Englewood Cliffs, NJ: Prentice Hall, 1993.

Hills, Patricia. *Modern Art in the USA: Issues and Controversies of the 20th Century.* Prentice Hall, 2001.

Holly, Michael Ann, and Keith Moxey, editors. *Art History, Aesthetics, Visual Studies.* Williamstown, MA: Sterling and Francine Clark Art Institute, 2002.

Kalinovska, Milena. *Rhetorical Image.* New York: New Museum of Contemporary Art, 1990.

Karp, Ivan and Stephen D. Lavine, editors. *Exhibiting Cultures: The Poetics and Politics of Museum Display.* Washington, DC: Smithsonian, 1991.

Kuspit, Donald. *The New Subjectivism: Art in the 1980s.* New York: DeCapo Press, 1993.

Lavin, Maud. *Clean New World: Culture, Politics and Graphic Design.* Cambridge, MA: MIT Press, 2001.

Layton, Robert. *The Anthropology of Art.* Cambridge: Cambridge University Press, 1991.

Lewis, Justin. *Art, Culture, and Enterprise.* New York: Routledge, 1991.

Luke, Timothy. *Shows of Force: Power, Politics, and Ideology in Art Exhibitions.* Durham, NC: Duke University Press, 1992.

Marien, Mary Warner. *Photography: A Cultural History.* New York: Harry N. Abrams, 2002.

McDonough, Tom, editor. *Guy Debord and the Situationist International: Texts and Documents.* Cambridge, MA: MIT Press, 2002.

Miller, James. *Fluid Exchanges: Artists and Critics in the Age of AIDS.* Toronto, Canada: University of Toronto Press, 1992.

Mirzoeff, Nicholas, editor. *The Visual Culture Reader.* London: Routledge, 1998.

Poggioli, Renato. *The Theory of the Avant-Garde.* Cambridge, MA: Belknap Press, 1968.

Preziosi, Donald. *In the Aftermath of Art: Ethics, Aesthetics and Politics.* New York: Routledge, 2005.

Staniszewski, Mary Anne. *Believing is Seeing: Creating the Culture of Art.* New York: Penguin Group, 1995.

Stiles, Kristine and Peter Selz, editors. *Theories and Documents of Contemporary Art.* Berkeley: University of California Press, 1996.

Tomlinson, John, *Cultural Imperialism: A Critical Introduction.* Baltimore: Johns Hopkins Press, 1991.

Van Laar, Timothy and Leonard Diepeveen. *Active Sights: Art as Social Interaction.* Mountain View, CA: Mayfield Press, 1998.

Wallis, Brian, editor. *Art after Modernism: Rethinking Representation.* New York: Godine, 1984.

_____. *Blasted Allegories: An Anthology of Writings by Contemporary Artists.* New York: New Museum, 1987.

_____. *Democracy: A Project by Group Material.* Seattle: Bay Press, 1990.

Williams, Raymond. *Keywords: A Vocabulary of Culture and Society,* revised ed. New York: Oxford University Press, 1985.

Whiteley, Nigel. *Design for Society.* London: Reaktion Books, 1998.

Who Cares. New York: Creative Time, 2006.

Wilson, Robert N., editor. *The Arts in Society.* Upper Saddle River, NJ: Prentice Hall, 1964.

Wolff, Janet. *The Social Production of Art.* New York: NYU Press, 1981.

_____. *Thinking Print: Books To Billboards, 1980–95.* New York: Museum of Modern Art, 1996.

Yanker, Gary. *Prop Art.* New York: New York Graphic Society, 1972.

Art in a Time of War

Al-Radi, Nuha. *Baghdad Diaries: A Woman's Chronicle of War and Exile.* New York: Vintage, 2003.

Andrews, Julian, and Henry Moore. *London's War: The Shelter Drawings of Henry Moore.* Surrey, UK: Lund Humphries Publishers, 2002.

Baigell and Williams. *Artists against War and Fascism.* Piscataway, NJ: Rutgers University Press, 1986.

Becker, Annette. *Otto Dix: Der Krieg/The War.* Milan, Italy and New York: 5 Continents, 2004.

Becker, Carol. *Surpassing the Spectacle.* Lanham, MD: Rowman and Littlefield, 2002.

Brett, Guy. *Through Our Own Eyes: Popular Art and Modern History.* Philadelphia: Library Company of Philadelphia, 1987.

Bruckner, D. J. R. *Art against War: Four Hundred Years of Protest in Art.* New York: Abbeville, 1984.

Cleveland, William. *Art and Upheaval: Artists on the World's Frontlines.* Oakland: New Village Press, 2008.

Eberle, Matthias. *World War I & the Weimar Artists: Dix, Grosz, Beckmann.* New Haven: Yale University Press, 1986.

Ensler, Eve. *Insecure at Last: A Memoir.* Villard, 2007.

Felshin, Nina. *Disarming Images: Art for Nuclear Disarmament.* New York: Adama Books, 1984.

Golub, Leon, and Nancy Spero. *War and Memory.* Cambridge: MIT List Visual Arts Center, 1995.

Goya, Francisco. *Disasters of War.* Mineola, NY: Dover, 1968 .

Gray, Chris Hables. *Postmodern War.* New York: Guilford Publications, 1998.

Hanh, Thich Nhat. *Being Peace.* Berkeley: Parallax, 1987.

Heartfield, John. *Photomontages of the Nazi Period.* New York: Universe, 1977.

Hedges, Chris. *War Is a Force that Gives Us Meaning.* New York: PublicAffairs, 2002.

Jacobs, Karrie, and Steven Heller. *Angry Graphics: Protest Posters of the Reagan/Bush Era.* Salt Lake City: Peregrine Smith Books, 1992.

Keen, Sam. *Faces of the Enemy: Reflections of the Hostile Imagination.* New York: Harper & Row, 1988.

Kunzle, David. *American Posters of Protest 1966–70: Art as a Political Weapon.* New York: New School Art Center, 1971.

Lippard, Lucy R. *A Different War.* Seattle: Real Comet Press, 1990

Macy, Joanna. *Despair and Personal Power in Nuclear Age.* Portland, OR: New Society Publishers, 1983.

Martin, Susan. *Decade of Protest: Political Posters from the United States, Viet Nam, Cuba 1965-1975.* Los Angeles: Smart Art Press, 1996.

McCormick, Ken, and Hamilton Perry. *Images of War.* Ukiah, CA: Orion Books, 1990.

McQuiston, Liz. *Graphic Agitation: Social and Political Graphics Since the Sixties.* London: Phaidon Press, 1995.

_____. *Graphic Agitation 2: Social and Political Graphics in the Digital Age.* London: Phaidon Press, 2004.

Nagler, Michael N. *Is There No Other Way? The Search for a Nonviolent Future.* Albany, CA: Berkeley Hills Books, 2001.

Phillipe, Robert. *Political Graphics: Art as a Weapon.* New York: Abbeville, 1980.

Roy, Arundhati. *An Ordinary Person's Guide to Empire.* Boston: South End Press, 2004.

Rubin, Susan Goldman. *Fireflies in the Dark: The Story of Friedl Dicker-Brandeis and the Children of Terezin.* New York: Holiday House, 2000.

Sacco, Joe. *Palestine.* Seattle: Fantagraphics, 2002.

Satrapi, Marjane. *Persepolis.* New York: Pantheon, 2003.

Shikes, Ralph. *The Indignant Eye: The Artist as Social Critic.* Boston: Beacon Press, 1969.

Shikes, Ralph and Steven Heller. *The Art of Satire.* New York: Horizon, 1984.

Sontag, Susan. *Regarding the Pain of Others.* New York: Farrar, Straus, and Giroux, 2002.

Spero, Nancy and Leon Golub. *War and Memory,* exhibition catalog. Cambridge: MIT List Visual Arts Center, 1995.

Spero, Nancy, Leon Golub, and Robert Storr. *Nancy Spero: The War Series 1966–1970.* New York: Charta, 2004.

Spiegelman, Art. *Maus: A Survivor's Tale.* New York: Pantheon, 1993.

Stafford, Kim, editor. *Every War Has Two Losers: William Stafford on Peace & War.* Minneapolis: Milkweed, 2003.

Stermer, Dugald. *The Art of Revolution: 96 Posters from Castro's Cuba.* New York: McGraw-Hill, 1970.

Tapies, Xavier. *Street Art and the War on Terror: The Images of Opposition: How the World's Best Graffiti Artists Said No to the Iraq War*. Chicago: Trafalgar Square, 2007.

Thomas, Claude Anshin. *At Hell's Gate: A Soldier's Journey from War to Peace*. Boston: Shambala, 2004

Vidal, Gore. *Perpetual War for Perpetual Peace*. New York: Nation Books, 2002

Walker, Alice. *We are the Ones We've Been Waiting For: Light in a Time of Darkness*. New York: New Press, 2007.

Zinn, Howard. *Artists in Times of War*. New York: Seven Stories Press, 2003

Body Image and Art

Andersen, Arnold E. *Making Weight: Men's Conflicts with Food, Weight, Shape and Appearance*. Carlsbad, CA: Gurze Books, 2000.

Bordo, Susan. *Unbearable Weight: Feminism, Western Culture, and the Body*. Berkeley: University of California Press, 1990.

Brumberg, Joan Jacobs. *The Body Project: An Intimate History of American Girls*. New York: Vintage Books, 1998.

Cooke, Kaz. *Real Gorgeous: The Truth about Body and Beauty*. Australia: Rathdowne Books, 1994.

Dotson, Edisol W. *Behold the Man: The Hype and Selling of Male Beauty in Media and Culture*. New York: Haworth Press, 1999.

Dutton, Kenneth R. *The Perfectible Body: The Western Ideal of Male Physical Development*. New York: Continuum, 1995.

Ensler, Eve. *The Good Body*. New York: Villard, 2005.

Felshin, Nina. *Empty Dress: Clothing as Surrogate in Recent Art*. New York: Independent Curators, Inc., 1996.

Grogan, Sarah. *Body Image: Understanding Body Dissatisfaction in Men, Women and Children*. London: Routledge, 1999.

Jensen, Robert. *Getting Off: Pornography and the End of Masculinity*. Cambridge: South End Press, 2007.

Jones, Amelia. *Body Art: Performing the Subject*. Minneapolis: University of Minnesota Press, 1998.

Maine, Margo. *Body Wars: Making Peace with Women's Bodies: An Activist's Guide*. Carlsbad, CA: Gurze Books, 2000.

Naidus, Beverly. *One Size Does Not Fit All*. Littleton, CO: Aigis Publications, 1993.

Novokov, Anna, editor. *Veiled Histories: The Body, Place and Public Art*. Critical Press, 1997.

Philips, Jan. *Divining the Body: Reclaim the Holiness of Your Physical Self*. Woodstock, VT: Skylight Paths, 2005.

Pope, Harrison. *The Adonis Complex: The Secret Crisis of Male Body Obsession*. New York: Free Press, 2000.

Poulton, Terry. *No Fat Chicks: How Big Business Profits by Making Women Hate Their Bodies—and How to Fight Back*. Secaucus, NJ: Carol Publishing Group, 1997.

Seid, Roberta Pollack. *Never Too Thin: Why Women Are at War with Their Bodies*. New York: Prentice Hall Press, 1989.

Stearns, Peter N. *Fat History: Bodies and Beauty in the Modern West*. New York: NYU Press, 1997.

Thone, Ruth Raymond. *Fat—A Fate Worse Than Death: Women, Weight, and Appearance*. New York: Haworth Press, 1997.

Wann, Marilyn. *Fat!So? Because You Don't Have to Apologize for Your Size*. Berkeley: Ten Speed Press, 1999.

Wallace-Sanders, Kimberly, editor. *Skin Deep, Spirit Strong: The Black Female Body In American Culture*. Ann Arbor: University Of Michigan Press, 2002

Warr, Tracey. *The Artist's Body*. London: Phaidon, 2000.

Willis, Deborah. *The Black Female Body: A Photographic History*. Philadelphia: Temple University Press, 2002.

Wolf, Naomi. *The Beauty Myth: How Images of Beauty Are Used Against Women*. New York: Perennial, 2002

Community-Based and Public Art Practices

Adams, Don, and Arlene Goldbard. *Crossroads: Reflections on the Politics of Culture*. Talmage, CA: DNA Press, 1990.

Augaitis, Daina, Lorna Falk, Sylvie Gilbert, and Mary Anne Mosser. *Questions of Community: Artists, Audiences, Coalition*. Banff, Canada: Banff Center Press, 1998.

Baird, George and Mark Lewis, editors. *Queues, Rendezvous, Riots: Questioning the Public in Art and Architecture*. Banff, Canada: Walter Phillips Gallery, Banff Centre for the Arts, 1994.

Billboard: Art on the Road: A Retrospective of Artists' Billboards of the Last 30 Years. North Adams: Mass MOCA/MIT Press, 1999.

Burnham, Linda Frye and Steve Durland, editors. *Citizen Artist: 20 Years of Art in the Public Arena, an Anthology from High Performance Magazine, 1978–1998*. San Francisco and New York: Critical Press, 1998.

Cleveland, William. *Art in Other Places: Artists at Work in America's Community and Social Institutions*. Amherst, MA: University of Massachusetts, 2000.

Cockcroft, Eva. *Towards a People's Art: The Contemporary Mural Movement*. New York: Dutton, 1977.

Cohen-Cruz, Jan, editor. *Radical Street Performance: An International Anthology*. London: Routledge, 1998.

Coutts, Glen and Timo Jokela. *Art, Community and Environment: Educational Perspectives*. Fishponds, UK: Intellect Ltd, 2008.

Doss, Erika. *Spirit Poles and Flying Pigs: Public Art and Cultural Democracy in American Communities*. Washington DC: Smithsonian Institution Press, 1995.

Edelson, Bob. *New American Street Art*. London: Soho Books, 1999.

Finkelpearl, Tom. *Dialogues in Public Art*. Cambridge, MA: MIT Press, 2000.

Goldbard, Arlene. *New Creative Community: The Art of Cultural Development*. Oakland: New Village Press, 2006.

Harding, Anna. *Magic Moments: Collaboration Between Artists and Young People*. London: Black Dog, 2005.

Kelly, Owen. *Community, Art and the State: Storming the Citadels*. London: Comedia, 1984.

Kester, Grant. *Conversation Pieces: Community and Communication in Modern Art*. Los Angeles and San Francisco: University of California Press, 2004.

Knight, Keith, Mat Schwarzman, Mat. *Beginner's Guide to Community-Based Arts.* Oakland: New Village Press, 2005.

Kwon, Miwon. *One Place After Another: Site-Specific Art and Locational Identity.* Cambridge: MIT Press, 2002.

Lacy, Suzanne, editor. *Mapping the Terrain: New Genre Public Art.* Seattle: Bay Press, 1995.

Raven, Arlene, editor. *Art in the Public Interest.* New York: De Capo Press, 1993.

Senie, Harriet F., and Sally Webster, editors. *Critical Issues in Public Art: Context and Controversy.* New York: Harper, 1992.

Sommer, Robert. *Street Art.* New York: Links, 1975.

Cultural Identity and Art

Allen. Jules. *Black Bodies.* New York: Delano Greenridge Editions, 2002.

Allen, Theodore. *The Invention of the White Race: The Origin of Racial Oppression in Anglo-America.* London: Verso, 1997.

Anzaldua, Gloria, editor. *Making Face, Making Soul/Haciendo Caras: Creative and Critical Perspectives by Feminists of Color.* San Francisco: Aunt Lute Books, 1990.

Arareen, Rasheed. *The Other Story: Afro-Asian Artists in Post-War Britain.* London: Hayward Gallery/South Bank Centre, 1990.

Artes Graficas Chicanas en California. Santa Barbara, CA: University Art Museum, University of California, 2003.

Berger, Maurice. *Fred Wilson: Objects and Installations 1979–2000.* Baltimore: Center for Art and Visual Culture, University of Maryland, 2001.

_____. *Modern Art and Society: an Anthology of Social and Multicultural Readings.* New York: Icon Editions, 1994.

_____. *White Lies: Race and the Myth of Whiteness.* New York: Farrar, Strauss, Giroux, 1999.

Bessire, Mark H. C. *William Pope L.: The Friendliest Black Artist in America.* Cambridge, MA: MIT Press, 2002.

Bloom, Lisa. *With Other Eyes: Looking at Race and Gender in Visual Culture.* Minneapolis: University of Minnesota Press, 1999.

Cahan, Susan, and Zoya Kocur. *Contemporary Art and Multicultural Education.* New York: Routledge, 1996.

CARA: Chicano Art: Resistance and Affirmation. Exhibition catalog. Los Angeles: Wight Gallery of Art, University of California, 1990.

Chicago, Judy. *Holocaust Project: From Darkness into Light.* New York: Penguin Books, 1993.

Crenshaw, Kimberle, Neil Gotanda, Gary Peller, and Kendall Thomas, editors. *Critical Race Theory: The Key Writings that Formed the Movement.* New York: New Press, 1995.

Delgado, Richard, and Jean Stefanic. *Critical White Studies: Looking Behind the Mirror.* Philadelphia: Temple University Press, 1997.

Dines, Gail, and Jean M. Humez Jean M., editors. *Gender, Race, and Class in Media: A Text-Reader,* 2nd ed. London: Sage Publications, 2002.

Elliott, Emory, Louis Freitas Caton, and Jeffrey Rhyne, editors. *Aesthetics in a Multicultural Age,* New York: Oxford University Press, 2002.

Ferguson, Russell, Martha Gever, Trinh T. Minh-ha, Cornell West, editors. *Out There: Marginalization and Contemporary Cultures.* New York: New Museum of Contemporary Art and MIT Press, 1990.

Frankenberg, Ruth. *Displacing Whiteness: Essays in Social and Cultural Criticism.* Durham, NC: Duke University Press, 1997.

Fusco, Coco, and Brian Wallis, editors. *Only Skin Deep: Changing Visions of the American Self.* New York: International Center of Photography/Harry N. Abrams, 2003.

Gaspar De Alba, Alicia. *Chicano Art Inside/Outside.* Austin: University of Texas Press, 1998.

Goldman, Shifra. *Dimensions of the Americas: Art and Social Change in Latin America and the U.S.* Chicago: University of Chicago Press, 1994.

Graves, James Bau. *Cultural Democracy: The Arts, the Community and the Public Purpose.* Urbana, IL: University of Illinois Press, 2005.

Hall, Stuart and Mark Sealy. *Different: A Historical Context, Contemporary Photographers and Black Identity.* London: Phaidon, 2001

Harris, Michael D. *Colored Pictures: Race And Visual Representation.* Chapel Hill, NC: University Of North Carolina Press, 2003.

Hill, Mike, editor. *Whiteness: A Critical Reader.* New York: NYU Press, 1997

Hooks, Bell. *Art on My Mind: Visual Politics.* New York: New Press, 1995.

———. *Yearning: Race, Gender, and Cultural Politics.* Boston: South End Press, 1990.

Hooks, Bell, and Amalia Mesa-Bains. *Homegrown: Engaged Cultural Criticism.* Boston: South End Press, 2006.

Hornstein, Shelley, and Florence Jacobowitz, editors. *Image and Remembrance: Representation and the Holocaust.* Bloomington IN: Indiana University Press, 2003.

Jensen, Robert. *The Heart of Whiteness: Confronting Race, Racism and White Privilege.* San Francisco: City Lights, 2005.

Kim, Elaine H. *Fresh Talk, Daring Gazes: Conversations on Asian American Art.* Berkeley: University of California Press, 2003.

Kinchloe, Joe L., Shirley R. Steinberg, Nelson M. Rodriguez, and Ronald E. Chennault, editors. *White Reign: Deploying Whiteness in America.* New York: St. Martin's Press, 1998.

LaDuke, Betty. *Compañeras: Women, Art, and Social Change in Latin America.* San Francisco: City Lights Books, 1985.

La Frontera/The Border: Art about the Mexico/United States Border Experience. San Diego: Centro Cultural de San Diego and the Museum of Contemporary Art, 1993.

Lippard, Lucy R. *Mixed Blessings: New Art in a Multicultural America.* New York: Pantheon, 1990.

Lloyd, Fran, and Siumee H. Keelan. *Contemporary Arab Women's Art: Dialogues of the Present.* London: Wal, 1999.

Machida, Margo. *Asia America: Identities in Contemporary Asian American Art.* New York: New Press, 1994.

McEvilley, Thomas. *Art and Otherness: Crisis in Cultural Identity.* Kingston, NY: McPherson and Co., 1992.

Next Generation: Southern Black Aesthetic. Chapel Hill, NC: University of North Carolina Press/Southeastern Center for Contemporary Art, 1990.

Noriega, Chon. *Just Another Poster? Chicano Graphic Arts in California = Solo un Cartel Mas?* Seattle: University of Washington Press, 1992.

Pinder, Kymberly N. *Race-Ing Art History: Critical Readings in Race and Art* History. New York: Routledge, 2002.

Powell, Richard J. *Black Art and Culture in the 20th Century.* London: Thames & Hudson, 1997.

Pritzker, Barry. *Native America Today: A Guide to Community Politics and Culture.* Santa Barbara. CA: ABC-Clio, 1999.

Rasmussen, Birgit Brander, Eric Klinenberg, Irene J. Nexica, and Matt Wray, editors. *The Making and Unmaking of Whiteness.* Durham, NC: Duke University Press, 2001.

Roediger, David R. *Black on White: Black Writers on What it Means to be White.* New York: Schocken Books, 1998.

Shohat, Ella, editor. *Talking Visions: Multicultural Feminism in a Transnational Age.* Cambridge: MIT Press, 2001.

Solomon-Godeau, Abigail, and Constance Lewallen. *Mistaken Identities.* Santa Barbara, CA: UC Santa Barbara, 1992.

Thompson, Cooper, Emmett Schaefer, and Harry Brod, editors. *White Men Challenging Racism: 35 Personal Stories.* Durham, NC: Duke University Press, 2003.

West, Cornel. *The Cornel West Reader.* New York: Basic Books, 1999.

Williams, Patricia J. *Seeing a Color-Blind Future: The Paradox of Race.* New York: Noonday Press, 1997.

Williamson, Sue. *Resistance Art in South Africa.* London: CIIR, 1989.

Wise, Tim. *White Like Me: Reflections on Race from a Privileged Son.* New York: Soft Skull Press, 2007.

Young, Walter Byron. *Black American Painters & the Civil Rights Movement.* University Park, PA: Ed. D. thesis, Penn State University, 1972.

"Racism is the Issue." *Heresies: A Feminist Publication on Art and Politics,* no. 15 (1982).

Eco-art

Atwood, Margaret. *Oryx and Crake.* New York: Nan A. Talese, 2003.

Beardsley, John. *Earthworks and Beyond.* New York: Abbeville Press, 1989.

Bookchin, Murray. *The Philosophy of Social Ecology.* Montreal: Black Rose Books, 1996.

_____. *Urbanization without Cities.* Montreal: Black Rose Books, 1992.

Butler, Octavia. *Parable of the Sower.* New York: Four Walls Eight Windows, 1993.

Callenbach, Ernest. *Ecotopia.* Berkeley: Banyan Tree Books, 1975.

Diamond, Irene, and Gloria Orenstein. *Reweaving the World.* San Francisco: Sierra Club Books, 1990.

Gablik, Suzi. *The Reenchantment of Art.* New York: Thames & Hudson, 1991.

Hawken, Paul. *Blessed Unrest: How the Largest Movement in the World Came Into Being and Why No One Saw It Coming.* New York: Viking Books, 2007.

Heller, Chaia. *The Ecology of Everyday Life: Rethinking the Desire for Nature.* Montreal: Black Rose Press, 1999.

Kester, Jeff, and Brian Wallis. *Land and Environmental Art.* London: Phaidon, 1998.

Kolbert, Elizabeth. *Field Notes from a Catastrophe: Man, Nature and Climate Change.* New York: Bloomsbury Books, 2006.

LeGuin, Ursula. *Always Coming Home*. New York: Bantam Books, 1987.

Louv, Richard. *Last Child in the Woods: Saving Our Children from Nature-Deficit Disorder*. Chapel Hill, NC: Algonquin Books, 2006.

Lippard, Lucy R. *The Lure of the Local: Sense of Place in a Multi-Centered Society*. New York: New Press, 1997

_____. *Overlay*. New York: Pantheon, 1983.

Macy, Joanna. *Thinking Like a Mountain: Towards a Council of All Beings*. Gabriola Island, BC Canada: New Catalyst Books, 2007.

Matilsky, Barbara C. *Fragile Ecologies: Contemporary Artists' Interpretations and Solutions*. New York: Rizzoli International, 1992.

Meade, Michael. *The World Behind the World: Living at the Ends of Time*. Portland, OR: Greenfire Press, 2008.

McEwen, Christian, and Mark Statman. *The Alphabet of the Trees: A Guide to Nature Writing*. New York: Teachers and Writers Collaborative, 2000.

Mies, Maria, and Vandana Shiva. *Ecofeminism*. Halifax, NS: Fernwood Publications, 1993.

Papanek, Victor. *Design for the Real World: Human Ecology and Social Change*, 2nd ed. Chicago: Academy Chicago Publishers, 1985.

_____. *The Green Imperative*. London: Thames and Hudson, 1995.

Piercy, Marge. *He, She and It*. New York: Knopf, 1991.

_____. *Woman on the Edge of Time*. New York: Knopf, 1976.

Shiva, Vandana. *Biopiracy: The Plunder of Nature and Knowledge*. Boston: South End Press, 1997.

Sonfist, Alan, editor. *Art in Land: A Critical Anthology of Environmental Art*. New York: E. P. Dutton, 1983.

Spaid, Sue. *Ecovention: Current Art to Transform Ecologies*. Cincinnati, OH: Contemporary Art Center, 2002.

Starhawk. *The Fifth Sacred Thing*. New York: Bantam Books, 1993.

Steingraber, Sandra. *Living Downstream: A Scientist's Personal Investigation of Cancer and the Environment*. New York: Vintage, 1998.

Strelow, Heike. *Aesthetics of Ecology: Art in Environmental Design: Theory and Practice*. New York: Birkauser, 2004.

Tobias, Michael and Georgianne Cowan. *The Soul of Nature*. London, New York and Harrisburg: Continuum Publishing, 1994.

Tokar, Brian. *Earth for Sale*. Boston: South End Press, 1997.

Wells, H. G. *The Prophetic Novels of H. G. Wells*. New York: Dover, 1960.

Feminism, Gender and Art

Broude, Norma and Garrard, Mary D., editors. *Feminism and Art History: Questioning the Litany*. New York: Harper and Row, 1982.

_____. *The Power of Feminist Art*. New York: Abrams, 1994.

Battersby, Christine. *Gender and Genius: Towards a Feminist Aesthetics*. London: Women's Press, 1989.

Brown, Betty Ann, editor. *Expanding Circles: Women, Art and Community*. New York: Midmarch Art Press, 1996.

Butler, Cornelia, and Lisa Gabrielle Mark. *WACK: Art and the Feminist Revolution.* Cambridge, MA: MIT Press, 2007.

Chadwick, Whitney. *Women, Art, and Society.* New York: Thames & Hudson, 1990.

Chicago, Judy. *The Dinner Party.* New York: Doubleday, 1979.

_____. *Through the Flower: My Struggle as a Woman Artist.* New York: Doubleday, 1975.

Chicago, Judy, and Edward Lucie-Smith. *Women and Art: Contested Territory.* New York: Watson-Guptill, 1999.

Frueh, Joanna, Cassandra Langer, and Arlene Raven. *Feminist Art Criticism: An Anthology.* New York: Icon Editions, 1991.

_____. *New Feminist Criticism: Art—Action—Identity.* New York: Harper Collins, 1994.

Guerrilla Girls. *Confessions of the Guerrilla Girls.* New York: HarperCollins, 1995.

Harris, Geraldine. *Staging Feminities: Performance and Performativity.* Manchester University Press, 1999.

Hedges, Elaine, and Ingrid Wendt. *In Her Own Image: Women Working in the Arts.* New York: Feminist Press, 1980.

Jones, Amelia, editor. *The Feminism and Visual Culture Reader.* London: Routledge, 2003.

Juno, Andrea, and V. Vale, editors. *Angry Women.* San Francisco: RE/Search, 1991.

Lippard, Lucy R. *From the Center: Feminist Essays on Women's Art.* New York: Dutton, 1976.

Parker, Roszika, and Griselda Pollock. *Framing Feminism: Art & the Women's Movement 1970–85.* London: Pandora Press, 1987.

_____. *Old Mistresses: Women, Art, & Ideology.* New York: Pantheon, 1981.

Phelan, Peggy and Helena Reckitt. *Art and Feminism.* London: Phaidon, 2001.

Pollock, Griselda, editor. *Generations and Geographies in the Visual Arts: Feminist Readings.* London and New York: Routledge, 1996.

Raven, Arlene, and Cassandra L. Langer. *Feminist Art Criticism: An Anthology.* New York: IconEditions, 1991.

Robinson, Hilary, editor. *Feminism-Art-Theory: An Anthology, 1968–2000.* Malden, MA: Blackwell Publishers, 2001.

_____. *Visibly Female: Feminism and Art Today.* New York: Universe, 1987.

Rosen, Randy. *Making Their Mark: Women Artists Move into the Mainstream, 1970–1985.* New York: Abbeville Press 1989.

Roth, Moira, editor. *The Amazing Decade: Women and Performance Art in America 1970–80.* Los Angeles: Astro Artz, 1983.

Schor, Mira. *Wet: On Painting, Feminism, and Art.* Durham, NC: Duke University Press, 1997.

Sexual Politics: Judy Chicago's Dinner Party in Feminist Art History. Los Angeles: Armand Hammer Museum/UCLA, 1996.

Spence, Jo. *Cultural Sniping: The Art of Transgression.* New York: Routledge, 1995.

Tucker, Marcia. *Bad Girls.* New York: New Museum of Contemporary Art, 1994.

Witzling, Mara R. editor. *Voicing Our Vision: Writings by Women Artists.* New York: Universe, 1991.

Wolverton, Terry. *Insurgent Muse: Life and Art at the Woman's Building.* San Francisco: City Lights Books, 2002.

Labor, Globalization and Art

Alewitz, Mike. *Insurgent Images: The Agitprop Murals of Mike Alewitz.* New York: Monthly Review Press, 2002.

Anreus, Alejandro, Diana L. Linden, and Jonathan Weinberg, editors. *The Social and the Real: Political Art of the 1930s in the Western Hemisphere.* University Park, PA: Pennsylvania State University Press, 2006.

Armbruster-Sandoval, Ralph. *Globalization and Cross-Border Labor Solidarity in the Americas.* New York and London: Routledge, 2004.

Bacon, David. *Communities without Borders: Images and Voices from the World of Migration.* Ithaca, NY: ILR Press, 2006.

Bigelow, Bill, and Peterson, Bob. *Rethinking Globalization: Teaching for Justice in an Unjust World.* Milwaukee, WI: Rethinking Schools Press, 2002.

Coles, Nicholas & Janet Zandy, editors. *American Working-Class Literature: An Anthology.* New York: Oxford University Press, 2007.

Coles, Nicholas & Peter Oresick, editors. *For a Living: The Poetry of Work.* Urbana, IL: University of Illinois Press, 1995.

_____. *Working Classics: Poems On Industrial Life.* Urbana, IL: University of Illinois Press, 1990.

Condé, Carole and Karl Beveridge. *It's Still Privileged Art.* Toronto, Canada: Art Gallery of Ontario, 1976.

Ehrenreich, Barbara. *Bait and Switch: The (Futile) Pursuit of the American Dream.* Orlando, FL: Holt, 2006.

_____. *Nickel and Dimed: On (Not) Getting By in America.* Orlando, FL: Holt, 2008.

Foner, Philip S. *The Other America: Art and the Labor Movement in the United States.* West Nyack, NY: Journeyman Press, 1985.

Johnson, Mark Dean, editor. *At Work: the Art of California Labor.* Berkeley: Heyday Books, 2003.

Lucie-Smith, Edward & Celestine Dars. *Work and Struggle: The Painter as Witness, 1870–1914.* New York: Paddington Press, 1977.

O'Connor, Francis V., editor. *Art for the Millions: Essays from the 1930s, by Artists and Administrators of the WPA Federal Art Project.* Greenwich, CT: New York Graphic Society, 1973.

Platt, Susan. *Art & Politics in the 1930s.* New York: Midmarch Press, 1999.

Solnit, David. *Globalize Liberation.* San Francisco: City Lights Books, 2004.

Tarrow, Sidney. *The New Transnational Activism.* Cambridge: Cambridge University Press, 2005.

Zandy, Janet. *Hands: Physical Labor, Class and Cultural Work.* Piscataway, NJ: Rutgers University Press, 2004.

_____, editor. *Liberating Memory: Our Work and Our Working-Class Consciousness.* Piscataway, NJ: Rutgers University Press, 1994.

Zinn, Howard. *People's History of the United States: 1492 to Present.* New York: Harper, 2005.

Media Theory

Cohen, Jeff & Norman Solomon. *Adventures in Medialand: Behind the News, Beyond the Pundits.* Monroe, ME: Common Courage Press, 2002.

Ewen, Elizabeth and Stuart Ewen. *Channels of Desire.* Minneapolis:University of Minnesota Press, 1992.

Ewen, Stuart. *All Consuming Images.* Washington, DC: Basic Press, 1990.

Klein, Naomi. *No Logo: Taking Aim at the Brand Bullies.* New York: Picador Press, 1999.

Lister, Martin, editor. *The Photographic Image in Digital Culture.* New York: Routledge, 1995.

Lovejoy, Margot. *Postmodern Currents: Art and Artists in the Age of Electronic Media.* Englewood Cliff, NJ: Prentice Hall, 2000.

Manovich, Lev. *The Language of New Media.* Cambridge, MA: MIT Press, 2002.

Weibel, Peter, and Timothy Druckery. *Net_Condition.* Cambridge, MA: MIT Press, 2001.

Williamson, Judith. *Consuming Passions: The Dynamics of Popular Culture.* London: Marion Boyars, 1986.

_____. *Decoding Advertisements.* London: Marion Boyars, 1978.

Pedagogical Theory

Atkinson, Dennis and Paul Dash, editors. *Social and Critical Practices in Art Education.* Staffordshire, England: Trentham Books, 2005.

Dewey, John. *Art as Experience.* New York: G. P. Putnam's Sons, 1934.

_____. *Experience and Education.* Florence, MA and Washington, DC: Free Press, 1997.

Freire, Paulo. *Education for Critical Consciousness.* New York: Continuum, 1973.

_____. *Pedagogy of the Oppressed.* New York: Continuum, 2000.

Giroux, Henry. *Border Crossings: Cultural Workers and the Politics of Education.* New York: Routledge, 1991.

Graff, Gerald. *Beyond the Culture Wars: How Teaching the Conflicts Can Revitalize American Education.* New York: W. W. Norton, 1992.

Hooks, Bell. *Teaching Community: A Pedagogy of Hope.* New York and London: Routledge, 2003.

_____. *Teaching to Transgress: Education as the Practice of Freedom.* New York and London: Routledge, 1994.

Illich, Ivan. *Deschooling Society.* London: Marion Boyars, 2000.

Miles, Malcolm, editor. *New Practices, New Pedagogies.* New York and London: Routledge, 2005.

Postman, Neil and Charles Weingartner. *Teaching as a Subversive Activity.* New York: Dell, 1987.

Powell, Mary Clare and Vivien Marcow Speiser, editors. *Little Signs of Hope: The Arts, Education and Social Change.* New York: Lesley University & Peter Lang Publishers, 2005.

Rose, Karel and Joe L. Kincheloe, editors. *Art, Culture and Education: Artful Teaching in a Fractured Landscape.* New York: Lesley University & Peter Lang Publishers, 2003.

Sandoval, Chela. *Methodology of the Oppressed.* Minneapolis: University of Minnesota Press, 2000.

Shahn, Ben. *The Shape of Content.* New York: Random House, 1957.

Trend, David. *Cultural Pedagogy: Art/Education/Politics.* New York: Bergin and Garvey, 1992.

Periodicals

Adbusters (Vancouver)
Alliance for Cultural Democracy Newsletter (Springfield, IL)*
Art Network (Australia)*
Artery (London)*
Artpaper (Minneapolis)*
Artweek (SanFrancisco)
*Clamor: New Perspectives on Politics**
Culture, Media and Life (Ohio)*
Doubletake (Somerville, MA)*
Framework (Center for Photographic Studies LA)
Fuse (Toronto)
Heresies (New York)*
High Performance (LA)*
In These Times (Chicago)
The Independent—Video & Film (New York City)*
Left Curve (San Francisco)
M/E/A/N/I/N/G (New York City)*
New Art Examiner (Chicago)*
New Internationalist (London, Toronto)
October (New York City)
Praxis (Goleta, CA)*
The Progressive (Madison, WI)
Punk Planet (Chicago)*
Women Artists News (New York City)*
Z Magazine (Boston)

*These periodicals are no longer in print, but check online or
 at your local library for back issues, as they are worth a look.

Other recommended authors

Lila Abu-Lughod, Margot Adler, Ben Bagdikian, Judy Bari, Kim Chernin, Pema Chodron, Noam Chomsky, Sandra Cisneros, Mike Davis, Ariel Dorfman, Alice Echols, Susan Faludi, Thomas Frank, Simon Frith, Eduardo Galeano, Sally Miller Gearhart, Charlotte Perkins Gilman, Amy Goodman, Edward T. Hall, Ursula Hegi, John Hersey, Aldous Huxley, Gish Jen, Nora Okja Keller, Barbara Kingsolver, Maxine Hong Kingston, Jonathan Kozol, Gerda Lerner, Doris Lessing, Paul Loeb, Barry Lopez, Audre Lord, Michael Moore, Toni Morrison, Bharati Mukherjee, George Orwell, Michael Parenti, Scott Peck, John Perlin, Ray Raphael, John Robbins, Theodore Roszak, Edward Said, Anne Wilson Schaef, Herbert Schiller, Andrew Schmookler, John Seed, Leslie Marmon Silko, Sulak Sivaraksa, Rebecca Solnit, John Steinbeck, Jonathan Swift, Studs Terkel, Russell Thornton, Mark Twain, Michael Ventura, Alice Walker, Michele Wallace, Anzia Yezierska, and Irene Zabytko.

Notes

Preface

1. By Pavel Tchelitchew.
2. By David Alfaro Siquieros.

Chapter 1

1. Cynthia Hamilton, "A Way of Seeing: Culture as Political Expression in the Works of C.L.R. James," *Journal of Black Studies* 22, no. 3 (March 1992), 429–443.
2. "Hooks believes that mainstream activists do not understand that literacy is a privilege, and one that is not available to everyone. She particularly targets academic feminist theorists, maintaining that their use of difficult language has caused a split between feminist activism, which is often practiced by working-class non-academics, and feminist theory, which is seen as widely irrelevant. Not only does feminist theory in the academy need to come down to earth, feminists as a whole need to undertake literacy as a progressive issue." From Alice Marwick, "Crossing Boundaries, Reaching Out: The Public Scholarship of bell hooks," University of Washington, <www.com.washington.edu/program/Grad/ps_marwick.pdf>.
3. I will talk more about Heller's influence in chapter 4. She is the author of *The Ecology of Everyday Life: Rethinking the Desire for Nature* (Black Rose Books, 1999).
4. Mari Womack, *Symbols and Meaning: A Concise Introduction*, Walnut Creek, CA: Altamira Press, 2005.

Chapter 2

1. It is important to mention that the radical cultural work produced by enslaved peoples in America predated the WPA and had a worldwide impact.

2. It is important to mention the radical cultural work produced by enslaved people in America that predated the WPA and had a worldwide impact.

3. Quoted in Richard D. McKinzie, *The New Deal for Artists* (Princeton, NJ: Princeton University Press, 1973), 250.

4. Don Adams and Arlene Goldbard, "New Deal Cultural Programs: Experiments in Cultural Democracy," Webster's World of Cultural Democracy, <www.wwcd.org/policy/US/newdeal.html>.

5. Susan Platt, *Art and Politics of the 1930s*, New York: Midmarch Arts Press, 1999.

6. The film *Cradle Will Rock*, directed by Tim Robbins, gives an interesting interpretation of this period.

7. Virginia Hagelstein Marquardt, "The American Artists School: Radical Heritage and Social Content Art," *Archives of American Art Journal* 26, no. 4 (1986), 17–23 .

8. Philip Evergood, "Building a New Art School," *Art Front*, April 1937, p. 21.

9. "Oral History Interview with Anthony Velonis, October 13, 1965," Smithsonian Archives of American Art, <www.aaa.si.edu/collections/oralhistories/transcripts/veloni65.htm>.

10. www.aaa.si.edu/collections/oralhistories/transcripts/shahn65.htm.

11. Arthur D. Efland, "Art Education during the Great Depression, *Art Education* 36, no. 6 (November 1983), 38–42.

12. Mishler, Paul C. (1999). Raising Reds. Columbia University Press

13. "Who owns WPA prints?" Transcript of panel discussion held at the Print Fair, November 4, 2000, <www.printdealers.com/learn_whoowns_pf.html>.

14. Paul Hart, "The Essential Legacy of Clement Greenberg from the Era of Stalin and Hitler,"*Oxford Art Journal* 11, No. 1 (1988), 76–87.

15. By Alfred H. Barr Jr. "Is Modern Art Communistic?" *New York Times Magazine*, December 14, 1952.

16. Attributed to Alice Neel on "Strange Wondrous Quotes and Quotations," <http://strangewondrous.net>.

17. **The Logic of Modernism,** Adrian Piper, *Callaloo*, Vol. 16, No. 3. (Summer, 1993), pp. 574-578.

Chapter 3

1. Technology Education Design, <www.ted.com>.

2. Presented during the inaugural session of the Caucus on Social Theory and Art Education during the National Art Education Association Conference in Atlanta, Georgia, 1980.

3. Visual Culture refers to a contemporary area of study that includes any examination of visual images. Its theoretical base may include any combination of cultural studies, art history, philosophy, performance and media studies, anthropology, critical theory, and may overlap with psychoanalytical theory, queer and gender studies.

4. See my definition of Critical Theory, page 58.

5. David Darts, "Art Education for a Change: Contemporary Issues and the Visual Arts," *Art Education*, Sept. 2006, 59, 5; Research Library, page 6.

6. From the 2009 College Art Association's national conference in Los Angeles, titled "The Changing Nature of Artist Educators' Work in a Global Economy."

7. Illich, Ivan. *Deschooling Society*. New York: Harper & Row, 1971.

8. From my previously published essay in Malcolm Miles, ed., *New Practices, New Pedagogies: A Reader* (Routledge, 2005).

9. The Comprehensive Employment and Training Act (CETA) provided funding to many community artists from 1973 to 1981.

10. See Loraine Leeson's, Jane Trowell's, and Devora Neumark's stories, for starters.

Chapter 4

1. More details about experiences at Goddard can be found in several essays I have written for *New Art Examiner, Women's Studies Journal*, and two books, *New Practices, New Pedagogies*, edited by Malcolm Miles, and *Little Signs of Hope: The Arts, Education and Social Change*, edited Mary Clare Powell and Vivien Marcow Speiser.

2. Institute for Social Ecology, <www.social-ecology.org>.

3. Social Ecology Education and Demonstration School, <www.socialecologyvashon.org>.

4. GreenMuseum.org <http://greenmuseum.org>, WEAD: Women Environmental Artists Directory <www.weadartists.org>, The Ecoart Network <www.ecoartnetwork.org>, and Art HEALS <www.artheals.org> are great resources on the Web.

5. Such as Justseeds <www.justseeds.org> and Center for the Study of Political Graphics <www.politicalgraphics.org>.

6. Artists discussed include Jenny Saville, Cindy Sherman, Rachel Lewis, Eleanor Antin, Joan Semmel, Jo Spence, Penelope Goodfriend, Nancy Fried, Guerilla Girls, Womanhouse, Valerie Export, Carolee Schneeman, Shigeko Kubota, Alice Neel, Niki de Sainte-Phalle, Alison Saar, Tanja Ostojic, Judy Chicago, Kiki Smith, Lorna Simpson, Laura Aguilar, Catherine Opie, Jana Sterbak, Janine Antoni, Tee Corinne, Laurie Toby Edison, Paula Modersohn Becker, Orlan, Spencer Tunick, Mariona Barkus, Margaret Lazzari, Zizi Raymond, Lauren Greenfield, Frida Kahlo, Larry Kirkwood, Renee Green, Hannah Wilke, Shirin Neshat, Ana Mendieta, James Luna, Robert Mapplethorpe, Carry Mae Weems, and Jimmie Durham.

7. *Shadow on a Tightrope* and *The Beauty Myth* (Naomi Wolf), *Body Image* (Sarah Grogan), *Fat History* (Peter Stearns), *Fat!So?* (Marilyn Wann), *Never Too Thin* (Roberta Pollack Seid), and *The Good Body* (Eve Ensler).

8. Daniel Chandler, "Notes on 'The Gaze,'" <www.aber.ac.uk/media/Documents/gaze/gaze.html>.

9. This term refers to the polarized debate between traditional and progressive forces that began to play out in academia and the art world in the late eighties and nineties and continues to this day.

10. This exercise was a gift from one of my mentors, Charles Frederick.

11. Examples include "Responsible Shopper," Co-op America <www.coopamerica .org/programs/rs/actions.cfm>; "Socially Responsible Shopping and Action Guide," Global Exchange <www.globalexchange.org/campaigns/sweatshops/ftguide.html>; and ResponsibleConsumer.net <www.responsibleconsumer.net>.

12. Some of these questions come from Susan Cahan and Zoya Kocar's book, *Contemporary Art and Multicultural Education* (Routledge, 1996).

13. Artists discussed include Pat Ward Williams, Fred Wilson, William Pope L., Betty Lee, May Sun, Yong Soon Min, David Avalos, Daniel Martinez, Border Arts Workshop, Taller Boriqua, Amalia Mesa-Bains, Carmen Lomas Garza, Coco Fusco, Guillermo Gomez Pena, Jaune Quick-to-See Smith, Jolene Rickard, Lorraine O'Grady, Celia Alvarez Munoz, Alison Saar, Delilah Montoya, Kay Walkingstick, Yolanda Lopez, Patricia Rodriguez, Rupert Garcia, James Luna, Glenn Ligon, Hulleah Tsinhnahjinnie, Gu Xiong, Hung Liu, Dread Scott, Barbara Carrasco, Jason S. Yi, Juan Sanchez, Milton Rogovin, Art Spiegelman, Edgar Heap-of-Birds, Jimmie Durham, Emma Amos, Sonia Boyce, David Wojnarowicz, Mark Niblock, Catherine Opie, and Brian Jungen

Chapter 5

1. The MacArthur Fellows Program awards unrestricted fellowships to talented individuals who have shown extraordinary originality and dedication in their creative pursuits and a marked capacity for self-direction. There are three criteria for selection of Fellows: exceptional creativity, promise for important future advances based on a track record of significant accomplishment, and potential for the fellowship to facilitate subsequent creative work.

2. David Perkins, "Making Thinking Visible," New Horizons for Learning, <www .newhorizons.org/strategies/thinking/perkins.htm>.

3. A popular form of visual narrative (especially in Spain, Latin America and France). They are similar to comics, but illustrated with photos instead of or in combination with drawings.

4. ArtTalk airs on KUSF, 90.3 FM, in the greater San Francisco Bay Area. All shows are available for download.

5. PAD/D—Political Art Documentation/Distribution was both an archive (first called for by Lucy R. Lippard in 1979) and an organization of activist artists founded in 1980 and active throughout the 1980's, having exhibitions in alternative spaces, on the street and facilitating interventions in many public contexts.

6. REPOhistory <www.repohistory.org>

7. Dark Matter Archives <http://darkmatterarchives.net>.

8. The Waitresses was the name of a collaborative performance art group formed by artists who worked as waitresses during the seventies in Los Angeles. They entertained audiences in restaurants, women's conferences, labor conferences; and designed installations for galleries and museums from 1978–85. They explored working conditions for women, used humor, and were precursors to later groups like the Guerrilla Girls. Sisters of Survival (SOS) was a collaborative, public-performance-art group addressing issues raised by the proliferation of the nuclear arms race in the eighties. The group conceived of a three-year conceptual structure; created an artist's book, billboard, site-specific performances for the media in New York and Los Angeles; and networked throughout the United States, Canada, and Western Europe, collecting over fifty artworks for exhibition.

9. GYST software can be downloaded at <www.gyst-ink.com>.

10. The Young Person's Guide to the Royal Docks, <www.ypg2rd.org>.

11. Beginning in 2002, Engrenage Noir's LEVIER Project has supported community groups and their artists in the development of collaborative art endeavors. LEVIER is dedicated to exploring how artistic creation in today's socio-economic, political, and cultural context can address the systemic causes of poverty while affirming individual and collective empowerment, diversity of ecosystems, human rights, and ethical responsibility. LEVIER supports art projects that challenge the current imbalance in resource control and distribution and that invite the creation of spaces within which individuals can strengthen their personal and political voice (whether resistant or celebratory). The LEVIER Project is currently also exploring how to extend this work into reforming social policy.

12. Devora says, "On occasion, we have worked with other practitioners in developing our training and exchange programs." Aside from Louise Lachapelle who has most frequently been part of this process, some of the others who have collaborated to make these programs successful are Pam Hall, Eve Lamoureux, Kim Anderson, and Aleksandra Zajko.

13. Maria De Figueiredo-Cowen, *Paulo Freire at the Institute* (London: Institute of Education,1995).

14. PLATFORM, <www.platformlondon.org>.

15. "The Body Politic," PLATFORM, <www.platformlondon.org/bodypolitic.asp>.

16. "Thatcherism" is characterized by decreased state intervention via the free market economy, monetarist economic policy, privatization of state-owned industries, lower direct taxation and higher indirect taxation, opposition to trade unions, and a reduction of the size of the welfare state. "Thatcherism" may be compared with Reaganomics in the United States. Thatcher was deeply in favor of individualism over collectivism, with self-help as a mantra (Source: Wikipedia).

17. MISCELLANEOUS Productions, <www.miscellaneous-inc.org>.

18. First F.R.E.E. Bus, <www.firstfreebus.co.uk>.

19. Reception Theory analyzes an artwork or a performance in relation the spectator's or the audience's response to the work.

20. A theatrical form presenting factual information on current events to a popular audience. Historically, Living Newspapers have also urged social action (both implicitly and explicitly) and reacted against naturalistic and realistic theatrical conventions in favor of the more direct, experimental techniques of agitprop theatre, including the extensive use of multimedia.

21. Universities that value research and creative work among their faculty as highly as they value teaching credentials. Research 1 institutions also offer doctorates, <http://en.wikipedia.org/wiki/Research_I_university>.

Chapter 6

1. Caribbean Medical Transport is a nonprofit that offers humanitarian aid to Cuba and other poor countries, and provides legal travel licenses to Cuba, <http://cubacaribe.com>.

2. In Santería, Yemayá is seen as the mother of all living things as well as the owner of all waters.

3. Spanish for "the blockade," referring to the economic embargo imposed on the Cuba by the United States that has continued unabated since Castro took power in 1962.

4. A practitioner of Santería, an Afro-Caribbean syncretic religion that has flourished in Cuba.

5. Batista was the brutal and corrupt dictator whose regime precipitated the revolution in Cuba.

6. "End time" in this context refers to the ending of one way of being and rebirth into another, although, in my mind, it does not imply doomsday, apocalypse or the rapture, but rather a coming to terms with the shadow of our culture, and, with that, new honesty, seeing new directions for the culture to take.

7. Backbone Campaign <www.backbonecampaign.org>, an activist art group that uses puppetry, banners, performance and public art interventions to embolden citizens and elected officials to stand up for progressive values.

8. Islewilde <www.islewilde.org>, a community arts group that uses pageantry, puppetry, performance, and interactive art projects to engage the island in many different issues, both social and otherwise.

About the Author

Beverly Naidus was born in Salem, Massachusetts, to two New Yorkers. She grew up in the Northeast and received a BA from Carleton College and an MFA from the Nova Scotia College of Art and Design. Early recognition in the New York City art world offered her many opportunities to exhibit her interactive installations and digital art projects in diverse venues, including mainstream museums and city streets. Inspired by lived experience, topics in her artwork include environmental illness, global warming, unemployment, the alienation of consumer culture, nuclear nightmares, body hate, celebrating cultural identity, confronting racism and anti-Semitism, and envisioning utopia and global justice.

Beverly has produced several artist's books including *What Kinda Name is That?* and *One Size Does Not Fit All*. Her art has been discussed in books by Paul Von Blum, Lucy R. Lippard, Suzi Gablik, Lisa Bloom and others, and reviewed in many contemporary journals. Her writing about art for social change has been published in two books (*New Practices—New Pedagogies* edited by Malcolm Miles and *The Arts, Education and Social Change: Little Signs of Hope* edited by Mary Clare Powell and Vivien Marcow Speiser, and in articles in *Radical Teacher*, the *New Art Examiner*, and the *National Women's Studies Association Journal*.

Her teaching career includes work as an artist/teacher in New York City museums, Carleton College, California State University Long Beach, Goddard College, Hampshire College, and the Institute for Social Ecology. She has guest lectured and led workshops all over North America and in Europe. Beverly has co-created a program, Arts in Community, with a focus on art for social change for the University of Washington, Tacoma. She lives in the middle of the woods on Vashon Island with her husband and son.

newvillagePRESS

Community building on the grassroots level is the heart and mission of New Village Press, a public-benefit publisher serving the interdisciplinary fields of community development. New Village publications focus on creativity, good news and tools for social change.

If you enjoyed *Arts for Change*, you may like other books we offer:

Art and Upheaval: Artists on the World's Front Lines,
by William Cleveland

Beginner's Guide to Community-Based Arts, by Mat Schwarzman, Keith Knight, Ellen Forney and others

Building Commons and Community, by Karl Linn

Doing Time in the Garden: Life Lessons through Prison Horticulture,
by James Jiler

New Creative Community: The Art of Cultural Development,
by Arlene Goldbard

Performing Communities: Grassroots Ensemble Theaters Deeply Rooted in Eight U.S. Communities, by Robert H. Leonard and Ann Kilkelly, edited by Linda Frye Burnham

Undoing the Silence: Six Tools for Social Change Writing
by Louise Dunlap

Works of Heart: Building Village through the Arts edited,
by Lynne Elizabeth and Suzanne Young

Upcoming titles include:

Between Grace and Fear: Arts in a Time of Change,
by William Cleveland and Patricia Shifferd

By Heart: A Prison Conversation, by Judith Tannenbaum
and Spoon Jackson

What We See: Advancing the Investigations of Jane Jacobs,
edited by Stephen Goldsmith and Lynne Elizabeth

Order books, join our online community, and learn more about the press:
www.newvillagepress.net